BEYOND THE SOVEREIGN SELF

B E Y O N D

THE SOVEREIGN SELF

AESTHETIC AUTONOMY

FROM THE AVANT-GARDE TO

SOCIALLY ENGAGED ART

DUKE UNIVERSITY PRESS
Durham and London 2024

GRANT H. KESTER

© 2024 DUKE UNIVERSITY PRESS
All rights reserved
Designed by A. Mattson Gallagher
Typeset in Untitled Serif and Helvetica Rounded LT Std
by Westchester Publishing Services

Library of Congress Cataloging-in-Publication Data
Names: Kester, Grant H., author.
Title: Beyond the sovereign self : aesthetic autonomy from the avant-garde to socially engaged art / Grant H. Kester.
Description: Durham : Duke University Press, 2024. | Includes bibliographical references and index.
Identifiers: LCCN 2023002547 (print)
LCCN 2023002548 (ebook)
ISBN 9781478025344 (paperback)
ISBN 9781478020585 (hardcover)
ISBN 9781478027478 (ebook)
Subjects: LCSH: Art—Philosophy. | Art criticism. | Autonomy (Psychology) in art. | Subjectivity in art. | Avant-garde (Aesthetics)—History—20th century. | Art, Modern—Political aspects. | Art and society—History—20th century. | BISAC: ART / Criticism & Theory | PHILOSOPHY / Aesthetics
Classification: LCC N7476 .K46 2024 (print) | LCC N7476 (ebook) | DDC 701—dc23/eng/20230825
LC record available at https://lccn.loc.gov/2023002547
LC ebook record available at https://lccn.loc.gov/2023002548

To Samira and Elliott, always and forever . . .

CONTENTS

1 Introduction

I. WITHIN AND BEYOND THE CANON

1

33 The Incommensurability of Socially Engaged Art

2

54 Escrache and Autonomy

II. FROM OBJECT TO EVENT

3
85 Dematerialization and Aesthetics in Real Time

4
105 The Aesthetics of Answerability

III. A DIALOGICAL AESTHETIC

5
137 Social Labor and Communicative Action

6
171 Our Pernicious Temporality

7
202 Being Human as Praxis

229 Conclusion
Beyond the White Wall

235 Notes
255 Works Cited
271 Index

INTRODUCTION

It is one thing to be active in relation to a dead thing, to voiceless material that can be molded and formed as one wishes, and another thing to be active *in relation to someone else's living, autonomous consciousness.*
—Mikhail Bakhtin, *Problems of Dostoevsky's Poetics*

Beyond the Sovereign Self explores the concept of aesthetic autonomy as it relates to contemporary activist art practices and to the broader processes of social transformation with which they are engaged. This linkage may seem counterintuitive, given the conventional association of aesthetic autonomy with a radical separation between art and political action. As I will argue here, however, the modern concept of aesthetic autonomy is inherently political. It is predicated on a set of interdependent claims regarding the privileged capacity of artistic production to reflect critically on the operations of the capitalist system and to empower us to imagine a future alternative to this system. The concept of aesthetic autonomy covers over a highly differentiated

field of meanings and values. First, we have the notion of aesthetic autonomy as marking the artist's freedom from what is seen as an intrinsically coercive social order (a meaning that first emerges in the work of figures such as Friedrich Schiller). As a result of this freedom, the artist is able to reflect back critically on a broader system of repression from which they themselves have escaped. In this manner, autonomy is collapsed into a notion of critical distance that is specific to the artistic personality and, as we will see, to art in general. Here, the concept of aesthetic autonomy as enjoining a freedom *from* external control is paired with a corresponding power *over* others. (The artist's exemplary freedom allows them to claim an adjudicatory relationship to the consciousness of those who are not yet free.) If the first meaning of the term "autonomy" understands the individual as existing apart from an external world that constantly threatens to erode the integrity of their core self, the second meaning understands the production of truth as necessitating a withdrawal from material entanglement with the world about which that truth is sought. In each case, what is naturalized is a version of personal sovereignty that will be a central concern in the following study.

This is a paradigm of aesthetic autonomy that continues to inform our understanding of art, and the personality of the artist, to the present day. And it is this same paradigm that is being challenged by new forms of engaged art practice that have emerged over the past thirty years. These can be defined as artistic practices that operate largely outside the institutionalized art world of galleries, museums, auction houses, and biennials and that are often produced in conjunction with forms of social or political activism. Representative examples include the escrache actions of the early 2000s, which addressed the violence perpetrated by Argentina's military junta during the 1970s and 1980s; the *Tamms Year Ten* project, which led to the closure of a notorious supermax prison in Illinois; Bishan Commune, a quasi-anarchist community-based project developed in rural China; the "Washing the Flag" performances in Peru, which contributed to the overthrow of Alberto Fujimori's regime in 2000; staged interventions on the streets of Iran in which women sing and dance openly in public; the Rhodes Must Fall protests in Cape Town, South Africa; the Rojava Film Commune, a collective operating in the autonomous region of northern Syria; Renata Carvalho's work with the National Movement of Trans Artists in Brazil; and art practices associated with the Black Lives Matter movement in the United States.[1] These examples give some sense of the remarkable variety of political and social concerns evident in this diverse body of work. My goal in this book is to examine the ways in which these practices have transformed

the notion of aesthetic autonomy outlined above, and to offer an alternative aesthetic paradigm that can account for their unique capacity to enrich our understanding of both art and political transformation.

In some cases, these projects were linked with broader social movements that produced concrete changes in particular institutional structures (contributing to the overthrow of a dictatorship or the closure of a prison), while in others they simply served to bind together, for a brief moment in time, a body of individuals who sought to register their opposition to seemingly intractable forms of social and political domination. Across this broader continuum, we can identify a set of key mediations: between localized action and more systematic forms of change, between the pragmatic demands of resistance and its creative and prefigurative potential, between transformations in individual subjectivity and a broader social or collective consciousness, and between artistic production and praxis. These are forms of mediation, as I will argue here, that have significant implications for our understanding of the relationship between political and aesthetic knowledge. We are witnessing, in this diverse body of work, a paradigm shift that has profound implications for our understanding of the longer trajectory of modernist art. In particular, it marks the transition from a residual aesthetic paradigm, associated with the traditions of the historical avant-garde (and dependent on the conventional notion of aesthetic autonomy sketched out above) to an emergent paradigm predicated on a dialogical understanding of aesthetic experience. Most crucially, these projects are concerned with how we come to resist. What forms of consciousness, sociality, and imagination lead us into action? And how does the experience of resistance itself encourage the emergence of new forms of creativity and critical insight?

The innovations evident in contemporary socially engaged art can be traced to a number of precedents, including "dematerialized" art practices during the 1960s and 1970s, as well as the subsequent emergence of new forms of activist and "new genre" public art during the 1980s and early 1990s.[2] It is important to bear in mind, however, that socially engaged art did not simply emerge sui generis over the past few decades. Rather, it marks only the most recent manifestation of a desire to engage creatively with the norms of aesthetic autonomy that extends back to the nineteenth century. It is evident in Honoré Daumier's lithographs following the July Revolution and in the Arts and Crafts movement during the 1860s and 1870s; in the prefigurative cultural politics of the Paris Commune and the anarchist illustrations of the Neo-Impressionists; in the revival of khadi cloth in the Indian Independence movement and in the prints of El Taller

de Gráfica Popular in Mexico in the 1930s; in Augusto Boal's Theater of the Oppressed and in Emory Douglas's images for the Black Panther Party; and in the performances of El Teatro Campesino in the 1960s and the theatrical productions of the Minjung Movement in South Korea during the 1980s.[3] Here art is understood to possess an important capacity to mobilize forms of critical and prefigurative insight in conjunction with processes of political and social transformation. For artists working in this tradition, the official "art world," composed of galleries, auction houses, dealers, and collectors, is seen as a key ideological component of the capitalist system, allowing for the symbolic staging of expressive freedom and critique only so long as they are restricted to cultural institutions dominated by the bourgeoisie and subordinate to the demands of the market. If art hopes to retain its critical and emancipatory power, it must operate outside these boundaries, establishing alliances with ongoing processes of social and political transformation that seek to challenge the underlying forms of economic domination on which the art world itself depends.

Even as artistic practice has been transformed over the past three decades, the theoretical discourse associated with contemporary art remains, by and large, invested in a more conventional understanding of the relationship between art, the institutional art world, and mechanisms of political transformation. In this view, art can preserve its unique "dissensual" power only by remaining sequestered within the institutional and discursive confines of the museum and the gallery. "To be a work of art," as literary theorist Nicholas Brown argues, "means to intervene in the institution of art, which is in turn the social basis of the artwork: what makes it count."[4] Rather than marking a shift in the underlying ontology of artistic production, socially engaged practices are understood as a misguided aberration that squanders art's critical potential by operating outside the protective enclosure of the bourgeois art world. Here we can identify a second tradition in which the utopic power of art rests precisely on its capacity to incarnate a pure, or ideal, form of consciousness that cannot be sullied by exposure to the fractious world of political and social struggle. In this tradition, famously articulated by Schiller in *Letters on the Aesthetic Education of Man*, art must confine itself to "the realm of semblance alone," where it will function to transform the consciousness of individual viewers or readers, making them less prone to instrumentalizing violence.[5] As Schiller will contend, humanity cannot be trusted to engage in substantive political change until *after* this process of "aesthetic education" has been completed. It is a process that unfolds in the protective enclosure of a bourgeois cultural sphere composed of galleries,

theaters, and concert halls, which emerged in conjunction with the modern art market during the late eighteenth century.

This belief system will be both challenged and renewed by figures such as Theodor Adorno, who will argue during the 1960s that meaningful political transformation is entirely foreclosed and that the only effect of an activist art practice is to foster the naive belief that "decisive change" is possible under a system of "total administration." The very conventions of autonomy (and the institutional art world that houses them) that the first tendency views as a disabling constraint reappear in this tradition as the only thing that prevents art's fragile emancipatory potential from being extinguished in a sea of kitsch and propaganda. While the art world is not understood as an entirely protected space in this paradigm (its complicity with capitalism has to be partially acknowledged in order for the artist to act out a symbolic resistance against it), this complicity is assumed to be relatively superficial and fundamentally different from the forms of complicity that operate in virtually every other sphere of bourgeois society. It is precisely this belief that many socially engaged artists have sought to challenge, not because they believe that art world–based practices cannot be critical but because they reject the assumption that *only* art world–based practices possess this capacity.

If the first orientation can underestimate the extent to which political action imposes its own forms of instrumentalization on the artistic projects produced in its orbit, the second orientation is characterized by an unrealistic faith in the ability of art world–based practices to transcend the often-ritualized forms of dissent that are tolerated in the space of the gallery, museum, or biennial. This outline suggests a bifurcation, however, that is often belied by the experience of individual artists who can work across both of these tendencies. These two positions should be understood as discursive horizons that orient the larger worldviews of artists and theorists rather than indicators of the actual freedom or autonomy enjoyed by a specific form of art practice. As I will argue here, the concept of artistic autonomy does not refer to an empirically verifiable quality of existing artworks. There is no art form that manages to abstract itself entirely from entanglement with complex political forces both within and beyond the art world. Thus, gallery- or museum-based artworks also engage with the social or political sphere in a myriad of ways (as financial instruments for the wealthy, as a form of symbolic capital that legitimates the larger art market, etc.). By the same token, activist artworks always bear a mediated and quasi-autonomous relationship to praxis. Even the most militant street action is caught up in a chain of signifiers, forms of affect, gestural politics, and spatial choreographies

that structure its political significance at any given moment. The discourse of aesthetic autonomy, performed through the self-understanding of artists and the embodied effects of specific art practices and institutional systems, is better understood as marking a set of a priori judgments regarding the potential for, or the impossibility of, substantive political change in a given historical moment. These judgments are, in turn, linked to a set of practice-based protocols and ideological formations that correspond to their respective claims (that meaningful political transformation is possible here and now or that it is premature or misguided). This accounts for the central tension within the history of modernism between a concept of art that must remain inviolable and pure and a concept of art that gains its power precisely through its active engagement with the impure actuality of the world as it is.

It is this second tendency that has reemerged in socially engaged art practices since the 1990s. My goal in this book is to examine the ways in which these practices have transformed our understanding of the aesthetic and aesthetic autonomy. This investigation will, by necessity, entail a closer examination of the normative forms of autonomy that evolved out of the earlier avant-garde tradition and that continue to be operative in the mainstream art world. In developing this analysis, I will be exploring theoretical sources (the concept of social labor in the Marxist tradition, anticolonial theories, Mikhail Bakhtin's analysis of "dialogical" experience) that can help us make sense of this transformation and that can contribute to the formation of an alternative paradigm of the aesthetic appropriate for this work. Thus, this book is also concerned with the complex interrelationship between Marxism and the aesthetic. I want to begin by offering the reader some provisos. First, this book is not intended to provide a single unified "theory" for socially engaged art practice. That seems both unrealistic (given the diversity of the field) and antithetical to the situational nature of the practice itself. Rather, it takes contemporary socially engaged art as the occasion for a broader set of reflections on the nature of aesthetic autonomy that can also help illuminate aspects of historical art practice that have remained less visible to us. I will contend that contemporary socially engaged art encourages us to think differently about the relationship between art, the aesthetic, and the political. At the same time, the term "socially engaged art" simply serves to identity the most recent iteration of a tendency that is threaded throughout the history of modernism and that has important antecedents and parallels both within and beyond the art world itself. For this reason, this study will examine earlier examples of artistic production in order to decipher deeper points of affinity across this broader historical continuum.

Second, while this book will range widely across critical theory as well as art history, it is not my intention to subordinate artistic practice to some overarching theoretical narrative. But neither do I wish to reduce theory to a set of simple prescriptive guidelines whose only function is to provide an analytic framework for socially engaged art. I view both theory and artistic practice as affiliated forms of creative production with their own unique qualities, points of convergence, and moments of disjunction. Rather than subsuming one into the other, I am concerned with the forms of insight that emerge at the intersection of each of these distinct modes of production. Thus, this book will explore the complex internal dynamics of individual theories at various points, not because they illustrate some specific feature of socially engaged art, but because they help to reveal a larger constellation of ideas around the aesthetic and the political. These ideas, associated with the ways in which subjectivity is produced at the "threshold" between self and other, as Bakhtin writes, mark a significant transformation in the discursive structure of contemporary culture more generally.[6] This shift is evident in new paradigms of participatory or collaborative creation that have emerged in a range of areas, from socially engaged art to political activism to theories of participatory democracy and beyond.

Here I should note a final proviso. While this book will offer some descriptions of specific projects, it is not intended to provide a survey of recent socially engaged art. There are a number of excellent books that fulfill that role, within an increasingly global context. I will address some newer projects, as well as some older projects, but not in a comprehensive or synoptic manner. I do so not because there is not any more recent work to discuss but because these projects exemplify specific theoretical or analytic themes developed in the book as a whole. My concern, in short, is not with the most current expression of socially engaged art but with identifying certain continuities in its broader evolution over the preceding decades. Additionally, my primary focus will be on projects that evolved out of specific sites of social or political resistance (the struggle against the Fujimori dictatorship in Peru, for example, or activism related to incarceration) rather than projects that have been commissioned by art institutions or foundations. These sorts of commissioned projects are especially common in the US and Europe due to the rapid institutionalization of "social" art practices in these regions.[7] This distinction is significant for my analysis because I believe that the emergence of resistance itself, from a specific matrix of political forces and in response to specific modes of repression, entails an important form of creativity. The same is true of the processes that are necessary for an artist

or collective to gain entry to and build a rapport with a given community engaged in organized forms of resistance or social change.

There is a growing critical literature devoted to the analysis of socially engaged art, with books by Jennifer González, Shannon Jackson, Gregory Sholette, Pablo Helguera, Nato Thompson, Izabel Galliera, Marc Léger, Meiqin Wang, Justin Jesty, Carlos Garrido Castellano, Jennifer Ponce de León, Kim Charnley, and many others.[8] It is notable that much of this research is by either curators and artist-critics, like Helguera, Sholette, and Thompson, or by figures who work in fields adjacent to art history, such as Jackson, who is a performance studies scholar, or Jesty, who is a Japanese studies specialist. Until fairly recently, conventionally trained art historians have exhibited less interest in socially engaged art, and when they did write about it, they often expressed skepticism about the artistic merits of this work or its capacity to generate a meaningful "aesthetic" experience.[9] This skepticism has taken varying forms over the years, but it is defined by two common assertions. First, it hinges on the argument that socially engaged or activist art practices necessarily subordinate any generative aesthetic qualities to mercenary calculations of political efficacy. Or, put differently, it assumes that it is impossible for a project that is concerned with the practical transformation of existing social or political reality to also incorporate a creative aesthetic dimension. And second, this skepticism is based on the contention that any emancipatory effects produced by these projects will be immediately recuperated by the mechanisms of capitalist hegemony and used to provide ideological validation for ongoing, structural forms of repression. The second argument, which I will discuss below as an "exculpatory" critique, has only an indirect link to the question of aesthetic or artistic value. The first critique, however, appeals directly to a set of theoretical claims about the nature of the artwork and the forms of knowledge generated by both aesthetic and politically transformative experience. This question, the question of the aesthetic significance of socially engaged art, is a central concern of this book. While I have discussed the aesthetic dimension of socially engaged art in my past books, my primary focus has been on developing a critical language and a set of research methodologies that are appropriate to this work. In this book, however, I will address the aesthetics of socially engaged art in a more sustained manner. In particular, I will explore the ways in which this work both contests and reinvents a principle of aesthetic autonomy and criticality that is associated with the traditions of avant-garde art. In conjunction with that endeavor, I will also

be exploring the complex imbrication of aesthetic and political meaning in the theoretical discourse of the avant-garde more generally.

After beginning this research several years ago, I concluded that the task of developing an aesthetic account of socially engaged art was impossible without first interrogating the normative paradigm of aesthetic meaning that is typically encountered in mainstream criticism and theory, and against which socially engaged art is measured and found wanting. What precisely do we mean when we say a given work of contemporary art possesses "aesthetic" value and another one does not? And how is that specifically aesthetic significance related to more generic forms of critical insight or creativity? My analysis of the contemporary articulation of aesthetic meaning required, in turn, an engagement with the political history of the aesthetic itself. This historical inquiry was necessary in order to comprehend what is distinct about contemporary socially engaged art while also recognizing its less visible continuities with earlier artistic and aesthetic traditions. Thus, *Beyond the Sovereign Self* began life as part of a longer manuscript, the first half of which analyzed the historical evolution of the aesthetic as it relates to questions of political transformation and subjectivity. In this analysis, the concept of aesthetic autonomy emerged as a central locus, allowing me to identify certain symptomatic tensions in the modern construction of both artistic meaning and artistic subjectivity. The task of addressing this complex history in a substantive manner, however, took on its own life. As a result, I made the decision to divide the original manuscript into two separate studies, each of which constitutes a unique, but interdependent, research project. The first volume, *The Sovereign Self: Aesthetic Autonomy from the Enlightenment to the Avant-Garde*, provides a new interpretation of the evolution of aesthetic autonomy, describing key continuities over the long trajectory from Enlightenment philosophy to the discourse of the avant-garde to contemporary art theory. The second volume, presented here, builds on this foundation to account for fundamental shifts that have occurred in the aesthetics of contemporary art with the expansion of socially engaged practices while also extending the analysis of the avant-garde introduced in *The Sovereign Self*. These two tasks are related, as the changes associated with the development of socially engaged art involve a transformation in the structure of aesthetic autonomy itself (at the level of the identity of the artist and the relationship of the work of art to the broader social and political world). Or rather, we might say that this work reflects the coming into visibility of an aesthetic paradigm within

modern art that has often been obscured. For this reason, it is impossible to develop a substantive theoretical account of engaged art without at the same time addressing the ways in which its contemporary production has been informed by deeper historical currents within the modernist tradition.

Chapter Summaries

The following study is divided into seven chapters. In the introduction, I will synopsize the underlying historical analysis that is developed more fully in *The Sovereign Self*. This will entail the description of a schema or discursive structure that informs the Enlightenment paradigm of aesthetic autonomy and that is carried forward in revised form in the traditions of the European avant-garde. This analysis will allow me to identify certain constituent features of aesthetic autonomy over its longer historical arc. These core features constitute a kind of preconscious horizon that continues to inform and constrain our understanding of the critical potential of contemporary art to the present day. One of the central characteristics of this structure is an apophatic orientation in which the identity of an avant-garde practice is predicated on its differentiation from an adjacent form of cultural production that can be accused of sacrificing art's unique critical potential. In chapter 1, I will examine this process as it unfolds in the work of French theorist Jacques Rancière. Rancière's effort to revive the analytic paradigm outlined in Schiller's work demonstrates the remarkable durability of Enlightenment-era concepts of the aesthetic. As I will argue, while Rancière's appropriation of Schiller is selective (he focuses on the principle of playful nonidentity embodied in Schiller's analysis of the *Juno Ludovisi*), he retains the underlying social architecture on which Schiller's analysis depends (the subject positions and forms of competence assigned to the artist and viewer in relationship to the work of art). Here I will explore the complex shifts that occur as Rancière's earlier commitment to the cognitive acuity of the working class is translated into his analysis of the avant-garde traditions of the nineteenth and early twentieth centuries. With Rancière, we can also observe the symptomatic differentiation between avant-garde artistic practice and a degraded other, represented for him by the escrache tradition, a form of activist art first developed in Argentina during the 1990s.

I will examine this conjunction more closely in chapter 2. For Rancière, the escraches violate the necessary separation of the artist from the exigencies of social or political change, thereby abandoning art's unique critical

potential. In this chapter, I will challenge this interpretation, drawing out aesthetic qualities associated with engaged art that are not apparent within the hermeneutic frame employed by Rancière. Through detailed readings of several projects (including an analysis of the escraches themselves), I will identify the ways in which aesthetic and critical experience is mobilized in these works through forms of sociality and resistance that operate outside the institutional art world. I will also link these contemporaneous practices with a longer tradition of collaborative and activist production within the avant-garde. Here I will argue that the new forms of insight catalyzed by the escraches are simply the most recent manifestation of a mode of creative production that has many precedents in the broader modernist tradition. While it has been periodically exiled from the canonical body of avant-garde art, it remains nonetheless an essential, if often spectral, presence on the margins of art historical discourse. This chapter will conclude with a discussion of the "melting down" of existing forms of aesthetic autonomy in the European avant-garde during the 1920s and 1930s, focusing on Walter Benjamin's analysis of Sergei Tretyakov's "operative writer."

This historical analysis will be carried forward in chapter 3, where I will explore the "dematerialization" of artistic practice through new, collaborative methodologies during the 1960s and 1970s. This period marked the shift from an object to an event-based aesthetic paradigm with significant implications for contemporary art. Both melting down and dematerialization imply a process by which a fixed or static form of identity—of cultural genres, of the artwork's physical embodiment—undergoes a process of creative dissolution and reassembly. In each historical moment, a window of transformative potential is opened through which the conventions of artistic autonomy become visible, and susceptible to reconfiguration, against the ground of a more general climate of political change. Here I will contrast two modalities of dematerialization that occur in artistic production during this period. On the one hand, we encounter a process of "de-transcendentalization" in the work of figures such as Adrian Piper, whose performance-based practice is concerned with forms of critical insight generated in the interstices between self and other. And on the other hand, we can identify a corresponding form of "re-transcendentalization," as the locus of critical insight is transposed to the speculative consciousness of the artist, exemplified by figures such as Joseph Kosuth and Lawrence Weiner. I will explore the tensions between these positions as they unfold in the contrasting methodologies of two experimental film collectives working in France during the late 1960s (the Dziga Vertov Group and the Medvedkin Group).

In chapter 4, I will build on the empirical analysis of specific projects presented in the previous two chapters to identify a set of generic characteristics associated with socially engaged art more broadly. If the avant-garde schema is predicated on the assumption that decisive political change is foreclosed in the current moment, engaged art assumes that its potential here and now is not yet exhausted. This entails, of course, a very different political imaginary and a mode of critical thought that is waged against the ongoing forms of repression or domination encountered in the social world beyond the gallery and museum space. This fundamentally alters the aesthetic claims of engaged art, requiring an analysis that is sensitive to the scalar specificity of this resistance, as it moves from the reshaping of the individual consciousness to collective action to social or political transformation. I will introduce specific examples to illustrate this scalar range, from the subversive interventions of Iranian women dancing and singing in public space to the *Tamms Year Ten* project in the United States to the *Lava la Bandera* actions in Peru. In each case, we can identify a unique mode of praxial insight that combines tactical knowledge, critical analysis, and prefigurative forms of social experience. Here the key features of the discourse of avant-garde aesthetic autonomy become points of heuristic inquiry rather than axiomatic truths.

This taxonomic outline will provide the foundation for chapter 5, in which I turn to the Marxist concept of "social labor" to delineate an alternate theoretical paradigm that can account for the creative and quasi-aesthetic qualities of collective resistance. In this view, the act of resistance is not simply pragmatic but also has the capacity to transform the consciousness of the agents of resistance themselves, laying the groundwork for the development of alternative social forms that can transcend the limitations of the capitalist lifeworld. While often derided in contemporary critical theory as a vestige of Karl Marx's early "humanist" writing, I argue that social labor provides a valuable resource for rethinking the self-transformative potential of political action. It will also inform a second and third generation of Frankfurt School thinkers (Jürgen Habermas, Axel Honneth, Hans Joas) as they seek to move beyond the melancholic resignation of Adorno and Max Horkheimer's later work through theories of "communicative action" and "recognition." We also encounter a significant parallel to the concept of social labor in the cultural modalities of "new social movements" during the 1960s and 1970s, which expanded to address forms of oppression based on gender, sexuality, and race as well as class.

While the concept of social labor is a valuable tool in helping us disclose the aesthetic potential of engaged art, it also carries its own liabilities. As

I will discuss in chapter 6, social labor relies on a conventional model of autonomous subjectivity, in which selfhood is defined by the appropriative mastery of the external world. As a result, it can effectively bifurcate an instrumental form of subjectivity, necessary for political change, from a prefigurative transformation of the self, necessary to envision and sustain an emancipatory society. Socially engaged art practices seek to combine these two modalities. In order to preserve this multivalent aspect of engaged art practice, it is necessary to supplement the concept of social labor with an alternative model of intersubjective experience found, among other places, in the work of Mikhail Bakhtin. With Bakhtin we can identify an aesthetic paradigm that accounts for the creative processes involved in the reciprocal transformation of self and other in "dialogical" artistic exchange. Bakhtin's critique of "monological" forms of identity allows us to think both within, and against, the Marxist tradition in order to advance a more fully materialist account of social interaction and political transformation. We find a parallel resource in anticolonial theory, which embraces elements of a Marxist analysis while at the same time drawing our attention to the liabilities of its often-Eurocentric outlook. This is evident in the work of figures such as Édouard Glissant, whose concept of cultural "creolization" parallels Bakhtin's notion of dialogical cultural exchange.

In chapter 7, I will draw these threads together to reflect on the broader political implications of a dialogical aesthetic paradigm. As the example of Glissant suggests, Bakhtin's work has important resonances in the realm of anticolonial theory, playing a significant role in Homi Bhabha's influential concept of cultural hybridity. At the same time, as critics such as E. San Juan Jr. note, there is a commensurate tendency in this approach to detach the experience of individual self-transformation that occurs in dialogical exchange from the processes by which these same individuals might come together to engage in meaningful social and political resistance. I will explore this tension here, sketching out a set of parallel discursive structures that impose a binary division between forms of localized social change and structural or global revolution and between forms of identity based on racial, ethnic, or sexual difference and class-based identities. As I will argue here, there is a danger in contemporary left theory of abandoning a close understanding of the material conditions that lead people to demand change and the specific, embodied conditions of both repression and resistance. We find valuable insights for understanding this embodied condition in the realm of anticolonial and Black theory, among other sources. Here I will reference Boaentura de Sousa Santo's notion of a "rearguard" theory that seeks to establish a dialogical,

rather than a regulatory, relationship with praxis. I will also outline a set of examples, including the Shackville protests at the University of Cape Town in 2016 and recent work by indigenous artists and activists in Canada, to suggest the ways in which embodied experience, political change, and self-transformation can be brought together within a single practice.

This research marks the culmination of a set of concerns that have gradually evolved since I first began writing about socially engaged art in the 1980s. As I will argue here, I believe this work reflects a new configuration of the aesthetic, with implications that extend beyond the realm of socially engaged art alone. Precisely in challenging existing paradigms of artistic production, this work can illuminate important aspects of past art history and theory that have remained inaccessible to us. At the same time, in its conscious engagement with processes of social and political transformation, this work also expands our understanding of the complex interaction between aesthetic and political experience today. My goal, in both this book and *The Sovereign Self*, is to understand more fully the nature of this interaction. Taken as a whole, these books do not simply outline a new aesthetic paradigm; they also constitute an attempt to reconsider the nature of the aesthetic within modernity more generally. As a result, they are in dialogue with scholarly traditions and readerships outside those associated with socially engaged art, including aesthetic philosophy, political theory, and the history of the avant-garde. Given the interconnected nature of these two books, it will be helpful to provide the reader with an outline of the historical and theoretical argument that is developed more fully in *The Sovereign Self*. This outline can, by necessity, only be schematic, but I hope to indicate some of the key tensions in existing paradigms of aesthetic autonomy that will be renegotiated in the evolution of socially engaged art practice.

Aesthetic Autonomy in the Enlightenment

Only the capacity to act as a moral being gives human beings a claim to freedom; but a mind that is capable of acting only according to sensuous motives deserves freedom as little as it is receptive for it.

—Friedrich Schiller, letter to Duke Friedrich Wilhelm Augustenberg, 1793

The concept of autonomy, which plays a central role in *The Sovereign Self*, originates in the Enlightenment political theory of figures such as Locke, Grotius, and Hobbes and only subsequently migrates into aesthetic philosophy. Autonomy in the context of liberal political theory refers to the

capacity of the individual to generate their own norms. It emerged in the seventeenth century as part of an effort to challenge absolutist and sacral forms of political authority.[10] Autonomy was thus concerned with defining a new mode of subjectivity that would be capable of generating its own social values and governmental forms instead of having them imposed by an external and arbitrary power. It appealed in turn to the complex process by which these values and forms might be generated through the creative negotiation of human differences and societal tensions. At the same time, autonomy, understood as a liberatory demand for absolute personal freedom, always carries within itself the justification for a process of intersubjective violence necessary to secure this freedom. It also carries the implication that the natal condition of the human self is a radical individuality, poised against the intrusion of coercive external forces (the "conception of myself as an absolutely free being" who emerges "out of nothingness," as Hegel wrote).[11] This facet of autonomous selfhood was dramatically enhanced by the linkage of political liberalism with the ethos of possessive individualism promulgated by capitalism. Here the "self" implied by the experience of autonomy is given a more specific ontological orientation, associated with an acquisitive model of subjectivity, in which one seeks to exercise a transcendent mastery over the world and other selves. As a result, a form of autonomous subjectivity that is defined by a dialogical openness to other selves, necessary to ground the process of consensual will formation, coexists with a form of autonomous subjectivity defined by the instrumentalization of other selves.

Norms are shared constructs that gain their significance from their ability to regulate social interactions beyond the individual conscience. How, then, do we ensure that individual selves, newly liberated from absolutist rule, do not simply impose their own self-generated norms on other, equally autonomous, selves? Or, to pose the question differently, how do we understand our capacity for freedom in the absence of the coercive external force that had previously regulated human conduct? There is an underlying fear in the early modern period that the natural human condition was one of primitive barbarism (now exacerbated by the rise of capitalism) that could only be held in check by the transcendent authority of a god or king. This fear of the innate violence of the human self was further heightened in the period following the French Revolution. Both Immanuel Kant and Schiller viewed the Reign of Terror as evidence that humanity was not yet ready for true liberation. Schiller's *Aesthetic Education* was, in fact, written in its shadow. As he famously observed, "The fabric of the natural State is tottering, its rotting foundations giving way, and there seems to be a physical possibility

of . . . making true freedom the basis of political associations. Vain hope! The moral possibility is lacking, and a moment so prodigal of opportunity finds a generation unprepared to receive it."[12] As a result, the moment that is promised in the concept of political (and aesthetic) autonomy, the moment at which human selves gather together to creatively and collectively generate their own consensual values, must be deferred. As Schiller wrote, "we must continue to regard every attempt at political reform as untimely . . . as long as the split within man is not healed."[13] It was the work of aesthetic experience, according to Schiller, to repair this division through the individual's privatized encounter with a work of art.

The new forms of democratic will formation made available by the decline of absolutist rule implied a social order predicated on a fundamental political equality. Here the fixed hierarchies of the ancien régime will be replaced by a radically egalitarian system that is prefigured in aesthetic experience itself. "No privilege, no autocracy of any kind," as Schiller writes, "is tolerated where taste rules and the realm of aesthetic semblance extends its sway."[14] But this utopian society was compromised in its earliest stages by the parallel emergence of new forms of bourgeois subjectivity that introduced their own hierarchical division, between those who deserve political freedom (the bourgeois subject, able to actualize his will in the transformation of the natural world) and the poor and working class, whose lack of entrepreneurial spirit condemns them to a life of dependence and penury. As Sylvia Wynter has argued, this division, structured around incipient forms of class division, was, in fact, dependent on a priori forms of racial difference that emerged in the wake of the European colonial enterprise. Here the non-European self was consigned to the status of barbaric other, incapable of accessing the core of natural human reason and driven instead by their animalistic bodily passions. "It was to be the peoples of the militarily expropriated New World territories, as well as the enslaved peoples of Black Africa," as Wynter writes, "that were made to reoccupy the matrix slot of Otherness—to be made into the physical referent of the idea of the irrational/subrational Human Other."[15] We encounter here the origin of a fundamental discursive division between mind and body, reason and emotion, that will be applied indiscriminately to women, colonized subjects, and the European working class, all of whom are deemed unworthy of the freedom made available by political autonomy.

Before we experiment with freedom, then, we must first undergo a process of "aesthetic education" by which our consciousness, damaged by the dehumanizing effects of modernity, will be rehabilitated. Through art we will learn to adopt an attitude of empathic openness to others rather

than seeking to dominate and instrumentalize them. In fact, the political imaginary of the aesthetic evoked by Kant, Schiller, and later G. W. F. Hegel is, precisely, the image of a society in which each individual is able to enjoy absolute personal freedom without any fear that their actions might impinge on the equally unconstrained actions of others. This is the mythos of the aesthetic state, pervaded by a natural social harmony in which intersubjective violence is entirely banished and all tensions between self and other are effortlessly reconciled because the very nature of the human self has been transformed. This will occur through the inculcation of a capacity for aesthetic "disinterest" facilitated by works of art or literature rather than the self-interest that is reinforced by the market. But for this ameliorative self-transformation to occur, the experience of art, of the aesthetic, must be restricted to "the realm of semblance alone," as Schiller writes (acting out, virtually, the reconciliation of self and other through our encounters with artworks rather than other human agents).[16] Any pragmatic effort to produce social or political transformation here and now, to mobilize actual processes of consensual norm generation, remains "premature," according to Schiller, due to the limitations of existing public consciousness, which is torn between the "crude, lawless instincts" of the lower orders and the "lethargy and depravity" of the civilized classes.[17]

The aesthetic emerges, then, as the solution to a key point of uncertainty within political modernity: Do we have the capacity to enjoy freedom without lapsing into violence?[18] The answer is yes, but that capacity is as yet only latent in the human personality and must be cultivated slowly over time. Only after the aggregation of countless moments of individual enlightenment, through the consumption of art, will a critical mass of transformed individuals emerge who are capable of exercising true political freedom in a civil manner. In this dynamic, the artist plays an absolutely central role, as the single agent able to prefigure the transformed paradigm of the self toward which society as a whole should aspire. And art, precisely because it unfolds at the level of the symbolic or virtual, entirely independent from the world of practical experience, is the only path along which this process can safely unfold (due to the otherwise corrupt nature of existing society). While this prefigurative experience of self–other harmony can only occur at the level of the individual consciousness, it holds out the promise that it will one day be universalized in practice. In *The Sovereign Self*, I outline a schema to more clearly describe the specific features of the Enlightenment aesthetic, which I will synopsize here. This schema is predicated on a set of implicit assumptions about the nature of modernity, the potential for—or

the impossibility of—substantive political change, and the role of art that will be carried over and reformulated in the discourse of the avant-garde.

This schema is organized on two related levels. The first level concerns the particular model of social reality implicit in the concept of aesthetic autonomy and against which an aesthetic experience is presumed to unfold. This would include a paradigm of social transformation as well as the ideal political system toward which this transformation aspires. It also includes a concept of human psychological development necessary to facilitate this transformation (a model of the kind of self that is produced by current social conditions as well as a model of the transformed version of that self that will result from an aesthetic encounter). Two features of this level are particularly important for my analysis here. The first concerns the perceived incapacity of the masses. The discourse of aesthetic autonomy that emerges out of the Enlightenment assumes that the experience of modernity (specifically, the materialistic self-interest promulgated by the capitalist system) has been deeply corrosive to the human personality, leading to the atrophy of our ability to treat others with respect and compassion. As a result of this quasi-pathological condition, the general population is incapable of higher forms of reasoning and marked by a level of cognitive immaturity that renders them unfit for forms of social or political action intended to challenge the existing distribution of social and political power (a proscription that is imposed even more forcefully on colonized subjects). As a result of the incapacity of the masses, any form of practical, collective action guided by the consciousness of the general public and drawing on their own experience of political action will fail. For Schiller, we must first undergo a process of aesthetic education, while for Hegel we still require the tutelage of the philosopher to resolve conceptual impasses.[19] I will refer to this second feature as the "prematurity of practice" thesis.

If the first level of the schema is concerned with general assumptions about the nature of the self and political transformation, the second level concerns the specific epistemological claims made on behalf of the work of art, and aesthetic experience more generally, in advancing this emancipatory vision. These claims are also organized around two central features. First, they are predicated on the belief that art and the personality of the artist serve as vessels for the new forms of consciousness necessary to launch a successful emancipatory project. Because the aesthetic operates at the level of individual somatic experience, it is uniquely equipped to transform the consciousness of the broader public, which is defined by its dependence on bodily sensation rather than intellect. The idea that art alone is capable of

this ontological reprogramming of the self stems from the growing bifurcation between "fine art" and various forms of popular culture identified by figures such as Schiller and Karl Philipp Moritz as early as the 1780s.[20] This entails a form of apophatic differentiation that will be carried forward in subsequent divisions between advanced art and kitsch in the avant-garde tradition. Here art defines its unique critical power as the negation of principles of semantic accessibility that are exemplified by more popular cultural forms. I will refer to these interrelated assumptions as the "singularity of art" and the "surrogacy of the artist" theses.

The second epistemological claim associated with the discourse of aesthetic autonomy involves the belief that emancipatory insight can only be generated through forms of monadic contemplation, removed from the exigencies of social interaction. While the aesthetic may reach us initially through our senses, its ultimate goal is a form of cognitive reprogramming that can only occur though a strategic transformation of the core self, as it exists prior to any external determination. To facilitate this ontological regression, it was necessary that aesthetic experience be produced through the individual viewer's self-reflective awareness of the operations of their own consciousness. In this sequestered space, social interaction is acted out in our apperceptive recognition of the harmony of the faculties (Kant) or the "free play" of the form giving and sensuous drives (Schiller). Rather than one drive, or cognitive modality, dominating the other, they work effortlessly together. The goal is a form of self-transcendence that occurs through the virtual reconciliation of self and other, or individual and collective, the very process that is meant to unfold in the practical, realized exchanges necessary to achieve consensual norm generation under a condition of true political freedom. In this manner, the experience of beauty lays the groundwork for our eventual participation in actual forms of political transformation. A key corollary assumption here is that all subsequent forms of intersubjective experience and critical insight are dependent on a more profound self-transformation that can only occur in isolation from the social.

Aesthetic Autonomy in the Avant-Garde

The unconscious aesthetic standards of the masses are precisely those that society needs in order to perpetuate itself and its hold on the masses. The pressures of a heteronomous life force them to accept diversion instead of making them reach for the concentration required by a strong ego.

—Theodor Adorno, *Aesthetic Theory*

Conventional wisdom suggests that the emergence of a discourse of avant-garde transgression in the mid-nineteenth century marked a decisive break with the principle of aesthetic transcendence that we associate with the traditions of the Enlightenment. Certainly, at the thematic level this would seem to be the case, as the belief that art must present idealized forms of beauty is replaced by the contention that the artist's role is to "lay bare with a brutal brush... all the filth at the base of our society," as Gabriel-Désiré Laverdant argued in 1845.[21] And clearly, models of reception change as well. A key source for this shift is the growing rapprochement between avant-garde artistic discourse and Marxist theory and political activism. It is a convergence that expresses itself in the transposition of the figure of the avant-garde artist and the vanguard revolutionary. In this exchange, artists would directly participate in revolutionary action (evident in Gustave Courbet's involvement in the Paris Commune), but equally importantly, they sought to craft an aesthetic paradigm in which their works would enact a form of revolutionary violence at the cognitive level. Here the relationship between the artist (capable of prefigurative and critical insight into the constitution of a just society) and the public in need of enlightenment is reframed in two variant modes. On the one hand, it is reproduced in the perception of the viewer as a prototypical bourgeois subject whom the avant-garde artist will assail through a punitive perceptual attack (evident in the rhetoric of the Dada and Surrealist movements). And on the other, it is carried forward in Marx's account of the relationship between the "theoretical" communist (typically a bourgeois intellectual who possesses a mastery of abstract revolutionary theory) and the "practical communist" (the worker, whose knowledge is limited primarily to forms of bodily affect and conative agency rather than theoretical insight). Here the Enlightenment hierarchy of mind over body and reason over emotion is reproduced in a revolutionary vernacular. This tendency comes to fruition in Leninism during the early twentieth century, and is evident later in the century in the work of figures such as Mao Tse-tung, who famously described China's masses as a sublimely "clean sheet of paper," upon which the vanguard leader could "paint the newest and most beautiful pictures."[22] This custodial relationship is replicated in avant-garde artistic discourse through the concept of an emancipatory, rather than a punitive, form of assault intended to rouse the somnolent proletariat to a consciousness of its revolutionary mission, evident in the Constructivist tradition of Sergei Eisenstein, Dziga Vertov, Vladimir Tatlin, and others.

The transition to an avant-garde aesthetic paradigm during the late nineteenth century was driven by the recognition that the cumulative model

of social transformation promised by the Enlightenment aesthetic had decisively failed. Notwithstanding several decades during which countless bourgeois viewers had enjoyed the experience of aesthetic transcendence provided by works of art, bourgeois society as a whole had failed to realize the utopian social order that was, ostensibly, anticipated by these individual viewing acts. Here the bourgeoisie hold out the ideal of social harmony as an object of aesthetic delectation even as they deny its practical realization in the realm of political life. In this manner the exculpatory function of the aesthetic allows the bourgeoisie to imaginatively equate its own class-bound experience of beauty with a universal paradigm of taste (and, by extension, to legitimate its own class privilege through cultural means). The avant-garde aesthetic paradigm will seek to reverse this dynamic. Now, the ideal of a disinterested aesthetic experience in which the individual transcends his or her social specificity (and class identity) is replaced by an aesthetic paradigm in which the role of art is precisely to deny the viewer this false transcendence, forcing them instead to confront their own class specificity and guilt. In this manner, an aesthetic discourse of shock and disruption replaces a discourse of contemplative beauty and pleasure.

Notwithstanding these transformations, there remains a subterranean continuity between the two aesthetic traditions. First, the utopian mythos of both traditions remains remarkably consistent. Thus, the telos of the Enlightenment aesthetic state, in which conflicts between self and other are entirely effaced due to a fundamental transformation of human subjectivity, is strikingly similar to the mythos of life under "full Communism" in the Marxist tradition, which is defined by the emergence of a "New Man" who has been entirely purged of self-interest through the crucible of revolutionary struggle. Schiller will argue that any practical political transformation must be deferred until humanity's "aesthetic education" has been completed. "All reform that is to have any permanence," as he writes, "must begin from our whole manner of thinking."[23] Here the prematurity of practice thesis is based on his belief that existing human consciousness was unprepared for the freedom entailed by such a transformation without devolving into violence. Vladimir Lenin will also seek to exercise a pedagogical authority over the masses, who are unprepared for freedom, or at least for truly revolutionary struggle, without the guidance of a vanguard party. However, the utopian reconstruction of human consciousness that he seeks will only fully express itself after the violence of revolution, carried out through the terrorism of the dictatorship of the proletariat, has subsided. In this view, there is no need to "practice" democratic forms of decision-making or experiment with new

social or political structures here and now because, in the aftermath of the dictatorship of the proletariat, human consciousness will be so profoundly altered that politics as we currently understand it will cease to exist and the state itself will gradually "wither away."[24]

As this outline suggests, each of these aesthetic paradigms, the Enlightenment and the avant-garde, is defined by a deliberate depreciation of the creative and prefigurative power of political practice itself. As a result, Lenin remained highly resistant to ongoing calls to introduce more democratic forms of political decision-making both before and after the revolution. It was only after a violent interregnum of "revolutionary terror" that the hardened, appropriative sovereignty of the vanguard leader will give way to a society in which there are no significant differences to negotiate or transcend. Rather than viewing the transition from the Enlightenment to the avant-garde aesthetic as a simple overturning of one tradition by another, it is more accurate to understand it as marking the reorientation of the paradigm of political transformation on which the aesthetic itself is based. The telos of this process remains consistent: a utopia in which the actual, creative processes necessary to produce normative political values have been rendered obsolete by mankind's evolutionary integration into a single, harmonious, universal class (contained embryonically, in the Marxist tradition, in the proletariat). The means to achieving this goal, however, are quite different. Instead of practicing virtualized forms of intersubjective harmony in the aesthetic encounter, we find a new aesthetic paradigm based on disruption, as art takes on a projective (and allegorical) relationship to the direct political violence necessary to produce an all-encompassing transformation of the existing (capitalist) political system. At the same time, the social architecture within which each of these forms of reception is staged (which identifies the artist as a privileged vessel of advanced consciousness) remains unchanged.

It is important to note here that the relationship between the symbolic violence enacted against the implicitly bourgeois viewer by the avant-garde artist and the actual violence of revolution is increasingly framed in the late twentieth century in terms of the perceived impossibility of real political change (due in part to the descent of the Soviet Union into authoritarianism). This marks a decisive shift in the discourse of the avant-garde. Here the "prematurity of practice" thesis of the Enlightenment period reemerges in the belief, central to the work of a figure like Adorno, that revolutionary change is foreclosed due to the implacable forward movement of capitalist instrumental reason. As a result, the utopic promise of the aesthetic is

deferred, once again, to an indefinite future, while the (now revolutionary) consciousness necessary to bring it into practical existence is displaced from the benumbed public to the artist or theorist who serve as their "plenipotentiary." Adorno reproduces an underlying pessimism regarding the revolutionary capacity of the proletariat that is already evident in Lenin, for whom the failure of the Paris Commune seemed to illustrate the inability of the masses, in their quasi-instinctual and spontaneous forms of resistance, to think strategically about their relationship to class domination.[25] For Lenin, this failure demonstrated the absolute necessity that the cognitive leadership of revolution be transferred to a special cadre of vanguard political leaders who would devote themselves entirely to the science of political change. This gesture entailed, in turn, the displacement of revolutionary consciousness from the field of praxis to the domain of theory, where it would be sustained and cultivated on behalf of a working class as yet unprepared to realize its historical mission.[26]

Here we can identify the symptomatic linkage between Marxist theory, which imagines the vanguard intelligentsia as a vessel for the "imputed consciousness" of the proletariat, and the avant-garde artist.[27] In each case, a form of autonomous subjectivity, rooted in a paradigm of bourgeois possessive individualism, is endowed with a revolutionary imprimatur due to its capacity to sustain an otherwise endangered form of proletarian class consciousness. In this manner, the avant-garde artwork, segregated in the museum and circulating within the rarefied precincts of the international art market, can nonetheless claim to represent a more acute and meaningful form of political engagement than projects developed by artists working in direct conjunction with existing social movements. It can do so precisely because it has access to an otherwise hidden revolutionary truth that only the avant-garde artists and theorist can grasp. Notwithstanding Adorno's command of revolutionary truth, the masses were unable to subordinate their unreflective bodily appetites to a disciplined, rational assessment of objective political reality (evident in their self-indulgent desire for immediate gratification in pursuit of political transformation). This view is clear in Adorno's critique of the German student movement during the 1960s, which he accused of a naive "actionism" in its belief that its protests could actually precipitate any meaningful political change.[28] As a result, the only remaining space within which a revolutionary intelligence can be safely preserved is the internal compositional sphere of the avant-garde artwork (as it acts out a symbolic resistance to normative values through its rejection of existing stylistic or formal conventions). In this manner, the avant-garde movement

appropriates the (now devalued) social form of the vanguard political party, without a parallel critique of its evident limitations. Here the artist becomes a "deputy," on behalf of the universal class of the proletariat and the utopian future society whose potential it unwittingly carries.[29]

Now the Enlightenment artwork, as the prefigurative anticipation of a future aesthetic state that can't yet be realized in practice, is superseded by the avant-garde artwork as a vessel for a form of revolutionary consciousness that can't yet be fulfilled through direct action. This is necessary precisely because the masses are now entirely subordinate to the ideological mechanisms of the capitalist system. It is the pervasive and monolithic nature of this cognitive domination that is distinctive in Adorno's analysis, the perception that it is entirely seamless in its effects and that literally the only form of consciousness that remains immune to its effects is that of the artist or theorist. In this new paradigm, the act of evoking intersubjective harmony through concrete forms of political resistance that incorporate a creative, prefigurative dimension (as evidenced by the student activism of the 1960s) is proscribed. It is proscribed because this resistance can never hope to be successful or to expand or multiply its effects in a way that allows for real, structural change to occur. This form of prefigurative knowledge always carries a fatal residue of the original exculpatory function of aesthetic pleasure and transcendence enjoyed by the bourgeoisie in its experience of beauty. For the same reason, Adorno was virulently opposed to new forms of performance-based or activist artistic practice during the 1960s, which would in his view surrender the necessary critical mediation between self and other provided by the physical art object and effectively collapse the only remaining refuge of truly critical thought into the maw of a profane capitalist culture. "It is not the office of art to spotlight alternatives," as Adorno writes, "but to resist by its form alone the course of the world, which permanently puts a pistol to men's heads."[30] In this manner, aesthetic autonomy reemerges and claims a second life, as the necessary bulwark that protects authentic revolutionary consciousness from co-optation by the engine of capitalist appropriation.

The singular privilege assigned to negation in avant-garde discourse is exemplified by Alain Badiou in his essay "Avant-gardes," a meditation on Andre Breton's poem *Arcanum 17*. Badiou's analysis provides a key example of the intellectual imaginary of the avant-garde as it has been constructed in contemporary theoretical discourse. For Badiou, the essence of the avant-garde lies in its "negative excess" as a gesture of sheer refusal and assault. The principle of "rebellion" that is carried by the avant-garde expresses itself as a "vital spark," purified of all teleological aspirations.[31] Breton, who wrote

Arcanum 17 while proselytizing for Surrealism in New York City during World War II, dismisses any concern with the actual repercussions of revolutionary political change as the passive "resignation" of the "miserable priest," who "entreats us to weigh up the worth of rebellion against its results."[32] Like a callous Gradgrind obsessed with utilitarian calculations of profit and loss (of lives rather than money), the priest of resignation churlishly ignores the sublime "presentness" of rebellion as it forges violently ahead, heedless of the form it might eventually take or the damage it might inflict in acquiring this form. The appeal of this position for Badiou, who continues to celebrate Mao's Cultural Revolution as one of the most significant political events of the twentieth century and who remained a staunch defender of the Khmer Rouge until 2012, is self-evident.[33] It serves as an implicit riposte to those who would question the ease with which intellectuals embrace the extreme suffering and repression that can result when the "violent aesthetic militancy" of the artistic avant-garde is translated into practical action. Badiou, of course, has no patience for this squeamishness, arguing that "The theme of total emancipation, practiced in the present, in the enthusiasm of the absolute present, is always situated beyond Good and Evil. . . . The passion for the Real is devoid of morality."[34]

Here we have two related themes that will be important for my subsequent analysis. First is the Manichean opposition between revolution (immediate, all encompassing, and sublimely violent) and resignation (the only other possible attitude toward political transformation), which is small-minded, timidly moralistic, and incapable of the majestic sacrifices necessary to produce real change. The second theme is a messianic concept of revolutionary time in which any possible form of temporal continuity (involving, for example, some recognition of the specific human costs of political violence) is dismissed as simply another expression of the ubiquitous conceptual reification imposed by the capitalist system, extending now to the principle of causality itself. Badiou describes this perpetual withdrawal from answerability or relationality by the avant-garde as a matter of "always . . . going further in the eradication of resemblance, representation, narrative or the natural."[35] As Badiou's description demonstrates, the avant-garde rejection of temporal or historical continuity is joined with a series of spatial or semantic conjunctions (the linkage between signifier and referent, for example) that will be subjected to a similar destabilizing assault. This disjunction is consistent with Badiou's own intellectual trajectory. For Badiou, a philosophy capable of revealing the "truth" must first purge itself of any troubling contamination by current forms of political resistance, which are irrevocably compromised

by the bankrupt pseudo-democracy of neoliberalism or the equally suspect traditions of existing political philosophy.[36] Drawing on the axiomatic truths revealed by mathematical set theory, Badiou's philosophy will occupy an autonomous realm of pure thought, allowing him to devise an entirely new and more perfect theory of the revolutionary "event." Here we encounter the symptomatic correlation between avant-garde art and theory itself, as twin expressions of a radical autonomy which bear a privileged relationship to revolutionary change.

During the 1980s and 1990s, we can identify a further evolution of the avant-garde ethos of autonomy. In this process, the locus of repressive normativity against which the avant-garde work will act out its symbolic resistance begins to shift from the reified compositional protocols of specific art media to the institutional enclosure of the art world itself. This is evident in the concept of a "neo" avant-garde popularized by historian Hal Foster and associated with emergent "Institutional Critique" practices during the same period.[37] In this view, art can retain its unique emancipatory power only by restricting its symbolic gestures of negation to the co-optative mechanisms of the museum and the gallery. What is critiqued, then, is precisely the art world's tendency to renormalize the proto-revolutionary disruptions introduced by the avant-garde artwork itself (in particular, the revolutionary art practices of the 1920s). The neo-avant-garde retains its critical power in two related ways. First, it does so by advancing a critique of the naive efforts of artists during the 1960s and 1970s (associated with Happenings, activist practices, and so on) to prematurely actualize certain utopic values associated with the aesthetic by operating outside the institutional art world and seeking to engage viewers as collaborators or participants (effectively treating artistic subjectivity as potentially mobile). In this manner, neo-avant-garde art defines its resistance through the negation of previous artistic practices that are seen as insufficiently critical of their own institutionalized status. Second, the neo-avant-garde seeks to critique the appropriative mechanisms of the art world itself, which function as surrogate expressions of the more overt forms of economic and political domination that exist in the world beyond the gallery and museum and with which the artist cannot risk direct engagement.

In this view, the only space within which a legitimate or meaningful form of critique can be generated is the institutional art world itself.[38] We encounter a more recent expression of this position in Philipp Kleinmichel's 2019 essay "The Symbolic Excess of Art Activism." For Kleinmichel, it is self-evident that "the political activism of radical, direct democracy," which

he associates improbably enough with the Bolshevik Revolution, "belongs to a bygone world."[39] As a result, "artistic political activism" can no longer play a meaningful role in the broader process of political transformation. The only function left for this work is to serve as a prophylactic reminder of the current impossibility of praxis itself. This will occur through what Kleinmichel terms the "museal" absorption of activist art into exhibitions in galleries, biennials, and museums. The very assimilation of this work into the institutional art world, where it will take its place alongside other once vital but now moribund art forms such as "Land Art," "readymades," and "abstract painting," will serve to foreground its anachronistic nature and, by extension, the more general absence of any truly revolutionary politics today. The viewer, confronted with this spectacle of de-actualized transgression, will be "forced" to recognize that the possibility of any reciprocal engagement between art and political transformation (in the form of "radical democratic activism") "ceased to exist... with the dissolution of the Soviet Union." "The political value of activist art resides," as he writes, "in the fact that it signifies the aesthetic and symbolic procedures of political activism... as forms of a lost world of the past."[40] All that is left, then, is for the artist or curator to preserve the "memory trace" of this failed utopic possibility, registered in the consciousness of individual gallery goers.[41] Thus, contemporary activist art, which naively imagines it can play some meaningful role in political transformation, comes to function as a kind of taxidermied object lesson, consigned to the museum as a warning to other artists. We encounter here the frankly Eurocentric belief that the Bolshevik Revolution represented the last legitimate expression of a viable form of revolutionary political transformation, coupled with the conviction that the only possible relationship that one can take to its failure is a kind of melancholic contemplation. Here the claim that the art world is the only site at which meaningful critique can be produced is justified precisely by insisting on its utter impossibility elsewhere and, by extension, minimizing those constraints that do operate in an art world context.

The avant-garde aesthetic is based on the imperative to preserve inviolate a vestigial trace of authentic revolutionary consciousness. But preservation implies a degree of fixity; the "thing" to be preserved must exist as a discrete and self-contained entity that can be uncoupled from any dialogical interconnection with the lifeworld of resistance while losing nothing of its essential character. In this manner, neo-avant-garde discourse surrenders the generative nature of resistance itself, effectively reproducing the conventional aesthetic paradigm of autonomous mind over dependent body,

abstract thought over material practice. This discursive system is predicated on a false equivalence in which virtualized gestures of art-world dissensus (waged against existing artistic conventions, art-world ideologies, etc.) are meant to sustain or prefigure the forms of consciousness that would result from political struggle against the structures of capitalist domination. However, the modes of propositional criticality engendered by conventional artistic practice are of an entirely different order than those mobilized in actual resistance, in which the normative system against which one resists is reciprocally responsive, requiring a continual retuning of the resistant gesture in real time. Avant-garde transgression also "retunes" itself as the art-world apparatus imposes its own normalizing powers, but that modulation is a constituent feature of the institutional art world itself rather than a threat to its fundamental existence. The evolution of artistic criticality ensures the ongoing supply of new material necessary to feed the larger system of validation on which the marketability of contemporary art as something both novel and "transgressive" depends. The art world as such is structured with the specific purpose of nurturing and monetizing these same critical energies. The significance of actual transgression is that it poses at least a potential challenge to the underlying stability of the social order against which it contends. But that potential, even as a distant horizon, has been abandoned in the neo-avant-garde paradigm. In this manner, the "preservative" impulse of the avant-garde aesthetic ends by destroying the very thing it claims to sustain.

Notwithstanding the tensions evident in Adorno's paradigm of the avant-garde, the fact remains that his critique of the "actionist" naïveté of the 1960s was, at one level, correct. It did not lead to the global communist revolution that he envisioned as the telos of aesthetic freedom. There are, of course, very good reasons for the pessimism that we encounter in figures like Adorno, Kleinmichel, and many others and for the ongoing salience of Adorno's critique of capitalist culture. One need only survey the current political landscape to find endless validation for Adorno's bleak assessment of the potential for real political change and the cognitive limitations of the general public. However, we must also consider the broader implications of Adorno's proposed response to this reality, delivered from the comforts of what Georg Lukács sardonically termed the "Grand Hotel Abyss."[42] Here the artist and theorist sit back and contemplate the disaster of the current moment from the relative privilege of the academy and the art world, dispatching encrypted messages to an imaginary revolutionary future, like so many bottles cast into an indifferent sea.[43] At the center of this paradigm

is the radically autonomous self-consciousness, impervious to external determination, first valorized in Enlightenment aesthetic philosophy. This autonomous self becomes the ur-form of a whole series of institutional and cognitive enclosures in subsequent art theory. These include, of course, the concept of a quasi-protected art world outlined by Foster, as well as the principle of defensive sequestration that is evident in the belief that art can preserve its redemptive power only by focusing its critical energies on its own institutional status. In this paradigm, as noted above, the institutional art world of galleries and collectors, auction houses and curators, a world that is heavily indentured to the multibillion-dollar market for contemporary art, constitutes the only meaningful locus of aesthetic and critical meaning. By the same token, artistic practices that choose to operate outside or only peripherally to this world have effectively abandoned the only available epistemological fulcrum necessary to generate real criticality. In the following chapter, I will examine the ways in which the conventions of avant-garde aesthetic autonomy I have outlined above are deployed in Jacques Rancière's analysis of the escrache actions in Argentina. Rancière's critique allows us to more clearly identify the unique features of socially engaged art, as it both transgresses and transforms these conventions.

I

**WITHIN
AND BEYOND** **THE CANON**

THE INCOMMENSURABILITY OF SOCIALLY ENGAGED ART

Agonism and Autonomy

> The core of this fantastic superiority of the subject conceals, however, the renunciation of every active alteration of the real world.
> —Carl Schmitt, *Political Romanticism* (1919)

In this chapter, I want to introduce some of the key themes that will be explored in the remainder of the book, as they have been elaborated in recent art theory and criticism. This will entail a closer examination of the specific ways that historians and theorists identified with the avant-garde tradition sought to critique socially engaged art practices that violate many of its core premises. I will be focusing primarily on the work of Jacques Rancière, who emerged as a leading inspiration for art critics during the early 2000s, along with a shorter discussion of Chantal Mouffe, whose work has also exercised a considerable influence on contemporary art criticism. My goal here is not to provide a comprehensive analysis of either thinker, but to focus instead on

the ways in which they understand the relationship between artistic production and social or political transformation. In each case, these theorists were deployed to justify the claim that socially engaged art practices possess no legitimate "aesthetic" value. As such, they can play an important diagnostic role in my broader analysis. Through a closer examination of these critiques, we can develop a more precise understanding of the ways in which the aesthetic has been mobilized as an evaluative category in contemporary art theory and criticism. This has entailed a shift away from previous associations of the aesthetic with formal composition or physical appearance and instead a redefinition of the aesthetic as a quasi-political discourse, effectively returning to an earlier aesthetic paradigm (evident in Rancière's resuscitation of Schiller). On the one hand, this discourse can provide us with valuable insights into the ways in which meaningful forms of negation or critique might still be produced today. On the other hand, precisely in its lacunae, we can discover some of the most generative dimensions of engaged art practice.

In the introduction, I outlined a set of underlying themes that have informed the broader evolution of aesthetic autonomy through its most recent iteration in the concept of a "neo-avant-garde" during the 1990s. One of the key features of this discursive system is an apophatic orientation to other modes of cultural production. If avant-garde art is understood as the single source of an authentic revolutionary consciousness, then it is axiomatic that all other forms of artistic or cultural expression are necessarily incapable of generating meaningful critical insight. This degraded cultural other has, in the past, been associated with popular or mass culture (kitsch for Clement Greenberg or Adorno, "prosaic" expression for Viktor Shklovsky). Since the 1990s, this role has increasingly been assigned to various forms of socially engaged art practice, which fail to maintain the requisite autonomy from the instrumentalizing effects of political practice or the co-opting mechanisms of hegemonic capitalism. This is consistent with a neo-avant-garde orientation in which an authentic art must locate the target for its acts of symbolic negation in something that is at least nominally "internal" to the institutional protocols of the bourgeois art world. For Hal Foster, this abject other was identified with various forms of participatory and activist art from the 1960s that threatened to desublimate art's utopian potential in collective action. This same set of oppositions migrated into art criticism during the 2000s, but they were now directed at new forms of activist or socially engaged art that also relied on collaborative or consensual production.

Here we can identify two contradictory modes of critique. On the one hand, participatory projects were accused of bringing the utopic potential

of the aesthetic into premature, if highly localized, existence through forms of shared creation (ineffectual "micro-utopias," as John Roberts describes them). And on the other hand, these works were accused of imposing a coercive consensus on the complex and multivalent personalities of individual participants while simultaneously surrendering the "dissensual specificity" of art itself.[1] The discourse of agonism, associated with political theorist Chantal Mouffe, played a key role in this second critique. Agonism emerged in the work of Mouffe (and her collaborator Ernesto Laclau) in conjunction with their broader mission to develop a post-Marxist political theory that dispensed with the notion of class determination while also attempting to retain some concept of counter-hegemonic resistance.[2] Mouffe's analysis begins with the assumption that we are driven by a naturally "antagonistic" orientation to the social world. Thus, she collapses the class-specific forms of violence identified by the Marxist tradition into a generic account of the innate human propensity for intersubjective violence. Inspired by the work of Carl Schmitt, Mouffe argues that we attain a coherent sense of selfhood by taking on an instrumentalizing relationship to other subjects (the other as an "antagonist" or "enemy" to be destroyed). This poses a considerable challenge for democratic systems of government, which call upon us to cultivate an empathetic openness to others. This problem is further exacerbated by the fact that conventional democracies rely on spurious concepts of universality that repress legitimate forms of conflict and dissensus under a stultifying "consensus," thereby further inflaming our antagonistic proclivities.

While we can never hope to fundamentally challenge the core ontology of the human self, defined by a reactive relationship to other subjects, we can at least attempt to "tame" this propensity by transforming "antagonism" into "agonism."[3] Thus, Mouffe argues for a retooling of human subjectivity in such a way that we begin to treat antagonists as "adversaries," who restrict their conflicts to civil disagreements over political matters, rather than life-threatening physical aggression. But how will people come to accept difference without antagonism? And how do we "harness the passions" of a public predisposed to violence? We cannot expect a meaningful form of self-transformation to occur through extra-parliamentary political action, since this always threatens to devolve into violence or fascism. Instead, it requires the mediation of theory to inculcate a new "common sense" that would bring us into a proper consciousness of the world and other selves. As Mouffe argues: "Political philosophy has a very important role to play in the emergence of this common sense and in the creation of these new subject positions, for it will shape the 'definition of reality' that will provide

the form of political experience and serve as a matrix for the construction of a certain kind of subject."[4] In this manner, a process of introspective self-reflection, catalyzed by our encounter with political philosophy, will lead us to abandon our dependence on antagonistic violence and model for us a new form of subjectivity (exemplified, presumably, by the theorist herself) toward which we can aspire. Artists also have a role to play in the civilizing mission of "agonistic pluralism." While they cannot claim to offer anything like a "radical critique," according to Mouffe, this does not mean that their "political role has ended." Rather, "critical artistic" practices can "foment dissensus," seeking to "unveil all that is repressed by the dominant consensus" and make "visible what the dominant consensus tends to obscure and obliterate."[5] At the same time, Mouffe charges art with the task of "giving a voice to all those who are silenced within the framework of the existing hegemony."[6] Thus, art is simultaneously the mechanism by which the repressed will be brought to consciousness (via the disclosure of "that which has been repressed") and the channel by which these same individuals will be "given" a voice to express their own dissent. Even "democratic consumer culture" has a role to play here, through its capacity to interpellate individual subjects "as equals in their capacity as consumers," leading them to "reject old forms of subordination" as well as "the real inequalities that continue to exist."[7]

The appeal of Mouffe's work for the institutional art world is due, in part, to its striking congruity with the core ethos of the avant-garde paradigm I outlined in the introduction.[8] Here again we have the public, incapable of subordinating its propensity for physical violence to a process of contemplative self-awareness, epitomized by philosophical thought. We have, as well, the image of the theorist or artist as the exemplar of this capacity, to be emulated by the public in order to facilitate the sublimation of a defensive and openly hostile antagonism into a merely "adversarial" agonism through the mediated consumption of philosophy and art. And finally, Mouffe defines art's role in the familiar vernacular of a disruptive "defamiliarization," characterized by a discourse of "revelation" by which otherwise imperceptible forms of ideological domination will be made apparent to the public. Of particular importance in the context of art criticism was Mouffe's critique of Jürgen Habermas. Where Habermas's democratic paradigm sought to repress real conflict under an imposed consensus, Mouffe's "agonistic" democracy would preserve the essential kernel of dissent necessary to prevent democratic systems from sliding into authoritarianism.[9] The key point of this analysis, for my purposes, is that Mouffe's critique of Habermas's naive and covertly repressive form of "consensus" was easily enough mobilized

to provide theoretical validation for attacks on artistic practices involving collaborative interaction, which could also be accused of trafficking in proscribed forms of "consensual" creation (evoking the specter of "a community whose members identify with each other, because they have something in common" as critic Claire Bishop writes).[10] Rather than emerging out of a set of provisional values, beliefs, or goals shared within a given community, art must devote itself solely to undermining all possible forms of collective identity (understood to be both fixed and inherently repressive).

Bishop developed this analysis most fully in her 2012 book *Artificial Hells*. Here she argues that socially engaged art practices abandon all "aesthetic" criteria and instead subsume art into a set of banal "ethical" concerns associated with fashionable forms of "identity politics . . . and an inflexible mode of political correctness."[11] Thus, for Bishop, the concept of consensus is linked with a related series of signifiers (ethics, political correctness, and identity) that depend on shared social values or forms of subjective experience and that impose an instrumentalizing closure on individualized modes of knowledge and being (including that of art itself), which must remain entirely autonomous from "external" constraint. Here we encounter a key transposition. Mouffe defines "agonism" in terms of individual members of the public freely expressing their dissent, against the encroachment of an imposed state consensus. For Bishop, it is the public itself (in the guise of gallery and museum patrons) that is in need of an "agonistic" awakening at the hands of the artist. Instead of a reciprocally expressed agonism, in which each individual registers their unique opinions within a conflictual field composed of other, equally autonomous, selves, we encounter a practice in which the artist subjects the viewer to a unilateral "antagonistic" assault through the creation of "highly authored situations" that inculcate a therapeutic sense of nonidentity. Now only one self (that of the artist) is allowed to express its unique autonomy and dissensual agency, while the other self (the viewer) is subject to an instrumentalizing attack that assumes, a priori, its cognitive deficiency and incapacity for self-regulation. As a result, the public becomes the target, rather than the agent, of an agonistic intentionality.

Mouffe certainly has good reason to warn against a model of democratic consensus that actively excludes dissent and conflict. In addition, her foregrounding of the ongoing necessity of agonistic negotiation is a useful corrective to the perception that revolutionary change will lead to a utopic society in which substantive forms of difference will simply cease to exist due to the emergence of a harmonious universal class. As Mouffe would no doubt agree, difference and the complex and creative social processes necessary

to negotiate it are central features of the human condition. However, it is precisely this "key difficulty," the question of how we might move from violent antagonism to civil agonism, that is largely unaddressed in her own research.[12] Instead, as political scientist Eva Erman suggests, Mouffe's work is defined by an implicit decisionism in which the transformation from antagonism to agonism is reduced to a simple "moral choice" that we reach through an essentially "solipsistic" process of personal "introspection."[13] It is, then, precisely in the contemplative domain of the individual consciousness (via the privatized consumption of political philosophy or art) that the essential movement from antagonism to agonism will occur rather than through an experiential engagement with the mechanisms of "consensual" social or political transformation.

By the same token, Mouffe relies on an analytic paradigm that views the human self as innately violent and ontologically static. While we might hope to "tame" our malevolent antagonism into the form of domesticated agonism, we are still left with a version of the self that can only define its relationship to the other as fundamentally conflictual. In this view, difference can be preserved only by sequestering it within an ontic shell that reproduces the very instrumentalizing orientation that threatened to destroy it in the first place, effectively normalizing a conventional paradigm of autonomous selfhood that gains its coherence through the identification of a resistant other. This is because Mouffe can only conceive of "consensus" as an inherently repressive operation, against which we must be prepared to constantly assert our own autonomous self-hood. There is no sense here of the fluidity of selfhood, which might combine a capacity for intersubjective violence with a capacity for compassion and reciprocal respect. Nor is there a sense of the dialogical formation of the self as an intrinsically creative act and an ongoing process (which might move through phases of both consensus and conflict) rather than an achieved state. It is this complex, creative dimension of consensual exchange that Mouffe's theory elides and that passes into art criticism as a reactive dismissal of any form of collaborative or collective artistic production. It is, of course, a relatively straightforward matter to acknowledge our human tendency toward violence. The aesthetic, however, has been historically concerned with the more challenging question of how we might mediate this tendency and transform the nature of the self. This transformative process, as it unfolds through the creation of socially engaged art, will be a central concern in the following chapters.

Lessons Unlearned

To prevent stultification there must be something between the master and the student.
—Jacques Rancière, "The Emancipated Spectator"

Socially engaged art practices, taken in the aggregate, effectively violate many of the constituent features of the schema of aesthetic autonomy, introducing a very different epistemological paradigm (the kinds of knowledge produced by an aesthetic encounter) as well as a very different social architecture (the specific set of subject positions and capacities assigned to the artist and the viewer within a given project). First, we encounter a revised concept of artistic subjectivity, evident in forms of production that involve collaborative interaction rather than authorial sovereignty. And second, we see this transformation in the transversal openness of artistic practice to other, adjacent, fields of cultural production and, in particular, political or social activism. As a result, it is quite typical in contemporary art critical discourse for socially engaged practices to be accused of a double failure. They are seen to fail at the level of politics because they never manage to precipitate the total revolution that is the single horizon of "real" political change in the avant-garde lexicon. And they are seen to fail at the level of aesthetics because they abandon the reflective distance between art and the mechanisms of social change and between the artist and the viewer that is necessary to preserve art's unique critical power.

This perception is widely shared at the highest levels of the institutional art world. As noted above, Jacques Rancière, one of the most revered figures in contemporary critical theory, has developed a variation of the same analysis. This is evident in an exchange between Rancière and Paris-based critic Stephen Wright during an event at the Universiteit van Amsterdam in 2006. Wright was discussing the work of the Argentine collective Grupo de Arte Callejero (GAC), which (along with HIJOS, Colectivo Situations, and Grupo Etcetera) was associated with the creation of escrache performances in Buenos Aires during the late 1990s. These were street-based interventions intended to reveal the (previously anonymous) homes of military and government officials associated with the widespread "disappearance" of leftists following the 1976 coup (and, equally importantly, to publicly challenge the perceived impunity of these figures). In response to this work, Rancière made the following observation:

> It's always the same artists whose examples are invoked in all congresses on art and engagement. You say there are "more and more" just because you think it is a good thing to do so. But the kind of thing that you showed us is in the tradition of political posters. Artists have made political posters for many, many years and it was not considered art denying itself or art disappearing. They were artists, which means they had a certain competence. And they used that competence to build images with or without words, conveying a certain political signification. . . . Why claim a new radical break in art?[14]

For Rancière, the escraches, far from constituting a "radical break" with existing forms of artistic production, were simply another expression of the long-standing tendency of artists to prematurely collapse art into the "heteronomous" condition of daily life or, in the case of GAC, "political mobilization." In fact, Rancière goes so far as to associate GAC's work with a form of "authoritarianism" while calling into question more generally the political efficacy of its efforts to publicly mark the homes of former members of the military junta.

> I think that there is something very authoritarian, something much more fitting the traditional concept of art, in your view of art making itself disappear to provoke some forms of political mobilization. There may be some connection between them, but I would say that the emphatic idea of the power of art and in some sense the character of the example that you showed, because obviously I don't think that there is something politically wonderful in that practice of making maps of Buenos Aires and saying "the perpetrators are here, here and here."[15]

While Rancière's remarks came in response to a single project, his suspicion of and even hostility toward socially engaged practice is consistent with his analysis of contemporary art more generally. As I noted above, my goal here is not to offer a detailed analysis of Rancière's aesthetic theory. Rather, I will be focusing on the reception of his work in the Anglophone art world. Rancière's critique of engaged art hinges on the assumption that advocates of engaged art practice actually believe that "an artistic work could—in and of itself—directly provoke political action in the strict sense of the term," as Gabriel Rockhill has observed.[16] In Rancière's view, if a work of engaged art is unable to "directly cause political action," then it fails as politics, even as its movement outside the protective enclosure of the museum or gallery

condemns it to "disappear" as art.[17] As he contends, "the singularity of art is linked to the identification of its autonomous forms with forms of life and with political possibilities. These possibilities are never fully implemented except at the expense of abolishing the singularity of art."[18] In this manner, the prefigurative potential of aesthetic experience can only be sustained so long as it remains "undamaged by praxis," as Adorno argued. We are left, then, with two diametrically opposed positions: one in which the ontological specificity of art is "abolished" as it is subsumed entirely into the "heteronomous" domain of social life and praxis and the other in which art can only express its true political potential by remaining autonomous from that same social world. It is precisely in the dynamic tension between these two positions that Rancière locates the operational hinge of his aesthetic theory, as artworks play at the boundary between art and non-art, the institutional art world and the social world beyond the gallery and museum.

As this outline suggests, Rancière's aesthetic paradigm is heavily indebted to the work of Schiller, who proposed a model of aesthetic experience centered around an ostensibly innate "play drive," which allows us to step back from our practical immersion in the external world and attend reflectively to our own cognitive processes. This occurs in aesthetic experience as we come to recognize the subterranean operations of the "form giving" and "sensuous" drives (associated with the intellectually disciplined but emotionally stunted ruling class and the passionate but irrational working class). While these are essential components of human consciousness according to Schiller, they are unevenly balanced in the contemporary psyche due to the fragmenting forces of modernization. In the act of reflective aesthetic perception, we learn to "harmonize" them with each other, producing a more advanced form of subjectivity in which the previously "divided halves" of the self (and, by implication, the respective capacities of bourgeois and working-class selfhood) are reconciled. Rancière will retain the central dynamic of Schiller's aesthetic, in which aesthetic experience serves to problematize an existing binary structure but will simply transpose into it a new set of categorical oppositions (art versus "not-art" or autonomy versus heteronomy) to be revealed by the aesthetic encounter. Where Schiller seeks to resolve this binary tension, Rancière wants to prolong it in order to subject the viewer to a therapeutic experience of "undecidability," thereby challenging their dependence on fixed systems of meaning.[19] Here the aesthetic produces its unique form of criticality by oscillating between the poles of "autonomy" (art that rejects any connection with the social) and "heteronomy" (art that subordinates itself entirely to the social, or political mobilization). These are

the necessarily static positions with which an aesthetic awareness will play in order to produce its critical charge. For this system to work, of course, it is necessary to identify existing artistic practices that conform to these reified perspectives (absolute autonomy or heteronomy), or alternately (since few artists would espouse either of these extremes), it is necessary to project these reified positions onto existing artistic practices whether they actually share them or not so that they can function as foils for a legitimate form of art. This is the foundation of Rancière's insistence that GAC's work is in no way innovative. Rather, its work must be slotted into the preexisting space set aside within his broader hermeneutic system for art forms that "collapse" autonomy into heteronomy.

For Rancière, the aesthetic fulfills its emancipatory mission by remaining detached from the actualities of political resistance. Instead, it will function to transform the consciousness of individual viewers, employing the tension between art and not-art to inculcate a sense of categorical ambiguity. As a result, their subsequent experience of political action will, presumably, be informed by a more nuanced awareness of the constraints of conceptual understanding. Rancière's notion of a destabilizing experience of aesthetic ambiguity reiterates the characteristic avant-garde commitment to cognitive disruption as a displaced form of political violence. Thus, an authentically "political" work of art, in Rancière's estimation, will produce in the benumbed viewer "a sensible or perceptual shock caused . . . by the uncanny, by that which resists signification."[20] At the same time, Rancière is concerned that his aesthetic model not simply devolve into nihilistic indeterminacy. Rather, he seeks to preserve the underlying spirit of Schiller's aesthetic, which always retained some positive correlation, however tenuous, with political emancipation. As a result, he pairs the idea of a "perceptual shock . . . which resists signification" with the claim that "political art" will simultaneously allow the "readability of a political signification."[21] Thus, even as the processes of representation are deliberately undermined by the "uncanny" experience of aesthetic undecidability, the work of art will also sustain a semantically determinate or "readable" connection to the real. We are allowed, in a manner of speaking, to retain our problematic investment in representational regimes (the idea that art can reveal a hidden truth about the world) so long as we are simultaneously subjected to an anti-representational assault: able to connect the dots between the artwork and the lifeworld it conveys and forced to recognize the folly of doing so. "So a critical art," as he writes, "must be an art that both gives the spectator the intelligence of what he or she did

not understand and the power of refusal, attached to the spectacle of the unconceivable."[22]

In this manner, some relationship between the aesthetic and the political is maintained (at least symbolically) at the level of individual reception, even as it is foreclosed at the level of practice. This is because, as Rancière contends, the aesthetic "promises a political accomplishment that it cannot satisfy and thrives on that ambiguity."[23] The accomplishment that it promises, of course, is the final realization of the sensus communis, now transformed into the utopic society that will follow the revolutionary destruction of the capitalist system. Since this prospect is denied to us in the current moment it is futile, and even reactionary, for art to engage directly with political praxis.[24] As a result, art's emancipatory insights must remain safely locked within the closed loop of aesthetic reflection, as the viewer toggles endlessly between categorical extremes. Faced with this reality, the artist is left with only two choices, "one of melancholy with respect to the failure of the promise, another of play with its very uncertainty."[25] A third option, in which the artist is able to work in proximity to mechanisms of political transformation while redefining the generative, critical power of the aesthetic, is not possible. While art can never successfully be linked with political praxis (for fear of sacrificing its unique critical power), it can at least "play" with this linkage in order to exhibit, for the viewer, an exemplary form of cognitive resistance. Peter Gratton, in his discussion of *Aisthesis*, captures Rancière's fundamentally quiescent view of the aesthetic: "The task is not to see the aesthetic as providing a program for political movements, which he dubs 'the action plans of the engineers of the future,' but as marking a cessation of all such regimes and programs. For this reason, Rancière will testify to an 'inactivity' at the heart of the modern aesthetic regime, one that highlights a 'free activity not subordinated to particular ends.'"[26]

A "free activity" not oriented to a particular purpose is, of course, the very definition of the Kantian aesthetic, made available through our experience of beauty. Notwithstanding his interest in artistic practices that trouble the distinction between art's absolute freedom and its equally absolute subordination, Rancière's system ultimately rests on a reassertion of traditional aesthetic autonomy (for which periodic infusions of "heteronomy" are the necessary but cognitively inert fuel). It is simply an autonomy that remains aware of its own political incapacity, as ambiguity becomes another placeholder for an absent revolutionary vision. Thus, the entire sequence identified by Rancière (art withdrawing itself from the social on the one hand or

surrendering to social or political utility on the other) is itself recaptured under the auspices of a conventional notion of detached aesthetic contemplation. What matters here are less the specific modes of artistic production generated in a given context (or through a specific orientation to the social or political world) than the extent to which this entire conceptual-historical movement can be apprehended by the viewer as an abstract object lesson in conceptual ambiguity. In the absence of any operational relationship between art and social change (due to the inevitable failure of all attempts by individual artists to realize the utopic power of the aesthetic), all that remains is a vestigial trace of utopic thought, safely housed in the consciousness of the individual viewer.

Rancière's position is, however, more complex than this outline suggests. His earlier writing (*Althusser's Lesson* and *The Philosopher and His Poor*) developed a trenchant criticism of the underlying authoritarianism of Marxist discourse in its division between a vanguard intelligentsia and a cognitively stunted working class, incapable of genuine insight. A great deal of Rancière's early research was devoted to championing the creative intelligence of the working class against the grain of this reductive formulation. As he writes in *Althusser's Lesson*, "The professor's 'Maoism' says the same thing as the cadre's economism or the manager's humanism: it defends the privilege of competent people, of the people who know which demands, which forms of action and which words are proletarian, and which bourgeois. It is a discourse in which specialists in the class struggle defend their power."[27] We encounter here an important corrective to the vanguardist hierarchies I outlined in the introduction. In this context, it is important to note that Rancière's conceptualization of a "perceptual shock" in contemporary art was informed by broader tensions within post–World War II French intellectual culture. In particular, Rancière's notion of rupture initially derived from the work of his mentor, Louis Althusser. During the 1960s, Althusser appropriated Gaston Bachelard's concept of an "epistemological break" to validate his efforts to renew Marxist theory and place it on a more "scientific" footing."[28] This entailed the deliberate division between "theory" (the realm of a quasi-objective truth of social reality, overseen by the Marxist thinker) and mere "ideology" (the realm of false consciousness inhabited by the stupefied masses). This occurred at a time of deep disillusionment among French left intellectuals, who were increasingly skeptical about the concept of a progressive history (Marxist, Hegelian, or otherwise) in the wake of the Vichy regime and France's ignoble colonialist adventures in Algeria and Indochina. In this manner, Althusser's notion of a "theoretical practice" as the antidote to the unforgiving ideological "interpellation" of the

masses exhibits interesting parallels with Adorno's notion of critical theory as a displaced form of revolutionary consciousness. It was precisely this paradigm that Rancière sought to unsettle in *Althusser's Lesson*. As Davide Panagia notes, Rancière criticizes here "a causal dynamic where the purpose of critical thinking is to enact change through a kind of cognitive-behavioral therapy. To break with ideology it is necessary to change people's minds so they will interpret the world differently."[29] Rancière will thus carry forward a notion of ideological disruption, in the subversive conceptual play of the avant-garde artwork, while seeking to abandon the hierarchical divisions (between mind and body, intellectual and masses) implicit in Althusser's valorization of high theory.

This egalitarian spirit is evident in his notion of a *partage du sensible* (a partition of the sensible), which governs the ways in which speech and visuality are policed within a given social order, delegitimating or effacing entirely the creative intelligence of those who are seen as incapable of meaningful self-expression or undeserving of recognition. "The distribution of the sensible reveals who can have a share in what is common to the community," as Rancière writes. It marks the "delimitation of spaces and times, of the visible and the invisible, of speech and noise, that simultaneously determines the place and the stakes of politics as a form of experience."[30] In his early writings, Rancière exhibited a particular interest in those historical moments in which the oppressed transgress these policing norms and make themselves visible on the "stage" of the political.[31] This is evident in books such as *Nights of Labor*, in which he explores the autonomous cultural production of French workers during the 1830s: a tailor who composes songs to perform in the local bar, a carpenter who writes poetry evoking the "wasted lives" of the working class, or clerks who debate philosophy at their neighborhood café. These "artisanal acts of aesthetico-political dissensus," as Panagia describes them, "always hold open the possibility of a political part-taking . . . by those who have no part in the established system of distribution."[32] These gestures are all the more powerful because they entail the appropriation of cultural modes that have traditionally been reserved for the bourgeois intelligentsia (poetry, musical composition, philosophy).

As Rancière began to take a growing interest in artistic practice, and contemporary art in particular, during the early 2000s, his analysis of the aesthetic underwent a significant transformation. Increasingly the creative production of the worker qua artist is replaced in his writing by extended mediations on such canonical figures as Gustave Flaubert, Stendahl, and Stéphane Mallarmé. This transformation is evident in one of Rancière's bellwether

books, *Aisthesis*, which is devoted to avatars of high art and literature such as Walt Whitman, Henrik Ibsen, Alfred Stieglitz, and Auguste Rodin. Now an aesthetic analysis originally derived from the artistic production of "those who have no part" is projected onto practices unfolding largely within the bourgeois art world. Forms of proletarian creative production that gained their "dissensual" specificity precisely by violating the cultural decorum of the middle class (produced by untrained artists in the vernacular spaces of working-class life) are replaced by an analysis of artistic practices that are validated at the highest levels of class privilege. Far from being "out of place," these works appear precisely where they are meant to be: in the galleries, theaters, and concert halls of the bourgeoisie.[33] This transformation in the institutional locus of Rancière's research is paralleled by an analytic shift, from the process of artistic production to the spectator's experience of reception (evident in books such as *The Emancipated Spectator*). In this process, the dissensual "rupture" produced in the *partage du sensible* as workers asserted their creative and intellectual autonomy (a precursor to their emergence as a collective revolutionary force) is replaced by the "perceptual shock" elicited in viewers by the avant-garde artwork.

While Rancière embraced the emancipatory aesthetic qualities of working-class creativity cultivated outside the bourgeois art world in his earlier writing, in his later work, he increasingly collapses art per se entirely into those practices that circulate within museums, galleries, and biennials. In this manner, he fails to fully analyze the specific ideological effects of the institutional art world (art's "social inscription," as Gabriel Rockhill describes it) while simultaneously naturalizing it as the only space within which art can release its authentic criticality. As a result, Rancière's Schillerian attack on socially engaged art is complicated by a second analytic vector. Here, the danger of socially engaged art is not simply that it disavows the protective enclosure of aesthetic autonomy but that it also assumes that art itself must "disappear" (or "collapse" into the social) in order to make itself available to the masses. If the critical meaning generated by art is dependent on the discursive and ideological framing provided by the bourgeois art world, then practices that choose to operate outside that world cease to exist as art. Rancière is responding here to Stephen Wright's contention that GAC's work constitutes a form of "stealth" art (with a "low co-efficient of artistic visibility") that is not generally concerned with being exhibited or staged in art-world contexts and does not conform to normative assumptions about the nature of the artwork qua object.[34] "What is disturbing to me," Rancière remarks, "is your idea those signs are not perceived as art."

> What is to me the heart of the problem is when you say that art has to disappear in order to act politically. It is a mechanistic logic: art has to disappear in order to make something for people who have no access to art. It is always the same presupposition. There are people who have no access to art, so art has to act so as to disappear, to make something which is only matter of fact.... What disturbs me, is the setting of this equivalence: if the artist disappears as an artist, he can address people who don't know what art is and who don't care for art.[35]

In this view, by challenging the existing norms of aesthetic autonomy, activist artists are implicitly expressing their contempt for the poor and working class, whom they assume are simply incapable of the more advanced forms of understanding demanded by high modernist art (precisely the kinds of work that Rancière himself praises: Rodin, Stendahl, Mallarmé, etc.). Rancière dreams of a proletariat that finally recognizes itself, its deferred revolutionary potential, its utopic striving, in the decanted formal experimentation of the avant-garde. Rather than being the artifacts of an alienated bourgeois intelligentsia struggling with its own vexed complicity with capitalist domination, these texts become the very emblems of an authentic proletarian consciousness, externalized and reflected back to them like the sensuous embodiment of the Hegelian ideal. Here the avant-garde work and the mode of reception that it implies act as an exemplary expression of the intellectual capacities of the working class (rather than being somehow "beyond" their ostensibly limited capacities). In this respect, we might say that Rancière has sought to naturalize the idea that avant-garde artistic practices enjoy a privileged attunement with the consciousness of the proletariat, such that any challenge to the validity of these practices must also entail a questioning of the integrity and cognitive sophistication of the working class itself, who are its implied (and even ideal) viewers.

Rancière, however, seems to misunderstand Wright's critique. Wright is not claiming that GAC's work ceases to be art in order to appeal to some ostensibly philistine working-class viewer, only that it ceases to be art as that term is currently understood within the frame of the institutional art world. As Wright points out, "how is aesthetic rupture . . . to take place without breaking with artworldly consensus? . . . For the artworld is a very policed world."[36] Thus, the members of GAC stopped identifying their practice as "art" not because they no longer believed that it exhibited the necessary qualities of art as they understood it but precisely to circumvent attempts by the institutional art world to appropriate their work. The decision came after

the group was invited to exhibit in the 2003 Venice Biennial, after which they made a conscious choice to "ignore or drastically limit invitations from the artistic circuit."[37] This is a difficult distinction for Rancière to grasp, since his view of the institutional art world is relatively benign (if not romantic). More specifically, he does not share Wright's critical view of the art world, and the extent to which the specific art practices it cultivates are deformed by the influence of wealthy collectors, dealers, and dedicated investment funds. Thus, while he is convinced that "political mobilization" will cause irreparable harm to the integrity of aesthetic experience, he is considerably more sanguine about the rampant commodification of contemporary art. As he argues in a 2007 *Artforum* interview: "Money is necessary to make art; to make a living you have to sell the fruits of your labor. So art is a market, and there's no getting around it."[38] Given the incontrovertible fact of the market, there is no real point in critiquing it and, presumably, nothing to be gained by attempting to work, to some extent at least, outside its grip. Rather, the "critique of the market today," as Rancière writes, "has become a morose reassessment that . . . serves to forestall the emancipation of minds and practices. And it ends up sounding not dissimilar to reactionary discourse."[39]

It is worth reflecting on that claim for a moment: any artistic practice that is concerned with critiquing the market actually impedes "emancipation" and can even be outright reactionary. Consistent with Rancière's broader theoretical orientation, the only appropriate role for art, the only authentic form of criticality, emerges in the liberatory "spaces of play" created by the artist within the institutional art world itself.[40] In this manner, Rancière collapses art per se (in all its current and potential manifestations) into the specific forms and modalities of artistic practice that are sanctioned by the market-driven art world. For this reason, he can only view Wright's notion of a stealth art practice as entailing the disavowal of art in its entirety. This benign view of the market is, of course, not unique to Rancière but is a central feature of the discourse of the neo-avant-garde. Here the complicity entailed by the commodification of contemporary art must be seen as entirely different, and far less debilitating, than the forms of complicity that might accrue to art practices developed outside the institutional art world. This distinction is necessary in order to preserve the legitimacy of the avant-garde schema of autonomy and the associated claim that the institutional art world is the only space within which an authentic form of criticality can be sustained. As a result, those forms of appropriation that do occur within the institutional art world must be minimized or downplayed.

One can certainly understand Rancière's frustration with Wright's position. Rancière's own model of critique requires a hypothetical viewer for whom the question of art's identity is of sufficient importance in the first place that they would experience its "shocking" destabilization (produced through the disorienting play of autonomy and heteronomy) as an actual provocation. In the absence of a viewer who is genuinely concerned with art's ontological status, there is no ground for an authentic criticality in his account of aesthetic experience. Needless to say, the effect of this discursive system is, again, to privilege art-world viewers as the primary constituency for critical aesthetic meaning. However, the transformations that Wright describes (in the nature of contemporary art) are not due to the fact that artists believe they have to somehow make their work less intimidating to the masses by denying its aesthetic qualities. They are occurring because these artists are redefining the nature of the aesthetic itself in a manner that might be meaningful beyond the privileged spaces of the institutional art world.

In my view, Rancière's analysis is based on a fundamental misrecognition of the nature of contemporary socially engaged art, precisely because it assumes that the only "complex" form of art to begin with is one that deploys the familiar mechanisms of avant-garde autonomy. Further, it effectively normalizes a paradigm of aesthetic autonomy that is very much connected to the traditions of political vanguardism. Thus, Rancière's understanding of modern art is based on a static division between artists, who are charged with the creation of "uncanny" images, objects, or texts, and viewers, who are present in order to have their consciousness destabilized by the "sensible or perceptual shock" that these works provoke. One does not have to believe that members of the working class are passive dupes to recognize that the model of aesthetic autonomy that Rancière proposes as an alternative to the ostensibly crude desublimation of engaged art shares certain genetic similarities with the vanguard notion of politics that he critiques in his earlier writings.[41] Each depends on the maintenance of a hierarchical system of cognitive labor, in which the artist, or the revolutionary theorist, is charged with infusing the viewer with a form of political or critical consciousness that they currently lack. Here the binary opposition between the theorist "presumed to know" and the masses in need of radicalization is replicated in the figure of the artist-savant who will teach the somnolent viewer to comprehend life in its full complexity or punish the middle class for its complacent mediocrity. ("Hatred of the bourgeoisie," as Flaubert famously observed, "is the beginning of all virtue.")[42]

It is here that we encounter most clearly the residual tension between Rancière's investment in the cognitive and creative capacities of the working class and his subsequent embrace of a concept of aesthetic autonomy based on the work of Schiller, for whom aesthetic experience is bifurcated between an advanced cadre of enlightened aesthetes and the vulgar masses.[43] What Rancière inherits from Schiller, then, is not simply the opening out of the aesthetic to a utopic political signification, it is the fixed allocation of roles or subject positions ("artist/author" versus "viewer/reader") that Schiller's system depends on. In particular, it is the mythos of the artist as the privileged medium of emancipatory insight, which has been a mainstay of modern aesthetics since David Hume celebrated a handful of "men of delicate taste" for the "superiority of their faculties above the rest of mankind" in the mid-eighteenth century. While Rancière's investment in the intellectual capacities of the working class may complicate Schiller's aesthetic, the fact remains that the only legitimate expression of these capacities, in his view, is to be destabilized by the ontologically shattering encounter precipitated by the artwork. As a result, their agency only extends to their ability to "interpret," or be acted upon by, the semantic material provided for them by the artist. "The students had learned without a master explicator," as he writes in *The Ignorant Schoolmaster*, "but not, for all that, without a master."[44]

Rancière's understanding of interpretive agency is outlined in the greatest detail in his essay "The Emancipated Spectator." Here he uses theater as the cultural frame within which to elaborate his defense of the liberatory power of viewing or reading works of art. In an analysis that extends from Plato through Denis Diderot to Bertolt Brecht and Antonin Artaud, he identifies a problematic set of beliefs associated with the participatory dimension of theatrical experience. In particular, he seeks to challenge the perception that theater's mission is to overcome the ostensible "passivity" that accompanies other artistic forms by welding the audience together into an ideal, physically proximate community. In this view, theater's task is to transform "passive spectatorship ... into the living body of a community enacting its own principles," in a kind of localized version of the aesthetic sensus communis.[45] Theater, understood in these terms, will activate the viewer qua participant, overcoming their infantile dependence on conventional spectacle. Rancière contests this view, arguing that the acts of reading or viewing, far from being passive, are in fact the only truly critical forms of aesthetic experience, while the "activation" of viewers in collaborative or participatory theatrical exchange actually relies on problematic notions of "presence" and "community." Theatrical forms that challenge the prosce-

nium arch (Brecht's epic theater, Artaud's theater of cruelty) are accused of abandoning the "distance" that is the essential precondition for all critical thought and aesthetic experience.[46]

In Rancière's analysis, criticality can only be secured via the spatial segregation between audience and stage, reader and page, or viewer and canvas. That's because this distance creates the crucial interpretive space within which the viewer/reader can "translate" the meanings of the text that they are consuming, allowing them to produce, in conjunction with the author, a shared zone of emancipatory "equality." In this manner, the act of reading or viewing becomes the locus of a utopic, egalitarian, and non-instrumentalizing form of intersubjective exchange defined by the "equal power of translation" (what he defines as a "community of equals"). As he contends, "no kind of social hierarchy can be predicated on this sense of distance."[47] In this view, Rancière believes that theater's mission is precisely to "question its privileging of living presence and [to] bring the stage back to a level of equality with the telling of a story or the reading of a book."[48] Thus, the reading of a text constitutes the ur-form of an authentic aesthetic experience for all other media to emulate, in which the individual reader communes with the author via the distanced mediation of the book, safely immune from the contaminating influence of direct "physical presence" and its essentializing corollaries ("community," "collectivity," etc.). Here the necessary autonomy between art and heteronomous life is doubled by the autonomy that exists between the author/artist and the reader/viewer.

For Rancière, the Schillerian prefiguration of an aesthetic sensus communis is renewed in the exchange that occurs between authors/artists and readers/viewers, mediated by works of art in a manner that allows for equal creative agency ("the power each of us possesses in equal measure to make our own way in the world").[49] This exchange is both transformative and ethically secure, precisely because the two selves are never fully (co)present to each other. It finds its antithesis in collaborative or participatory models of aesthetic experience, which are incapable of maintaining a mediated relationship to the world and can only ever be naive and even politically reactionary. In these works, "the spectator is supposed to be redeemed when he is no longer an individual, when he is carried off in a flood of the collective energy or led to the position of the citizen who acts as a member of the collective."[50] To avoid this dire fate, it is essential that we preserve a fixed set of enunciative and receptive positions, distanced from each other by the mediating apparatus of the artwork ("there must be something between the master and the student").[51]

What Rancière seems to most fear in the concept of theater is the perceived dissolution of the autonomous self that is at the core of modern aesthetics (the spectator "who is no longer an individual") and the "confusion" of roles that seek to turn "spectatorship into activity by turning representation into presence." What Rancière must naturalize, then, is the belief that the origin of all critical insight is the individual monadic consciousness of the artist and, secondarily, the viewer who is allowed to "translate" or "interpret" the artist's work. Any challenge to this hierarchical system, any "blurring" of the "distribution of roles," is symptomatic of a crippling dissolution of ontological boundaries, "when all artistic competencies stray from their own fields and exchange places and powers with all others."[52] This is a prospect that clearly dismays Rancière, as it makes the aesthetic an accomplice to an ideology of "mass individualism" linked to the "hyperactive consumerism" of our age, which is "expressed through the relentless exchange between roles and identities, reality and virtuality."[53] If we fail to maintain the sovereignty of the artistic self, with its clearly differentiated categories of creator and viewer or author and reader, then art itself will devolve into the groundless, kitsch-like splay of capitalist mass culture. In this manner, the categorical ambiguity that Rancière celebrates in the tension between autonomy and heteronomy in the work of art is condemned when it is produced in the performance of artistic subjectivity itself.

The idea that viewing a work of art constitutes an "active" form of aesthetic experience is, of course, hardly controversial. Aesthetic contemplation, for both Kant and Schiller, was always understood to have a profound effect on the recipient. It is, in fact, the default assumption throughout the modernist period that the function of art is to produce some active transformation in the viewer or reader's consciousness. From Viktor Shklovsky to Guy Debord, the notion of reading or viewing as "passive" is primarily associated with critiques of mass culture and not with vanguard art forms. Further, one of the defining features of the avant-garde is that it is differentiated from prosaic culture on precisely this basis (Clement Greenberg's analysis of kitsch is emblematic). In fact, the raison d'etre of the avant-garde concept of shock that Rancière relies on in his own account of aesthetic experience was based on the perception that the typical viewer was "habituated" and unreflective. This legacy is difficult to reconcile with Rancière's avowed commitment to the acuity of working-class consciousness and accounts for the deflationary character of his model of reception, in which the viewer is denied any authorial agency but allowed a compensatory "interpretive" power over the materials provided by the artist. This slippage is symptomatic, as Rancière presents

himself as challenging a hidebound cliché about the nature of aesthetic experience that he must attribute to an imaginary interlocutor in order to portray what is essentially a reiteration of existing avant-garde conventions as novel or transgressive. What is striking, then, about Rancière's work is not the contention that object-based aesthetic experience is active rather than passive; it is the corollary belief that by accepting this fact, one must simultaneously reject any other approach to aesthetic experience or any other form of "mediation."

There is a core tension between Rancière's portrayal of aesthetic "interpretation" as the scene of a utopic, mediated exchange between artist and viewer (a kind of embryonic public sphere, entirely devoid of hierarchy and instrumentalization, in which each actor is able to fully express his or her creative and intellectual potential) and the avant-garde paradigm that he relies on to define the specific modes of interaction and subjectivity that unfold within this space. For Rancière, avant-garde artists no longer serve to reveal "the hidden contradictions of capitalism" (a procedure that relies on proscribed forms of representation).[54] Rather, their function is to expose the viewer to an exemplary manifestation of conceptual undecidability (by producing works that play on the ambiguous boundary between art and not-art). However, the supervisory relationship of artist to viewer remains the same in either case. Notwithstanding Rancière's contention that "no kind of social hierarchy" is possible within his aesthetic paradigm, it is clear that one side of this intersubjective matrix is defined by an intrinsic lack (the position of the viewer or reader is characterized by a reliance on categorical forms of meaning, conventional modes of signification, etc.), which necessitates a corrective, quasi-punitive intervention. At the same time, the figure on the other side of the matrix (the position occupied by the author/artist) is understood to possess a singular ability to precipitate this correction, based on their implicit mastery of the cognitive insights inculcated by their own work. The fact that Rancière is willing to concede some nominal interpretive agency to the viewer/reader does nothing to challenge the assumption that they were in need of an externally directed "emancipation" in the first place. The student must be rescued from the "swamp of self-contempt," as he writes.[55] There is no place here for an account of aesthetic experience in which the consciousness of the author or artist would also be seen as incomplete or subject to reciprocal transformation through the agency of and interaction with the viewer/reader. This question, the potentially reciprocal relationship between artist and viewer, self and other, will be central to the remainder of this book.

ESCRACHE AND AUTONOMY

Performative Mediation

Our concern is how one begins to look at these experiences as just the opposite: not for what they can't do, but for everything they can do in a time in which it was said that nothing more could be done.
—Colectivo Situaciones, "Colectivo Situaciones in Conversation with HIJOS"

Although Rancière has had a few detractors (critic Hal Foster attacked his work as the "opiate of the artworld left"), he has remained remarkably popular.[1] Thus, Thomas Hirschhorn, one of the most visible artists on the contemporary scene, has proclaimed that "Jacques Rancière gives me the *strength* to keep my *eternal flame* burning for art."[2] Rancière's success, like that of Chantal Mouffe, is due in part to the fact that he provides theoretical validation for a set of beliefs that are already well established in the institutional art world. In particular, in Rancière's work we find confirmation that the neo-avant-garde work of art, precisely by refusing any engagement with the social or political

sphere beyond the art world, actually becomes *more* authentically critical than works that do operate in those spaces. We also find affirmation that the artists' own subjective autonomy, communicated to the public through the production of conventionally authored objects or texts, is the very precondition for radical thought. And finally, Rancière reassures us that the exigencies imposed on a body of artistic production that depends on the taste patterns of wealthy collectors and museum boards are simply the price to be paid for preserving this singular radicality. As Alain Badiou has observed, in Rancière's theory we encounter "the means for taking up political *results* by cutting them off from the processes that give rise to them."[3] This "cutting off" of political emancipation from the forms of praxis necessary to bring it about refers, as well, to the vaunted "ambiguity" (acted out in the play between autonomy and heteronomy) that is so central to Rancière's aesthetic paradigm.

In this chapter, I want to return to GAC and the escrache tradition, which I introduced in chapter 1. In this work, as Rancière argued, art was forced to "disappear" into "political mobilization" in a process that was both "authoritarian" and "traditional." Here, then, is a form of artistic practice in which the play between autonomy and heteronomy is handled quite differently and in which art no longer chooses to remain "cut off" from the social world where its emancipatory aspirations might find a willing interlocutor. The escraches will serve as a case study, allowing me to identify certain constituent features of socially engaged art practice. Building on this and other examples, I will outline a scalar analysis that accounts for the complex relationship between individual consciousness and political transformation. I will also identify key points of interconnection between contemporary practices and the historical traditions of activist art outlined in the introduction, focusing on work produced during the 1920s. I will extend this analysis in chapter 3 with a more detailed discussion of activist art during the 1960s. My goal here and in chapter 3 is to understand more fully the specific operations of engaged art practice and their relationship to a set of underlying tensions within the broader traditions of the avant-garde. Taken as a whole, these chapters will provide a set of core insights into the historical evolution of engaged art that will set the stage for my description of an alternative aesthetic paradigm in the second half of this book.

Through the juxtaposition of Rancière's critical theory and a concrete instance of practice, we can gain a better sense of how the conventions of the avant-garde schema are being renegotiated in contemporary engaged art and the very different ways in which each of these traditions conceptualize the nature of political change. Autonomy is reproduced at three levels

in Rancière's aesthetic model. First, the production of the work of art must remain separate from the viewer (the work is produced a priori and delivered over to them, like a book to be read). Second, the sovereignty of the artist, as the sole authorial agent, must not be "blurred" or challenged in any way. And, finally, the work of art must remain separate from affiliated forms of cultural production (activism, etc.). Given this outline, one can certainly understand Rancière's antipathy toward the work of collectives like GAC, which violate virtually every one of these strictures. But what would it mean for us to think autonomy differently, beyond the "holy trinity," as Stephen Wright describes it, of artwork, authorship, and spectatorship that is normalized in Rancière's account?[4] In the following section, I will explore this question through an examination of the escrache actions that so troubled Rancière in his remarks at the University of Amsterdam.

We must begin with a clearer account of the work itself and the context in which it was produced. GAC, along with many other art collectives (e.g., Arde Arte!, Taller Popular de Serigrafia, and Grupo Etcetera) emerged during the widespread social and political unrest that accompanied Argentina's economic collapse in 2001.[5] The collapse was the result of a draconian set of economic policies first imposed during the late 1980s by President Carlos Menem (and reinforced by his successor Fernando de la Rúa), intended to bring the country into line with the "Washington Consensus" of neoliberal reforms (privatization, reduction of social services, etc.). These policies led to dramatic levels of unemployment and poverty, the collapse of the peso, bank closures, and the demise of thousands of businesses and factories. The political unrest of the mid- to late 1990s culminated in a massive nationwide protest in December 2001 in which twenty-six people lost their lives. This period not only witnessed the emergence of a wide range of new artist collectives and practices, it also spurred new forms of political and cultural activism more broadly. This is evident in the creation of neighborhood assemblies, *fábricas tomadas* (worker-occupied factories), the Cacerolazo rallies, the piquetero movement, and the Movimiento de Trabajadores Desocupados, among many other examples.[6]

These two factors are related. Some of the most innovative forms of socially engaged art practice have emerged during periods of profound political crisis, as normative values across a range of cultural and social fields are called into question. As a result, existing genres of cultural production and activism are transformed, and new configurations of practice emerge at the interstices of artistic production and political resistance. The escraches are a case in point, as they were first developed by the activist group HIJOS

(Children for Identity and Justice against Forgetting and Silence) but soon expanded beyond their initial form with the direct involvement of artists and art collectives such as GAC and Etcetera. HIJOS's broader goal was to demand justice for the thirty thousand or more Argentines who were killed by the military during the Proceso, or National Reorganization Process.[7] This is a euphemism for the post-Peron military dictatorship that lasted from 1976 to 1983. It was preceded by a 1966 coup d'etat by General Juan Carlos Onganía against the democratically elected government of Arturo Illia. Once the junta crumbled, following its disastrous handling of the Falklands War, there were initial efforts to bring the perpetrators of the "Dirty War" to justice. In 1984, the new government issued a report that documented the deaths of some nine thousand Argentines, and the leader of the junta (General Jorge Rafael Videla) was sentenced to prison. However, by 1986–1987, the government was eager to move on and passed two "impunity" laws (the Ley de Punto Final and the Ley de Obediencia Debida), which effectively curtailed any further investigation into the disappearances and excused former and current members of the military and security forces from prosecution. By 1990, when President Carlos Menem pardoned several of the key leaders of the junta, the historical repression was complete.

HIJOS was founded in 1995 by the sons and daughters of the "disappeared" generation in an attempt to contest this imposed social amnesia and to challenge the state-sanctioned impunity enjoyed by the perpetrators.[8] The normalization of the Dirty War and its atrocities was reinforced by the freedom enjoyed by its leaders and operatives, who continued to live and work throughout the country. In the view of HIJOS, the state, by refusing to prosecute these figures or to even acknowledge the full extent of their crimes, had failed in its duty to defend the interests of the Argentine public and, instead, had chosen to openly side with the criminals of the junta. As a result, it was necessary for HIJOS to redeem the concept of justice through the innovation of the escrache ("where there is no justice, there is escrache"). Taken from a slang term meaning to expose or bring to light, the escraches sought to publicly mark the homes of former junta members, replacing the now inoperative apparatus of formal legal judgment with a gesture of informal social condemnation. This act of collective condemnation also performed a more complex function, according to the members of the Buenos Aires–based group Colectivo Situaciones, who worked closely with HIJOS. The escraches sought to "reconstruct social bonds" that had been frayed by the isolation and fear inculcated by both the original Dirty War and its ongoing legitimation by the current government to allow for

the reclaiming of a public voice from the previously silenced margins of civil society.[9] In the streets of post-junta Argentina we are returned, in a manner of speaking, to an earlier moment in the life cycle of modern liberalism, when the nascent public sphere was just beginning to coalesce out of the domain of private life in order to challenge the legitimacy of official forms of power. The escraches, which began in 1996, gained momentum from the growing political militancy that led to the 2001 uprising.[10] By the early 2000s, the escrache technique had expanded to include actions organized by a range of different groups against corporate malfeasance, police violence, and governmental corruption.[11] The escraches are also credited with helping bring about the eventual reversal of the 1986 and 1987 impunity laws in 2003.[12]

The escrache operated at the intersection of Situationist urbanism and real-world doxing. One of its most visible features was a large, raucous public procession (with chants, music, banners, etc.) that ended at the house or apartment of a specific junta member (although some escraches consisted primarily of leafletting and posters). These processions, which could attract thousands of participants, would culminate with the crowd launching balloons filled with red paint at the walls of the residence, marking it in symbolic blood. The processions were often organized around murga bands, a Latin American tradition based in Carnival and used to convey political critiques of the powerful. As the escraches became increasingly popular, they began to face growing resistance from the Argentine judicial system, in some cases being declared illegal. As a result, the police began to prepare defensive positions around the targeted homes prior to the procession's arrival, complete with barricades and riot gear. It was at this point that Grupo Etcetera, working with HIJOS, pioneered the use of "denunciatory" performances or "theatrical diversions." After arriving at a given house or apartment building, the participants would initiate a form of Dadaistic street theater, intended to reenact the crimes of the targeted individual. The escrache at the home of Dr. Raul Sánchez Ruiz in 1998 was typical. It entailed a parodic restaging of Ruiz's role in kidnapping the children of pregnant women who were later tortured and murdered at the infamous detention camp at the Navy Mechanics School in Buenos Aires and giving, or selling, them to childless military families. The performance centered on a Grupo Etcetera figure called "The General," a grotesque embodiment of military entitlement, bombast, and aggression.

The General reappeared in the escrache of former president Leopoldo Galtieri (also in 1998). Galtieri oversaw the Falklands War and authorized numerous disappearances and kidnappings during the late 1970s. The

escrache (which took place several days prior to a match between England and Argentina in the 1998 World Cup) took the form of a reenactment of the 1978 World Cup, which was held in Argentina at the height of the junta's repressive violence. The General served as the goalkeeper for Team Argentina (representing the military). At the climax of the performance, one of the opposing team members (representing HIJOS) made a penalty kick with a ball filled with red paint that landed on the wall of the home above the heads of the police, who ducked out of the way. This was immediately followed by the launching of several additional paint balloons by members of the assembled crowd. As this description suggests, the goal of these performances was twofold. First, they provided a focus for the assembled crowds. In the absence of the actual perpetrator (who would often remain hidden in their home or simply leave before the day of the escrache), they provided a vivid manifestation and reminder of their crimes. And second, they served a crucial tactical function. The performances were designed to distract the police who were guarding the apartment or house, opening up a clear field of fire for the balloon throwers at the crucial moment.[13]

The performative repertoire of the escrache varied widely, constantly responding to new political contexts and the constraints of specific configurations of urban space (the location of sidewalks, the frequency of traffic, sight lines, building heights, etc.). Escraches also employed a range of stylistic formats. We can gain some sense of this diversity from a 2016 escrache by the group Fuerza Artística de Choque Comunicativo (FACC) directed at the homes of five junta members living in close proximity to each other in the upscale Belgrano neighborhood of Buenos Aires.[14] It featured over 150 participants, accompanied by musicians playing trumpet, violin, cello, drum, and trombone. The participants arrived in silence at each site. Thirty members of FACC began the event by pacing back and forth in the street directly in front of each apartment building while the musicians accompanied them with sounds intended to evoke the terror of the death flights (in which detainees were drugged and then dropped from airplanes over the Rio de la Plata). While pacing back and forth in front of the building, the performers would turn their heads and stare up at the window of the perpetrator's apartment. Gradually their pacing increased in tempo and then suddenly stopped, as they knelt slowly in the middle of the street with their hands behind their backs, still staring up at the building. Each performer's mouth was thrown open, in a kind of strangled scream or gasping for air. A set of figures dressed entirely in black with beak-like masks, reminiscent of plague doctor costumes, wandered among the performers. Individual figures would

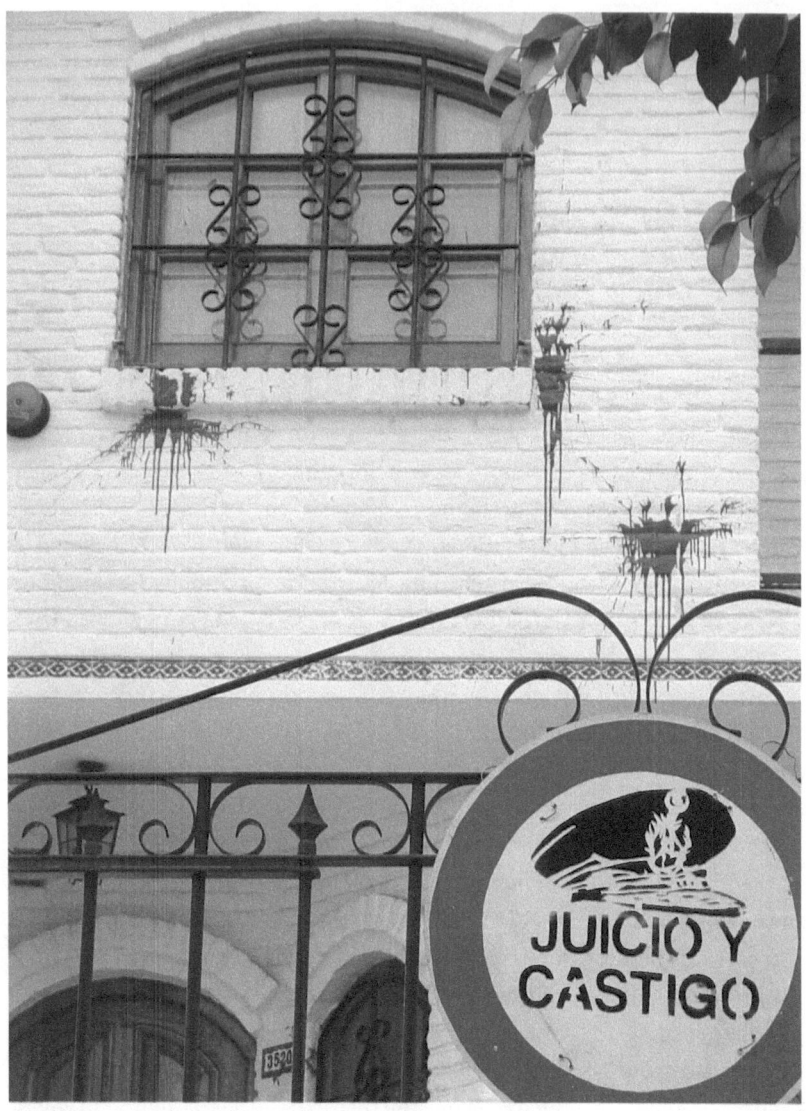

FIGURE 2.1. *Escrache a Olea*. Caballito, Buenos Aires (June 28, 2003). Photo from Archivo GAC/Grupo de Arte Callejero.

take up a position behind each kneeling performer and slowly pull a black plastic bag over their head, symbolizing their immersive death. Eventually the performers slowly rose, removed the bags, and dropped them to the ground, walking away.

The performances are only a single element within a larger repertoire that constituted an escrache. GAC, for its part, developed a set of images that

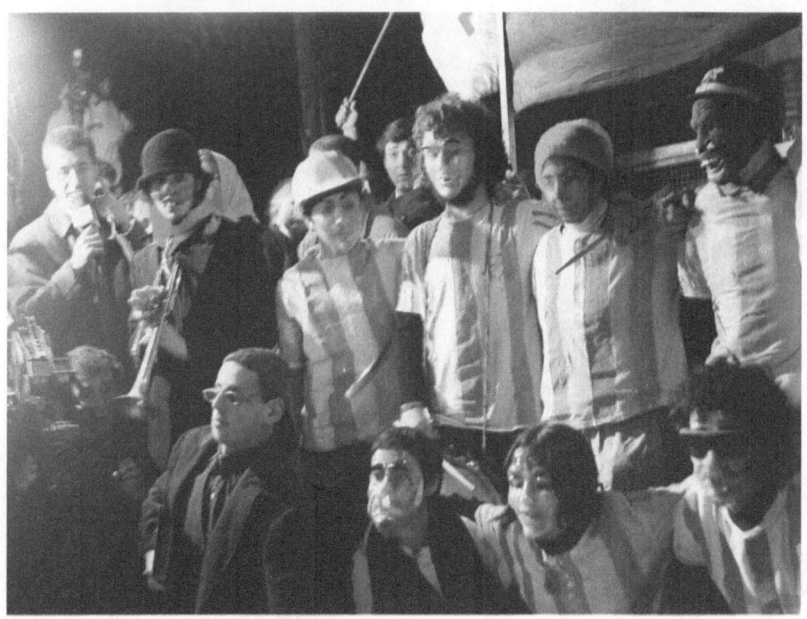

FIGURE 2.2. *Escrache Leopoldo Fortunato Galtieri*. Buenos Aires (1998). Photo from Archivo Etcetera.

reproduced the appearance and style of conventional road signs and navigational markers but altered them to feature phrases like "500 meters to the home of a torturer." These were infiltrated into various locations in the area surrounding the targeted home in the weeks leading up to the performance. They also created a wide range of other graphic materials, from stencils to graffiti, that were incorporated into each neighborhood, effectively transforming the entire streetscape into a semantic field that worked to reframe the community's relationship to both the historical violence of the junta in general and the transgressions of one of its agents, living among them.[15] GAC's work with the conventions of signage can be seen in the context of both urban detournement and the conceptual street signage of Repo History in New York, among many other groups who developed urban interventions during the 1980s and 1990s. These are the materials that Rancière saw and dismissed in Wright's presentation ("artists have made political posters for many, many years"). The formal and visual elements of the escrache performance were accompanied and preceded by two equally important but less visible components. First was the research necessary to actually identify the perpetrators. Given the deliberate secrecy that surrounded legal cases associated with former junta members, it was often quite difficult to

confirm that a given individual was associated with a specific set of crimes. (Some of the perpetrators had already been tried and convicted, but those convictions were not always made public.) Even confirming their identity and securing photographs that would show their current likeness could be challenging. Here HIJOS was able to take advantage of the extensive legal archives of the Madres de Plaza de Mayo.[16]

The second component entailed the laborious process of community interaction that preceded each escrache performance. Thus, long before the final procession, the members of the escrache collective would spend months visiting the neighborhood, meeting with community groups, going door-to-door to talk with and interview residents, circulating leaflets, holding meetings, and so on, in order to inform the neighbors about the history of the individual targeted by the escrache, to learn about their own backgrounds and their own relationship to the violence of the junta, and to build a social network of participants for the final procession.[17] In this manner, a large segment of the community would be mobilized and active in supporting the performance. In many cases, the members of HIJOS would actually live in a given neighborhood for the duration of this process.[18] As a result, as Diego Benegas writes, "a multitude of groups, organizations, and individuals are gathered in an action that becomes entangled with their lives in the most immediate way." In this manner, the escrache functions to reconstruct "the collective memory of the area."[19] This reconstructive process was necessary precisely because of the failure of the Argentine government to fully come to terms with and communicate the extent of the junta's violence and its authors. Thus, some residents were familiar with aspects of the perpetrator's background, while others might have been entirely unaware. The escrache process effectively transformed this mosaic into a network, allowing the residents to understand the full nature of the perpetrator's culpability and to reframe their own relationship to him accordingly.

Artistic Practice as Working Hypothesis

From its origins in the Enlightenment era, the aesthetic has been identified, metonymically, with an image of social emancipation. The decisive question is how our experiential encounter with art relates to the actual realization of this emancipatory ideal. Within the broader avant-garde tradition that I have outlined thus far, the promise of the aesthetic is destined to remained unfulfilled in the current moment because it is linked syllogistically with the mythos of total revolution, against which virtually any form of contemporary

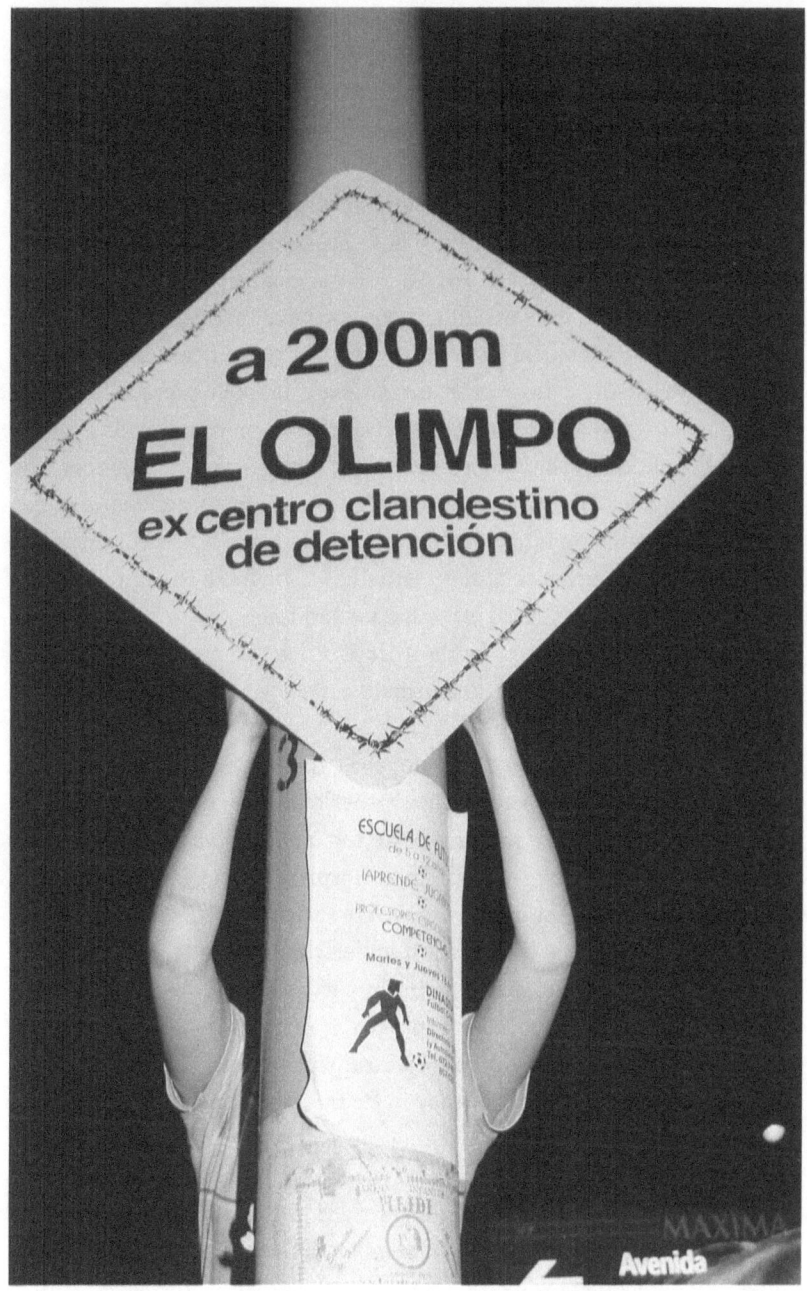

FIGURE 2.3. Grupo de Arte Callejero, *Road Sign*, El Olimpo, former center for Clandestine Detentions (March 20, 1998). Photo from Archivo GAC/Grupo de Arte Callejero.

activism will fail to measure up. In this scenario, art functions as a kind of battery, storing up insurrectional energies absorbed from previous revolutionary moments (which are transposed into various formal or technical innovations and preserved in the privatized encounter between viewer and artwork) that will only be discharged later, when the proper moment arrives. As a result, any "premature" cathexis of art into political practice will only serve to deplete art's liberatory power and justify the continuation of systematic forms of repression. Here the flow of emancipatory energy moves in only one direction: from art into praxis, as these energies will one day be released in the form of ideal modes of revolutionary political consciousness. Precisely by refusing to take on an answerable relationship to social change (a relationship in which the modalities of art itself would be open to reciprocal transformation by the insights generated through practical action), the aesthetic imagines that it is preserving the authentic insurrectional energies of the past on which a future revolution will depend. When this moment arrives, the utopic promise of the aesthetic will be finally be universalized rather than being squandered in ineffectual (and easily co-opted) moments of situational desublimation (forms of art practice that evoke a utopic sense of collectivity, solidarity, or transformative agency that falls short of total revolution).

In this scenario, there is no way for the experience of ongoing social or political praxis to reciprocally infuse art with new conceptual energies in turn. By the same token, practice or action here and now can never lead in any meaningful way to more systematic forms of political transformation. This system reiterates the quintessential structure of conventional aesthetic autonomy, in which the work of art is understood as a monadic entity that can act on the world but that remains impervious to all "external" determination. The problem with this approach, from my perspective, is not the desire to universalize the utopic social transformations anticipated in the aesthetic. Rather, it is the tendency to tie this realization irrevocably to a discursive system that uncouples the conceptual and imaginative resources of the aesthetic from the very forms of practice that might bring this expansion about. With the escraches, the members of Grupo Etcetera and GAC have, in effect, refused this paradigm and the corollary bifurcation of artistic practice between melancholic resignation on the one hand and a displaced critical play on the other. Instead, they have chosen a third option: to redefine the promise of the aesthetic itself. By extension, this also entails a redefinition of the paradigm of political transformation on which the aesthetic depends.

The new forms of artistic production generated in conjunction with the escraches were developed under the assumption that some form of meaningful political resistance is possible here and now (and, by extension, that this resistance would not be immediately absorbed by the engines of capitalist appropriation). This perception is evident in Colectivo Situaciones' commentary on the escraches: "Our concern is how one begins to look at these experiences for everything they can do in a time in which it was said that nothing more could be done."[20] The escraches envision the universalization of the aesthetic as a process that is set in motion as individual subjects invent new forms of situational agency and critical consciousness through practices that push off against concrete manifestations of political domination. In this view, the universalization of the aesthetic will not be achieved by waiting patiently for the proper conjunction of historical forces to finally arrive but, rather, by seizing the transformative potential that is always latent in any given moment.[21] As Colectivo Situaciones observes: "The escraches are ... a practical confirmation that transformative action exists now or not at all. They are the opposite of the melancholy of those that wait, seated, for a better world. . . . Moreover, the future has already arrived, because it is nothing other than that which we are constructing, that which depends on us: it is the future of the present. Thus the escrache founds a present, decisive and full of potentialities."[22]

One can easily enough accuse the writers of an unrealistic optimism or even a naïveté about the difficulties of political change, just as one can identify an equally reductive skepticism in the avant-garde tradition regarding the impossibility of any meaningful political resistance in the current moment. However, one must also recognize that we are in the presence of two very different worldviews, one in which action is always deferred, premature, or inadequate and another in which action, flawed and constrained though it may be, is nonetheless the crucible out of which any future expanded form of practice must emerge. This second approach clearly diverges from the avant-garde paradigm I have sketched out here, in which political action entails the merely mechanical application of a prior emancipatory vision first generated by artistic or theoretical production. Rather, for Grupo Etcetera and GAC, resistance itself can be generative, autopoietic, and transformative. This does not mean that distanced theoretical reflection is unnecessary, but it does mean that theory and practice do not always unfold in a fixed, sequential order, with theory preceding and governing practice or aesthetic education preceding and governing social action. It suggests, in fact, that this binary

opposition itself is subject to renegotiation and that reflective insight can be produced in proximity to rather than only in segregation from praxis.[23]

This position contrasts with the perception, evident in the neo-avant-garde tradition, that forms of political and social resistance are largely utilitarian in nature. Rather, in their work, the conjunction of artistic production and social or political resistance has the capacity to transform consciousness and reframe subjectivity in a manner that is both pragmatic and prefigurative. This capacity is evident in the very core of the escrache: the verbal confrontation with the residence of the torturers. What is most notable about these events is the fact that the targeted individual is often not home when the escrache is being performed. Rather, the entire panoply of actions, gestures, and denunciations unfolds before an imaginary interlocutor. The primary goal here is not to shame the individual directly but, rather, through the freeing up of speech in an environment in which the truth of the junta was constantly denied by the official organs of the state, to transform the consciousness of the protestors themselves. As Colectivo Situaciones writes: "The escrache seeks to put an end to the dictatorship's control of social and public space, to bring people out of their homes again, to place them in relation to one another, to bring them into a collective that is more than just a community and less than a political party. The escraches militate against and work to displace the climate of suspicion, silence and fear that characterized Argentine society under the dictatorship."[24] In fact, the procession, street theater, graphic interventions, and pre-escrache outreach, taken in the aggregate, seek not simply the practical goal of drawing public attention to the impunity of torturers but also to "produce a different subjectivity," as Benegas writes.[25] This is, of course, the central goal of aesthetic experience as well: the reframing and reconstitution of selfhood and consciousness as a precursor to social or political emancipation. But there, the transformation of the self was always understood as occurring *prior* to praxis, as a preparatory reshaping of the self for some future moment of socially transformative action. In the escraches, praxis and self-transformation coincide and overlap in a process that entails "activating the potential in a given situation."[26] Further, this transformed subjectivity possesses both a reparative and a prefigurative dimension, as it overcomes the social fragmentation of the post-dictatorship period ("the escrache . . . produces social bonds in order to counteract their on-going and systematic destruction") while also laying the groundwork for new forms of solidarity that might be mobilized in the future.[27]

This transformative potential is produced along two dialogical relays. First, it unfolds through the physical copresence of the participants and

collaborators, working together over a period of weeks and even months, leading up to the final escrache event. For Rancière, this would, presumably, mark the moment at which the necessarily detached role of "spectator" is abandoned and viewers are transformed into dangerously deindividualized participants, "carried off in a flood of . . . collective energy."[28] However, the escraches conceive the interaction of the individual and the collective less as a zero-sum game, in which the concession of too much personal autonomy to collective interaction marks the complete abrogation of coherent selfhood, than as an experience that can enrich and complicate our ontic condition. In the work of GAC and Grupo Etcetera, artistic subjectivity is mobilized and made available to a broader range of social actors. Here artistic subjectivity is understood not as the exclusive possession of specific, institutionally validated individuals but as a competence that can be cultivated and enhanced, negotiated and exchanged, acquired and surrendered. In the same way, we see the work of art itself ramified out into an expanded field of processes that are collaboratively realized.[29]

The second relay through which an aesthetic transformation unfolds in this work occurs through the imbrication of artistic production and political action in a way that transcends the limitations of each. The conventional avant-garde work measures its criticality through the resistance posed by various "immanent" constraints (e.g., academic style painting for the Fauves, flatness in Abstract Expressionism, or the categorical extremes of autonomy and heteronomy evoked by Rancière). In each case, the rigid surface against which the artwork differentiates itself serves as a metaphorical substitute for existing modes of political repression with which art cannot risk direct engagement.[30] In this manner, the artwork seeks to act out a virtualized form of antagonism, which is protected from the complicity that actual forms of "political mobilization" would otherwise impose. This "surface" must, by necessity, appear as entirely reified or conventional, incapable of exerting any generative reciprocal pressure on the work itself, except as a point of apophatic differentiation. In this manner, it allows artistic production to demonstrate its own exemplary fluidity and nonidentity.

Socially engaged art practices frame the concept of criticality quite differently, as resistance is produced through direct interaction with forms of political repression that are internally complex, ambivalent, and able to actively modulate themselves in response to intervention and critique. As a result, the rigid surface against which art "kicks off" is now reciprocally responsive and answerable in real time rather than being a static placeholder for "real" repression. The work thus unfolds through a dialectical exchange

of force and counterforce as a given repressive apparatus modifies itself in response to a given artistic intervention. For this reason, Colectivo Situaciones describes the escrache as constituting a "Hypothesis in Practice," in which the escrache "self corrects, subjecting itself to ongoing changes and verifications."[31] The escrache produces criticality and critical distance not through the flickering interference patterns created in the viewer's mind by the tension between abstract concepts of "art" and "non-art" but by creating a epiphenomenal civic space that transcends the existing legitimating apparatus of the Argentine state. Thus, as Colectivo Situaciones writes, "the escrache valorizes autonomy in so far as it allows one to abandon acting via opposition. Its independence with respect to the other—the enemy, the system—converts escrache into an instrument of self-affirmation."[32] Where conventional activism might petition the state to fulfill its obligations and bring the perpetrators to justice, the escraches openly acknowledge that the state can no longer be relied on to fulfill this role and that justice itself is an empty abstraction. The escrache, as they write, "doesn't ask for anything."[33] As a result, justice must be "produced," here and now, rather than bestowed like a gift from a benevolent sovereign.

Bracketing and Melting Down

In the schema of avant-garde autonomy I outlined in the introduction, the aesthetic fulfills its emancipatory mission by remaining detached from the contingencies of political "mobilization," which entails dangerously unmediated forms of intersubjective exchange (the physically proximate bodies of collaborators and participants) and which precludes any form of reflective or critical experiential knowledge. This general schema has been carried forward from the late eighteenth century to the present with remarkable fidelity. The socially engaged art practices of the past thirty years suggest a very different aesthetic paradigm, one in which artistic projects developed in proximity to concrete sites of social or political resistance can exhibit many of the core attributes of conventionally "mediated" aesthetic experience (the cultivation of a reflective, critical intelligence, the creation of prefigurative forms of intersubjective exchange, an awareness of the limitations of conventional epistemological forms, etc.). More accurately, we might say that these practices produce the crucial epistemological values associated with mediation differently. When we speak of mediation, we are also, in effect, speaking of the longer historical trajectory of aesthetic autonomy itself, as mediation is simply the most recent theoretical expression of the

long-standing belief that art can only produce its critical or prefigurative meaning through forms of spatial or temporal displacement from the sphere of daily life. How, then, is mediation, or critical distance, achieved in artistic projects that no longer operate primarily within the protected enclave of the art world or that seek to thematize the a priori conventions of authorial sovereignty that we associate with works anchored in conventional models of aesthetic autonomy?

The answer to this question requires a further reassessment of the history of modernism itself. As I noted in the introduction, rather than marking a decisive break with past practice, this work represents the coming into greater visibility of a tendency that has always been present in the history of modernism, even as it has often been marginalized in art historical accounts. Moreover, it is a tendency that has deep roots in forms of cultural production far afield from the institutional sphere of the European art world, in which the paradigm of aesthetic transcendence is challenged at the level of what Bakhtin would term the social "architectonics" of art itself. I want to begin this discussion by acknowledging that Rancière is essentially correct to view GAC's work in Buenos Aires as constituting a violation of the norms of aesthetic autonomy. Its work was produced during a period of growing instability in Latin American political culture, when a range of normative political and cultural values (especially those associated with the virtues of neoliberalism) were being widely challenged. Socially engaged art practices locate their oppositional fulcrum in concrete instantiations of political repression that can answer back in real time. As a result, these practices can modify their underlying structure, often in quite profound ways, in response to these constantly modulating forces. These changes are especially pronounced during hinge periods, like the Pink Tide in Latin America, which are defined by a more general shift in political worldview. Walter Benjamin identifies a similar dynamic in his famous "Author as Producer" lecture, written in the wake of the Russian Revolution. Benjamin describes a "vast melting-down process" following the revolution, which affected contemporary art and literature throughout the country. As Benjamin argues, this process not only "destroyed the conventional separation between genres, between writer and poet, scholar and popularizer," it also challenged "the separation between author and reader."[34]

Benjamin points to poet and playwright Sergei Tretyakov as an exemplar of this radical reframing of aesthetic norms, noting his distinction between the "operative" and the "informative" writer: "The operative writer's mission is not to report but to fight; not to assume the spectator's role but

to intervene actively."³⁵ Tretyakov's activities extended well beyond the conventional processes of journalistic or novelistic writing to include the organization of mass meetings and traveling film screenings, the creation of wall newspapers, and so on. The concept of an "operative" writer developed by Tretyakov emerged out of his long-term involvement with Communist Lighthouse, a kolkhoz, or collective farm, in the Stavropolskii area. It is here, as Tretyakov describes it in his field notes, that he took on the remarkable range of creative activities alluded to by Benjamin.³⁶ In this process, as Gerald Raunig notes, Tretyakov's perception of the role of the artist in a revolutionary context changed significantly. He had come to the kolkhoz still invested in a paradigm of the "specialist Bolshevik," who served as a "savior figure" exercising a benevolent but hierarchical mastery over the kolkhoz community. This paradigm was supplanted by what Tretyakov termed "the flexible socialist active of very different personalities," a concept that depends on the shared labor of multiple kolkhoz members, each possessing "different, specific competencies." "Linking these competencies," as Raunig observes, "meant linking one specific knowledge with another specific knowledge in a patchwork that did not have wholeness as its goal, but rather a transversal relationship of exchange."³⁷

For Benjamin, this work, rather than entailing the collapse of aesthetic autonomy into the utilitarian demands of political praxis, actually demonstrates a practical reconfiguration of aesthetic norms. "I quoted Tretyakov's example deliberately," as he writes, "in order to point out to you how wide the horizon has to be from which, in the light of the technical realities of our situation today, we must rethink the notions of literary forms or genres if we are to find forms appropriate to the literary energy of our time. Novels did not always exist in the past, nor must they necessarily always exist in the future; nor, always, tragedies; nor great epics."³⁸ In this view, the forms of creation and subjectivity that we identify today as essential to preserving the specificity of art were themselves the artifacts of a previous historical moment and its unique "technical realities," to which they were situationally responsive. In Benjamin's view, these normative conventions must inevitably change and adapt themselves to new configurations of political and cultural power. Benjamin contrasts Tretyakov's "operative" paradigm with the approach of the poets and novelists associated with the "Activist" tendency in Germany during the 1920s, such as Alfred Döblin and Robert Müller. For Döblin, poets and writers can only preserve the unique critical agency of art by refraining from any "practical" action. Instead, their most important function is to occupy the "original communist position," as yet unclaimed by

the proletariat itself, embodying the "individual human freedom" that will one day be available to all, after the successful conclusion of a communist revolution. Thus, the poet or writer plays a role in the unfolding struggle between communism and fascism by simply continuing to express his or her own subjective freedom through the conventional, autonomous production of poetry and literature.[39] Thomas Mann, a contemporary of Döblin, offers a corollary expression of this view in *Doctor Faustus*. "Art is mind," he writes, "and mind does not need . . . to feel itself obligated to the community, to society." "An art that goes unto the folk," as Mann continues, "which makes her own the needs of the crowd, of the little man, of small minds, arrives at wretchedness, and to make it her duty is the worst small-mindedness, and the murder of mind and spirit. And it is my conviction that mind, in its most audacious, unrestrained advance and researches, can, however unsuited to the masses, be certain in some indirect way to serve man in the long run."[40] Here we have the characteristic avant-gardist division between the artist and the "little man," between the exalted domain of "mind" and the mediocrity and wretchedness of the crowd. We have as well the belief that forms of artistic production "unsuited" or entirely inaccessible to the masses nevertheless carry some as yet unrealized emancipatory potential.

The transformation in aesthetic norms outlined by Benjamin is a consistent theme in Russian art more generally following the 1917 revolution. Thus, Varvara Stepanova, in her "General Theory of Constructivism" from 1921, proposes a concept of artistic "flux" to account for the dramatic reconfiguration of the norms of aesthetic autonomy evident in the postrevolutionary period, as artistic practice became responsive in real time to the ongoing evolution of new political forms. This "principle of ceaseless shift" unfolded on two related levels. First, we see the opening out of artistic production to other forms of culture (especially mass or popular culture) and other disciplines (engineering, design, etc.) as well as to political praxis itself. And second, Constructivist art practices transformed the sociality of art, forging a new dialogical structure in which the categories of "viewer," "reader," "author," and "artist" were reconfigured. In each case, it is the plasticity of artistic form and of the modes of subjectivity and agency mobilized by a given work that Stepanova calls our attention to. Rather than expending "long hours of manual labor . . . on each new form and object," as Stepanova writes, the revolutionary epoch privileges the "temporary and the transient," in which the "static object" defined by "external form" is superseded by "function, action, dynamics and tectonics." As a result, any formal innovation has only a "short term significance" before it is subject to "further expansion and evolution"

in response to ongoing changes in the surrounding political ecosystem.[41] Rather than being held in abeyance for some future revolutionary moment, the formal innovations associated with a given artistic practice must remain reciprocally responsive to changing social and political circumstances. The artistic mentality that is appropriate to this context must also be transformed, moving from a conventional paradigm of "contemplation" to an aesthetic based on "experimental cognition" or "active thought."

It was this utopic moment of aesthetic and political cross-fertilization that inspired the founders of the influential art journal *October*. But their admiration for the 1917 revolution was joined with a corollary belief that its eventual failure marked the final moment during which any meaningful relationship between art and political change was possible. As a result, art could no longer afford to remain open and reciprocally responsive to unfolding forms of political resistance and reinvention. Instead, it had to seal itself off from the contaminating impurity of activist practice, restricting its critical power to an internalized, neo-avant-garde assault on the conventions of the institutionalized art world itself.[42] In this context, one can easily enough understand Rancière's perception that the "melting down" process evident in contemporary socially engaged art practice (involving the renegotiation of conventional authorial roles and the suspension of certain forms of spatial and temporal displacement) is simply the deleterious effect of a banal consumer culture blurring the essential hierarchical structure of artistic "competence" rather than the symptom of some more fundamental reshaping of the nature of artistic practice. Here I return to the question that I introduced earlier. What constitutes a legitimate form of political transformation, sufficient to finally abandon the avant-garde prohibition on any operational involvement with direct political action or to justify some erosion of the defensive sovereignty of the artistic personality? Within the structure of avant-garde autonomy developed under the influence of early twentieth-century Marxism, the only legitimate form of political change involves a cataclysmic revolutionary event that completely transforms the existing capitalist system and, along with it, our underlying human nature. In this case, anything short of the absolute destruction of the existing order can be dismissed as reformist, complicit, or counterrevolutionary. Here "revolution" must invent itself ex nihilo, out of the ashes of an entirely moribund historical past.

More than a century has passed since the 1917 revolution, and the moment of real political change memorialized in this schema still eludes us, while the avant-garde continues to hold its revolutionary powers in suspensive

reserve, awaiting some future St. Petersburg. The "memory trace" of past revolution ostensibly carried in the genetic fibers of the contemporary avant-garde is, thus, arrested in an early-twentieth-century paradigm of capitalism, communism, and resistance. In this view, revolution, both artistic and political, is radically discontinuous with the present moment and radically autonomous from current political values and institutional structures, which exist only in order to be manipulated and discarded in pursuit of a pure revolutionary vision. There is a venerable tradition behind this model, but it is not without its limitations, not the least of which is its reliance on an implicit millenarianism, along with a profound Eurocentrism that continues to valorize a handful of revolutionary moments in Russia and France as offering the only legitimate model of radical political transformation. In the mythos of Leninism, "capitalism" appears as an unnatural excrescence, imposed on an otherwise uncorrupt human nature, which will be wiped away in its entirety through a form of radical negation that renders all existing institutions and political discourses obsolete in a single convulsive revolutionary event. However, while the sheer violence of revolution can certainly destabilize existing power structures, on its own it has seldom produced a more enlightened public better able to determine its own destiny. Here we return to a fundamental aporia of Leninism: the belief that human consciousness itself would be changed through the violence of the dictatorship of the proletariat, reappearing on the other side of this bloody crucible as the transmogrified "New Man" who would be literally incapable of greed or intersubjective violence. It is one thing to acknowledge, as we must, that meaningful social and political change has often involved violent resistance (waged against the systemic violence imposed by capitalism itself). It is another to assume that this violence, in and of itself, has a necessarily emancipatory effect on human consciousness that would enable us to generate new and more just political models, especially violence as articulated in the coldly calculating vernacular of the early-twentieth-century political vanguards who appointed themselves the caretakers of the "imputed consciousness" of the habituated masses.

History suggests that we cannot wait to address the fundamental question of alternative social and political modalities or the structures of intersubjective exchange that could sustain them until *after* the world has been turned upside down. It is precisely this essential, prefigurative dimension that is so often disavowed in the traditions of the avant-garde, which remains invested in a discourse of symbolic negation and assault (safely housed within the protective enclosure of the institutional art world) while

dismissing artistic practices that seek to explore the emancipatory potential of collective experience as naively affirmative ("innovative micro-solutions" that abjure any "deep criticism" of the prevailing social order). And it is this same form of speculative research that we encounter in socially engaged art. However, it is important to note that what distinguishes this work is not simply a creative engagement with new modes of social being but, rather, the dialectical relationship between this creative, exploratory process and the tactical demands of resistance itself, as artistic production pushes off against concrete instantiations of repression, instead of the reified protocols of the institutional art world. The result of this shift is the emergence of a very different problematic of aesthetic and political knowledge that marks a significant departure from the "normal science" of the avant-garde.

The "melting down" of aesthetic autonomy identified by Benjamin in the early 1930s was not unique to the Russian Revolution. Rather, it has been a consistent feature of political and social struggle over the past century or more, not just within the context of European history but across a much broader range of global cultural production. We can identify three key vectors for this tradition. First, as the example of Benjamin suggests, within Marxism itself there exists an important lineage of research concerned with the epistemologically generative nature of praxis and the creative capacity of the working class. In the Soviet context, this tendency is associated with figures such as Aleksandr Bogdanov and the Prolekult movement, as well as Antonio Gramsci's writing on subaltern cultural practices. Second, we encounter an important set of precedents in the history of anticolonial resistance, ranging from Mahatma Gandhi's innovative use of popular cultural forms during the struggle for Indian independence (hand-loom spinning, dhotis, etc.) to the development of an aesthetic politics of Négritude by Leopold Senghor, Aimé Césaire, and others working in Africa and the Caribbean. And third, there is a significant body of cultural production that emerged in conjunction with new social movements during the 1960s, from the Black Arts movement in the United States to new forms of performance art emerging out of the feminist movement to activist art practices related to anti-authoritarian struggles in Latin America.[43] In each case, we encounter a repudiation of the key tenets of the avant-garde schema of aesthetic autonomy. Where Adorno viewed popular culture as a realm of degradation and false consciousness, artists in this tradition focused on its potential as a vehicle of emancipation. Where Rancière abjures the recourse to collective forms of production in contemporary engaged art, we find a willingness to experiment with new modes of collaborative creation. And finally, where Thomas Mann wrote of

the danger posed by artists who collapse the necessary distance between themselves and the "needs of the crowd," Césaire warns his readers: "Beware above all of crossing your arms and assuming the sterile attitude of the spectator, for life is not a spectacle, a sea of miseries is not a proscenium."[44] One of the central features of this alternative tradition is a recognition that the form taken by revolution or social change is as important as the end.

We require, then, an analysis of political transformation that can account for the imbrication of both radical negation (the necessary assault on existing structures of political domination) and positive or generative insight. These should be understood as existing in a symbiotic relationship rather than bifurcated between two entirely disjunctive moments (pre- and post-revolution). In this way, the act of resistance has the potential to be both instrumental (concerned with the immediate, tactical actions necessary to challenge existing power structures) *and* conceptually generative (producing new insight into the lifeworld that might replace these structures as well as into resistance itself). This is precisely the combination we can observe in the escraches of Argentina. In this view, resistance can shape human consciousness in a progressive manner, transform our awareness of our own agency, and open up prefigurative and creative insight into the reconstitution of the social and political. This is unlikely to occur, however, through a process that views the actual agents of social change as a kind of kinetic resource "placed at the disposal" of the revolutionary intelligentsia. I would also argue that political change, and anticapitalist resistance in particular, have historically taken many more diverse forms beyond that enshrined in the 1917 revolution. For this reason, it is misleading to define meaningful political change solely in terms of a singular, world-shattering event, abstracted from its surrounding historical context. If we accept this as the only legitimate criterion by which to judge the efficacy of resistance, then we are also obliged to accept the melancholic resignation that comes along with the failure of these "singular" moments (prototypically, the Bolshevik Revolution) to precipitate a universal form of emancipation. Along with this melancholy comes a hardening or reification of the emancipatory imagination itself.

While political change, revolutionary or otherwise, is always generated through unique and often unexpected situational configurations, conditions, and agents, it is also always grounded in an existing repertoire of material, discursive, institutional, and counter-institutional practices and precedent events. This temporal continuum is paralleled by a spatial continuum, through a mode of capillary action that runs from the transformation of individual consciousness to collective action and violent resistance and that involves the

emergence of new solidarities and their subsequent dissolution, moments of provisional consensus, and moments of dissensus. While the awakening of an individual consciousness does not necessarily lead to a specific political action, it is clearly the precondition for it. What we call the "Russian Revolution" did not begin with Lenin reading Hegel in Berne, it began with the resistance movements of the nineteenth century, with the Kolokol, with the Peasant Movement, with Zemlya i Volya, and with Young Russia, which led to the 1905 Revolution, which led to the February 1917 uprising that actually drove the tsar from power, which led, finally, to the Bolshevik takeover. In fact, as Lenin admitted, the Bolsheviks did not "seize" power at all, they simply found it "lying in the street," in the aftermath of the February Revolution (an event in which Lenin himself played no role). Each of these nodal points was decisive in producing the eventual transformation that we describe as the Russian Revolution. As this example suggests, meaningful political change is cumulative, through longer cycles of reaction and counterreaction, in ways that we often cannot recognize at the time. At the same time, it unfolds across multiple spatial registers from the micro-political scale of the face-to-face encounter to the local, national, and transnational (evident, for example, during the Pink Tide period in Latin America).

To bring this discussion back to the question of socially engaged art, I would argue that in writing about this work we need a more sophisticated model of political change that can account for this capillary nature. Even the most privatized example of "art for art's sake" has a practical effect in the transformation of an individual viewer's consciousness. The challenge is understanding how the transformation of consciousness through the encounter with a work of art might affect the viewer's subsequent actions in the world. This is the more interesting question: How do we determine what "change" means and which forms of change are more creative or generative? Here is one provisional set of categories for understanding this question, drawing on a broader range of activist traditions.

1 Transformations in individual consciousness (which may or may not lead to a transformation in social agency and which may or may not be serially communicated to others). This is, of course, evident in a myriad of art practices both within and beyond the avant-garde paradigm. We see an expression of this in the *Offering of Mind* project developed by Chu Yuan in Myanmar. Another pertinent example can be found in Saba Zavarei's *Radio Khiaban* and the *Fashion Parade* at Makerere University in Kampala (both discussed below).[45]

2. Prefigurative modeling (the creation of new modes of social organization that challenge existing hierarchies of power and decision-making). This is evident in many contemporary art practices that involve the invention of new, para-institutional forms. The work of the Tambo Colectivx in La Paz is emblematic, as well as the Tabacalera of Lavapiés, an abandoned tobacco factory that became a center for autonomous cultural production in Madrid and the Rojava Film Commune in the Democratic Federation of Northern Syria. The question of prefiguration is also central to social movement theory and has emerged in analyses of decision-making protocols in the civil rights movement in the United States.[46]
3. Transformations in cultural or symbolic discourse (the introduction of new value systems, the reframing of debates or the alteration of social relationships at a given site, or the delegitimization of existing forms of state authority). This is evident in the escraches discussed above and projects such as the Transborder Immigrant Tool developed by Electronic Disturbance Theater 2.0/b.a.n.g. lab, the Rhodes Must Fall protests in Cape Town, and Renata Carvalho's National Movement of Trans Artists in Brazil.[47]
4. The reshaping of spatial boundaries, the defensive partitioning of space or territory, or the temporary occupation of public space. This is evident in the anti-gentrification struggles of groups like Gezi-Park Fiction in Hamburg or the many actions associated with Occupy Wall Street and more recently the ZAD (Zone à Defender) occupations, which evolved to block large-scale development projects that threatened to damage specific communities or ecosystems in France.
5. The reshaping of temporal frames, via the blocking or delaying of repressive action. This is evident in the Prestes Maia occupation in São Paulo, in which an abandoned apartment building was occupied by families, activists, and artists, becoming a hub for new educational and political initiatives developed in conjunction with the surrounding community, the initial victory of the Water Protectors at Standing Rock in South Dakota, and the work of Spain's Platform for People Affected by Mortgages (La Plataforma de Afectados por la Hipoteca).[48]
6. Transformations in public policy or public attitudes toward existing policies (police oversight, corporate regulation, housing, etc.). This is evident in the *Tamms Year Ten* project, which I will discuss subsequently; the work of the Gulf Labor Artists Coalition, which has exposed the repressive labor practices employed in the construction

of the Guggenheim Abu Dhabi; and recent activism associated with the Black Lives Matter movement, evident in the work of artists such as Shamell Bell and Lynnée Denise, who use the traditions of dance and DJing to change perceptions of anti-Black violence.[49]

7 Efforts to transform existing political regimes, at the local, regional, or national level (which might call on any number of the preceding strategies). This is evident in the *Lava la Bandera* project, discussed later, which was developed as part of broader protests against the Fujimori dictatorship in Peru, and cultural actions associated with the January 25 Revolution in Egypt, the Saffron Revolution in Myanmar in 2007, and elsewhere.

Taken in the aggregate, these are some of the imperfect, improvisational, and inevitably compromised modalities by which political and social change actually occurs. They often coexist within a given activist project or historical moment. The extent to which any project is meaningfully transformative, creative, or revolutionary (or has a potential to affect events beyond its local context) has to be gauged through a situational analysis of these interactions, among many others. They each involve encounters that can provoke new insights and new modes of practice and that can, in turn, provide the foundation for subsequent action and insight. In this sense, they can be simultaneously pragmatic (involving processes of concrete problem-solving), diagnostic (revealing new cognitive and institutional blockages and openings), and prefigurative (disclosing new modes of contestation that might be scalable or replicable in the future as well as new insights into the process of social change more generally).

The fact remains, however, that none of these projects can be seen as exhibiting a properly "revolutionary" form of resistance, as that term is understood within an avant-garde tradition that remains dependent on the mythos of the Bolshevik Revolution. There is no self-conscious, allegorical reference to the political imaginary mobilized by the events of 1917, no "memory trace" of the history of global communist revolution to be deciphered. Equally crucially, class is referenced directly in some cases (Gulf Labor Coalition, OWS, etc.) but only obliquely or not at all in others. A further problem concerns the status of the viewer qua participant. Conventional avant-garde practices are assumed to inculcate a uniquely critical perspective on the capitalist system simply because they continue to construct the viewer as the representative embodiment of capitalism's primary beneficiary (the self-interested bourgeois subject). In the absence of any real potential

for substantive political change, the only way to preserve a revolutionary impulse is to implant a vestigial trace of the violence of insurrection in the artwork's cognitive assault on the viewer's consciousness.

Viewed from this perspective, virtually all of the projects or practices discussed above can be seen as exhibiting variations of the same basic problematic. While they are capable of producing situational transformations (contributing to the reversal of the Ley del Punto in Argentina, defending the Hafenstraße from gentrification, closing down a prison, etc.), they fail, by and large, to deploy any deliberate referential links to the historical traditions of communist revolution, nor do they engage in a ritualistic assault on the viewer's consciousness. In fact, in many cases, these projects forego the conventional viewer/artwork relationship entirely, focusing instead on participatory or collaborative modes of production. As a result, they are subject to the same problem that I discussed earlier. In this view, socially engaged art, in the words of critic Mikkel Bolt Rasmussen, is reduced to "a kind of socially reparatory activity that addresses very specific problems and tries to highlight or solve them."[50] Rasmussen reiterates here the familiar exculpatory critique, in which any practical improvement in existing social reality will simply be used by the state to validate its refusal to undergo a more systematic transformation, thereby defusing an authentic revolutionary ethos that might otherwise emerge if the state were not provided with this reformist alibi. ("All energy wasted on half measures strengthens the tyrannical grip of the old regime," as the Situationists expressed it.) I am entirely sympathetic with this critique. It arises from an understandable concern about the depoliticized nature of many collaborative or "social" art practices. However, it can, if elaborated within an excessively mechanistic model of political change, become constraining and even conservative. More specifically, it provides us with no way to distinguish between the most naively affirmative form of participatory art practice and projects, like the work of GAC and other groups, that are developed with a complex understanding of the interconnection between the aesthetic and the political. As a result, we can risk losing sight of the generative nature of resistance itself, at the local or situational level.

We are confronted here with two different temporalities. On one hand, we have the temporality of avant-garde autonomy, in which political practice is always premature and in which art's emancipatory power must be remain "undamaged by praxis" until some future moment. Until then art remains the singular carrier of an otherwise repressed revolutionary truth. Its task is the serial radicalization of individual viewers, under the assumption that critical

insight into the contingency of art will necessarily trigger a series of cascading insights into the contingency of broader systems of political domination. And on the other hand, we have a view of political transformation that is built up through an ongoing dialogical process of pragmatic experimentation and through art's direct engagement with existing processes of social and political opposition. The form of art changes through this process, often in quite profound ways, under the assumption, as Colectivo Situaciones writes, that transformative action exists "now or not at all."[51] This is, of course, an ultimately undecidable question. Are all efforts to initiate situational change subject to a fatal complicity? Can we really assume that artistic practices that reference the Russian Revolution or that allegorize "workers' self-activity" in the simple act of artistic collaboration are the *only* site at which an authentic revolutionary consciousness can be cultivated or preserved?[52] And is it really accurate to claim that anyone engaged in localized resistance is incapable, at the same time, of sustaining a broader awareness of the need for a systematic political transformation? One can easily enough find artistic practices that exemplify either of these worldviews. For me, the most generative and meaningfully disruptive practices (exemplified by the escraches, among many other examples that I have written about over the past thirty years) tend to fall in the second category. But this is also because my own worldview of political change is inconsistent with the underlying assumptions of the avant-garde schema that I have outlined here. We can view this body of work as an abandonment of art's sacred power (heedlessly merging the ethical and the aesthetic, or "collapsing" art into social change) or as the expression of a fundamentally new configuration of aesthetic autonomy, appropriate to the current moment.

This question requires, in turn, a closer analysis of the principle of mediation, which plays a central role in Rancière's work and within the avant-garde tradition more generally. For Rancière, the mediation provided by the artwork qua object or text ("like a book to be read") is intended as a safeguard against our naive investment in forms of physically proximate interaction (which can all too easily collapse the individual into proscribed modes of communal identity, or problematic notions of "presence"). But mediation carries another set of implications. In particular, mediation has the effect of reasserting the mastery of the author (whose own consciousness becomes the "medium" through which criticality is produced), over and against forms of insight generated through collective interaction and exchange. Notwithstanding Rancière's claims about the readers' ostensible interpretive agency, the model of mediation he proposes entails the implicit privileging

of authorial hierarchy. This authority, this self-certitude, is nowhere more evident than in the underlying assumption that the artist or theorist alone possesses a privileged knowledge of what, precisely, constitutes authentic revolutionary action and when the proper historical moment has arrived to justify it. Rather than locating the core productive tension within modernity in the flickering movement between the autonomy and heteronomy of art per se, I would contend that an equally decisive set of tensions unfold in the relationship between a self that is defined as autonomous and sovereign and a self that is malleable and open to the shaping influence of the other. In the next chapter, I will identify a parallel expression of this tension in the "dematerialization" of artistic practice during the 1960s.

II

FROM OBJECT TO
EVENT

3

DEMATERIALIZATION AND AESTHETICS IN REAL TIME

Within and beyond the Art World

Let's begin with the individual painter or sculptor ensconced "high" in his loft world, making his pile of shit . . . having ingested art information and raw material from the shared world, pissing his time away, the labor of his love perhaps to be redeemed, to be *realized*, at some other time.
—Dan Graham, "Art Worker's Coalition Open Hearing"

As I outlined in the previous chapter, socially engaged art practices reflect a long-standing set of tensions within the history of modernism regarding the relationship between art and political transformation. In this chapter, I want to continue this investigation by examining artistic practices in the 1960s and 1970s, focusing on the discourse of "dematerialization" in visual art as well as new approaches to activist cinema. During this period, we can observe the creative process by which artists whose work evolved out of a more conventional model of avant-garde autonomy sought to reframe

the relationship between aesthetic experience and political resistance. This is evident in the emergence of collaborative or participatory art practices, often developed in conjunction with broader social and political movements.[1] Examples include Joseph Beuys's creation of the Free International University, the Tucumán Arde project in Rosario, the Wall of Respect in Chicago, Atelier Populaire in France, and Suzanne Lacy and Leslie Labowitz's early projects on sexual violence in Los Angeles. At a more general level, this shift openly thematized a collaborative and performative dimension already evident in earlier activist practices (Tretyakov's figure of the operative writer, the Worker's Photo movement, and, further afield, Gandhi's perambulatory activist gestures, such as the Salt March during the 1930s). Of particular importance is the fact that art practices during the 1960s and 1970s made these existing strategies more visible and coherent as expressions of a creative intentionality rather than simple tactical necessity. In the process, they also made them available to subsequent artists as a field of potential experimentation and development. This chapter is organized around three central questions: How is a capacity for autonomous criticality preserved in this work? How are the positions of artist and viewer reconfigured? And how is this reconfiguration related to political transformation and critique?

The temporality of the conventional avant-garde is defined by a principle of deferral, as we await an ideal revolutionary moment that has yet to arrive. The temporality of socially engaged art, on the other hand, is based on the assumption that we cannot predict the precise historical juncture at which meaningful change might emerge or how situational actions here and now might aggregate over time to contribute to more systematic forms of political and social transformation in the future. This approach does not absolve us of the obligation to assess the potential appropriation of a given project by the legitimating mechanisms of the capitalist system. It does, however, imply that this complicity cannot simply be assumed beforehand, as the inevitable fate of any artistic practice that engages with the process of social or political transformation. The risk of the first temporality is a withdrawal from the circuits of social and political change that can both challenge and renew artistic practice, along with a necessary complicity with the normalization of the market as the sole legitimating mechanism for artistic production. The risk of the second temporality lies in its potential co-optation by political reformism and the subordination of a critical aesthetic capacity to functionalist forms of social or political resistance that can reduce art to a crudely propagandistic role.

If we no longer conceptualize change solely through a principle of simultaneity (a revolution that is immediate and all-encompassing), then we are also compelled to reconsider the plasticity of aesthetic autonomy itself, as existing modes of artistic production are "melted down" and reinvented during periods of political disruption and transformation (1917, the 1960s, the Pink Tide). This process is characterized by two distinct effects. First, it produces a set of shifts in the social structure of aesthetic autonomy, leading to the reconfiguration of specific roles and identities associated with artistic production ("artist," "viewer," etc.) while also opening up interconnections between art and other genres of cultural production (the blurring of art and design in Constructivism or art and political activism in the 1960s). Second, periods of political transformation can alter the stylistic or formal structures of specific art media (i.e., the thematic material to which a given artwork refers or the ways in which it modulates existing compositional protocols). In the ethos of the avant-garde, only the changes that occur in art's ostensibly "immanent" formal condition matter because they are seen as the displaced remnant of a depleted revolutionary consciousness. The changes that occur in the social architecture of aesthetic autonomy, on the other hand, are seen as extra-artistic and consigned to the realm of naïveté or hubris, errors to be corrected rather than insights to be learned from.

This is exemplified by critic Hal Foster's account of participatory art practices during the 1960s that began to operate in spaces outside the institutional art world. For Foster, the significance of this work, exemplified by Alan Kaprow's Happenings, lies in the negative example provided by its "anarchistic" collapse of art into life.[2] As this formulation suggests, Kaprow's gestures are seen as effacing rather than rearticulating aesthetic value. As such, they carry no intrinsic artistic worth but, rather, only acquire significance as an apophatic foil, against which a legitimately critical and aesthetic practice can differentiate itself. This takes the form of what Foster terms a (second-generation) "neo-avant-garde" during the 1970s, associated with an embryonic institutional critique tendency evident in the work of figures such as Daniel Buren and Michael Asher. Here Foster introduces a key transition in the discourse of the avant-garde aesthetic, in which stylistic or formal conventions are replaced by art's own institutional structures (the legitimating operations of museums or galleries, etc.) as a point of symbolic resistance and self-reflexive criticality. Kaprow, by failing to adequately acknowledge the constraints imposed on his practice by these structures (or by assuming he could transcend them simply by operating outside art-world spaces), effectively made them visible and available for

critique by the generation of neo-avant-garde artists who followed after him. In order for this strategy to work, of course, one must begin by making art that is precisely about the institutional nature of art itself rather than work, like that of Kaprow, for which this institutional structure is often of secondary importance.

In Foster's view, performative or dematerialized art practices like those of Kaprow abandon the physical or institutional mediation necessary to sustain an authentic criticality. They also risk sacrificing the artist's unique intelligence, perhaps our most reliable guide in the "zombie confusion" of the current age, to the random "dispersal" of participation. "Might it be," as Foster writes of the subsequent evolution of this tendency, "that the critique of authorship as authority has done its job... too well?"[3] Kaprow's work, however, can offer us another lesson, about the constraints of art criticism rather than art practice. Kaprow, as noted above, is emblematic of a generation of artists during the 1960s who began to move beyond an exclusive focus on the fabrication of physical objects sited in art institutions into the realm of performance and event. With the transition to this more dematerialized artistic paradigm, the division between the purely "aesthetic" qualities of artistic form, embodied in the material and compositional structure of objects and images or the structural protocols of the art world and the "nonartistic" qualities associated with works of art that locate themselves beyond the protected sphere of the gallery or museum, becomes far more difficult to sustain. It is, in fact, precisely these ostensibly nonartistic factors that become a major locus of investigation for figures like Kaprow, Helen and Newton Harrison, Adrian Piper, Joseph Beuys, Oscar Masotta, Hélio Oiticica, and many others. This is not to say that these artists did not address issues "immanent" to art or the art world. However, they also developed works that sought to address audiences and issues beyond those deemed relevant to the institutional art world itself. Moreover, they sought to denaturalize the normative social architecture of conventional art by problematizing the static subject positions of "artist" and "viewer" and engaging directly with adjacent cultural and political practices (evident, for example, in the Harrisons' involvement with environmental science).

This transformation modifies both the temporal and the spatial modes of displacement that are a central feature of the avant-garde schema. At the temporal level, we encounter a persistent desire to engage viewers here and now (in "real time," as Jack Burnham would write) and to challenge the deliberate discontinuity between artwork and viewer that is typical of the avant-garde tradition.[4] Rather than the work of art being "realized at

some other time," for a future viewer who might be sufficiently evolved to grasp its significance, artists sought to actualize aesthetic meaning here and now, learning from the unexpected configurations of affect and agency that emerged through their interactions with specific constituencies and publics. Adrian Piper provides an illuminating demonstration of this shift in her 1971 essay "Concretized Ideas I've Been Working Around," where she describes her *Catalysis* series of street performances. Here she explicitly identifies the constraints of an artistic practice centered on "discrete forms or objects." This movement away from the creation of fixed objects is associated, for Piper, with a parallel commitment to developing artistic projects that can precipitate a meaningful, "catalytic" exchange between herself and the members of the public who witness her performances. As she writes, the "significance and experience" of this work is "defined as completely as possible by the viewer's reaction."[5] This investment in the responses of actual viewers is atypical in the avant-garde tradition, where the artwork is often oriented toward a fictive persona (a hypothetical bourgeois subject embodying heedless class privilege) rather than a specific human agent. Piper, however, was clearly driven to address actual viewers and to develop projects in which the responses of these viewers were essential to the work's meaning. ("Ideally the work has no meaning or independent existence outside of its function as a medium of change. It exists only as a catalytic agent between myself and the viewer.")[6]

This constitutes a significant restructuring of the norms of avant-garde autonomy. Instead of Adorno's radically monological art object, "entirely closed off and blind" to the world around it, Piper's artworks *only* come into existence through a reciprocal exchange of affect, consciousness, observation, gesture, and reaction between the artist and her surrounding social milieu. For Piper, the engagement with concrete interlocutors was closely linked with a deliberate suspension of art's institutional framing and of the artists own self-presentation ("not overly defining myself to viewers as artwork by performing any unusual or theatrical actions of any kind"), even as it foregrounds her physical, intersubjective "presence."[7] Here Piper challenges the specular nature of the aesthetic encounter (the artwork as a form of textual mediation, standing between two human agents). She does so, however, not from the perspective of a naive Platonic merging of self and other but precisely because some of the most acute forms of intersubjective exchange thrive in contexts defined by reciprocal agency and vulnerability.[8] Of course, Piper also developed a large body of gallery-based work, epitomized by projects such as *Aspects of the Liberal Dilemma* (1978) and *Cornered* (1988). Notably,

this work also evolved out of a more specific understanding of the viewer, in this case predicated on the explicit but unacknowledged whiteness of the institutional art world itself.

As this outline suggests, the 1960s and 1970s marked an important watershed for evolving notions of artistic autonomy. What if we were to engage this work, in its full complexity, as a tradition that can be extended and refined rather than a symptom of critical failure? This is precisely what has occurred across a range of socially engaged art practices. Consider the case of Grupo Etcetera and GAC in Argentina, who cite the crucial influence of the Tucumán Arde ("Tucumán Is Burning") project during the 1960s on their own work with the escraches. Tucumán Arde represented precisely the kind of "anarchistic" blurring of boundaries that is disparaged by Rancière. It was a collaborative, proto-conceptual, and frankly activist project developed by the Grupo Argentino de Vanguardia (GAV), a collective of artists, journalists, and social scientists from Buenos Aires and Rosário who worked in conjunction with the Confederación General del Trabajo de los Argentinos (the General Confederation of Labor or CGTA), a radical union that was attempting to challenge the military junta that took over the country in a coup d'etat in 1966. The project entailed an investigation into the living and working conditions of laborers in Tucumán, a province in which the military government's inept economic policies were causing widespread suffering. After an extended period of research and data collection, the GAV created an installation for the CGTA union hall in Rosário. The installation featured film, recorded interviews, wall posters, audio components, and other elements exposing the failure of governmental efforts to address poverty in the area. Art historian Fabián Cerejido provides a vivid account of the cacophonous environment:

> Big black and white photographs displayed shocking destitution and violent struggle, loud-speakers reproduced the oral testimonies, and super 8 footage flicked tumultuous scenes of demonstrations and sugar cane workers clashing with the police. Coffee without sugar was served in reference to the shortage of sugar; the names of the owners of the sugar refineries of Tucumán were written on big posters and glued to the floor so that people would walk on them. Every so often the lights were briefly turned off in reference to the rate of deaths by hunger in the country. There were corridors covered in newspaper clippings and serialized paper signs repeating over and over: "Tucumán Arde," "Tucumán Arde," "Tucumán Arde."[9]

As Cerejido notes, Tucumán Arde was inspired in part by the ideas of Argentine philosopher and artist Oscar Masotta, who famously declared, "happenings and conceptual art were destined to become 'building blocks of post-revolutionary consciousness' and not 'archival materials for the bourgeoisie.'"[10] The staging of the exposé as an art exhibition provided sufficient cover for the material to be presented for a highly successful two-week run at the CGTA union hall, but shortly thereafter the government threatened to rescind CGTA's legal status, and the subsequent exhibitions were canceled. While the artists of Tucumán Arde understood the social field of art's engagement very differently than Piper, they nonetheless shared her commitment to developing an artistic practice predicated on transformative interaction with the world beyond the gallery or museum.

This notion of reciprocal feedback between artwork and social world or between artist and viewer is at the center of the transition to dematerialized forms of art practice during the 1960s. While the artists and collectives associated with this shift were concerned with forms of intersubjective immediacy, this was not, by and large, because they felt that the interactions that unfold between a viewer and a gallery-based artwork are somehow less authentic than those that occur when the artist is present. All forms of intersubjective exchange are mediated, whether by the discursive conventions of language, speech, and gesture or by the materiality of a physical object or human body. What is at stake here is not a question of immediacy or proximity per se but, rather, the willingness of the artists involved to address their work to specific viewers, to shape their work so that it retains a reflexive awareness of and attunement with the consciousness of actual viewers, and to allow the viewer's responses to the unfolding of a given project to inform its subsequent evolution. This does not mean that the work does not seek to challenge the viewer qua interlocutor, but rather that it grounds both the agonistic and the consensual dimensions of intersubjective experience in the actuality of the other's self-present being while also opening up the artist to this same transformative experience.

It is possible, then, to understand the shift toward a "dematerialized" art practice as a generative opening out from the paradigm of aesthetic autonomy that had governed previous avant-garde movements. If this paradigm was centered on the decomposition of certain modes of radical consciousness into a set of techniques intended to modify the formal or representational protocols of the art object, then dematerialization represented, at the very least, a deemphasis of this orientation and a conscious effort to identity other fields or contexts in which art's critical and aesthetic potential might

be realized. It is worth recalling that it was precisely the perceived failure of a formalist paradigm of mediation that motivated many artists of Kaprow's generation to develop a critique of conventional aesthetic autonomy in the first place. The great fear that motivated the persistence of the formalist paradigm in the avant-garde was that art, released from its protective formal enclosure and placed in more direct contact with the multidimensional lifeworld beyond the gallery space, would be immediately subsumed into kitsch and propaganda. But, by the 1960s, it was apparent to many artists that this kind of potential subsumption was no worse than the multifarious forms of appropriation that confronted more conventionally "autonomous" art practices situated entirely within the institutionalized art world. They were keenly aware that the effort by the Abstract Expressionist painters to preserve the purity of their art by withdrawing from the social world had done nothing to prevent the rapid appropriation of their work by the mechanisms of the market, consumerism, and political expediency.

What does it mean to attempt to actualize art's critical and emancipatory potential through a reciprocal engagement with viewers that is no longer displaced through a formal or compositional apparatus? Based on the outline above, we can identify four key fields in which this process was carried out. First, we have a shift from an object-based aesthetic paradigm to what we might term an event-based paradigm associated with the emergence of performative art practices. This does not mean that objects do not play a significant role in many of these practices, as Piper's own subsequent work demonstrates. Objects have been and continue to be a central feature of contemporary socially engaged art practice, functioning in a myriad of ways. What is distinct is the opening up of alternative channels of exchange between artist and interlocutor or among participants that operate outside but often in parallel with object-based forms of mediation. Second, we can observe a concern with the consciousness of actual viewers and a willingness to explore their specific identities. This is evident in a preliminary way in Hans Haacke's *MoMA Poll* (1970) and *Gallery Goers Birthplace and Residence Profile* at Howard Wise Gallery (1969). These works attempted to determine the professions, political beliefs, and class backgrounds of people who frequent art galleries and museums, effectively "de-transcendentalizing" the viewer. It is also evident in Mierle Laderman Ukeles's *Touch Sanitation* (1979–80), which involved direct physical contact via the gesture of hand-shaking.[11] Other examples include the work of post-Concrete artists such as Hélio Oiticica and Cildo Meireles in Brazil, who sought to "posit the spectator not as a disembodied receptor of optical stimuli but as an active

subject engaged in a new kind of attentiveness and tactile encounter," as Alexander Alberro has written.[12] Third, we encounter various efforts to thematize the artistic personality itself and to critically foreground the subject position of the artist as it functions discursively and institutionally within the contemporary social order. Rather than conceiving of the artist as occupying a transcendent position (as deputy, surrogate, or exemplary agent of critique), we find a willingness to question the prerogatives of the artistic self and to understand artistic agency as something that can be relinquished and acquired, centered and decentered. And fourth, we encounter a movement outside the conventional institutional spaces of the art world, evident in Joseph Beuys's various political and educational initiatives, among many other examples.

The Double Movement of Dematerialization

The original conceptual art is a failed avant-garde. Historians will not be surprised to find, among the ruins of its utopian program, the desire to resist commodification and assimilation to a history of styles.
—Victor Burgin, "Yes, Difference Again"

I have focused thus far on dematerialized art practices that operated, in many cases, outside conventional exhibition spaces or involved participatory interaction because these were especially influential for the development of contemporary socially engaged art. The shift toward dematerialization was, however, characterized by a double movement, which we have already observed in Benjamin's analysis of the tension between the "activist" writers of Germany and the Soviet avant-garde. Thus, the emergence of art practices that sought to decenter autonomy by exploring the conventions of artistic subjectivity was paralleled by an adjacent set of practices, primarily associated with Conceptualism, that reaffirmed a normative model of the artistic self. In the development of North American Conceptual art in particular we can observe a process by which a critique of the art object as commodity was effectively uncoupled from a critique of the broader institutionalization of art, under the assumption that economic value attaches only to physical objects and not to authoring personalities. Thus, figures such as Joseph Kosuth, Douglas Huebler, and Lawrence Weiner sought to defeat the commodification of art by exhibiting deliberately mundane objects or documentary materials. These served primarily as carriers for a preexisting set of conceptual or philosophical propositions, which constituted the "real" content of the work.

"The idea," as Sol Lewitt wrote in 1967, "becomes a machine that makes the art."[13] Across a broad range of gallery-based Conceptual art, we encounter a rejection of commodification, defined by the creation of complex, artisanal objects ("morphological" or "aesthetic" forms in Joseph Kosuth's terms), but no real challenge to the ideological status the authoring personality itself.[14]

In this process, the autonomous art object, as the repository of a unique form of counter-normative thought, is dispensed with, only to have this same critical capacity migrate fully into the consciousness of the artist. This accounts for the widespread fascination during the 1960s and 1970s with various forms of analytic philosophy, systems theory, and linguistics (e.g., Ludwig Wittgenstein, A. J. Ayer, etc.), which seemed to provide artists with access to an entirely self-enclosed domain defined by axiomatic truths, universal linguistic structures, logical constructs, and semantic propositions untroubled by the nagging contingencies of political repression, social conflict, and even the body itself. Here the leaden materiality of the artwork would be transcended in the movement from the merely "visual" domain of pre-Conceptual art to a purified realm of abstract contemplation. The sequestered, recursive nature of this space is evident in Kosuth's 1969 essay "Art after Philosophy":

> The validity of artistic propositions is not dependent on any empirical, much less any aesthetic, presupposition about the nature of things. For the artist, as an analyst, is not directly concerned with the physical properties of things. He is concerned only with the way (1) in which art is capable of conceptual growth and (2) how his propositions are capable of logically following that growth. In other words, the propositions of art are not factual, but linguistic in character—that is, they do not describe the behavior of physical, or even mental objects; they express definitions of art, or the formal consequences of definitions of art.[15]

In its concern with "analytic propositions," Conceptual art is most closely affiliated not with aesthetics (which depends on degraded notions of "beauty" and "taste" that are "conceptually irrelevant to art") but with the rigorous, systematic disciplines of "logic," "mathematics," and even "science" as a whole.[16] But while art "shares similarities" with these other fields, it remains utterly unique precisely because of its nonutilitarian nature. Art's only task is to explore the meaning of art itself in an endless, self-referential loop that is sealed off from the universe of nonartistic experience or knowledge. Art is not "about anything . . . other than art," as Kosuth writes.[17] His essay ends,

fittingly enough, with a reaffirmation of aesthetic disinterest in its purest form: "whereas the other endeavors are useful, art is not. Art indeed exists for its own sake."[18] In this manner, the conventions of aesthetic autonomy are reinscribed in the very heart of the Conceptualist project.

This work, in its characteristic conflation of art with logic, mathematics, or analytic philosophy, suggests a kind of belated realization of the Hegelian ideal, as the messy physical embodiment of the artwork qua object gives way to the untrammeled ideational freedom of pure, self-contemplating thought. Here philosophical inquiry, transposed into a Conceptual art idiom, serves as yet another autonomous sphere, displaced from the "empirical" and material actuality of social interaction and experience. Kosuth's artwork exhibits the austere beauty of a mathematical formula or logical syllogism, which possesses a perfect internal coherence but has no practical function in the world. In this sense, Kosuth's Conceptual installations are a corollary expression of Arnold Schoenberg's twelve-tone serialism, so beloved by Adorno, or Greenberg's "immanent" sphere of painterly flatness, evoking a domain that is insulated from the contamination of the external world. It is, precisely, a disembodied space and in that sense reiterates once again the long-standing division between intellect and sensation or reason and sentiment that has been a primary undercurrent of the aesthetic since the Enlightenment.

As this linkage suggests, there is a symptomatic parallel between the two strands of dematerialized art practice sketched above and certain discursive tensions that originate in the Enlightenment aesthetic. On the one hand, the aesthetic emerges as part of a process of what Jürgen Habermas terms "de-transcendentalization" in the post-absolutist period, as it became possible to actualize collective human agency in the creation of new and more egalitarian social forms, no longer dictated by an external authority that placed itself beyond any temporal accountability.[19] In this view, the aesthetic becomes a key mechanism for exploring and literally performing this new mode of consensual and embodied interaction. At the same time, the Enlightenment aesthetic is marked by a countervailing tendency, evident in the perception that the public is not *quite* prepared for these forms of actualized, intersubjective exchange. As a result, the practical realization of this process is perpetually deferred. Here we encounter a corollary process of "re-transcendentalization," as the collective intelligence necessary to bring this more harmonious social order successfully into existence is drawn back into the sequestered consciousness of the individual artist, the surrogacy of the artwork, or the metaphysical concept of a viewer yet

to be. Like the premodern public in Hegel's *Aesthetics*, we still require that our own innate capacities be re-presented to us in an externalized form because we are unable to recognize them fully in ourselves.

The participatory art practices of the 1960s and 1970s sought to reclaim, at least in part, the initial, de-transcendentalizing gesture of the modern aesthetic. In the works of Beuys, Piper, Laderman Ukeles, Meireles, Lacy and Labowitz, Tucumán Arde, the Harrisons, and many others, the speculative consciousness necessary to envision and actualize a societal transformation is no longer decanted into the formal apparatus of the artwork or the sole proprietorship of the artistic personality. Instead, these works open up a space of materially grounded, reciprocal exchange in which the viewer qua collaborator is potentially capable of autonomous critical insight and no longer wholly dependent on the deputized consciousness of the artist. Moreover, this material grounding extends to an awareness of the situational specificity of the intersubjective encounter as well as the transformative agency of individual bodies and forms of bodily knowledge. Here the influence of feminism on performance-based practice is of particular importance, as it sought to engender the body of both artist and viewer.[20] Certainly, works created within the "mentalist" paradigm of Conceptualism represented by figures like Kosuth and Huebler are capable of generating significant insight into the discursive structures of art as well as broader forms of meaning associated with logic or semantics (extending, of course, to their absurdist deconstruction). And viewers of these works are equally capable of accessing those insights. However, there is no point at which the viewer's experience of the work entails the counter-assertion of their own independent cognitive agency in a manner that might transform the consciousness of the artist or materially affect the nature of the work itself. Rather, their agency is limited to receiving the insights achieved a priori by the artist and delivered over to them via the mediated object. The legacy of Conceptualism is thus split between a more conventional notion of authorship, which would go on to inform subsequent generations of artists working in a neoconceptualist paradigm, and a more experimental approach that sought to openly thematize artistic subjectivity in the creation of a given work. It is important to note that the dialogical mode of creation that I have outlined above only unfolds in a partial and exploratory manner in many of the collaborative practices that emerge in the 1960s and 1970s. However, the aesthetic horizon that is implicit in these works marks a decisive break with existing paradigms with significant implications for new forms of socially engaged art in the 1990s.

The Absent Addressee

The bifurcation that I have identified in the visual arts between a dialogical and a conventionally autonomous aesthetic paradigm finds its corollary expression in the work of Jean-Luc Godard and Chris Marker, who were key figures in European experimental cinema during 1960s and 1970s. While Kosuth and the other proponents of an institutionalized Conceptual art practice hoped to insulate their work from the political turmoil of the period, both Godard and Marker viewed their films as part of a broader movement of political and cultural resistance that was embodied in the upheavals of May 1968 in France. As part of this effort, they sought to recover certain technical or compositional procedures associated with the interwar European avant-garde, remobilizing the critical potential that was ostensibly latent in forms of production rooted in the revolutionary politics of the 1920s. What is especially notable, for my purposes, is the fact that they drew very different lessons from this historical legacy. In Marker's case, he sought to revive a form of participatory filmmaking associated with the Prolekult tradition and, in particular, with Aleksandr Medvedkin. Godard, on the other hand, was skeptical that workers were capable of revolutionary consciousness and instead drew on the vanguardist tradition, presenting himself as a filmic equivalent of the "theoretical communist" and identifying with figures such as Lenin and Dziga Vertov. This required, in turn, the reliance on an ensemble of formalist procedures intended to provoke a defamiliarizing critical awareness that, in practice, tended to restrict his audience to a small cadre of politicized cinephiles. Marker's and Godard's work has the benefit of openly thematizing historical continuities associated with efforts to redefine the nature of aesthetic autonomy during the 1960s, which are often less evident in the visual arts. As a result, they can also allow us to recognize the ongoing influence of certain key discursive structures associated with the schema of avant-garde autonomy.

Marker's evolution toward a participatory or collaborative mode of production occurred through the process of creating two films during the late 1960s: *Be Seeing You* (1968) and *Class of Struggle* (1969). *Be Seeing You* was produced after Marker was invited to observe a strike by French textile workers at the Rhodiaceta factory in Besançon in 1967. The Rhodiaceta strike attracted considerable attention because the workers were not simply demanding higher wages or reduced working hours. Rather, they linked these more pragmatic demands with the claim that class oppression

had also stunted their intellectual and cultural development. ("They want us to always be proles, uncultivated men who are there for work and that's it. How do you think a guy who has just worked eight hours at Rhodia can look to develop himself intellectually? It's impossible.")[21] In fact, Marker was invited to the Rhodiaceta plant by a representative of the Centre Culturel Populaire de Palentes-les-Orchamps (CCPPO), an organization in Besançon that sought to encourage working-class education and empowerment. This combination of cultural aspirations and economic demands was widely seen as a precursor to the new forms of revolt that would unfold soon thereafter during the events of May 1968.[22] If Rancière imagined a working-class audience eagerly recognizing its own optimal consciousness in the poems of Mallarme or the plays of Ibsen, the workers of Besançon seemed to exhibit a genuine desire to embrace advanced artistic forms as a component of their political awakening. In fact, Marker's second film in Besançon ends with the protagonist, a militant named Suzanne Zedet, talking about her discovery of Picasso. In this respect, we might say that the workers of Besançon served as a prefigurative symbolic resource for Marker and other French intellectuals at the time, as they seemed to anticipate the unification of the aesthetic and the political in a revolutionary moment, as theory, or formally encoded critique, was finally desublimated into practice.

Be Seeing You focuses on George "Yoyo" Maurivard, a neophyte labor organizer, as he gains increasing confidence in his ability to mobilize Rhodiaceta's workers during the course of the strike. The title is taken from Yoyo's veiled warning to the bosses, after the strike fails, that he's not giving up the fight. Following the completion of *Be Seeing You*, Marker screened the film for an audience of workers at the CCPPO. Historian Trevor Stark describes the subsequent responses. While the reactions were generally positive, there were also several criticisms, including Marker's failure to acknowledge the role played by women in the strike (they appear primarily as passive companions to their worker-husbands) and his tendency to focus on a small number of dramatic moments during the strike rather than the slow and difficult organizational work necessary to challenge the factory owners ("I think the director is incompetent.... And I also think ... that the workers of Rhodia have been exploited").[23] Through this set of exchanges, Marker underwent something of a catharsis, as he become conscious of the profound disjunction between the hypothetical or implied viewer typically assumed by avant-garde film (the viewer yet-to-be whose consciousness it prefigures or the bourgeois caricature whose consciousness it assaults) and the actual responses of those workers on whose behalf the film was ostensibly

produced. This is the "hinge" moment, as Marker describes it, at which his understanding of the relationship between film and political practice was transformed. This transformation entailed a kind of filmic corollary to the process of dematerialization, as Marker sought to open up cinematic practice as an embodied social form. His next step was to organize a collective consisting of himself, Mario Marret, and a number of the Rhodiaceta workers who were trained in filmmaking workshops held at the CCPPO ("putting cameras and tape recorders into the hands of young militants ... workers themselves will show us films about the working class").[24] They named the collective after Aleksandr Medvedkin, a Russian filmmaker who organized the *Kinopoezd*, or "film trains," established in 1931 to reach peasants and factory workers in the hinterlands of Russia through the production of in situ films.[25]

The Medvedkin Group's first film, *Class of Struggle*, followed a similar narrative arc to *Be Seeing You* but replaced the figure of Yoyo with a female watch factory worker (Zedet) who appeared briefly in the earlier film. Zedet, like Yoyo, is shown gaining a greater sense of agency and political awareness as she comes to embrace her identity as an organizer; a kind of proletarian bildungsroman. She moves from being a relatively subdued presence in the first film to a vocal and engaged militant in the second, literally acting out the mythos of the proletariat achieving class consciousness (and, presumably, serving as a model for other workers to emulate). The film also foregrounds images of the workers themselves in the act of making films: operating cameras, editing footage at the CCPPO, and so on. As Stark notes, the Rhodiaceta films were less formally experimental than Marker's previous work. Thus, *Be Seeing You* dispensed with the "disjunctive montage, critical voice-overs and estranging camerawork" that was typical in films such as *Le Joli Mai*. Instead, *Be Seeing You* is characterized by "a degree of authorial self-effacement," as the process of producing the film collaboratively (evident in the presentation of the workers as filmmakers rather than subject matter) took precedence over its status as a privileged expression of authorial self-reflexivity.[26]

It was this same transformation, as Stark describes it, that set the stage for Marker's break with Jean-Luc Godard. (The two had collaborated on previous films, including *Far from Vietnam*.) Thus, while Godard sought to overcome the "avant-garde hermeticism" of existing experimental cinema as Stark describes it, he was unwilling to question the underlying social architecture of film production centered around the exemplary consciousness of the individual auteur.[27] Godard dismissed Marker's interest in training

workers in filmmaking as "utopic" for the simple reason that the workers themselves were incapable of the level of critical and reflective intelligence necessary to produce advanced cinema. Instead, they were besotted by the cinematic equivalent of Greenbergian kitsch ("the men who know film can't speak the language of strikes and the men who know strikes are better at talking [Gérard] Oury than Resnais or Barnett").[28] As a result, it was necessary to maintain the sovereignty of the artistic persona, with the artist taking on a custodial relationship to the consciousness of the workers. Godard identifies an unbridgeable "gap" between the competence of the artist and the competence of the worker, with each assigned a specific epistemological role.[29] The worker, as the experiential body of labor, carries a kind of phenomenological trace of capitalist exploitation, while the avant-garde filmmaker (with their technical command of the norms of cinematic language and the mechanisms of their potential subversion) occupies a role analogous to that of the vanguard party, translating the bodily or somatic experience of the masses (what Godard terms "perceptual knowledge") into "rational knowledge" (the "scientific knowledge of revolutionary struggle").[30] As Stark notes, Godard identifies his "militant" film work as a corollary of the vanguard party.

> As explicitly stated in *Vladimir et Rosa*—"Ours is a vanguard party," the narrator proclaims—the Vertov Group adopts the Leninist position that the "role of the vanguard fighter can be fulfilled only by a party that is guided by an advanced theory." As with the relationship established by Lenin between the working class and the advanced theoretical position of the party, Godard's militant films attempt to translate "the People's" experience into a form of rational knowledge—exceeding mere documentation for "a concrete analysis of a concrete situation"—and, at the same time, to teach that same "People" about their own experience.[31]

Left to their own devices, the workers of the Medvedkin Group would only be capable of the grossest form of documentary filmmaking and immune to the underlying complexities of representational form. It requires the avant-garde filmmaker to transform this crudely empirical, sense-based form of knowledge into an advanced cinematic practice capable of preserving and communicating a revolutionary truth. Godard's skepticism regarding the capacities of the Rhodiaceta workers was linked with his broader sense of disillusionment following May 1968 (due in part to the failure of the French working class to fully commit itself to an ostensibly revolutionary struggle). It

was now clear that the Rhodiaceta strike and factory occupation of 1967, rather than being a precursor to France's own version of the Bolshevik Revolution, was little more than a "spontaneist" anomaly. As a result, the insurrectional consciousness it seemed to presage (and which Marker unwisely sought to desublimate in collaborative practice with workers) must be drawn back into the consciousness of the militant auteur for safekeeping. The result of this process was evident in a series of films that Godard produced with J. P. Gorin as part of the Dziga Vertov Group between 1968 and 1973 (*British Sounds*, *Tout va Bien*, *Wind from the East*, *Vladimir and Rosa*, *Letter to Jane*, etc.). Stark links this set of ideas, already familiar to us from the history of the political vanguard, to the work of Marxist philosopher Lucien Goldmann. Goldmann wrote about Godard's films in the 1968 essay "The Revolt of the Arts and Letters in Advanced Civilizations," where he introduces an analysis that exhibits clear parallels with Adorno's notion of the artist as a "deputy," carrying the as-yet-unrealized revolutionary intelligence of the masses. In Goldmann's version of this story, "great philosophical and artistic works" are both "individual and social," as they represent the "maximum of potential consciousness . . . of the social class" in their formal and compositional makeup.[32] Thus, as Stark observes, "the maximum potential consciousness of the proletariat must paradoxically come from outside its own ranks, from a professional class of almost exclusively bourgeois artists."[33]

Goldmann's analysis faithfully mirrors the vanguardist discourse that extends back to Lenin and Karl Kautsky. Here revolutionary truth, or "socialist consciousness," must be "introduced into the proletarian class struggle from without" (in particular, as Kautsky insisted, from the "bourgeois intelligentsia").[34] Yet again we encounter the long-standing division between the masses (mired in sense-based immediacy and incapable of abstract thought or creativity) and the bourgeois artist qua intellectual as the repository of an advanced consciousness (embodied in formally innovative modes of cinematic expression), explaining to the masses the deeper political significance of their own lived experience. For Godard, this is the basis for the crucial distinction between making a "political film" and "making film politically." In a 1969 manifesto, carrying the Leninist title "What Is to Be Done?," he describes these two approaches as "antagonistic to each other." Making a "political film" relies on an "idealistic and metaphysical conception of the world," which assumes that film's role is to simply document a preexisting truth (to "make descriptions of situations," as he writes).[35] This is the naive, proto-realist approach he attributes to the workers of the Medvedkin Group. To make a film "politically," on the other hand, requires a "Marxist

and dialectical conception of the world." What this means in practice is less clear. "What Is to Be Done?," which was written while Godard was directing *British Sounds*, can be difficult to decipher. Thus, the act of making *British Sounds* is identified as an expression of the first impulse ("to remain a being of the bourgeois class"), while the ability to get that film screened on British television (something that Godard ultimately failed to accomplish) is presented as an example of "making film politically." Here the distinction between a purely "bourgeois" gesture (making a film) and a properly militant action would seem to depend on the question of how the film is distributed (and which audience it reaches) without regard for the content of the film itself. As Godard's work demonstrates, however, it also entailed the introduction of certain formal techniques, inspired by the defamiliarizing ethos of the Russian avant-garde, which would prevent viewers from suspending disbelief in the presence of filmic spectacle. Instead, they will be forced to recognize the contingency of cinematic meaning while also imbibing revolutionary theory. These techniques included the use of voice-overs reading Marxist texts, deadpan or absurdist acting styles, self-consciously impoverished forms of staging, and so on.

While Chris Marker sought to collaborate directly with workers through film production workshops and screenings at the CCPPO, Godard was, as we have already seen, quite skeptical of the revolutionary potential of the French working class. "The workers talk like Henry Ford, not the Black Panthers," as he laments in *Pravda*.[36] True "militants," in Godard's estimation, were just as likely to be middle-class students or intellectuals, as they were workers (as the events of May 1968 seemed to prove). And even among this constituency it was necessary for the radical filmmaker to remain ever vigilant against the risk that his work might be coopted by audiences with less rigorous revolutionary sensibilities. In James MacBean's account, the disruptive de-familiarizing techniques that are typical in the Dziga Vertov films are actually designed to weed out those viewers who are insufficiently disciplined in their political beliefs, leaving only a hardened cadre of communist militants as Godard's desired interlocutors. As he writes, "The dogged persistence of the voice-over texts—delivered in monotone—in the Dziga Vertov Group's films, presents a calculated obstacle aimed at separating the superficial, posturing radical role-player from the serious individual who is willing to do the work of exploring and acting upon the issues presented in the films. . . . It's the latter, finally, the actively committed Marxist-Leninist or Maoist militant for whom the films of the Dziga Vertov Group are made."[37]

In this view, the failure of May 1968 had made it clear that any direct action with the working class was premature.[38] Instead it was essential to develop films exclusively for a small coterie of politically advanced radicals (primarily drawn from the middle class), who were the carriers of an authentic revolutionary consciousness that the French workers had failed to exhibit.[39] This represents a further refinement of Goldmann's notion of the artist as embodying the "maximum of potential consciousness" of the proletariat. Here the artist as deputy works in tandem with a parallel stratum of militant political activists, with each carrying a fragment of a larger body of revolutionary knowledge. While the activist is a specialist in political resistance, the artist's assigned role is to educate the activist about the complex imbrication of political resistance and the realm of cultural production, which plays an essential but unrecognized role in both the maintenance of political domination and its potential subversion. May 1968 was, in this sense, "premature," a revolution that failed because the consciousness of the masses had not yet been adequately prepared by a vanguard intelligentsia. As a result, the failure of May 1968 will inevitably be repeated unless any future attempts at political transformation are preceded by this form of speculative, theoretical exchange.

This set of beliefs was common across a wide spectrum of French intellectual and cultural production during the late 1960s and 1970s. We find a parallel example in Julia Kristeva's notion of a "revolution" in poetic language, developed in the wake of her disillusionment with May '68. Here the prototypical elements recur: the "betrayal" of the working class, mired in consumerism, and the necessary displacement of revolutionary consciousness into self-reflexive forms of vanguard literature. "Everyone knows," as Héléne Cixous wrote in 1975, "that a place exists that is not economically or politically indebted to all the vileness and compromise. That is not obliged to reproduce the system. That place is writing."[40] In the face of a totalizing system of domination against which any meaningful resistance is futile, all that remains is a form of libidinal jouissance that is produced through the symbolic transgression of norms in the micro-political fissures of literary texts, even as their actual destruction in the broader social world remains impossible. It is only in this manner that the revolutionary conscious of a proletariat which "does not yet exist, but remains to be constituted," as Bernard Sichere wrote, can be preserved.[41]

The practices outlined earlier in this chapter—the collective productions of the Medvedkin Group, Adrian Piper's embodied performativity, the militant research of Tucumán Arde—are predicated on a very different

worldview. Here aesthetic experience is, as I noted, "de-transcendentalized" and autonomy reconstructed in the reciprocal interactions between self and other. The effect is precisely to dismantle the defensive sovereignty of the artistic personality and the binary division between the revolutionary theorist and the culturally instrumentalized masses. By extension, these projects are committed to the necessary interdependence between the ontologically transformative effects precipitated by an aesthetic encounter and political transformation here and now.

4

THE AESTHETICS
OF ANSWERABILITY

Tactical Autonomy

But by going from the object to the situation . . . there appear new elements.
—Luis Camnitzer, "Contemporary Colonial Art"

"New elements" begin to appear, as Luis Camnitzer observed over a half century ago, when we move from an art practice predicated on object-based mediation to art that is defined through a "situational" engagement with the world beyond the gallery or museum. In this chapter, I will draw on the empirical analysis of specific projects presented in the preceding two chapters to define a more general set of characteristics associated with socially engaged art. I will focus on three related issues. First, what modes of political transformation are implicit in socially engaged art practice? And how do they relate to the mythos of total revolution that informs a more conventional avant-garde orientation? Second, how does socially engaged

art practice establish a form of critical mediation in its relationship to the social and political world? How is autonomy produced differently in this work? And third, how does engaged art catalyze critical self-reflection? How does it contribute to the (prefigurative) process of creative self-transformation that we associate with the aesthetic through its relationship to praxis? This last point is decisive and will provide the foundation for the final three chapters of this book, in which I outline an alternate aesthetic account of socially engaged art.

As we have seen, in the tradition of vanguard politics, an emancipatory self-transformation will only come to fruition after the violent work of revolution is complete. Until then, revolutionary praxis is an entirely instrumental affair, predicated on rigid hierarchies and the subordination of the individual to the vanguard leader. In the avant-garde tradition of aesthetic autonomy, self-transformation must occur prior to any form of political action (through the individualized consumption of artworks in bourgeois cultural institutions) precisely because praxis as such will fail until this self-transformation has been carried out. In each paradigm, praxis is understood as largely utilitarian. There is little sense that the act of resistance itself can be creative or generative, or that it can transform the self in a manner that has emancipatory or prefigurative potential. From this perspective, we might say that socially engaged art practices over the past three decades represent a practical and speculative attempt to reconceptualize the nature of both political and aesthetic consciousness. In this respect, they are aligned with a broader effort that extends across a range of activist and formally political groups to experiment with new forms of resistance, criticality, and solidarity, evident in the development of new modes of resistance among the Zapatistas, in the "movement of the squares" in Spain and Greece, and in the Arab Spring, among many other sites.[1] For the artists and collectives producing this work, revolutionary consciousness, like revolution itself, is communicable and social. It emerges through the process of collective social action, as the experience of resistance produces new modes of agency and new capacities to envision an alternate future. Thus, what makes consciousness "revolutionary" is not simply its ability to delineate an "objective" theoretical truth but its dialogical relationship with other selves, along with the repertoire of cultural forces, political institutions, and modes of resistance that constitute a given historical moment.

The avant-garde schema can effectively privatize this social medium by confining it to the enclosed self-awareness of the individual viewer or artist and a set of epistemological tensions registered in the internal compositional

systems of specific artworks. A variant of this belief (evident in aspects of Godard's work as well as Hal Foster's neo-avant-garde) entails the contention that art preserves its autonomy by critiquing systemic ideological structures of which the general public remains unaware (encoded in language, media, various ideological mechanisms, etc.) rather than situationally specific instances of repression, which are merely the epiphenomenal expressions of these deeper structuring forces. In each case, the act of resistance is assumed to be protected from the co-optive forces that accompany a more specifically targeted engagement with repressive social systems. But this dynamic raises a central contradiction. By internalizing and formalizing resistance at the level of monadic contemplation, the aesthetic also threatens to reify it as a mental construct, uninflected by the experiential world or by the dialogical resistance posed by other selves, other materialities, or other perspectives.

The avant-garde schema assumes that any attempt to engage with processes of political transformation will fail, not simply because the current historical moment precludes real change but also because the individual agents or social groups that undertake these actions are driven by the naive belief that they can produce meaningful change by a simple act of will, uninformed by any critical self-reflection. I do not find this to be a particularly realistic assessment. The artists and activists associated with the escraches, for example, were certainly capable of recognizing the necessity for theoretical reflection as a central component of their practice. Moreover, the fact that they pursued their specific, tactical goals in bringing junta criminals to some form of justice was not because they were incapable of conceptualizing more systematic forms of change. In fact, the "idea" of revolution as an absolute overturning of the capitalist system is hardly a forbidden secret, known only to an isolated caste of neo-conceptualist esoterics or marginalized critical theorists. There is a veritable cottage industry in academic publishing devoted to this question, including numerous calls for a resuscitation of communist revolution by Slavoj Žižek, one of the most visible public intellectuals on the contemporary scene.[2] Moreover, there is ample evidence of what an actual communist revolution looks like in the historical record, especially with the opening of long-inaccessible Soviet archives after the fall of the Berlin Wall. The ability to conceptualize revolution in the abstract, as a horizon toward which to orient practice, is not especially novel. What is far more difficult is understanding what form its actual unfolding might take, what kind of social system would follow in its wake, and how people might come to embrace the new political vision on which its realization would depend. And that question requires a materialist engagement with

existing structures of political domination and social consciousness, as well as a speculative and prefigurative capacity. It also requires a more nuanced understanding of the generative capacity of both political resistance and, for my purposes, artistic production.

The socially engaged art practices of the past thirty years share a commitment to the emancipatory vision carried by the aesthetic, but they do not accept the corollary belief in the prematurity of practice. Instead, their criticality is produced through an answerable relationship to an actual site of resistance, entailing specific institutional forces and counterforces and concrete interlocutors that can act back on the work in real time. As a result, the production of criticality in these projects must constantly be rearticulated and modified in response to these ongoing exchanges. The work evolves, then, through a series of iterations, each building on the experience accrued from the one that came before. This accounts for the intrinsic plasticity of engaged art practices as they move away from the physical stasis of an object-based aesthetic paradigm. It also accounts for the scalar complexity of socially engaged art projects, which seek to socialize the transformation of consciousness that is central to the aesthetic rather than holding this transformative potential in suspension in the mind of the individual artist or viewer. As a result, socially engaged art practices operate along an expanded continuum that reflects the interdependence between individual consciousness and social or collective action. Here I will outline this continuum with a series of brief examples.

On one end of this continuum are projects that are restricted to a small number of participants, with only the most limited extension into a larger social space. This is exemplified by Saba Zavarei's *Radio Khiaban* project in Iran, which began in 2018. Zavarei left Iran in 2010 to live in London, following violent government reprisals against the Green movement protests in which she participated. She developed the *Radio Khiaban* project ("khiaban" is Farsi for "street") to explore the ways in which gender is policed in public space in Iran. In particular, the project took aim at an Iranian regulation that bans women from singing in public. The seed for *Radio Khiaban* was planted in 2014 when Zavarei was visiting the famous Safavid-period Sheikh Lotfollah Mosque in Isfahan, which was familiar to her from her childhood. While there she recorded herself surreptitiously singing a love song to Iran. The architectural enclosure of the mosque provided an ideal acoustic environment for this improvisational performance. "I felt intoxicated by the glory of that empty space," as she observed. "It was time

to do something, to make that place mine somehow."³ The resulting video was widely viewed and inspired her to expand the project to document other women engaging in the same act. What would, in another context, be the most routine occurrence became, in the context of Iran's repressive policing of women, a simple but beautiful act of transgression. Zavarei described the next steps in the process in a 2021 interview: "I invited women in Iran to sing in public spaces . . . through my Instagram account. I was expecting to receive 30 or 40 responses so I could put all these videos together to make a longer video. . . . In less than 24 hours I received more than 1000 responses. It was so overwhelming that I fell into a fever! It was then that I decided that I had to do something with these singing interventions, something for as long as the discriminations against women were in place."⁴

The result was an ongoing series of recordings that document these transgressive public performances by women throughout Iran (via a podcast and website), along with interviews in which each singer reflects on her experience of singing in public space. Zavarei chose the concept of "radio," an aural form that is associated with the public broadcast of information, to represent the aspirations of the project as it documents hundreds of individual acts of resistance on the streets of Iranian cities. Thus, the "street" that is alluded to in the project's title is, as yet, only prefigurative. *Radio Khiaban* thus seeks to explore how "silenced and constrained women must creatively navigate the same streets that men easily move through," as Zavarei writes. Zavarei has also documented the proliferation of interventionist public dancing in Iran by women who risk detention or flogging by staging epiphenomenal performances in public space. Even the act of documenting these performances carries considerable risk, especially in those cases in which the dancer is not fully covered. In her essay "Dancing into Alternative Realities," Zavarei examines the work of Mitra, an Iranian photographer who staged a series of public performances on the streets of Tehran with a female ballet dancer. The images were especially poignant for Zavarei because they were photographed in the Ekbatan neighborhood where she grew up. They thus offered a glimpse into a future in which public space might one day be reclaimed by women. As Zavarei writes, Mitra's photographs "prefigure another possible world, in which bodies disobey social restraints and move freely in order to interact with space in unexpected ways." "For anyone familiar with those places," she continues, "her photographs depict a fantasy rather than document a reality, the dream of freedom, the imagining of a possibility. The photographs create an alternative world which, on the one hand, is surreal

owing to its detachment from the current situation in Iran; but on the other hand, pointing to the possibility of an alternative future, the photographs highlight the impermanence and frailty of the current regime."[5]

The actual ability of women to express themselves freely in public has yet to be achieved in Iran, but in these countless acts of micro-resistance, we can recognize the forms of critical consciousness and creative expression necessary to eventually win this freedom. As I was revising this manuscript for publication in the fall of 2022, a remarkable series of events unfolded in Iran. A set of initially small demonstrations in Tehran quickly evolved into the most widespread protest movement since the founding of the Islamic Republic. The protests were spurred by the death of a young Kurdish woman named Mahsa Amini, who was being held in custody by the Gasht-e-Ershad, or morality police, for wearing an "improper hijab." The protests have been led by women. Young women in particular have played a key role in openly denouncing the government, removing their hijabs in raucous demonstrations in cities across Iran. In this manner, the surreptitious performances of dancers and singers documented above have become collective public actions. These women are exhibiting remarkable courage in challenging a regime that is notorious for its violent reprisals against even the most innocuous forms of dissent. Given the media blackout imposed by the Islamic Republic, it is difficult for an outsider to know how many people have died or how far the resistance has spread, but these protests, however they develop, mark a watershed moment in contemporary Iran.

Operating at a slightly larger scale, the *Fashion Parade*, staged at the Margaret Trowell School of Industrial and Fine Art (MTSIFA) at Makerere University in Kampala, entailed a set of coded critiques of the increasingly authoritarian regime of Ugandan President Yoweri Museveni.[6] The *Fashion Parade* was organized by an MTSIFA faculty member named Sarah Nakisanze, who invited students to develop their own costume designs for a runway-style fashion show at the school's gallery in October 2017. A number of the students chose to create clothing that reflected on the growing violence associated with Museveni's efforts to consolidate his rule and suppress dissent. Only a month before the *Parade*, Museveni's supporters physically attacked members of parliament who were opposing a constitutional amendment that would allow him to rule for life, while others were imprisoned. The result was a nationwide protest movement known as the "Togikwatako" campaign (a Luganda term meaning "do not touch," in reference to the Ugandan constitution) that unfolded throughout the fall and winter of 2017–2018. As art historian Angelo Kakande notes in his analysis of the *Parade*, the campaign was committed to

FIGURE 4.1. Mitra, *Ballet and the City* (2019).

nonviolent protest, and its actions included popular music, graffiti, internet memes, posters, and other forms of cultural production, waged against an increasingly violent ruling party. Kakande examines the specific role played in the Togikwatako campaign by the *Fashion Parade* students, who sought to "act in solidarity" with the popular resistance to Museveni's attacks.[7] He describes the work of Sanyu Loyce Naigino, who designed a sleeveless dress featuring the colors of the Ugandan flag but used ropes and nets to fasten the dress around the model's body and neck in order to illustrate her critique of Uganda's postcolonial condition. "We say we have independence," as she writes "But are we really free? . . . We are betrayed by our own." Another student, Vivian Naume Logose, who was active in the opposition Ugandan Young Democrats, designed a dress that combined the colors of the flag with long silver spikes inspired by punk fashion. "It was the safest way to speak out [publicly] in the face of those in power who have all the guns," as Logose noted, "the best way for me to showcase my anger was through fashion."[8] As with the Iranian protests, we can recognize here the essential prefigurative dimension of these actions as they seek to preserve some space of autonomous criticality within an increasingly repressive political regime while also employing modes of popular culture (fashion in Uganda, singing and dancing in Iran) that have a broader public resonance. In the case of the Iranian protests, this space was secured temporally by limiting the singing and dancing actions to very short periods of time. While in the

FIGURE 4.2. Sanyu Loyce Naigino, *The Question of Uganda's Independence*, image from *Fashion Parade* catwalk, Makerere University, Uganda (2017). Photo from Sarah Nakisanze.

Fashion Parade, it was secured by restricting the gestures of dissent to the Makerere campus gallery rather than the street, where dissent was being ruthlessly repressed.

At the next level, we encounter projects that move beyond the intimate, intersubjective sphere of *Radio Khiaban* to encompass larger collective interactions and concrete transformations in specific institutional systems. The *Tamms Year Ten* project was developed by the Tamms Year Ten Committee, a collaboration between Laurie Jo Reynolds and current and former incarcerated persons and their families that was launched in 2007. Reynolds had begun working at the Tamms Correctional Center in southern Illinois as part of a poetry program but quickly discovered that poetry was relatively meaningless for inmates who were struggling to survive the dehumanizing conditions of a supermax prison that consigned its entire population to permanent solitary confinement. Reynolds was led by this experience to reframe her involvement in the prison and her understanding of her own artistic practice. Working with inmates and their families, she developed a platform-based initiative called the *Tamms Year Ten* project, which combined a grassroots legislative campaign and lobbying, tactical media interventions, performative demonstrations and public actions, and cultural projects with prisoners. Its goal was to generate the support necessary to close the Tamms facility within a decade. She describes the complex process of achieving this goal as a form of "legislative art," and it led to the actual closure of Tamms in 2013. In this process, Reynolds and her collaborators became adept at deciphering and creatively intervening in the complex flow of authority and decision-making both within the prison bureaucracy and at the legislative level. Their task was to reconstruct a kind of archaeology of this power structure in order to discern its hidden points of access and intervention. This involved, in turn, a precise attunement to key moments of performative potential in the otherwise routine or pragmatic interactions that they had with prison officials, wardens, and legislators in which subtle shifts in body language, affect, or expression might signal an opening up of their awareness regarding the condition of the prison's inmates. Reynolds and her collaborators learned how to use these moments (the warden agreeing to conjugal visits for the first time, for example) to provide the foundation for more ambitious reforms by linking them with subsequent organizational work. It was precisely Reynolds's identity as an artist that allowed her to experience a degree of trust and receptivity among prison officials that would not have been possible for someone aligned with an NGO or conventional activist group.[9]

The work of the Tamms collective, as well as the Iranian protestors and the *Fashion Parade*, raises an essential question for engaged art. What does critique look like when the latitude for resistance is so thoroughly constrained? What forms of practice can emerge in prison-like societies or in the societies that exist within prisons? And what is the relationship between the more modest forms of criticality that can be generated in these contexts and larger or more systematic forms of social change? This is a core question that I will return to later in this book. In *Marking Time*, her study of artistic creativity and incarceration in the United States, Nicole Fleetwood examines the important linkage between contemporary prison-based art programs, the Attica Uprising of 1971, and the broader climate of radical change that emerged out of the Black Power Movement of the 1960s. Among the key demands of the Attica Liberation Front was access to cultural and educational opportunities. In response to the Attica Uprising (and its brutal repression), the Black Emergency Cultural Coalition (BECC), a group of primarily New York–based African American artists, including Benny Andrews, Romare Bearden, Camille Billopps, Faith Ringgold, and others, developed a "Prison Cultural Exchange Program" that would send "artists into the prisons to teach, lecture, exhibit their works and assist in arranging exhibitions of the work of prisoners."[10] We are "especially committed," the BECC continued, "to the struggle to uphold the validity of art as an agent for cultural revolution and social change." "The BECC followed the lead of Attica protestors," as Fleetwood notes, "listening to their needs in refuting state-mandated ideas of rehabilitation and also the urgent need for 'exchange' with a nonincarcerated public."[11] Only a month after the uprising, BECC members had already begun working in the New York state prison system. The group created a formal "Prison Arts Program" in 1972, which expanded to fourteen states by the late 1970s, with funding from state arts councils and the National Endowment for the Arts (NEA).

By the early 1980s and the ascent of Reaganism, the BECC's prison art program lost its NEA funding and went into decline.[12] It was a key influence, however, on the rapid expansion of prison art programs during the 1980s and 1990s in which professional artists, writers, and poets offered workshops and training for incarcerated individuals. While often valuable, these programs were also characterized by a fundamental tension, as Fleetwood notes, between a form of prison-based cultural production intended to enforce compliance and docility among prisoners (effectively redirecting or sublimating their propensity for resistance) and a form of culture in which, as the BECC hoped, art might serve "as an agent of social change." The gradual

institutionalization of prison art programs and the growing conservatism of political culture in the United States created a new set of dangers as the revolutionary visions that inspired the early BECC gave way to what could often become an exploitative relationship between non-incarcerated artists and arts administrators and incarcerated communities. In her interviews for *Marking Time,* Fleetwood spoke with a prison administrator who "recalled an incarcerated person stating 'They are using us,' when she pitched the proposal of a collaboration by a group of prominent artists who had already secured funding. The imprisoned man was aware of how the captivity of some served to buttress the careers of others." "We need to interrogate," as Fleetwood contends, the "liberal humanist assumptions about what it means to collaborate between 'prisoner' and 'artist,' when such collaborations obfuscate paid labor (artists and organizations) and unpaid labor (incarcerated people) and promote both idealized and punitive notions about the rehabilitative role of art for the most marginalized and criminalized individuals, leaving carceral systems unchecked."[13] At the same time, as Fleetwood writes, the radical traditions of the post-Attica period have been carried forward by subsequent generations of prison-based artists and art collectives, who have developed a remarkable body of resistant cultural production within incarcerated populations. These are predicated on what Fleetwood terms a "pedagogy of the incarcerated" that evolves through dialogues "that cross the boundaries [of race or ethnicity] used by prison administrators to manage and segregate populations."[14]

The first set of examples I gave entailed subtle transformations in individual consciousness, as dancers and singers reclaimed some momentary sense of agency and freedom from the spatial hegemony of the Iranian state. The second set entailed actions that produced change not simply at the level of individual consciousness but also in specific institutional structures (the closure of a prison, the facilitation of artistic production among the incarcerated) while remaining relatively localized in scope. At the third level, we encounter projects in which the correlation between artistic production and broader forms of political activism is practically realized. This approach, which we have already encountered in the escraches of HIJOS, GAC, and Grupo Etcetera, is exemplified by the "Washing the Flag" (*Lava la Bandera*) performances staged by Colectivo Sociedad Civil (CSC) in Peru during 2000. CSC consisted of artists and activists who came together in opposition to the dictatorial behavior of then-president Alberto Fujimori (who was in power as the result of a coup in 1992). The performances were initially staged in the Plaza Mayor, directly in front of the presidential palace

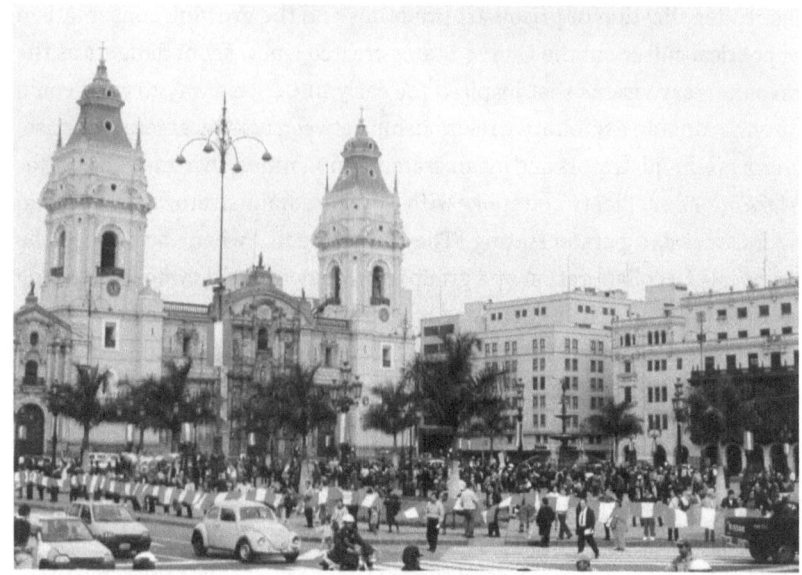

FIGURE 4.3. *Lava la Bandera*, Plaza Mayor, Lima, Peru (2000).

in Lima, and entailed the simple act of washing the Peruvian flag in the large fountain at the plaza's center. This gesture was directed at the corruption of the Fujimori regime (which was engaging in widespread fraud during the 2000 presidential election). The act of washing the flag (a "patriotic cleansing ritual," as founding member Gustavo Buntinx describes it) was soon replicated in towns and villages throughout the country, providing a powerful visual expression of the breadth of public revulsion at Fujimori's leadership.[15] It finds its parallel in the reclaiming of the iconography of the national flag in the Togikwatako campaign in Uganda. The government, sensing the threat posed by this performance as a locus of popular discontent, attempted to block or delegitimize the flag washing through police interventions and efforts to incite violence among protestors. At every step, the protestors had to revise and modify their own actions in response to the government's provocations. Here is Buntinx's vivid account:

> When agents from the National Intelligence Service attempted to infiltrate the crowd, instigating it to react violently against the patriotic laundering, the people opted instead to debate and refute their nonsensical arguments, overwhelming them with a democratic practice that proved too disconcerting and ultimately scared them off.... On several occasions the fountain's water supply was cut off, but nevertheless water was

made available in bags, bottles or basins provided by the area's residents, workers and merchants. Other days loud military bands attempted to drown out the protest with their martial tunes: the population responded by adapting their own oppositional chants to that beat. On July 7th, a swat team warned that any washing would be interrupted by force and all flags hung to dry would be torn down. Despite that threat, the participants proceeded with the ritual, but intoning the national anthem as a symbolic protection, and then bearing the wet banners on their bodies in order to form a gigantic human clothesline. The resulting situation thus became keenly more moving and powerful than the one the police intended to prevent.[16]

Where *Tamms Year Ten* sought to win concessions from an existing municipal or state-level power structure, CSC was part of a broader national protest intended to overthrow the country's political leadership. The *Lava la Bandera* performances began in May 2000, and by mid-November Fujimori had fled the country. Of course, the flag washing was simply one part of a broader mosaic of oppositional gestures and press revelations about Fujimori's corruption that led to his downfall. However, the performances did play a crucial role in sustaining public opposition and solidarity. As Buntinx argues: "With the political parties on the retreat and many politicians on the defensive, overwhelmed by fear or by a misdirected sense of guilt, when not directly bought by the regime, *Lava la Bandera* coalesced the citizenry's simple and sheer will to *not yield*, to *not surrender*."[17] Each of these projects defines itself through a process of critical differentiation, a mode of alterity that is generated through the act of resistance itself. In some cases, this differentiation is produced by the intervention of an external agent into a relatively static system of domination. In *Radio Khiaban*, Zavarei enjoyed the mobility and freedom necessary to facilitate and document the covert performances of Iranian women and generated the initial gesture of dissent through her own experience of displacement (from Tehran to London). In other cases, we encounter a political system undergoing a process of repressive disequilibrium, in which the social agents already present at the site still enjoyed sufficient freedom to contest this process. This is evident in the *Lava la Bandera* actions, as Peru was sliding into an increasingly autocratic form of rule.

The projects I am presenting here are defined by a form of non-monological semblance. Rather than dissolving representation entirely into practice, they employ highly resonant representational motifs (the symbolic and quasi-theatrical action of the flag washing, the body in motion in public space)

not simply as an image to be consumed but as an action to be performed. It is an action that gains its power precisely by violating the proscenium arch evoked by Césaire and by being taken up through serial repetition and reenactment (the outpouring of singing performances documented by Zavarei, the viral expansion of flag washing in the cities and towns of Peru that gave *Lava la Bandera* such power). In this process, the sovereignty of the conventional artistic personality is challenged; what matters is not the singular authorship of this original gesture but its replication among dozens and then hundreds of other "authors." In this manner, seriality (not a single consciousness engaged in self-contemplation but multiple selves, dialogically linked) and plasticity (the mobility of authorship and agency within a given work) are combined as key elements in a renewed concept of the aesthetic. As we review the three spatial registers outlined above we can identify a symptomatic continuity, moving from the transformation of individual consciousness (evident at the most privatized level in the *Radio Khiaban* performances), to the expansion of this process to encompass a larger social body (in the work of the *Tamms* project), to the cultivation of new forms of political agency, and, finally, to collective resistance directed at repressive political systems. Buntinx captures this relationship in his analysis of *Lava la Bandera*: "There is *a cultural overthrow of dictatorship* as important and decisive as its economic, political or military overthrow. For what is thus obtained is an alteration of public consciousness that is also an awakening of the most intimate individual consciousness—and a lasting turn in the prevailing common sense of the times."[18]

Taken in the aggregate, these projects demonstrate the potential congruence between the creative transformation of individual consciousness (the primary locus of critical meaning in conventional artistic practice), "public" consciousness, and collective political action. Of course, the specific forms of action that are possible at any given moment will vary greatly, depending on the particular modes of social or political domination against which they contend. Thus, a project like the escraches, which entailed open confrontation with former members of the Argentine junta, would be inconceivable in the context of contemporary Iran. In this case, there is only a minimal mediating zone of public expression between the authoritarian state and the individual Iranian citizen. What is essential, in each case, is understanding the complex calibration of resistance in a manner that preserves the essential tension between the tactical and the prefigurative and between the reality of existing political constraints and the capacity to transcend those constraints both imaginatively and practically.

As the previous analysis demonstrates, socially engaged art practices regularly violate the key strictures of the neo-avant-garde model of aesthetic autonomy. Rather than assuming a priori that any form of activist or oppositional practice will be subject to immediate co-optation, they choose to operate in a contiguous relationship to concrete processes of social or political resistance. This does not mean that these artists and collectives are blind to the dangers of co-optation or political instrumentalization. They are fully cognizant of the complex tensions that exist between the situational breakthroughs achieved by specific projects and the self-legitimating discourse of the state. They understand, moreover, that a key part of their practice entails the creative negotiation of this tension in ways that can minimize the exculpatory benefits accrued by existing systems of social domination. These risks are a necessary part of any attempt to cultivate new political competencies and create new modes of resistance and political consciousness through practice. By the same token, these groups do not view their collaborators as cognitively deficient, unable to recognize the nature of their own oppression or pursue their own emancipation, and incapable of self-reflection or creative thought without the custodial oversight of the artist or theorist. While they understand that the transformation of consciousness is an essential feature of aesthetic experience, they view this process as reciprocal rather than unilateral, evolving out of the experience of practice and resistance itself. This does not mean that the collaborative processes that unfold in these projects are not characterized by phases of conflict or dissension. It does mean, however, that these experiences are not staged exclusively around a set of fixed subject positions.

As we have seen, at the core of the conventional model of aesthetic autonomy is a bifurcation between art, the privatized domain of representational play and critical distance, and the world of political practice or action, which is seen as instrumental and unreflective. In socially engaged art, these two domains are no longer segregated, and an engagement with symbolic or representational modes unfolds in an action-oriented context. Rather than devolving into kitsch-like simplicity, the forms of representational experimentation that occur in these projects are enriched and complicated by their association with oppositional practice. I have described this shift above as marking the transition from an object- or image-based aesthetic to an event-based aesthetic paradigm. To this extent, it challenges Adorno's insistence on the "priority of the object" in art practice, against which our own "subjective" tendency toward instrumental thought will be exposed.[19] For Adorno the artwork qua object serves as a placeholder for another

complex, self-identical consciousness, whose presentation must, by necessity, be defined by compositional finitude and hermeneutic opacity rather than dialogical openness. The artwork as event also entails an engagement with representational materials that provide a frame within which the participants' critical distance from normative values can be given semantic form. However, these "mediated" materials are placed in an answerable relationship to actual modes of repression. Here we must understand symbolic or representational meaning not in terms of fixed semantic units (a meaning created by the artist and handed over to the viewer for interpretation) but as an utterance, a form of speech that is by necessity incomplete, changing, and "unfinalizable," as Bakhtin writes. Thus, these projects (referring specifically to the projects discussed above) are constituted around a symbolic armature that faces both inward, where it is linked with the recognition of semantic and normative contingency among the participants, and outward, to an "audience" consisting of the representatives of the state.

Rather than a paradigm of aesthetic production divided between a realm of autonomous critical reflection, on the one hand, and a realm of utilitarian political action, on the other, an event-based aesthetic combines moments of mediated, reflexive critique with moments of tactical action. Or, rather, these are understood as two complimentary phases within a larger artistic process, effectively condensing the temporal delay between self-reflective insight here and now and some future moment of revolutionary practice. As a result, criticality is no longer produced solely through the institutional segregation of artistic production from other forms of social practice (via its enclosure in an ostensibly self-contained art world or in the consciousness of the individual artist). Instead, critical distance is secured in these projects through forms of displaced symbolic production oriented toward the broader social world. This is evident in the Dadaistic performances of the escraches, the flag-washing gesture of the *Lava la Bandera* actions, the detourned garments of the *Fashion Parade*, and the mobilization of a parodic urban planning process in the work of groups such as Gezi-Park Fiction. For these gestures to be situationally meaningful, they must also be legible to the participants at the level of content or symbolic referent. This does not mean, however, that their significance is reductive or fixed; in fact, the scenography of the escraches, the flag washing, or the covert public singing of *Radio Khiaban* is extremely complex.

What is occurring here is not a simple reduction of artistic meaning to the crude equivalence of propagandistic representation (a signifier irrevocably linked to a given referent). Rather, what we observe is a process by which

those forms of meaning that were seen as natural or given (embodied in symbolic materials or concepts like "flag" or "justice" or "public" space) are revealed to be contingent, and available to be taken over and infused with new meaning. This realization is the foundation of any practice of resistance—the recognition that change is possible and that those forms of experience that seemed eternally fixed are open to transformation. This semantic indeterminacy extends to the very social space within which these projects unfold. Thus, the publicness of these gestures is often tentative, partial, or incomplete. The singing performances of *Radio Khiaban* attempt to actualize a sphere of autonomous public expression and even dissent that does not yet exist in Iran. And the escraches attempt to reinvent justice in the degraded civil society of a post-junta Argentina in which the state has abandoned its role as an independent adjudicator of the public good. The "public" in this case, like the sensus communis itself, is not a fixed entity but, rather, a prefigurative capacity, a space of potential that can, at the same time, be performed in proximity to the mechanisms of social change necessary to bring it into practical existence.

To the participants, these projects serve as enunciations that express volition, agency, and desire. And they are alive as enunciations rather than edicts, as expressions that change or shift over time, interlocutor, and situational context. For the police and the representatives of the state, they are experienced with a degree of uncertainty and indecision. Their meaning is provocative (they seem to point an accusatory finger at dominant power), but at the same time, this antagonistic gesture is often indirect, decentered, or even poetic. The escraches are histrionic and at times comical, even as they are fueled by profound levels of indignation. The flag washing is a domestic and inwardly directed action. One washes with one's head down, immersed in an action that is set apart from the surrounding context. The participants were engaged with the flag, with an indirect symbol of power, even as the presidential palace was only fifty yards away. And yet this simple act was imbued with subversive criticality, as the average Peruvian claimed a transcendent position above the state from which to judge and condemn its conduct. The seriality of this gesture is an essential feature. One person washing a flag in the Plaza Mayor is idiosyncratic, a handful of people can be discretely arrested, but hundreds of people and then thousands across the country are a threat that requires a level of overt repression that calls into question the very legitimacy of the regime that marshals it. Here again we witness the symptomatic linkage between individual consciousness and social or collective action.

These gestures are directed at those who are more accustomed to authoring communications than receiving them and with monopolizing expression in the public domain. In the presence of these often ambiguous, even oddly passive, gestures (why not burn Fujimori in effigy or throw rocks through the windows of the torturers' homes?), the state is forced to engage in a complex political calculation. Is this gesture threatening? Is it likely to escalate or lead to other, more aggressive action? Can it be co-opted? What level of counterresponse, what level of violence, will the broader public tolerate in reacting to this gesture? This suggests the key role played by displacement or discontinuity in the symbolic economy of these projects. Each of these gestures foregoes a direct assault on authority (extended physical occupation of public space, destruction of property, staged conflicts with police, etc.), which can easily enough be used to justify a retributive violence. Instead, they take up a symbolic or mediated relationship to dominant power, presenting what are often apparently trivial or purely symbolic gestures of protest (the innocuous act of washing the Peruvian flag, for example, or absurdist performances in the escraches). Since they are not aggressively challenging the entrenched authority of the state, in a situation where there is a profound asymmetry of power, these anomalous actions often result in a tactical delay in the state's response, which only gradually increases in severity due to the fear of appearing too authoritarian. The delay or disorientation of the state's response is decisive because it produces a quasi-autonomous space in which new forms of social and political agency can be both created and verified in practice.

This tactical autonomy is paralleled by a cognitive autonomy in which the very experience of resistance produces among the participants a sense of their own distance from normative social or political values. This is evident in the imaginative and cognitive autonomy claimed by the individual Iranian women who risked detention by singing or dancing in public, embodied in the self-expression of their desires in a profoundly constrained social environment. We can observe it in the autonomy of the individual prisoners and family members, activists, and artists associated with the *Tamms Year Ten* project or the prison collectives documented by Fleetwood. And finally, we can identify the autonomy of the Peruvian citizens who sought to reclaim the power to define the meaning of their flag and of Peruvian political subjectivity for themselves. We encounter here some of the ways in which aesthetic autonomy is recoded and rearticulated in socially engaged art practice. Certainly, in these projects there are moments of discontinuity and distanciation (the ability to stand outside of an existing system of

political domination and survey it critically). But this autonomy cannot be understood through a paradigm of an absolute transcendence that is entirely independent from "external" material reality. Autonomy, or the capacity for autonomous critical thought, is not something that is simply possessed, like a mental faculty, by certain preternaturally gifted individuals. Rather, it is better understood as a contingent effect produced within a given field of social relationships and institutional tensions in conjunction with specific forms of practice. While it is possible to accumulate a body of theoretical knowledge based on the insights gained through individual practices, each context, each situation, also provides new challenges and opportunities and calls forth new responses.

We can identify three discrete but contiguous forms of insight generated by socially engaged art practice. In each case, these insights are derived from the new modes of agency and speculative understanding that are opened up by a practical engagement with specific articulations of dominant power. Here power is understood to operate on three levels. First, power is manifested in concrete effects at a local or situational level (the deployment of police in Lima's main plaza, the surveillance of Tehran's streets by the Basij and Gasht-e-Ershad, prison administrators). Second, this physical expression of power is conditioned by a series of affiliated discursive systems that are specific to a given location, such as the symbolic and spatial vocabulary of the Plaza Mayor in Lima or the bureaucratic rituals of the prison industrial complex in Illinois. And finally, these localized ideological systems are structured in turn by a broader set of political and economic protocols (neoliberal capitalism, the civil structure of a military regime, etc.). Drawing on the conventions of music theory, we might describe the forms of knowledge generated by socially engaged art practices in these contexts as "praxial," entailing both performance-based learning and new mental or cognitive orientations that emerge in response to the situational matrix of the performance.

The first form of praxial insight involves tactical knowledge, which emerges as participants observe the effects produced on an existing apparatus of power by particular symbolic gestures and physical interventions (the washing of a flag, the escraches, etc.). These may include changes in public policy, the blockage of certain economic logics, temporary or more lasting shifts in the distribution of power, or transformations in specific ideological fields or value systems. This knowledge is highly situational and includes the capacity to adapt and modify a given ensemble of actions or gestures as they elicit a counterresponse from the particular governmental or regulatory structure they are targeting (evident in the *Lava la Bandera*

performances). It should also be noted that this form of knowledge is both creative and pragmatic and carries along with it the capacity to transform the consciousness of the participants or collaborators, as the initial success of a specific set of gestures can produce an enhanced sense of agency and a greater willingness to project the practice into new contexts in the future.

The second form of insight is associated with new modes of critique and structural analysis, directed at a given system of domination. Here critique is linked to the principle of negation, as a process that seeks to destabilize normative perceptions of specific political or economic institutions and ideological systems. In the case of the escraches, this involved a conscious effort to delegitimize a culture in which the perpetrators of past violence were simply absorbed unquestioningly back into the fabric of Argentine civil society. Here, as in the avant-garde tradition, the artist adopts a position external to the surrounding, hegemonic culture. But in socially engaged practice, the artist does not claim this exteriority as a singular and unique capacity. Nor do they assume that their critical awareness can only be preserved by abjuring any practical resistance to the culture it critiques. Rather, the forms of critical consciousness mobilized by engaged art practices are produced out of a process of collective exchange. At the same time, critique is drawn along with action (rather than isolated from it), which has the effect of providing critical intelligence with a far more nuanced understanding of the material nature of domination itself. Domination is not a fixed or static thing, to be analyzed in abstraction. It is a living culture that evolves and modifies itself over time, through the exigencies of historical development and ongoing opposition.

The third form of knowledge production entails a prefigurative awareness associated with the modes of self-transformation, consensual decision-making, and creativity that unfold in a specific project. These can require highly complex negotiations across the differing epistemological orientations, forms of identity, and belief systems held by individual participants. We might describe the process of reflectively working through these intersubjective tensions as a kind of social labor that partially suspends normative modes of being driven by autonomous self-interest. At their optimal level, these interactions elicit a form of intersubjective experience that resonates quite clearly with the ethos of the Enlightenment aesthetic. In particular, they evoke the key moment, long deferred, when a given socius is able to generate its own norms and values rather than having them imposed by an external and arbitrary authority. But now, this moment of intersubjective exchange is no longer simply represented metonymically within the self-

reflective consciousness of the individual artist; it is actualized through the collective interaction of concrete interlocutors. For Adorno, and for many others in the long history of the avant-garde, this is the dreaded moment of premature desublimation, as we naively try to call the sensus communis into practical existence. But the goal of these interactions is not to affect some final, utopic reconciliation of self and other or subject and object (the spectator "carried off in a flood of collective energy"). Rather, these projects seek to preserve the fundamental irreconcilability of these two terms (as they are conventionally understood) while at the same time facilitating forms of action that are both visionary and pragmatic. Here the tensions and discontinuities that exist between self and other are not dissolved but openly thematized, as part of the very material of artistic practice itself.

Rather than two fixed selves, each seeking to defend its a priori autonomy, a space is opened here for a concept of the self that no longer conforms to the ethos of bourgeois sovereignty. It is a space that is defined by modes of self-transformation that are reciprocal rather than unilateral (the artist repairing the viewer's damaged consciousness). The goal is not a finished or finalized version of the self, like Schiller's idealized aesthetic subject or the communist "New Man," which will render all subsequent forms of intersubjective negotiation unnecessary. The goal is precisely to understand more deeply and more thoroughly the process by which the self is transformed and made more open with the understanding that this process will never be fully complete. This is a process that no longer depends on a fixed notion of identity, which can only view external determination as marking the expansion of one self at the expense of another. Instead, socially engaged art practices call into question the very concepts of externality and interiority on which the schema of conventional aesthetic autonomy is based. What these projects embody, then, is an ongoing experimentation with the parameters of identity itself. They ask if it is possible to produce a social space that exists apart from both the repressive universality of the community, party, or state on the one hand and the sovereignty of the monadic self (epitomized by conventional artistic identity as much as bourgeois subjectivity) on the other through a series of experiential encounters that are both practical and reflective.

While I have outlined three core characteristics of socially engaged art, it is important to bear in mind that these are articulated in varying ways across an extremely broad geopolitical spectrum. This is consistent with the more general commitment to situational answerability in socially engaged art. Thus, projects developed in Lusophone Africa are organized around a

very different set of political and cultural referents than those produced in eastern Europe, Southeast Asia, or South America. At the same time, the articulation of these methodologies is also affected by the operational scale of a given project. In some cases, we find projects that place primary emphasis on a contemplative or reflective exchange among a limited number of interlocutors. The work of the Tambo Colectivx in La Paz is typical of this approach, in the exchanges among collective members regarding the repression of indigenous cultural traditions in Bolivia. While this work directly engages the discursive mechanisms of neocolonial domination, it is only peripherally related to specific institutional structures. Here the prefigurative dimension outlined above plays a more central role. In other cases (work associated with the Prestes Maia occupation in São Paulo, for example, the Rhodes Must Fall campaign in Cape Town or Lilian Mary Nabulime's work around issues of HIV and AIDS in Uganda), we find an emphasis on tactical engagement with particular social or political institutions.[20] I would argue, however, that all three elements are consistently present across the broader range of contemporary socially engaged art practice; they simply appear in varying ratios and levels of emphasis.

From the Axiomatic to the Interrogative

Throughout this study, I have stressed the central role played by the schema of aesthetic autonomy in the evolution of modernist art. I identified an underlying continuity that extends from Enlightenment philosophy through the current neo-Adornian moment, in which contemporary art can survive only at the expense of a radical bifurcation between art and social or political praxis. It is a bifurcation that must be maintained not simply because the immense appropriative powers of the capitalist system render any direct action pointless but because the bifurcation itself can be employed as a heuristic device to further demonstrate the barbarity of that same system. I have also identified an alternative tradition of artistic practice that challenges this schema, most recently in the emergence of new forms of socially engaged art. The nature of this transformation is already apparent in the process of artistic dematerialization that began during the 1960s and in the transition from the artwork as object to the artwork as event. Dematerialization unfolded along two parallel tracks. In conventional conceptual art (the work of Huebler, Kosuth, etc.), the movement away from object-immanence is followed by the reconsolidation of what we might term subject-immanence as the nexus of meaning production is returned to the consciousness of the individual

artist and externalized in the form of "immaterial" discursive systems that function as the direct correlates of the artist's speculative consciousness.

The work of figures such as Piper, Beuys, Oiticica, and others demonstrates a second passage through the moment of dematerialization, in which the principle of immanence itself is openly thematized, both negated and carried forward in a different form. We observe a partial dissolution of the singular subject-immanence of the artistic personality as well as a reconfiguration of the object. Here the generative semantic field of a given work is no longer confined to a process of autonomous conceptual ideation undertaken by the artist but instead unfolds diachronically through a series of social or inter-subjective encounters. We find here, then, two distinct aesthetic paradigms. On the one hand, we have an avant-garde concept of art as the vessel for a unique form of critical or proto-revolutionary knowledge. While the artist may well find their understanding altered as a result of social interactions, the locus of insight remains immanent and necessarily autonomous from both other selves and from the perceived exigencies of praxis itself. This is epitomized by artist Thomas Hirschhorn's commitment to a principle of "unshared authorship" in his participatory artistic projects.[21] And on the other hand, we have a concept of the aesthetic in which meaning is spatially decentralized, interstitial, and temporally cumulative, produced through the reciprocal movement between individual and collective self-reflection and the experiential testing of new modalities of expression and resistance in response to the counterpressures exerted by particular configurations of power.

Of course, the avant-garde tradition also views the history of art as fluid and discontinuous. Here art is understood less as a static set of formal procedures than as a generic capacity for negation, which must regularly change its presentational form over time in order to retain its critical capacity. This self-transformation, this pushing off against previously authentic but now senescent modes of artistic production, is, in fact, the very engine of art's claim to an ongoing critical relevance. It is precisely this allegorical "resistance" (of new against old) that allows art to preserve, in a nonoperational form, some vestigial trace of revolutionary consciousness. However, across all of the modal transformations necessary to preserve this space, across the endless differential cycling of the critical and the co-opted, the underlying social architecture of avant-garde art, the way in which the subject positions of artist and viewer are constructed and assigned, remains consistent. This is, for me, the value of the schema that I have outlined here. It allows us both to recognize these continuities and to think past them. In socially

engaged art, the "plasticity" of art reflects a more fundamental reshaping of the ontology of the artwork. As a result, the artist does not locate the primary nexus of resistance in their critical relationship to earlier modes of artmaking. Rather, socially engaged art identifies its point of resistance and differentiation in concrete forms of social and political repression against which it struggles here and now.

The transformation from an object to an event-based mode of artistic production also entails a transformation in the schema of aesthetic autonomy itself. The schema is centered on a series of interdependent truth claims about the relationship between artistic practice and political change. These claims operate on two levels. The first level concerns the specific model of sociopolitical reality against which aesthetic experience is presumed to unfold and the forms of selfhood produced by this social reality. The second level concerns the specific epistemological claims made on behalf of the work of art and the artist in advancing the emancipatory vision embodied in the aesthetic. These claims represent an accumulated set of insights produced out of the concrete historical circumstances of the past. On the one hand, they can be seen as mnemonically "preserving" a form of radical political consciousness (epitomized by the Russian Revolution) that is otherwise repressed in contemporary society. But this preservative impulse can also lead to a tendency to view past revolutionary moments with a veneration that can border on idolatry. Along with this comes a tendency to abandon any effort to learn or gain inspiration from subsequent modes of political struggle (which can never measure up to the radicality of the past). What is occurring in socially engaged art is a systematic reassessment of each of these postulates and a transformation of the epistemological structure of the schema, from the axiomatic to the interrogative.

The "incapacity of the masses" thesis can be traced to a set of historical assumptions regarding the political immaturity of the working class (its failure to embrace the revolutionary destiny assigned to it by the Marxist tradition), which are transposed into a set of corollary assumptions about the cognitive limitations of art audiences. Here we encounter the characteristic avant-garde elision, as the viewer is constructed as both a bourgeois in need of punishment (Adorno) and a proletarian in need of awakening (Brecht). This cognitive incapacity is understood as the result of the habitualization imposed by capitalist ideology. As a result of this incapacity, the implied viewer or audience for avant-garde artistic practice is capable of only a "spontaneous" level of action and, by extension, is incapable of the critical and reflective thought necessary to grasp the systematic complexity of cap-

italist social reality and the steps necessary to overthrow it. This analysis captures an undeniable aspect of reality under capitalism, which is characterized by powerful forms of ideological coercion and manipulation. But what differentiates the avant-garde presentation of this fact is a deliberately hyperbolic framing, in which hegemonic control is not simply pervasive but entirely seamless, offering no openings through which an alternate form of consciousness might gain a foothold. The only exception to this scene of absolute ideological domination can be found in the avant-garde artwork and the personality of the avant-garde artist, who possesses a singular capacity for an advanced form of critical and conceptual ideation that is denied to the population as a whole.

Socially engaged art practices are concerned with the experiential testing of all of these assumptions. They are treated not as a priori truths to be preserved in the semantic structures of the artwork but as open-ended questions. Is the ideological domination of the capitalist system entirely monolithic, or is it possible to envision new modalities of resistance? At the same time, in socially engaged art practice, there is no a priori assumption that either the artist or their collaborators possess a privileged level of insight into the constitution or dismantling of existing political reality. This can only be ascertained via practice itself and, in particular, through the reciprocal determination of the actual effects of specific forms of action (physical, discursive, etc.) at a given site. This feedback loop becomes a primary engine of evolving creativity. Thus, the work of art is no longer conceived of as a prefabricated conceptual apparatus to be handed over to the viewer for decoding but as a process in which modes of expressive agency, reflective insight, and criticality are mobile and reciprocally negotiated rather than grounded autochthonously in a single subject. As a result, the axiomatic assumption of the incapacity of the masses becomes the question: What are the impediments to substantive social or political change at the level of human consciousness, including that of the artist? And how might the consciousness of all of these agents be transformed in a critical and emancipatory manner through an aesthetic encounter?

The "prematurity of praxis" thesis is initially derived from Schiller's pessimistic assessment of the French Revolution and takes its contemporary form in Adorno's equally fatalistic account of protest movements during the 1960s. The thesis is accompanied by two related postulates. First, it assumes that the transformative experience of an aesthetic encounter must precede and condition any future political action. Second, it assumes that any direct action taken before this aesthetic reprogramming occurs is destined to end

in complicity, thus reinforcing the exculpatory logic of capitalism. This is the implication of the scalar analysis I outlined in chapter 2, in which "merely" local or situational actions can never hope to generate any practical or theoretical insight that might be applicable in other spaces of resistance. Nor is it conceivable that local or situational forms of resistance might cohere or aggregate in any meaningful way over time, leading to more systemic forms of change. In the absence of a global horizon for systemic change, we are left with two choices. We can assume that we are sufficiently prescient to predict the precise moment at which authentic political change has finally become possible (however we might choose to define that term) while remaining detached from any relationship to actually existing forms of political resistance. Or, alternately, we can develop modes of artistic production that seek to learn from and through resistance itself in the myriad forms that it might take. This is the path followed by socially engaged art practice. While each of these approaches carries its own advantages and liabilities, I would contend that socially engaged art practices are founded on a less functionalist, and more complex, understanding of political practice. They view political practice not as the rote application of a priori forms of insight but, at least potentially, as a form of creative production that is capable of generating its own unique insights and of reshaping consciousness and subjectivity. For this reason, socially engaged artists are especially attentive to those liminal spaces that exist between new forms of political action, or activism, and new forms of artistic production. As a result, in socially engaged art, the prematurity of practice thesis becomes the question: What is the relationship *between* situational action here and now and systemic change or revolution? And what are the mechanisms by which situational action might be transmitted or expanded in scale?

The "surrogacy of the artist" thesis argues that the artist has come to serve as the repository of a form of revolutionary consciousness that the masses have failed to exhibit. It is not simply the claim that artists, among many other potential agents, have some contribution to make to the ongoing pursuit of a more just society. Rather, the discourse of the neo-avant-garde is based on the claim that art, and art alone, possesses the unique ability to decipher existing forms of capitalist domination and to preserve the generative nucleus of a revolutionary consciousness capable of contesting this domination. In this view, as John Roberts argues, the neo-avant-garde artwork carries forward "the collective memory of the revolutionary Event."[22] Of course, art itself is centrally implicated in the logic of the market, constituting one of the most privileged forms of the commodity fetish. It is only possible to

sustain the idea that art occupies a unique discursive and institutional space that is somehow insulated from capitalist mechanisms of appropriation by minimizing its commodity status as well as its key legitimating role as a form of symbolic capital for the wealthy. This disavowal is produced in Rancière's writing by simply normalizing the uniformity of commodification ("So art is a market, and there's no getting around it") without explaining how, in this case, art can continue to claim to possess a quasi-autonomous critical perspective that is somehow entirely unique.

The subject-category of "artist" in contemporary society is the contingent product of a series of historical precedents, ideological determinations, and structuring institutional forces. One "becomes" an artist by submitting to these various shaping mechanisms (the acculturation of art school; the identification or counteridentification with specific cultural norms as these are disseminated in the form of art history, theory and criticism, and broader cultural attitudes toward art; one's relationship to the art market and its ancillary institutions; etc.) and through the simple act of self-declaration. There is no rational justification for the contention that individuals who undergo this process are necessarily endowed with an advanced form of revolutionary intelligence or that they are the only contemporary agents truly immune to the forms of ideological control that are otherwise all-encompassing in contemporary society. Certainly, there is a venerable history of artistic engagement with the political (revolutionary and otherwise), but there is no genetic cognitive capacity, immanent to the artistic personality, that would preclude any other social actor from acquiring a similar knowledge. This is not to say that artists and art do not have something important and unique to contribute to unfolding forms of political resistance and critique; it is only to question the belief that they "alone" are able to do so in an authentic manner due to their singular resistance to ideological control. As these questions suggest, in socially engaged art, the axiomatic concept of the surrogacy of the artist becomes the question: What is the relationship *between* the artist and artistic production and social or political change? In the same manner, the "singularly of art" thesis (the belief that artistic practice is the only cultural mechanism able to sustain a form of revolutionary knowledge) becomes the question: What is the relationship *between* art and other modes and mechanisms of social or political change?

The "monadic self-reflection" thesis is a corollary expression of the singularity of art thesis. If the totalized nature of capitalist domination means that genuine critical insight can only find a refuge in the culturally isolated sphere of fine art, then the monadic self-reflection thesis imposes

a further level of sequestration, arguing that genuinely critical insight can only originate within the consciousness of the individual artist or theorist. Further, it insists that this critical insight must not be linked in any manner with actual processes of social or political resistance. Rather, it can only be expressed through a kind of sublimated metonymic display, in which the (now-reified) forms of previous artistic practice or the normalizing institutional forces of the art world function as the displaced manifestations of a repressive authority whose real point of origin (the capitalist system itself) can never be directly challenged. What is being conveyed to the viewer is less a specific locus of critical analysis than it is the mechanism of the artist's own paradigmatic form of self-reflexive thought (which allows them to acknowledge art's inevitable complicity and undermine it in the same gesture). This is not to say that a great deal of valuable insight does not derive from inwardly focused forms of contemplation or reflection. What is distinctive about the discourse of the avant-garde is its Manichean quality, in which this is the only form of thought that possesses a generative, critical value, able to carry forward a truly revolutionary ethos.

Self-reflexivity is produced in two registers in the avant-garde tradition. First, it is produced at the level of the individual viewer through a penitential discourse, as they are forced to reflect critically on their reliance on a set of violently instrumentalizing conceptual structures of which they were previously unaware. Thus, the goal of an avant-garde art practice is to show us the extent to which we unselfconsciously impose categorical fixity on the indeterminant complexity of the world and other selves while at the same time reinforcing barbaric forms of economic domination that are endemic to the capitalist system (hence the frequent recurrence in Adorno's writing to the viewer's experience of "shame" and "guilt"). And second, avant-garde self-reflexivity is produced through a parallel critical reflection on the limitations of art itself. In the discourse of the neo-avant-garde, this critical self-reflexivity is directed at art practices that exhibit an insufficiently rigorous understanding of the ambivalent nature of aesthetic autonomy. In particular, it is targeted at the naive belief that art can simply actualize its latent utopic power here and now with no risk that this affirmative gesture will be subject to immediate co-optation. In neither case, of course, is the "self" (or the mode of artistic production) that is targeted in this process of self-reflexive criticality actually coincident with the personality of the artist who is directing it or the work they produce. Rather, the avant-garde artist is assumed to have already achieved the critical autonomy that is only spuriously claimed by the bourgeois self or affirmative art practices, having

passed through the state of un-self-reflective cognition characteristic of the implied viewer (and other artists).

The implicit telos of this ongoing process of self-transformation is the emergence of a new social order defined by intersubjective freedom. Here we would be able to acknowledge others in their full complexity rather than treating them as mere fodder in our narcissistic quest for ontic mastery. This may not entail a reconciliation of self and other, which always threatens to devolve back into a false unification, but at the least it implies some rapprochement with the other that can only occur in the wake of capitalism's demise. This is the emancipatory horizon that unites both neo-avant-garde and socially engaged art practice today. Critical insight into the myriad ways in which the human imagination is constrained by authoritarian political systems is essential to any act of resistance. And the history of the avant-garde provides a valuable set of resources for exploring this process. At the same time, there is a price to be paid for predicating the discourse of avant-garde aesthetics so fully on a conventionally autonomous concept of the self and, by extension, for normalizing this monadic self as the necessary point of origin for all subsequent forms of critical thought. In this view, the artistic self is never produced (or fundamentally altered) *through* social interaction, but rather always arrives at the site of practice as a finalized agent whose self-identical consciousness will be unfurled before a waiting audience and whose very autonomy becomes a paradigm of inner-directed selfhood for others to emulate. While they may have their consciousness supplemented in some way by social interaction, the crucial formative structures of the self are all established prior to any social or intersubjective experience resulting from the artistic process. This Odyssean self, to use Adorno and Horkheimer's phrase, is not reciprocally produced but, rather, acquisitive and hardened into an enunciative nucleus. Its primary function is to externalize the speculative insights that are derived from an essentially monological process of critical reflection and conceptualization. While the externalized form taken by these insights might entail the orchestration of various social interactions, the artist's role remains choreographic; they establish the physical and discursive conditions within which these interactions unfold, while the interactions themselves constitute an essentially dependent form of "spontaneous" expression that derives entirely from the artist's original framing gesture.[23]

In socially engaged art practices, we typically encounter a very different understanding of selfhood and of the artistic personality. As a result, we also encounter a very different version of self-reflexive criticality. In

projects such as the escraches, *Lava la Bandera*, *Radio Khiaban*, and many others, criticality not only is the product of individual self-reflection but also results from an extended process of intersubjective exchange within and among a network of social agents. In this manner, the insights derived from an inwardly directed inventory of the self and of the ideological determinations affecting a given work are regularly tested against the reflective perceptions of others. No single locus of reflective analysis is understood as the singular origin of or prototype for all others. In this manner, the production of criticality becomes decentered and mobile rather than fixed within a single agent. Thus, in socially engaged art, the axiomatic belief that critical thought must originate in the sphere of autonomous self-reflection becomes the question: What is the relationship *between* individual self-reflection and social or collective consciousness or action? At the same time, the tendency in avant-garde discourse to devalue bodily or sensate knowledge and to valorize the realm of conceptual ideation is also unsettled. As a result, the axiomatic assumption that activist practice must always be preceded and guided by a set of a priori theoretical insights becomes the question: What is the relationship *between* the forms of knowledge generated by the body or somatic experience in the act of resistance (or collaborative interaction) and contemplative or theoretical insight? Finally, the axiomatic assumption that political practice is, by definition, entirely driven by instrumental calculations of immediate efficacy becomes the question: What is the relationship *between* the instrumental or tactical orientation of a given project and the forms of speculative and prefigurative insight that it might also generate? In chapter 5 I will turn to the concept of social labor to delineate a theoretical paradigm that can more fully grasp the aesthetic implications inherent in these questions.

III

A DIALOGICAL AESTHETIC

5

SOCIAL LABOR AND COMMUNICATIVE ACTION

The Thorn of Alterity

In chapter 4 I analyzed some of the complex points of interconnection between socially engaged art and processes of social or political transformation. I focused in particular on the forms of creativity that are generated in this relationship and the ways in which the act of resistance might contribute to the reconstruction of the self in a manner that challenges the conventional mode of autonomous selfhood associated with the rise of the bourgeoisie. This is significant because the traditions of both the artistic avant-garde and the political vanguard have often normalized an essentially instrumental model of the subject defined by a relationship of appropriative control over the world "external" to the self (the vanguard theorist who molds the "bricks of socialism" into revolutionary cadres or the avant-garde artist who subjects the viewer to a destabilizing cognitive assault). Both entail a position of mastery and a fixed ontology of subjective interiority and external otherness, effectively reproducing core attributes of

bourgeois selfhood. In this manner, the autonomous self serves as the protective enclosure for a form of revolutionary truth that is, at least ostensibly, dedicated to the destruction of this same form of subjectivity. This is not to say that political change does not also require hierarchal structures or instrumental calculation. Rather, it is to question the belief that political transformation is entirely utilitarian and possesses no creative potential. It is this creative and, I will argue, aesthetic dimension that is especially salient for our understanding of socially engaged art practice. In this chapter, I want to examine this aesthetic quality in greater depth.

Precisely because engaged art practices have long been marginalized in art criticism, there is no established theoretical armature that would allow us to more fully explore their relationship to aesthetic experience. It requires, then, assembling an alternative framework from materials that are relatively unfamiliar in the field of art history. It will also require a degree of theoretical exegesis to provide the reader with a broader sense of the specific ways in which questions of the aesthetic and the political are handled in these materials. While I will make some reference to specific projects in this chapter, my primary focus will be on the concept of "social labor" in the Marxist tradition, which is introduced in the *Economic and Philosophic Manuscripts*. In the concept of social labor, we can discover an important tool for rethinking the nature of aesthetic experience and for understanding more fully the creative and generative qualities of socially engaged art. During the 1970s and 1980s, the concept of social labor was taken up by a younger generation of Frankfurt School thinkers (Jürgen Habermas, Axel Honneth, Hans Joas) to address certain lacunae around the nature of social change associated with their predecessors (Horkheimer and Adorno in particular). At the same time, as I will discuss below, the 1960s and 1970s witnessed a broader reckoning with the ambivalent legacies of conventional vanguard politics, which was evident across a range of social movements. In this chapter, I will examine the ways in which social labor, translated into a concept of "communicative action," evolved to account for the new forms of political resistance that emerged in these movements. I will also discuss the limitations of this analysis for our understanding of socially engaged art, pointing to a further elaboration of the concept of social labor in the following chapter.

Socially engaged art practices are concerned with thematizing autonomy itself as part of their critical operation. In this respect, socially engaged art is not defined by a simple inversion of the schema of aesthetic autonomy, in which the artist is no longer a privileged surrogate for revolutionary consciousness but instead becomes a servant of the party or in which "practice" now claims

a naively unmediated access to the political real. Rather, in socially engaged art practice, each of the forms of autonomy that are hierarchically ordered in the conventional schema (practice subordinated to theory, naive actionism subordinated to authentic avant-garde art, or the consciousness of the viewer subordinated to that of the artist) is now dialogically reconstructed. We can thus view each nodal point in the schema as a space of heuristic inquiry, opening up a set of as-yet-unresolved questions to be worked through in practice. There are two related questions to be considered here that the concept of social labor can help illuminate. First, how does the self relate to the other, and to a larger social body? And second, how do we come to envision a different world? Or, more precisely, what forms of cognitive, somatic, and affective knowledge are necessary for the emergence of new forms of insight into the constitution of the social and political?

In the Marxist tradition, these questions are framed through the concept of praxis, a term derived from Aristotle. Marx, under Hegel's influence, defines praxis as a fundamental feature of our "species being," which is brought forth through the act of externalizing our will in the appropriation of the natural world. This transformative experience is the very fountainhead of an authentic, autonomous selfhood. It is denied, however, to the proletariat through the repressive mechanisms of capitalism, necessitating the transformation of praxis as collective human labor into praxis as collective revolutionary struggle. Here I will use the term "praxis" to refer to modes of embodied action and discursive production oriented toward emancipatory social change. This can entail demonstrations and occupations, the creation of new political blocs, involvement with formal political institutions, and interventions directed at the transformation of existing structures of domination, as well as less direct forms of practice oriented toward the creation of prefigurative social and political forms. These exist along a continuum, from open insurrection at the national or regional scale to more localized actions. I will argue that praxis can also refer to new modes of cognitive and somatic insight into the effects of these actions (as well as the broader analysis of a given social or political totality and the envisioning of its potential alternatives) that may be produced either by subsequent forms of self-reflection or by dialogical exchanges among the agents involved in the practice itself.

In the avant-garde schema, this question is typically framed in terms of the relationship between thought, which is understood as self-reflexive and critical, and the externalization of this generative insight via physical action and social interaction, directed by the organizing will of the artist or vanguard leader. Here thought unfolds along a teleological axis that is realized

in practice or action, which remain the essentially passive expression of an originary intention formed through reflective contemplation. In the vanguard tradition, these capacities are often projected onto specific modes of selfhood. We have observed this attitude in the division between the "theoretical" and the "practical" communist or between the "spontaneous," instinctual masses and the vanguard theorist. The guiding intelligence, the generative power to envision and actualize an alternate reality, is always displaced from the conscious awareness of the human subjects who are its presumed beneficiaries and the agents of its practical realization. This dynamic is rooted in the discursive tradition of postsacral modernity, which is characterized by a cyclical movement between moments of what Habermas has termed "de-transcendentalization" and "re-transcendentalization."[1] I introduced this analysis in chapter 3. I will return to it here in order to draw out some resources for an alternative model of the aesthetic. Habermas begins his analysis with a discussion of the characteristic "mentalism" of Kantian philosophy, which seeks to determine how the "transcendental subject" can secure knowledge of the "objective world." "Kant started," as Habermas observes, "from the idea that the knowing subject determines the conditions under which it can be affected by sensory input."[2] The "knowing subject" thus "frames 'with perfect spontaneity an order of its own according to ideas, to which it adapts the empirical conditions.'"[3]

We can identify here two key features of Kant's model of transcendental knowledge. The first is autonomy. The knowing subject is fundamentally separate from the world-to-be-known, to which they have no direct access except through the presentational mechanisms of their own mind. As a result, our interior "mental" consciousness is "circumscribed by a boundary, drawn from the first-person perspective, between what is 'inside' and what is 'outside' of my consciousness," as Habermas writes.[4] The second related feature is self-reflection, understood as "reflection on myself as a subject having ideas or representations of whatever objects." Objective knowledge of the world entails a process of becoming apperceptively aware, not of the world as such but of the interiorized conceptual mechanisms through which we present that world to our inner consciousness. "In representing my representations," as Habermas writes, "I disclose an internal space, called subjectivity. Thus, the sphere of consciousness is intertwined with self-consciousness right from the beginning." Transcendence here carries two related meanings. First, the subject transcends the physical, proximate locus of knowledge and gains access to a set of immanent conceptual mechanisms (embedded in human cognition) that impose order and intelligibility on the "disordered" experiential world while also providing us with the

epistemological tools necessary to control and manipulate that world. As his analysis of the aesthetic suggests, Kant assumed that most people were ignorant of these mechanisms, thus instantiating the core Enlightenment division between a caste of cognoscenti and the general public, who remain unaware of the extent to which their "natural" or intuitive knowledge is conceptually preformed. This parallels the more general modernist division between the European self, defined by its mastery of cognitive abstraction, and the non-Western other (natives, colonized subjects) who remain subordinated to their bodily instincts ("brute people without reason," as Sylvia Wynter writes).[5] The second feature of transcendence entails the process by which the knowing self gains access to a sense of its own totality (and ontic stability) as a subject through the identification of the boundaries that differentiate and separate it from the surrounding world. We can see here the clear correlation between these ideas and the emerging discursive structure of the aesthetic in the priority placed on introspective self-reflection as the originary form of critical knowledge, the essentially subsidiary status of the "external" world and selves in the process of knowledge production, and ontic sovereignty.

Hegel sought to reverse Kant's transcendental model of the subject by arguing that the self does not stand apart from the "external" world but is, quite literally, brought into being by it. For Hegel, as Habermas contends, "there is no need to bridge any gap between the mental and the physical, the sphere of our consciousness and the sphere of what we are conscious of. In his account the knowing subject 'always already' finds itself 'with its other.'"[6] Thus, Hegel identifies a set of mediating devices that reciprocally link the self to the world and to other selves. These include both "labor," the act of securing our survival through the creative transformation of the natural world, and "language," which links us to the community of other selves through a communicative medium. Here is Hegel's evocative description of this process by which the interiorized self is externalized in concrete form: "The speaking mouth, the laboring hand, even the legs if you will, are the actualizing and accomplishing organs which embody the act as act, or what is inward, in themselves. . . . Language and labor are forms of expression in which the individual no longer contains and possesses himself within himself, but allows the inward to become completely external, and surrenders it to the other."[7] As a result of the "mediating" systems of work and language, we come to understand that the production of knowledge unfolds not simply through the monadic self, reflecting on its own interior cognitive states, but also through forms of intersubjective exchange and collective production.

The ontology of the self is thereby transformed. As Habermas writes, "It is to Hegel's credit that he discovered the epistemological relevance of language and work. He uncovered in them the 'spirit' that mediates the knowing subject with its objects in ways that undercut any dualist description. Language and work provide media in which the internal and external aspects, split by the mentalist approach, now merge."[8]

This dialogical concept of the self, formed in and through conscious social relationships, is a central feature of Hegel's early writing (evident in the Jena lectures of 1805–1806). It will be dramatically curtailed, however, in Hegel's later writing. Increasingly, following the *Phenomenology of Spirit*, the unfolding of Geist is no longer operationally linked to or expressive of the achievements of actual human intersubjective exchange (embodied in the creation of new social and political structures able to reconcile the conflicting demands of self and other in a just and emancipatory manner). Rather, Geist is now re-transcendentalized, in Habermas's analysis, taking on the form of quasi-autonomous political institutions (the office of the Constitutional Monarch or the abstract operations of the estates in *Elements of the Philosophy of Right*).[9] These "stabler forms of objective spirit," as Habermas writes, provide concrete manifestations of man's utopic ability to reconcile self and other, but due to the limitations of existing "subjective" development, they must remain essentially autonomous from the broader public over whom they preside.[10] This is consistent with Marx's own critique of Hegel, where he famously states, "Hegel has accomplished the feat of deducing the hereditary peerage, landed estates, etc., these 'supports of the throne and society,' from the absolute Idea."[11]

This shift is evident in the treatment of Geist itself at the theoretical as well as the practical level. In the *Encyclopedia* and *Science of Logic*, the social media of language and labor are dramatically reduced in importance, and Geist is presented as an entirely autonomous entity.[12] Here we move from an "intersubjective" notion of Geist to the concept of Geist as an "Absolute" that is evident in Hegel's later writing ("This subject is thought of as the One and All, as the totality which 'can have nothing outside itself'").[13] This shift marks what Habermas describes as the "suppression of the dialogic situation" that previously defined Hegel's account of spirit.[14] "The knowing subject," as he writes, "assuming now the shape of 'absolute spirit,' internalizes, as a conceptual dynamic occurring within itself, what previously had been external differences between subject and object, mediated by language, work and mutual recognition."[15] Geist thus reemerges as the very epitome of the autonomous self, which must now draw within itself the forms of external,

reciprocal otherness (performed through labor and language) on which Hegel's previous model of the decentered self depended. As a result, the role of a concrete other, in relationship to which truth could be reciprocally disclosed, is abandoned, and Geist must reproduce within its own immanent structure a kind of surrogate other (like the avant-garde work pushing off against its own immanent formal constraints). Geist "can no longer tolerate," as Habermas writes, "'the other of itself' as the constraining opposition of a resistant reality, or as an alter ego with equal rights *external* to itself. It can accept such an other only *within itself*, downgraded to the status of raw material for its own process of development." In this manner, the "thorn of alterity," as Habermas writes, "the tension of a distance which is both bridged and maintained, is removed from 'being-with-the-other,'" and the distinction between a prefigurative metaphysical principle and instrumentalizing reason is collapsed.[16]

The Speaking Mouth and the Laboring Hand

The reform of consciousness consists entirely in making the world aware of its own consciousness, in arousing it from its dream of itself, in explaining its own actions to it.
—Karl Marx to Arnold Ruge, September 1843, in *Karl Marx: Early Writings*

In Habermas's analysis, Marxism constitutes the next stage in the unfolding cycle of transcendentalization. Marx, of course, is associated with the quintessential de-transcendentalizing gesture, with his famous call for philosophers to move from a merely "contemplative" relationship to the world to a transformative one. Feuerbach's analysis of our tendency to repress our consciousness of human agency and project it instead onto an external deity ("in God man confronts his own activity as an object") becomes the Marxist image of the proletariat finally overcoming its subordination to the bourgeoisie and claiming its own revolutionary potential.[17] The proletariat as a class, moreover, becomes the crucible in which the subjective and objective, the particular and the universal, are reconciled ("I am nothing but I must be everything," as Marx wrote in his *Critique of Hegel's Philosophy of Right*).[18] When it finally achieves full awareness of its immanent destiny, it will be transformed, chrysalis-like, into a new universal class that will forever banish all forms of intersubjective violence in the utopic state of full Communism. Marxism will also reproduce certain underlying tensions evident in Hegel's thought around agency and consciousness. Notwithstanding its unique world-historical mission, in Marx's time the proletariat had not yet attained

full self-reflective awareness and thus required a custodial agent, drawn from advanced elements within the bourgeois intelligentsia, that could rouse it "from its dream of itself." It is symptomatic, then, that the ability to link contemplative insight with political action, which Marx identifies in the "Theses on Feuerbach," is specifically associated with *philosophers*, not with the actual historical agents of the revolutionary change he hopes to precipitate.

This tension around the generation of revolutionary insight is a paradigmatic feature of the Marxist tradition. Habermas examines what he terms "the vindicating superiority of those who do the enlightening over those who are to be enlightened" in his 1971 book *Theory and Practice*.[19] In the introduction, he focuses on György Lukács's analysis of the vanguard party. In this account, only the party, through its mastery of advanced Marxist theory, is able to fully transcend the epiphenomenal conditions of political struggle and grasp the totality of forces underlying the current historical moment. As a result, its judgments about the conduct of resistance are beyond question. Theory, as Habermas writes, comes to possess an "unassailable objective authority."[20] For Lukács, the party (and, in particular, the party leadership composed of "professional revolutionaries") takes on the synthesizing function previously assigned to language and labor in the Hegelian tradition. In this view, the party is the necessary "form of mediation between theory and praxis," and as such no "theoretical deviation" from its specific outlook can be tolerated.[21]

The justification for this unyielding monological authority will, by now, be familiar to us. As Habermas notes, "Like Lenin, Lukács is convinced that the proletariat is still powerfully ensnared in the forms of thinking and feeling of capitalism, that the subjective development lags behind the economic crises."[22] As a result, as Habermas contends, "The Party as the embodiment of class consciousness must act representatively for the masses, and not allow itself to be made dependent on their spontaneity. . . . In the Party the still backward class may see a consciousness, anticipated but as yet inaccessible to it, at least as a fetish."[23] Like the vision of a utopic aesthetic state prefigured in our experience of beauty, the party, as Lukács writes, allows the proletariat to "perceive its own class consciousness as a historical figure."[24] In Hegelian terms, we might say that the party provides the proletariat with an objectivized expression of its own as-yet-unrealized agency.

For Lukács, the party functions to generate, preserve, and propagate a form of transcendent (revolutionary) insight that originates solely from within the reflective theoretical intelligence of the party leadership. As

a result, the theory itself is effectively "withdrawn from confirmation by the agreement of those whom it is to aid in the attainment of self-reflection," as Habermas observes.[25] If the consciousness of the proletariat is, in fact, fatally constrained by the ideological domination of the capitalist system, then its consent regarding theoretical questions is a matter of indifference from the perspective of the party's intelligentsia. It is not for "overburdened" workers to form opinions regarding theoretical matters that they are manifestly unprepared to grasp, at least until they have finally achieved full class consciousness. Here, again, "practice" refers to the tactical and strategic steps necessary to bring theoretical insights into existence. This does not mean that the theorist does not also learn *from* praxis, but the ultimate point of arbitration for these insights remains the theorist's own reflective consciousness. Lenin will certainly analyze political action in order to adjust or refine his strategic analysis of a given nexus of forces, but not because any form of knowledge thus acquired will fundamentally alter either the broader teleological orientation of his theory or his conviction in the explicit superiority of his own contemplative insights.

Beginning in the 1960s and 1970s, second-generation Frankfurt School thinkers like Habermas and Albrecht Wellmer, along with a third generation associated with Honneth and Joas, sought to come to terms with the impasses left in place by Adorno and Horkheimer in their later writing. In particular, they sought to challenge the increasingly bleak view of the potential for meaningful change that is evident in works such as *Dialectic of Enlightenment* and *Negative Dialectics* and the corollary decision to uncouple critical theory from any reciprocal relationship with ongoing forms of social or political resistance. At the same time, Habermas identified an underlying tension in the position taken up by Adorno and Horkheimer as intellectuals who insisted on the absolute necessity of critical self-reflection for all other disciplines but who seemed unable to apply this same self-reflexive rigor to their own theoretical production. For this reason, we find Habermas and Honneth exploring both the constraints and the potentials of earlier iterations of Frankfurt School critical theory.[26] Although seldom referenced in contemporary art theory, their attempts to come to terms with this legacy are highly suggestive for a discussion of socially engaged art. There is, in fact, a productive convergence between the critique of vanguard transcendentalism that evolves out of the post-1960s Frankfurt School and the parallel emergence in artistic practice of a practical critique of certain forms of conventional avant-garde artistic production.

For both Habermas and Honneth, the salvaging of an operational form of critical theory began with their effort to recover the "repressed intersubjectivity" of the Hegelian and Marxist traditions.[27] They did so through a reinterpretation of the Marxist concept of social labor, which is founded in turn on Hegel's presentation of labor as one of the essential mediating processes through which (dialogical) subjectivity is produced. Social labor (*Gesellschaftliche Arbeit*) is a complex and multivalent concept in Marx, referring to both the physical modes of collective (material) production characteristic of a given historical period and the affiliated forms of social, cultural, or collective interaction and discursive production necessary to sustain, legitimate, and potentially transform it. Social labor is thus a realm of both instrumentalization (of labor at the hands of capital) and incipient agency (through our shared consciousness of workplace oppression and in the collective forms of resistance that result from this consciousness). The "social" nature of labor is, precisely, antithetical to the privatized notion of labor prevalent in bourgeois thought. It implies that wealth derives not from the efforts of a small number of protean industrialists but, rather, from the vast collective capacities of the proletariat on whom they actually depend.[28] The concept of social labor, for Habermas and Honneth, provides an opening within the Marxist tradition to account for the varying forms of critical agency and prefigurative expression made available by the social interactions that ground collective action and resistance. Its foregrounding in their work signals a desire to learn from and through praxis and to account for its unique epistemological qualities. In this respect, it can be seen as a response to the devaluing of praxis in first-generation Frankfurt School thought.

The emancipatory potential of labor is a central theme in Marx's early writings. For Marx, labor entails more than the simple appropriation of nature; it carries a cognitive and pedagogical significance as well. In Marx, as Honneth writes, "the active processing of nature by corporeal subjects may be understood both economically, as a factor of production, and morally, as a process of intellectual self-development."[29] Habermas remarks on the crucial mediating role of labor, as the act of transforming a resistant natural world "allows for the synthesis of subject and object, freedom and constraint, necessary to enable the dialectical unfolding of the self.[30] As Marx writes in the *Economic and Philosophic Manuscripts*, "The object of labor is, therefore, the *objectification of man's species life*; for he duplicates himself not only, as in consciousness, intellectually, but also actively, in reality, and therefore he contemplates himself in a world that he has created."[31] In this manner, externalized labor becomes the process by which

critical self-reflection, previously contained within the internal, "mentalist" consciousness of the Kantian self, is generated. In fact, our authentic labor, undefiled by capitalism, is endowed with a decidedly aesthetic quality. In his "Fragment on James Mill," Marx offers a compelling account of "production" as it would be carried out within a truly free society.

> Let us suppose that we had carried out production as human beings. Each of us would have in two ways affirmed himself and the other person. In my production I would have objectified my individuality, its specific character, and therefore enjoyed not only an individual manifestation of my life during the activity, but also when looking at the object I would have the individual pleasure of knowing my personality to be objective, visible to the senses and hence a power beyond all doubt. In your enjoyment or use of my product I would have the direct enjoyment both of being conscious of having satisfied a human need by my work, that is, of having objectified man's essential nature, and of having thus created an object corresponding to the need of another man's essential nature. I would have been for you the mediator between you and the species, and therefore would become recognized and felt by you yourself as a completion of your own essential nature and as a necessary part of yourself, and consequently would know myself to be confirmed both in your thought and your love.[32]

Here the fundamentally aesthetic qualities of labor are clear, as production becomes the "mediator" that allows for a dialogical reconciliation in which each self is able to "complete" its "essential nature" in and through the other. In this relationship, each self remains free without, at the same time, seeking to instrumentalize the other or withdraw into monadic isolation. Thus, even as they remain entirely autonomous or self-governing, they are also able to enter into mutually affirming social relationships through the articulation of their respective selfhoods in the production and consumption of objects. Here, labor assumes its utopic "social" capacity, in which reciprocal exchange between self and other overcomes the "abstract" and dehumanizing relationships produced by the mediation of capitalist exchange. In this process, the respective "products" of our labor become "so many mirrors in which we saw reflected our essential nature."[33]

Social labor, in this formulation, demonstrates the implicit aesthetic-critical potential imbedded in the Marxist tradition before that potential was extracted from concrete forms of intersubjective exchange and transcendentalized. As Marx makes clear, this process exhibits both prefigurative and

politically transformative qualities.³⁴ Thus, if labor allows the individual subject to gain an authentic selfhood and access a harmonious "community," it also helps the proletariat as a whole achieve its own sense of legitimacy and self-identity as a class. This occurs as the capitalist system concentrates large numbers of workers in factories and teaches them to work with a collective discipline while simultaneously subjecting them to a common form of exploitation that draws them together in solidarity. In the *Economic and Philosophic Manuscripts*, Marx famously praises worker's associations on similar grounds. "When communist artisans form associations, teaching and propaganda are their first aims. But their association itself creates a new need—the need for society—and what appeared to be a means has become an end. . . . Smoking, eating and drinking are no longer simply means of bring people together. Society, association, entertainment which also has society as its aim, is sufficient for them; the brotherhood of man is no empty phrase but a reality, and the nobility of man shines forth upon us from their toil-worn bodies."³⁵ Theorist Shlomo Avineri captures the crucial, prefigurative capacity of these assemblies, arguing that, for Marx, "the act and process of association, by changing the worker and his world, offer a glimpse into future society."³⁶

As this outline suggests, Marx's concept of labor is characterized by a tripartite structure. It is the crucible in which an authentic, autonomous self can be forged, the foundation for (or anticipation of) a utopic form of community and social interaction, and the catalyst for a critical class consciousness. At the same time, labor as a historically specific form of production was becoming increasingly rationalized under the system of modern capitalism. The artisanal model of labor as a space of self-actualization was rapidly being eclipsed in Marx's lifetime by forms of industrial production that reduced work to "merely burdensome toil and stressful effort."³⁷ But in that case, there is nothing left of the consciousness-transforming experience of labor that would allow the individual proletarian to undergo the kind of ontic transubstantiation necessary to give birth to an entirely new human subject, capable of finally resolving the world-historical progression of class difference. There is, of course, the crucial sense of solidarity that arises from the collective experience of capitalist oppression, but it has limited value as a form of what Honneth terms "intellectual self-development."³⁸ Certainly the experience of shared oppression can lead the proletariat to become a class "for itself," as Marx famously observed. But this refers primarily to the working class recognizing its collective interest in uniting to defend its interests, a form of emancipatory insight that would accrue to any form of

collectively experienced repression. From the perspective of the vanguard party, this insight is of importance primarily as a motivational force. It releases a class hatred that can be harnessed by the intellectual leadership of the vanguard party to realize its theoretically determined goals, but it has little epistemological value that would allow the proletariat as such to generate meaningful theoretical insight of its own.

This historical shift is reflected in a transition in Marx's later work toward a more functionalist account of labor. As Honneth writes, "the underlying conceptual tension within which the young Marx attempted to interpret social labor as a practical and moral learning process . . . lost all of its original clarity with the universalization of mechanized work."[39] While social labor, the intersubjective processes of collective work, and the mediating operations of cultural discourse are central features of the *Economic and Philosophic Manuscripts*, *The German Ideology*, and Marx's historical studies (*The Civil War in France*, *The 18th Brumaire*, etc.), they are increasingly deemphasized in his later economic works (*Capital*, *Grundrisse*, etc.), which tend to collapse social labor into instrumentalized labor per se. As a result, the positive forms of self-transformation and prefigurative expression that are generated by the proletariat's experience of labor are deemphasized at the analytic level, and social labor in general (both the physical experience of collective labor and the affiliated forms of cultural interaction and expression that sustain it) loses much of its transformative potential. Both Habermas and Honneth point to the correspondence between Marx's reduction of work to pure instrumentalization and his increasingly deterministic account of the evolution of capitalism itself as the locus of potential revolutionary change is shifted from the consciousness of workers to the inexorable historical unfolding of capitalism's immanent logic. Thus, the "social antagonisms" of capitalist production are interpreted in *Capital* as "laws" that work "with iron necessity towards inevitable results" (increasing oppression and economic suffering, leading to the final collapse of capitalism itself).[40] And in the *Communist Manifesto*, the end of capitalism and the "victory of the proletariat are equally inevitable."[41] Here capitalism takes on a decidedly Geist-like quality as it proceeds inexorably toward its violent demise, regardless of conscious human agency.[42] As a result of this shift, the "'action-theoretic' aspect of Marx's theory of emancipation," as Jean-Philippe Deranty writes, "tends to recede into the background. In *Capital*, the dominant argument is that of the self-induced, systemic crises of capitalism, not that of class struggle."[43]

By the time that the second generation of Frankfurt School theorists came of age during the 1970s, the belief that capitalism was in imminent danger of

collapsing under the weight of its own internal contradictions was increasingly difficult to sustain. It was also evident that capitalism has been able to maintain its hegemony not merely through forms of direct coercion but far more successfully through efforts to legitimate its values ideologically and culturally.[44] Whereas Adorno took from this fact the belief that any practical resistance to this system was self-evidently futile, Habermas, Honneth, and others took it as a call for theoreticians to examine more closely the modes of existing intersubjective experience, communication, and value formation that can most effectively challenge this legitimizing process (drawing on their analysis of new social movements that emerged during the 1960s and 1970s). This shift in the discursive structure of political resistance is evident across a broad range of contexts and practices. The anticolonial movement is of particular importance here. Long before the 1960s, it exhibited a fundamental awareness of the essential role played by culture as a site of both repression and contestation, since the colonial enterprise itself was founded on an intensive process of cultural erasure, extending to the denial of the personhood of the enslaved or colonized subject. This is evident in such bellwether works as C. L. R. James's *The Black Jacobins*, which features an incisive analysis of the role of cultural resistance in the Haitian Revolution. There is also a strong current of skepticism within the anticolonial movement regarding the conventional hierarchies of the vanguard party. Thus James, in a book he coauthored with Cornelius Castoriadis and Grace Lee in 1958, warns that the "philosophy of the Party is the philosophy of the organized elite ... the organizing intellect." "Its conception of the masses of the people," he continues, "is that they are the means by whose labor and sacrifice are to be achieved ends which only the elite can visualize clearly."[45] James argues instead for a form of critical theory that evolves out of and in conjunction with praxis rather than administering it from above.[46]

We find a similar sentiment in Fanon, who observes in *The Wretched of the Earth* that "each generation must discover its mission, fulfil it or betray it, in relative opacity."[47] Against the grain of the omniscience of the vanguard party, Fanon captures the necessarily improvisational and extemporaneous qualities of resistance, the aggregative logic of experience, the unexpected detours and breakthroughs that only occur by heeding the wisdom of praxis in its continual unfolding. We find a practical demonstration of this shift in the work of Guyanese historian Walter Rodney, who developed a form of reciprocal learning through his notion of "grounding" intellectual production in the lives of the Jamaican working class.

> I have spoken in what people call "dungle," rubbish dumps, for that is where people live in Jamaica. . . . I have sat on a little oil drum, rusty, and in the midst of garbage and some Black Brothers and I have grounded together . . . we spoke about a lot of things and it was just the talking that was important, the meeting of black people. I was trying to contribute my experience in travelling, in reading, my analysis, and I was also gaining . . . Because I learnt. I got knowledge from them, real knowledge. . . . The system says they have nothing, they are illiterate, they are the dark people of Jamaica. . . . But you learn humility after you get into contact with these brothers.[48]

Rodney's cultural pedagogy exhibits significant parallels with the roughly contemporaneous work of Paolo Freire in Brazil. As I noted above, this is simply one facet of a much larger reconfiguration of political imaginaries that occurred during the 1960s and 1970s. These traditions will provide an important foundation for the reemergence of new modes of resistance during the post-1989 period (marked by the dissolution of Soviet Communism and the evolution of China into an authoritarian state capitalist system). This period has witnessed a widespread exploration, both theoretical and practical, of alternative modes of social and political resistance and organization, acted out in Chiapas, Tahrir Square, Tehran, Wall Street, Buenos Aires, and many other places. None of these events resembles the popular image of a communist revolution, but all of them hold crucial lessons for us in devising forms of political transformation that are appropriate to our own era.

Labor, Language, and Mediation

For figures such as Honneth and Habermas, the turn toward "social labor" can be understood as an attempt to return to the question of agency and political transformation that had receded to the margins in Adorno's work and in the more deterministic models of Marxism that emerged following the Second International. It was in this context that Habermas hoped to reclaim communicative action from the repertoire of social labor, as the medium through which collective resistance to domination might be more clearly understood. In the process, Habermas sought to renew, once again, the gesture of de-transcendentalization by bringing theoretical attention to the creative process by which human agents consciously negotiate the creation of new norms and values in opposition to the "systematically distorted communication" that is a central feature of capitalist domination.[49]

Habermas will focus, in particular, on the role of language as a mechanism that can mediate the relationship between self and other. This entails a shift from the mentalist (Kantian) paradigm that identifies the decisive locus of generative insight in the individual consciousness to the externalized "media" of language.[50] In the two-volume study *Theory of Communicative Action*, Habermas develops his well-known account of "communicative action," in which individual subjects work together toward a common goal. Habermas contrasts this "strong communicative action" with "strategic action," which entails a form of interaction in which each agent seeks only to optimize their interests. Here mutual understanding is relevant only to the extent that it can be used to anticipate the other agent's actions, thereby optimizing a given subject's self-interested ends. In communicative action, on the other hand, the process of intersubjective exchange is anchored in a shared commitment to a given task. Insight is produced in consciousness-oriented theoretical paradigms through the individual self's reflective awareness of their own internal cognitive processes. The other exists only as a residual trace left in the indirectly social constitution of the concepts on which cognition depends. In communicative action, on the other hand, we are called upon to engage with a concrete interlocutor and to reciprocally tailor our communications to that interlocutor in pursuit a larger shared project. "The essential presupposition of a successful speech act," as Habermas observes, "is that the speaker enter into a specific engagement, so that the hearer can rely on him . . . to prove trustworthy, to show in the consequences of his action that he has expressed just the intention which actually guides his behavior."[51] Habermas seeks to identify a human disposition to intersubjective trust embedded in the normative protocols of language itself.

The assumption here is not that every form of pragmatic intersubjective exchange should result in a universally valid consensus, only that the possibility of a provisional consensus inevitably forms the teleological horizon of these exchanges, which are oriented toward an "intersubjective communality of mutual comprehension, shared knowledge, reciprocal trust and accord with one another."[52] In fact, what is important here is not whether a given collective project results in actual agreement or even practical success but, rather, the calling into existence of a human capacity for reciprocal openness that occurs as a result of these interactive engagements. Here the (noninstrumentalizing) reconciliation of self and other that, in a consciousness-oriented paradigm, is acted out monologically in the individual aesthetic encounter is instead performed through the messy, indeterminate process of actual intersubjective exchange. A second and related feature of communicative action is that it

suggests a model of practice that has pragmatic, socially emancipatory effects (evident in Habermas and Honneth's research into contemporary social movements) while also exercising a transformative effect on the subjectivity of the individuals involved, who find their own sense of self altered by these interactions. Thus, in the process of communication, individuals not only express their own views and beliefs regarding the matter at hand, they also learn to imaginatively inhabit the consciousness and subjectivity of their interlocutory partners. They do so not in order to gain a tactical advantage but in order to optimize the completion of a shared project. This suggests, at least at a provisional level, a very different understanding of the self, one that harkens back to Hegel's original de-transcendentalizing model of the self, called into existence by the other.

Here I want to summarize three of the positive features of Habermas's "communicative action" paradigm that have particular relevance for the analysis of socially engaged art. First, as outlined above, it suggests a model of the self brought into existence by dialogical exchange. In the transcendentalist paradigm that Habermas sought to challenge, the decisive form of consciousness transformation occurs through introspection, after which the transformed self can enter into subsequent social interactions in a more enlightened state. In the case of communicative action, the self is understood, at least potentially, to be transformed by the experience of sociolinguistic interaction. Second, communicative action provides a model of knowledge production that challenges the primacy of monadic self-reflection. In particular, it suggests that concrete, intersubjective encounters have the capacity to produce meaningful insight of their own into the social world as well as the constitution of the self. This stands in contrast to the transcendentalist epistemology, which locates the decisive source of generative insight in forms of reflection that are housed in "objective" forms (Geist for Hegel, the party for Lenin, etc.) that remain immune to external determination or reciprocal influence. And third, communicative action provides a model of non-transcendental consensus that remains only provisionally binding and that is always subject to subsequent revision and reconsideration. Moreover, it is a model of consensus that exists in a dialectical relationship with ongoing moments of dissensus and disruption through the course of a given project or action. This stands in contrast to a mentalist paradigm that can understand noninstrumentalizing sociality only as a fixed and finalized state, perpetually deferred to a utopic future (full Communism, the aesthetic state).

Each of these features has significant implications for our understanding of socially engaged art projects, which typically unfold through extended

collaborative interactions, staged in relationship to concrete forms of resistance, and which are characterized by fluctuating moments of both consensus and dissensus. At the same time, there are other aspects of Habermas's model that remain problematic for our understanding of this work. There are three issues in particular that I want to note here. First, there remains an underlying tension around the ontological model on which "communicative action" is based. On the one hand, Habermas suggests a notion of the self that is open to external determination via the transformative presence of the other. At the same time, he often presents communicative action through an agonistic paradigm of competing viewpoints among various contending agents. Here one of the agent's "wins" when the superiority of their argument compels the assent of the others. This suggests a vision of the self as a logical-expressive nexus, forming a priori opinions that are then introduced into the contentious sphere of public debate to gain or lose the agreement of other equally expressive selves. While this is entirely accurate as an account of certain forms of deliberative social interaction, this presentation is inconsistent with a model of intersubjective experience that entails a more malleable notion of the self. In Habermas's account, the only thing that allows for the non-instrumentalizing relationship of self to other is their mutual commitment to an existing, practical task that orients and determines their interaction. But this pragmatic model diminishes the importance of the prefigurative dimension of intersubjective exchange, which can transcend a practical or pragmatic orientation. It is precisely this prefigurative intersubjective experience that places us in contact with a mode of being together that is dependent on neither a common, external enemy nor a shared, pragmatic task. This dimension of non-pragmatic intersubjective experience (entailing the potential of a more profound reorientation of the self and self-consciousness) is a feature of a number of socially engaged art practices, either in conjunction with other experiential modes or as the central component.[53]

In a related manner, Habermas's notion of "communicative action" requires the speaker to "to show in the consequences of his action that he has expressed just the intention which actually guides his behavior."[54] But this assumes a continuity, transparency, and identity between thought and action and a consequent subordination of action to the generative primacy of an original intentional thought that is problematic for our understanding of socially engaged art projects. In many cases, these projects seek to foreground the agency of action itself (as well as its unanticipated effects) and, by extension, to deconstruct the opposition between (internal) thought

and (external) action. This is paralleled by a tendency, noted by Michael Theunissen, for Habermas's model of communicative action to lead to an inadvertent process of re-transcendentalization, in which the normative structures of language itself, rather than the action-oriented exchanges of human subjects, carry the primary generative agency.[55] Here praxis is simply the acting out of a set of emancipatory norms associated with the potential reconciliation of self and other that are sedimented in the pre-conscious horizons of language itself. In this account, praxis becomes a purely instrumental undertaking, only preserving a prefigurative dimension through its dependence on a set of transcendental values (carried in the epistemological structure of language) of which the actual participants remain unaware. This implicit re-transcendentalization can also have the effect of minimizing the ways in which these same normative values (intersubjective harmony and a noninstrumentalizing consensus) can be claimed by a given hegemonic system in order to immunize itself from critique (a variation of the exculpatory critique, evoked by Mouffe). As a result, we can lose sight of the fact that, in many cases, these values are only tolerated to the extent that they pose no threat to the underlying forms of economic and political domination on which this system depends. In addition, Habermas's model of communicative action can lead to the privileging of linguistic expression specifically over other forms of embodied or somatic communication, which are equally central to socially engaged practice (for example, the physical action of flag washing in the *Lava la Bandera* performances).

Third and finally, Habermas's bifurcation between strategic and communicative action can make it difficult for us to grasp the necessary, dialectical connection between these two modes of action, as they interrelate in socially engaged art practice and political resistance more generally. Thus, a strategic or instrumental action, defined by the ability to materially alter specific social or political structures, can also have transformative effects on the intersubjective and prefigurative experiences of the social actors involved (in the same way that physical, objectival labor does for Marx). Or, put differently, the outer-directed component of praxis (which requires taking up an instrumental or openly antagonistic relationship to the agents or institutional structures acting to reinforce particular forms of domination) can have a reciprocal and generative effect on the inner-directed (cognitive) processes of a given collective (producing changes in consciousness, an enhanced sense of agency and solidarity, proto-theoretical insight, etc.). As in the case of the escraches discussed earlier, a given project can incorporate moments of both strategic/instrumental action and communicative/expressive

action. In this manner, the theory of communicative action can have the effect of normalizing a deliberative, quasi-parliamentary approach to social and political change that is abstracted from the broader range of tactics by which change has been historically produced. This is, in fact, the essence of Axel Honneth's critique of Habermas, developed through his concept of "recognition." Honneth's target here is the potential depoliticization of communicative interaction that occurs in Habermas's account, which portrays a set of essentially equal subjects contending in an open and nonhierarchical public space and in which none of the forms of systemic inequality that characterize life outside that sphere are able to intrude.[56]

Honneth turns to the concept of recognition (drawn from Hegel) to argue that communicative action is always already deformed by systemic inequalities that affect the capacity of specific agents to have their public claims respected and to have their very personhood recognized by the larger society. Examples would include protests against Jim Crow laws during the civil rights struggles of the 1950s and 1960s, African American communities demanding to be treated with equal respect as white Americans by the police, queer or trans people seeking the right to marry or adopt, and so on. In a 2001 essay, Honneth cites Ralph Ellison's *Invisible Man* as an exemplary expression of this political dynamic (the withholding or bestowal of recognition as an index of political repression). Thus, Ellison's narrator writes of the white self who refuses to acknowledge the very existence of the black subject ("one looks straight through him; he is quite simply invisible").[57] Rather than a physical disability, this selective blindness is the result of "an inner disposition that does not allow them to see his true person."[58] It is precisely through the process of "recognizing" the other, through gesture and facial expression, as Honneth writes, that we "demonstrate to one another in general a motivational readiness to be guided in our actions by the moral authority of the other person."[59] And it is precisely by withholding that recognition, by refusing to see the other or simply reducing the lived complexity of the other's personhood to stereotype, that we justify our refusal to allow our own actions or sense of self to be reciprocally informed by their personhood. Recognition thus entails a willingness to open the boundaries of the autonomous self and a form of mediation between self and other that operates through both bodily and cognitive registers.

If domination can be imposed at the level of intersubjective exchange, then it can also be contested there. Here Honneth points to the integral connection between the practical task of social transformation and the new forms of being and prefigurative expression that are generated in its wake.

> The collective resistance stemming from the socially critical interpretation of commonly shared feelings of being disrespected is not solely a practical instrument.... For the victims of disrespect engaging in political action also has the direct function of tearing them out of the crippling situation of passively endured humiliation and helping them, in turn, on their way to a new, positive relation-to-self... through involvement in collective resistance, individuals uncover a form of expression with which they can indirectly convince themselves of their moral or social worth.[60]

For this reason, Honneth argues that it is essential to ground processes of communicative action in specific sites of injustice and resistance in order to fully realize its promise. For Marx, social labor was always a component of actual work. In developing his own theoretical paradigm, Habermas uncouples communicative action from labor per se (which constitutes an entirely instrumentalized realm in his account). The result, according to Honneth, is to effectively abandon labor as a meaningful site of praxis. While work may well be increasingly instrumentalized, it still functions as a significant space in which capitalist domination is experienced both physically and cognitively and a space in which meaningful resistance might be cultivated as a result. "Habermas completely dissolves the categorical connection which Marx attempts to establish between social labor and social liberation," as Honneth argues, "for him, the self-development of social revolutionary consciousness follows a logic of action fundamentally different from that of the social processing of nature."[61] As a result, Habermas's reduction of social labor to a proceduralist form of communicative action threatens, in Honneth's words, to "eliminate those forms of resistance and emancipation which are rooted in the structure of the capitalistic work process itself."[62] For Honneth, it is precisely in the space of work that the disjunction between the ideal of a consensual model of democratic will formation and its systematic denial can most directly be recognized and challenged. I would argue here that it is necessary for us to further expand our understanding of social labor, beyond either the workplace or the normative political institutions identified by Habermas, to encompass sites of resistance and antagonism that operate throughout the lifeworld of capitalism.

While Honneth's recognition theory can help us recognize some of the constraints of the original communicative action paradigm it also carries its own liabilities.[63] In particular, it tends to elide those forms of civil and political conflict that operate outside the framework of recognition per se. Just as Habermas can be accused of normalizing a particular model of

resistance or opposition (defined in terms of conventional deliberative democracy), so Honneth's approach is less useful in describing those forms of resistance that demand more than simple recognition from hegemonic forms of power. The paradigm of recognition still implies an essentially conciliatory relationship to repressive systems, in which the oppressed subject petitions those in a dominant position of power to acknowledge their rights and personhood. Or, we might say, it seeks to produce a relationship of mutual respect that has remained unrealized due to the inattention or self-interest of the dominant party. Thus, Honneth bases his concept of recognition on an underlying principle of reciprocity, "in which the individual learns to see himself from the perspective of his [or her] partner in interaction as a bearer of equal rights."[64] This approach suffers from two related drawbacks. First, the simple demand for equality is seldom sufficient to actually produce decisive change. Thus, a recognition-based paradigm assumes a singularly accommodating and responsive form of domination. In fact, the demand for recognition must often be coupled with forms of civil disobedience and even open insurrection. In many cases (colonialism, for example), the refusal to acknowledge the fundamental humanity of certain subjects is part of a conscious and deliberate practice of domination and social control. Here resistance does not simply require the assent or voluntary cooperation of those in a position of power; rather, it seeks to destroy the authority they have to give or withhold recognition in the first place by overturning the system on which this authority depends.

The Epistemology of Praxis

As the preceding discussion suggests, the concept of social labor provides an important resource for developing a revised model of the aesthetic, capable of grasping the distinctive nature of contemporary socially engaged art. Its relevance here is not entirely surprising. Social labor, in its concern with prefigurative forms of collective interaction, represents the latent aesthetic potential at the heart of the Marxist tradition. The discourse of Marxism and the aesthetic emerge out of a similar set of historical and philosophical coordinates, associated with the recognition of both the unprecedented emancipatory potential and the unprecedented capacity for instrumentalization that reside at the core of modernity. This is why the telos of both traditions (the aesthetic state and full Communism) are so closely related. Each evokes a world, as Antonio Gramsci wrote, "in which the individual can govern himself without his self-government entering into conflict with political

society... but rather becoming its organic compliment."[65] This is also why it comes so naturally to figures working in the avant-garde tradition (from Adorno to the proponents of a current "neo-avant-garde" revival) to identify the avant-garde as the carrier of a unique revolutionary potential. What we identify as the "aesthetic" in the avant-garde tradition is more accurately understood as a fragment of a previously whole concept of revolution, now segregated between an instrumental/strategic component (in Leninism) and a prefigurative/critical component (in Adorno). Here praxis and prefigurative insight are held apart, with the avant-garde imagining itself as the essential but temporarily exiled aesthetic core of the Marxist enterprise. In this view, we can understand socially engaged art practices as seeking to recover the aesthetic and prefigurative qualities of intersubjective exchange evident in Marx's initial formulation of social labor, holding them in dialectical tension with strategic forms of social or political action. In this way, prefigurative experience, no longer sequestered in the monadic consciousness of the artist or the recursive insularity of art-institutional auto-critique, is able to resist its reduction to a purely affirmative gesture and avoid or at least diminish the exculpatory recapture of capitalist domination.

Here we have the theoretical framework for a materialist concept of the aesthetic that returns to the central motifs of the Enlightenment aesthetic (the emancipatory relationship of self to other, the facilitation of counter-normative insight, the generative potential of somatic as well as cognitive experience) while linking them dialogically with processes of social and political resistance by which these utopic qualities might be practically realized. This would entail neither a perpetually arrested gesture of symbolic negation (standing in for a currently foreclosed praxis) nor premature desublimation (realized in depoliticized gestures of community or participation that maintain their utopic aura by excising the "thorn of alterity" constituted around differences of class, race, gender, and so on). Rather, it would involve the dialectical interrelationship between both (critical) negation and dissensus and (prefigurative) reconciliation and consensus within a single mode of praxis. It is not sufficient, however, to merely carry Marx's existing concept of social labor forward to the present moment. Rather, as Habermas and Honneth demonstrate, it is necessary to reconsider the ontological paradigm on which the concept of social labor is based. Habermas and Honneth, each in their way, help us identify a key point of tension in this paradigm, elaborated along two parallel tracks. In Marx's early (quasi-anthropological) writings on mankind's "species being," the self is defined against a resistant external nature from which survival must be won. Thus,

the emancipatory, self-actualizing effect of labor (on the consciousness of the worker) is brought about by the experience of appropriating, transforming, and mastering a recalcitrant natural world. And in Marx's historical analysis of capitalism, the proletariat is also defined in opposition to an external other (the bourgeoisie), whose own being and consciousness are seen as expendable. Thus, the identity of the proletariat, the experience that allows it to move (transcendentally) from a class in itself to a class for itself, originates with its shared or collective antagonism against an oppressive external force (embodied by the bourgeoisie), which must be overcome and destroyed in order to attain subjective freedom. In each case, we encounter an appeal to a conventionally autonomous notion of the self. As Marx writes in the *Economic and Philosophic Manuscripts*:

> A *being* only considers himself independent when he stands on his own feet; and he only stands on his own feet when he owes his existence to himself. A man who lives by the grace of another regards himself as a dependent being. But I live completely by the grace of another if I owe him not only the maintenance of my life, but if he has, moreover, created my life—if he is the source of life. When it is not of my own creation, my life has necessarily a source of this kind outside of it.[66]

Rather than a paradigm involving the reciprocal constitution of selfhood, we have instead a rejection of interdependence on behalf of an absolute subjective autonomy. As Baudrillard wrote, Marx offers us an "ideal of freedom and of disposability... of the achievement of a subject... that would not contradict bourgeois, liberal thought in its better moments."[67] Thus, to have the "source" of one's life "outside" the enclosed boundaries of the self is to be a dependent, inauthentic self. In neither case (in Marx's presentation of the specific subjectivity of the proletariat or the generic subjectivity of our species being) is there a model of the self that is not produced against the grain of an antagonistic other (or natural world), whose own selfhood or subjective integrity is entirely inconsequential.

At the same time, this experience of autonomous self-determination is also understood in the Marxist tradition as the catalyst for an entirely new form of identity (the proletariat as a "universal class") that would transcend humankind's habitual reliance on intersubjective violence and objectification (this is its aesthetic dimension). Thus, the ontological foundation out of which this utterly new and socially harmonious self will be born depends precisely on the act of taking up an instrumentalizing relationship to the

world. We need only liberate this tendency from the shackles of capitalism, in which the spoils of instrumentalizing labor are stolen by the bourgeoisie. Certainly, Marx would argue that this mode of self-actualization should be restricted to our interactions with the natural world, but the history of our "species being" is replete with examples of this same instrumentalizing drive extending to our relationship to other human selves and entire cultures. Marx would assume, of course, that once capitalism is vanquished and human nature irrevocably altered in the process, it would be a simple matter for humanity to again recover a natural equilibrium in its instrumentalizing drive, applying it only to the natural world (a position that is itself problematic). There is, however, little in the ensemble of revolutionary methods (the tactics and procedures outlined most fully in the Marxist tradition by Lenin) that would necessarily have the effect of cultivating a sense of selfhood in which external determination or reciprocal interdependence would be seen as an integral part of subjectivity rather than a threat to revolutionary purity. For Lenin, revolution was an entirely instrumental, even mercenary affair. Lenin had no time for softhearted concerns over egalitarian forms of decision-making, even long after the revolution had successfully overthrown the remnants of the Tsarist forces. There was always the danger of further counterrevolutionary tendencies to be rooted out, which excused the perpetual extension of revolutionary "terror" and the ongoing refusal to allow democratic freedoms to the Russian people.[68] We encounter here, then, a symptomatic tension, as a conventionally autonomous, even defensive, form of identity (free from all external determination) persists at the very center of the Marxist concept of the self. Why do we assume that a mode of selfhood formed through the externalization of an (ostensibly) immanent instrumentalizing drive would necessarily encourage the emergence of the kind of receptive selfhood and noninstrumentalizing social interaction that is the destiny of life under "full Communism"? A community, as Marx writes in *The German Ideology*, in which "individuals obtain their freedom in and through their associations"?[69]

This tension is also evident in the prefigurative structure of both the Marxist and aesthetic traditions. Each theoretical paradigm is oriented around a teleological endpoint toward which all previous thought and action have been directed. This endpoint, whether taking the form of the aesthetic state or full Communism, is consistently defined in terms of a fundamental reordering of human consciousness that would allow us to produce, for the first time, a genuinely free society. In this final stage of human cognitive development, each individual would remain entirely autonomous and free

from external determination (e.g., the imposition of coercive societal norms) while at the same time enjoying a form of nonhierarchical communion in which they could fulfill their own selfhood through a reciprocal openness to others. In such a society, the conventional normative and policing institutions of the state would no longer be required to maintain social harmony. Rather, this harmony would result naturally from the releasing of an innate but heretofore repressed capacity for love and altruistic care. In both the Marxist and aesthetic tradition, this moment clearly carries utopic, even eschatological associations. In this sense, it is understood as marking a terminus, an achieved and essentially static condition of evolved human ontology after which it will no longer be necessary for humanity to engineer complex forms of social mediation (the monarch, the king, conventional laws or norms, or even formal democratic processes) to regulate human intersubjective exchange.

However, both the Marxist and the aesthetic traditions are characterized by an underlying ambiguity about the process of realizing this ideal social condition. This is apparent in the concept of premature desublimation. Here we require a more precise understanding of premature or "repressive" desublimation (to use Herbert Marcuse's term). First, it entails the attempt to actualize *elements* of this utopic end-state via an experimental engagement with new modes of sociality in artistic practices that may or may not be concerned with broader societal transformation and in a manner that potentially anticipates the forms of social coexistence that might follow after a revolution. And second, it can involve attempts to bring this end-state into practical, universal existence in an ostensibly nonrevolutionary moment through a process that may incorporate elements of altruism or noninstrumental community as part of a broader mosaic of resistant practices. In the Enlightenment aesthetic, these prefigurative elements can only be evoked virtually, through a mimetic reenactment (in poetry, plays, etc.) intended to symbolically reconcile humanity's divided halves (essentially fabricating the preconditions for this utopic future at the level of individual consciousness). Any attempt to create a social order that brings these forms of reconciliation into concrete or "objective" existence is premature precisely because humankind as a whole is insufficiently evolved to coexist peacefully without some externally imposed regulatory force. Instead, this telos (taking the form of the aesthetic state in Schiller) is projected into an indefinite future, which can only be intuited for now in solitary aesthetic contemplation.

This paradigm is carried forward, in altered form, in the discourse of Marxist critical theory. Adorno plays a key role here, largely because his

work represents a symptomatic merging of the traditions of Marxist and aesthetic theory. In Adorno's analysis, both the virtualized expression of premature desublimation (in the fictive social transcendence brought about by the experience of aesthetic beauty in artistic media) and the concrete efforts to universalize social harmony through political transformation (in the action-oriented practices of artists and student protestors during the 1960s) are equally suspect. Both manifestations of social harmony are subject to the exculpatory critique due to the perceived impossibility of praxis or meaningful ("revolutionary") political change. Here prematurity is indexed not to the inadequate moral development of humankind but to the now totalizing nature of capitalist domination, which precludes anything other than "symbolic" forms of resistance (even as the source of that domination still resides in the inhibited consciousness of actual human subjects). The solution, however, is strikingly similar to that found in the Enlightenment aesthetic. Only the monadic work of art is able to safely evoke this utopic possibility, through its mediated expression of a radical autonomy from all external determination.[70] The viewer's experience of these displaced "social problems" can unfold only at the level of the individual consciousness reflecting on its own moral complicity. This is paralleled by the resistance to nonhierarchical forms of decision-making or consensus-based political practice in the Leninist tradition and the consequent off-loading of the theoretical and practical knowledge necessary to universalize an eventual social reconciliation to the party's transcendent intelligentsia.

In both of these paradigms, in the Enlightenment aesthetic and in Marxist theory, the experience of social harmony and noncoercive community is understood as a final, static achievement, a singular, epochal event after which a liberated human nature will enter into an entirely new state of being. For Lenin, revolution is defined in terms of the utter destruction of all that came before in order to clear the ground for an entirely new way of life. And for Adorno, the experience of "retrogressive anthropogenesis" has so corrupted human nature that nothing remains to be salvaged. As a result, the means by which revolution is precipitated (mercenary, calculating, and rigidly hierarchical) has no necessary effect on the form of the new social order that will follow in its wake. While Lenin would regularly invoke the idea that the soviets and the workers were the nucleus of revolution, to be followed and supported by the Party, this rhetoric focused primarily on securing the assent of the workers rather allowing them to have any substantive involvement in revolutionary strategy or political decision-making. When it came time to determine the actual unfolding of the revolution around

contentious issues (the dissolution of the Constituent Assembly, the governing power of the soviets, the response to the Kronstadt uprising, etc.), decision-making authority always devolved upward to the Party leadership and to Lenin himself.[71] This is why Lenin was comfortable rejecting calls for greater democracy in the soviets, which were the ostensible seedbed of a future communist society. In this view, the process of revolutionary change possesses no meaningful prefigurative dimension, but rather is defined by a set of purely utilitarian actions necessary to seize and retain power.

If Lenin represents a philosophy of political action uncoupled from prefigurative expression, then Adorno will invert this relationship, insisting that art's utopic powers be entirely partitioned off from the exigencies of praxis. In his efforts to evoke the experience of nonidentity in the aesthetic, Adorno sought to preserve a capacity for noninstrumental social experience that would be reactivated (however improbably) during a future revolutionary moment. Here is Adorno from *Aesthetic Theory* describing the epochal moment at which art would release its stored up utopic energies to the newly liberated masses: "Art draws its power of resistance from the fact that the realization of materialism would also be the abolition of materialism, that is, of the domination of material interests. Weak as it may be, art anticipates a spirit that would step forth at that point."[72] Here we have "anticipatory" vision separated from action, arrested at the level of the individual consciousness and held in trust until an authentically revolutionary moment (decipherable by the avant-garde theorist) finally arrives. We encounter then, in Adorno and Lenin, the divided halves of a theory of revolution broken apart by the disappointments, fractures, and upheavals of twentieth-century political history. While the Party carries forward the strategic-instrumental discipline necessary to overthrow capitalism, the prefigurative dimension of revolutionary change is off-loaded to the avant-garde. There is no framework in either of these traditions for understanding praxis as carrying a prefigurative capacity that is available to the agents of political transformation in the act of resistance itself. Thus, both Lenin and Adorno effect a re-transcendentalization of insight (the insight necessary to both imagine a utopic future and steer a pragmatic course toward its realization) away from the conscious awareness of the constituents of this future. In each case, we can observe a defensive recapitulation of conventional subjective autonomy in the person of the avant-garde artist or vanguard theorist, intended to vouchsafe a future in which precisely this form of autonomous selfhood would presumably be rendered obsolete. This division effectively reiterates the initial tension in Marxist discourse between an appropriative model of the self, associated

with the transformation of nature, and a noninstrumentalizing version of the self brought into existence under full Communism.

What is being "prefigured" in both the Enlightenment and the avant-garde aesthetic traditions is, of course, a new form of the "self" and, by extension, a new social or intersubjective architecture that might be brought into existence following a revolutionary transformation. It is, however, a form of selfhood and the social that can have no practical existence here and now and that exists primarily as an ideological construct in the theorist's imagination. We can identify the potential for a very different ontological model, along with an alternative aesthetic paradigm, in the materialist concept of revolution evident in Marx's early writings. "In revolutionary activity," as Marx writes in *The German Ideology*, "the changing of self coincides with the changing of circumstances."[73] This is the version of social labor that Habermas and Honneth sought to retrieve. Here activity, praxis, not just of the theorist but of the constituents of revolution themselves, entails a generative transformation of subjectivity, a "changing" of the self, that "steps forth" not after revolution has already been achieved but, rather, emerges though the necessary political and cultural processes that lead up to and precondition any profound political transformation. Hannah Arendt outlines a similar paradigm in her analysis of the processual, self-transforming effects of "action."[74] I would argue that the cognitive potential of this self-transformation is not exhausted by the simple, apophatic production of class solidarity against the grain of a bourgeois other. Rather, the transformative effects of collective interaction can generate a set of important insights into the constitution of self and other, and solidarity and individuality, that transcend either the image of the enraged worker or the hardened, defensive self, associated with Rakhmetoff's heroic vanguardist in *What Is to Be Done?* that so inspired Lenin.[75]

This transformative quality is evident in the forms of collective and intersubjective experience catalyzed across a range of social movements, as well as in the artistic practices produced in their orbit. In her study of Black Lives Matter (BLM), Deva Woodly explores the complex ontology of resistance and its effects on the lives of its participants. "Not only did Black Lives matter in the abstract, as an aspirational political goal," she writes, "but their politicized and mobilized Black selves, very clearly and concretely, mattered to each other."[76] In the experience of "mattering to each other," we can identify the unique interrelationship between the practical and the prefigurative. Certainly, the BLM movement marked a coming together or aggregation of bodies, both in person and online, that had enormous

tactical value as it expanded internationally in response to ongoing racist violence. At the same time, the movement entailed complex negotiations around difference in the African American community itself. Thus, Woodly describes the tensions that occurred within the emerging coalition that was brought together by BLM, from more conservative elements, often associated with black churches, to nationalists, to queer and trans activists. These tensions were evident at the National Convening of the Movement for Black Lives at Cleveland State University in July 2015, which featured thousands of participants from dozens of organizations working across the United States. As organizer Mary Hooks recounts, "What were the plagues we were seeing inside the movement and what was the medicine? It showed up in that people didn't always know how to struggle in a principled way. We saw the tactics that we were using in the street to shut down political candidates, talking over mics, and you know, folks were using that inside of a movement space. . . . What I saw were people elbowing out space when an invitation had already been made."[77]

Here the instrumentalizing orientation of the street was reproduced in the speculative space of the convening, as schisms between and among specific groups fractured the sense of solidarity necessary to act in unison. These schisms were, at the same time, an essential step in the process of forming a collective with some prefigurative potential, precisely by openly thematizing the specific differences among BLM members that might otherwise be repressed in the name of a tactical coherence. As the convening ended, the participants encountered an iteration of the violence that brought them together occurring in real time, just outside their conference center. Cleveland police offers were arresting a young black man, ostensibly for drinking in public, and had already placed him in handcuffs. Several hundred BLM participants crossed the street and surrounded the police car, as Hooks describes the scene: "And all the people coming out of the convening were like 'not today!' People kept gathering—folks got off their buses, folks missed their flights—there had been about 1,200 people at the convening and I would say at least four to six hundred of us massed in the streets to protect this kid. We surrounded the police car. Shit got tense. The police [sprayed] mace at everyone."[78]

Now all of the internal dissension that had characterized the convening itself, the tensions between churchgoers and trans activists or strategic differences over what forms of action the movement might take next, was suspended. As Hooks notes: "All the queer and trans folks who had been upset were on the front lines fighting to keep this boy from being taken.

And all the churchwomen who had been upset because they thought they didn't have a space in movement anymore. And the healers, who had been concerned about what kinds of direct actions would be traumatizing for our people... were on the grass putting milk in people's eyes so they could see and be ready to fight. I mean, people got *in formation*."[79]

The police were finally prevailed upon to release the young boy to his mother, and the protestors formed a protective corridor for them to walk through as they departed the scene, providing both physical and emotional shelter. As Hooks recalls, "They were shouting 'We love you, we love you!'"[80] Here the "collective" is neither monolithic nor static. Rather, through the course of the convening and its dramatic aftermath, we can identify a notion of collectivity as a process rather than a fixed state and a willingness to acknowledge those often-uncomfortable forms of difference that subtend a given collective combined with an equal readiness to set this critical, reflective process aside during moments of action. As Woodly notes: "The fact that this highly effective action took place spontaneously, after participants in the convening failed to agree about how to conduct a planned action, served up a key lesson: Everyone didn't have to agree about everything. In the midst of tactical divergences, concerns about health and safety, tense conversations about harm, conflicts over differential resource levels, and even petty jealousies about credit claiming, one thing was clear—none of it could or would outshine the movement's reaffirmed purpose: fighting for, protecting, and defending Black life."[81]

Here, then, is a riposte to the belief, so frequently encountered in the discourse of contemporary critical theory, that collectivity as such is an entirely suspect social form; precursor to fascism or destined to repress the unique identities of its constituent members under a stultifying consensus. This experience also challenges the perception typical in both the vanguard and avant-garde traditions that those who experience suffering are incapable of challenging its sources in a reflective and critical manner. The complex interdependence between praxis and prefiguration, solidarity and dissensus, participative body and contemplative mind has seldom been so eloquently expressed as it is in this sequence of events. Woodly also notes the absence of overt hierarchies in the BLM's "decentralized" structure. "The planning and organizing team, which included the three co-founders of #BlackLivesMatter, barely introduced themselves to the attendees and there were no pictures or bios of them to be found in the program or on the official website... no headliners or lionized personalities."[82] This does not mean that the movement was, and is, unable to make quick tactical decisions (as the example

above shows). As Woodly contends, the founders of the Movement for Black Lives, which grew out of the convening, argue that their movement is not "leaderless" but "leaderful."[83] Here "leadership," like authorship in engaged art practice, is mobile rather than fixed in a single personality. At the same time, as Woodly notes, this decentralized structure carries its own liabilities in terms of sustaining the movement "between mobilizations" (a topic to which I will return in the final chapter).

The questions raised by this encounter, around the constitution of the subject and forms of collective being in the act of resistance, bring us back to the concept of autonomy itself. Here we must return to the origins of modern political autonomy in the period of de-sacralization. The potential that was opened up at this historical juncture did not have to terminate in a quasi-theological concept of human perfectibility. Rather, what was enunciated was simply the novel possibility of a process by which concrete human agents, existing in a provisionally egalitarian social framework, could develop their own consensual norms rather than having these norms imposed on them by a monological external authority. In this view, it is accepted that *some* normative institutional structure is necessary for any complex society to function, but it is also understood that this structure must be open to ongoing reinvention and reciprocal attunement in order to preserve its legitimacy. There is no claim here to release a natural but moribund capacity for social harmony that would render all (subsequent) political infrastructure redundant. Rather, there is a conviction that this capacity only evolves *through* practice and the ongoing transformation of human consciousness and selfhood that results from it. It must be produced and reproduced, learned from and modified over time (in the Cleveland Convening, in the escraches of Argentina, in the streets of Tehran). In this view, autonomy is not a fixed state or ontic condition; it is simply a *precondition* for a far more complex process of dialogical interaction and self-constitution. So long as we understand autonomy simply as the monadic individual acting out their own subjective freedom, it will fail to capture the complexity of this process and its affiliated problematics.

If we are seeking to construct an aesthetic paradigm that is oriented around a processual and dialogical concept of the interface between the individual and the social, rather than a telos of absolute subjective freedom and indeterminacy, then we are also obliged to reconsider the role of prefiguration in the aesthetic and the specific form of subjectivity that it evokes. Here prefiguration is released from the imperative to simply mirror this absolute freedom (in a synecdochical expression of nonidentity). Rather, prefiguration

now takes on the task of facilitating a set of cognitive and affective capacities (through situational praxis) that would be called upon in the dialogical reconstitution of the self and the social at a larger scale or a more enduring temporality. A further clarification is in order here. In the case of Adorno's aesthetic, prefiguration is not concerned with the pragmatic expression of a form of subjectivity defined by receptivity and reciprocal openness. Rather, it is focused on a precursor stage in which the always already instrumentalizing viewer is provoked into reflexive awareness of their own reified consciousness. The actual locus of nonidentity (the artwork) remains closed off and monadic. As a result, there is no reciprocal relationship between the artwork qua other and the viewer. Rather, there is simply an inverted instrumentalization in which the self previously accustomed to objectifying the world is objectified in turn. This kind of conflicted prefiguration is, of course, consistent with Adorno's more general skepticism about the presence of any (implicitly) positive or affirmative experiential dimension in the aesthetic encounter. The effect, however, is to reproduce a conventional model of mastery and transcendental authority, in the personality of the artist and the surrogate selfhood of the work of art, directed against the nature-like consciousness of the bourgeois viewer.

If we can understand the aesthetic as involving the ongoing development of new forms of the social and of self-consciousness in praxis, then the process of prefiguration will be quite different. It will no longer function by evoking a virtualized sense of either social reconciliation (in the experience of beauty) or therapeutic nonidentity (in the avant-garde tradition) in the consciousness of the individual viewer. Rather, it will entail the literal production of new forms of social composition among and between physically proximate subjects (evident in many of the examples I have referenced here). While these encounters might operate at a relatively small scale, they are always oriented toward the potential for expansion or replication in conjunction with the spatial extension of resistance itself. In this way, the cultivation of a reflexive awareness of the nature of both the social and the self is no longer privatized but disclosed, instead, in the very act of intersubjective exchange in a manner that is, by necessity, tentative and imperfect rather than finalized or resolved. This insight is, I would suggest, central to understanding the significance of a broad range of socially engaged art practice since the 1990s. More specifically, we might say that this work, taken in the aggregate, seeks to actualize the political nexus (opened in post-sacral modernity) through which discrete subjects negotiate the inevitable tensions that exist between autonomy and interdependence, antagonism and vulnerability, self and other, and instrumentality and prefiguration in the act of resistance. This

accounts for the distinct, dual nature of this practice. On the one hand, the work mobilizes forms of prefigurative experience through a commitment to nonhierarchical decision-making systems, alternative social forms, and compositional structures intended to thematize intersubjective conflict or dissension ("movement space," as Woodly describes it). On the other hand, this prefigurative modeling is held in tension with practical forms of resistance (efforts to gain policy breakthroughs, challenge gentrification, transform public consciousness, circumvent police violence, etc.). This process is evident across a range of socially engaged art practices: in the "Desiring Production" of Gezi-Park Fiction, in the flag washing of *Lava la Bandera*, and in the moment of vulnerability and doubt when Chris Marker screened his film for the workers of Rhodiaceta or Adrian Piper sought to unhinge racist stereotypes in her *Mythic Being* performances.

In the avant-garde schema, "resistance" is waged against a surrogate interlocutor (formal or compositional conventions or other examples of artistic reification) against which authentic art will differentiate itself. These conventions are, in effect, incapable of answering back but serve simply as placeholders for forms of political repression that take on concrete, materially specific existence in the lifeworld of capitalism. In socially engaged art, on the other hand, resistance is produced against the grain of existing forms of domination that can and do answer back to provocation or critique in real time. Artists and collectives are called upon to learn from these responses and to modify or reshape their own practice in turn. This reciprocal cycle of call and response, evident for example in the escraches of Argentina and *Lava la Bandera*, is an essential feature of socially engaged art. In this manner, new forms of knowledge emerge through the act of resistance, knowledge that is cumulative and can be built on over time, transposed, and shared. Here praxis is not simply iterative or cognitively sterile but generative and capable of producing meaningful insight into the transformation of both the social world and the self. This does not mean that valid insight is not also produced through conventional forms of contemplative theoretical production, but it does entail the recognition that praxis itself has distinct epistemological and creative qualities. While the concept of social labor provides an important starting point for developing an aesthetic analysis of engaged art practice, it also carries its own constraints relative to the prefigurative qualities of this work. As I will argue in the following chapter, the writing of Mikhail Bakhtin provides an important resource for thinking beyond these constraints and developing a more nuanced account of the complex imbrication of aesthetics and politics in socially engaged art.

6

OUR PERNICIOUS TEMPORALITY

Bakhtin and Theoreticism

It is only in a life perceived in the category of the other that my body can become aesthetically valid, and not in the context of my own life as lived for myself, that is, not in the context of my self-consciousness.
—Mikhail Bakhtin, *Art and Answerability*

As I have already noted, a typical criticism directed at engaged art practice entails the claim that this work relies on essentialist notions of community, effectively subsuming the unique identities of individual participants under an imposed consensus. While it is no doubt possible to identify collaborative art projects that operate in this manner, it is equally possible to identify projects that take up a critical relationship to the formation of community itself. This is evident across a broad range of practices, from Augusto Boal's Theater of the Oppressed in Brazil, to the new cultural forms that have emerged in

conjunction with the Oaxaca Commune in Mexico, to the communicative protocols developed by the Dialogue project in central India.[1] We also observe, in the works of literally hundreds of artists and art collectives over the past thirty years, an effort to de-transcendentalize aesthetic experience, returning it to the experiential field of social and political praxis. It is in the nature of this work to hold in creative suspension both the instrumental-tactical orientation necessary to transform repressive systems and an inner-directed, reflective consciousness of the new social forms that might be constructed in their place. This is why, as Colectivo Situaciones argues, the "pre-escrache" is just as important as the escrache performance. In the same way, the flag washing ritual in *Lava la Bandera* was not simply a mediated event, to be relayed through television and newspaper coverage. Rather, what gave it a unique power was precisely the societal diffusion of a new sense of critical agency and solidarity within the Peruvian public that was literally performed around public fountains across the country. Here the pragmatic learning process of resistance carries along with it an ontologically transformative potential originally captured in Marx's concept of social labor (in which "the changing of self coincides with the changing of circumstances").[2]

The new forms of subjectivity that are opened up in this manner clearly have significant implications for our understanding of socially engaged art. It is necessary here to return to the revised concept of social labor presented in Habermas and Honneth's work and, in particular, to the conventionally autonomous form of selfhood that it reproduces. This is evident in Habermas's reliance on a model of communicative action defined by the competitive presentation of preexisting opinions and in Honneth's model of recognition, which implies a set of discrete, autonomous subjects conferring, denying, or soliciting recognition. Neither figure pursues a more profound reconsideration of the underlying model of the self that is potentially made available in praxis or social labor. One might, in the course of communicative action, become more accomplished at presenting opinions or more willing to modify one's own opinions in relationship to the "truths" presented by other selves, but the core architecture of the self remains relatively stable. As a result, the prefigurative dimension of social labor, which could envision forms of the self and the social that transcend the constraints of conventional autonomy, drops away in what can become a proceduralist account of deliberative democracy.

In this chapter, I will turn to the work of Mikhail Bakhtin in order to identify a dialogical model of the self that can transcend these limitations and allow us to more fully recover the aesthetic potential of engaged art practice. This paradigm is, of course, not unique to Bakhtin. Rather, we

can find parallel expressions of this sensibility across a broad range of intellectual traditions, often in conjunction with critiques of certain lacunae within Marxism itself associated with the normalization of a conventional paradigm of autonomous selfhood. This alternative sensibility was evident in the early twentieth-century writing of figures like Bogdanov and Gramsci and was renewed in the development of new social movements during the 1960s and 1970s. We find a particular interest in this dialogical paradigm in the field of anticolonial theory that has, from its earliest stages, had to contend more deeply and critically with the underlying ontology of the bourgeois self that drove the colonial enterprise, as well as in the field of Black studies. The Martinican poet and critic Édouard Glissant proposes a concept of "creolization" to capture the complex forms of cultural and intersubjective hybridity generated by the violent uprooting and displacement of peoples through colonization and slavery. As Glissant contends, creolization promises a form of identity that "would not be the projection of a unique and sectarian root, but of what we call a rhizome, a root with a multiplicity of extensions. . . . Not killing what is around it, as a unique root would, but establishing communication and relation."[3] In this manner, the dialogical cultural effects of the colonization process effectively undermine the forms of instrumentalizing ontological sovereignty on which colonization itself depends. "Creolization creates a new land before us," as Glissant writes, "and in this process of creation, it helps us to liberate Columbus from himself."[4] I will return to the broader set of questions raised by this formulation in the final chapter.

As I have suggested above, the dialogical concept of the self evoked by figures such as Bakhtin, Glissant, and many others can help enrich our understanding of socially engaged art specifically and the nature of political transformation more generally. In socially engaged art, the generation of new insight is not restricted to the field of monadic self-reflection. Rather, this work is also predicated on the transformative potential of social interaction among and between two or more concrete selves. This is the case not because this form of interaction is assumed to be more authentic but quite simply because it mobilizes a unique range of communicative media (physiognomy, expression, gesture, proxemics, physical vulnerability, etc.) that enrich reciprocal intersubjective experience in ways that are distinct from the forms of mediation associated with conventional artistic production. Thus, the experience of Saba Zavarei and other women as they recorded themselves singing or dancing surreptitiously on the streets of Iran entailed a complex admixture of reclaimed agency and physical danger, along with an

enhanced consciousness of their relationship to public space. This original, solitary transgression unfolded precisely because the women understood their connection through it to other women in Iran taking the same risk. What forms of knowledge are generated at the intersection of the somatic and the intersubjective? These are, preeminently, aesthetic questions. We have, over the course of this book, seen how these questions are handled in conventional aesthetic theory. Bakhtin's concept of a dialogical aesthetic experience provides an important extension and complication of the theory of social labor, grounded in a perspective that operates both within and against the grain of the broader traditions of both Marxism and the aesthetic.

Bakhtin's intellectual career began in postrevolutionary Russia and overlaps with that of Viktor Shklovsky, whose work played an important role in the evolution of avant-garde aesthetics. Shklovsky's career blossomed following the revolution, as many of the previously marginalized figures associated with the Formalist movement found themselves in key positions in universities being reorganized under the new Soviet regime.[5] Bakhtin's experience of the early postrevolutionary period was considerably less salubrious. He was not associated with the then-fashionable currents of Formalism or Futurism and struggled to find a teaching position throughout the 1920s. Moreover, in 1923 he was diagnosed with osteomyelitis, which eventually necessitated the amputation of his leg. In 1928, Bakhtin was arrested by the OGPU (the Soviet secret police) (in part because of his associations with the Saint Petersburg Religious-Philosophical Society) and sentenced to a ten-year term in the notorious Solovki labor camp.[6] Due to his poor health (and the intervention of Maxim Gorky's wife), his sentence was reduced to six years of exile in Kazakhstan. After his return from exile, Bakhtin operated on the margins of Soviet intellectual life and only received some recognition during the 1960s as his work was rediscovered by a younger generation of Russian scholars. I mention this history not in order to romanticize Bakhtin, but rather to provide a historical context for the specific theoretical issues that preoccupied him throughout his career. In Bakhtin's work we encounter an aesthetic paradigm that emerged in response to the lived experience of revolution rather than a theory for which revolution exists primarily as a metaphysical ideal. As such, it provides a valuable counterpoint to the often-idealized accounts of the Bolshevik Revolution we encounter in the traditions of the European avant-garde.

With Bakhtin and Shklovsky, we gain some sense of the remarkable fecundity of the revolutionary moment, as both a positive and a negative example. For Shklovsky, the violent upheavals of the revolution would

be reproduced in the cognitive disruption precipitated by the poetic text, as reified language replaces a reified political system as the point of attack. This was the much-anticipated moment of revolutionary synthesis, in which avant-garde artistic experimentation would make common cause with radical political transformation. For Bakhtin, the upheaval of the revolution covered over a deeper continuity at the level of the human drive for mastery that manifests itself across a broad range of cultural production, informing everything from political and scientific discourse, to poetry, to the micro-politics of daily communication. This context can help us understand more clearly the central concern in Bakhtin's research with what he variously termed "theoreticism" and "monologism," forms of thought that conceive of the relationship between abstract conceptual knowledge and the experiential world of human social interaction as essentially custodial. Here individual theoretical contemplation alone is capable of generating meaningful transformative insight, which then serves to dictate the evolution of any subsequent, practical action. "The theoretical world," as Bakhtin writes, "is obtained through an essential and fundamental abstraction from the fact of my unique being and from the moral sense of that fact—'as if I did not exist.' . . . Any kind of practical orientation of my life within the theoretical world is impossible."[7] Coming of age as an intellectual in the USSR during the 1920s and 1930s would have given Bakhtin a visceral appreciation for the violence of a theoretical intelligence that seeks to transform the broader social world in its own image of perfection.

This critique is also linked with Bakhtin's analysis of Shklovsky's work and the Formalist tradition more generally.[8] Shklovsky's interpretation of poetics during the 1920s gave coherent theoretical form to many of the key tenets of the avant-garde schema. Of particular importance here is his description of the debilitating mass "habituation" of the public, who have been rendered incapable of grasping the material specificity of the world around them (they "see the object as though it were enveloped in a sack," as he writes).[9] In order to break through this reified perceptual shell, it is necessary for the poet to free the word from the utilitarian demands of referential meaning and to bring it instead into a realm of absolute freedom. "Art is a means of experiencing the process of creativity," Shklovsky writes. "The artifact itself is quite unimportant."[10] The liberation of the word from the shackles of signification will, in turn, precipitate the liberation of the reader from the miasma of habituation, as the nonreferential strangeness of poetic language reveals to them the true complexity of the experiential world. What is required is the intervention of an enlightened external agent

(the vanguard poet), able to grasp the mechanisms of a stultifying system of domination of which the average individual remains unaware. To fulfill this emancipatory mission, the poetic word must remain entirely autonomous.[11] "A literary work is pure form," as Shklovsky wrote in 1925, "It is neither thing nor material, but a relationship of materials.... It is from this that comes the inoffensive character of art, its sense of being shut up within itself, its freedom from external coercion."[12]

Shklovsky's understanding of habitualization as the uniform condition of the nonpoetic world is used to justify the semantic quarantining of language, reduced to its immanent structural elements. Poetry can make no appeal to the "external" social world through an opening out to referential material that is generated within the broader culture because the profound corruption of that culture will only degrade the creative function of poetic language itself. The disavowal of the word's signifying function further implies that the word can bear no meaningful relationship to a shared social space in which two or more speakers orient their communicative interaction toward some common goal or mutually cognizable subject (the preconditions for social labor). Here again we encounter the characteristic discursive architecture of aesthetic autonomy, centered around a form of self-referential interiority (of reflective consciousness or nonrepresentational poetic language). Bakhtin will contest Shklovsky's concept of poetry as a purified linguistic form precisely because he does not share Shklovsky's perception that the entire field of nonpoetic speech and language is irredeemably corrupt. In place of the absolute autonomy of poetic expression from interaction with nonpoetic speech or creation (the "beauty of the self-sufficient and self-centered Word," as the Futurists wrote), Bakhtin will insist on the dialogical constitution of language and utterance.[13] As he argues, "In point of fact, *word is a two-sided act*. It is determined equally by whose word it is and *for whom* it is meant.... Each and every word expresses the 'one' in relation to the 'other.' I give myself verbal shape from another's point of view."[14]

This critique of autonomy at the level of the individual semantic unit is reiterated in Bakhtin's analysis of the apophatic orientation of Formalist poetics.[15] Here he calls attention to the Formalist tendency to define poetry through its reflexive negation of conventional linguistic usage. In this view, the poet must take up an antagonistic relationship to all existing forms of language, which are understood to be creatively sterile. The poet, as the Futurists wrote in their 1917 manifesto, must "feel an insurmountable hatred for the language existing before their time."[16] In order for this discursive system to operate, it is necessary to construct all nonpoetic language as

entirely utilitarian and lacking in any creative potential.[17] Bakhtin will challenge autonomy here as well, insisting on the creative capacity of the same forms of quotidian discourse that, for the Formalists, constitute the degraded foil of authentic poetic expression. This accounts for Bakhtin's interest in the novel, which he understands as an intrinsically impure form of literature that only acquires meaning as the nexus of other discursive modes and genres. Thus, the novel combines "several heterogeneous stylistic unities, often located on different linguistic levels." These include "various forms of ... extra-artistic authorial speech" as well as "street songs, folk sayings, and anecdotes ... social dialects ... professional jargon, generic languages, languages of generations and age groups, tendentious languages, languages of the authorities, of various circles, and of passing fashions, [and] languages that serve the specific socio-political purposes of the day."[18] These are, precisely, "prosaic" forms of expression (spoken as well as written) that are taken into the novel, not as a raw material to be turned against the reader as a vehicle of therapeutic estrangement but precisely because they convey the "multiplicity of social voices" that is characteristic of "heteroglossic" existence.[19]

Bakhtin's critique of Formalism was grounded in his analysis of the traditions of Saussure-ian linguistics, on which Shklovsky's own work was dependent. More specifically, Bakhtin was critical of Ferdinand de Saussure's decision to focus his analysis on the synchronically fixed system of language at the expense of the diachronic unfolding of individual speech acts (Saussure's famous distinction between *langue*, which is "essential," and *parole*, which is merely "accessory").[20] As a result, the meaning that we conventionally attribute to specific words or specific modes of human consciousness or speech actually originates in a deeper ideological substrate of which most speakers remain unaware. This decision opened up a rich vein of theoretical investigation into the contingency of linguistic meaning. However, the broader implication of this outlook, as Bakhtin recognized, was to devalue the capacity of individual human interlocutors to communicate in a critical, reflective, and creative manner. By refusing to engage with the complex generative potential of actual human dialogue, Saussure reiterated the broader traditions of theoreticism, which sought to impose abstract conceptual principles on the "un-repeatable uniqueness" of human existence.[21]

Bakhtin identified a key locus of this tendency in the tradition of Kantian ethics. For Kant, the individual comes to reconcile the tensions between self and other that are introduced in the post-sacral moment by mobilizing a capacity for "internal lawgiving" (an innate disposition to subordinate

self-interest to a universal moral law), which fortuitously coincides with the demands of "external" lawgiving, imposed by general societal norms.[22] As a result, in behaving ethically, we are simply obeying a law that we have already "given" ourselves, thus preserving our individual freedom and autonomy while at the same time ensuring a general societal harmony. It was, of course, Kant's failure to provide a compelling explanation for our willingness to actually obey this "internal" law that led to the *Critique of Judgment*, which finds an ostensible proof in our subjective response to beauty. In Kant, Bakhtin argues, agency is displaced from what he calls the "subjectum" (the body-mind nexus of individual, concrete selves) into a universal moral law (the categorical imperative) that has simply been implanted in us and that is accessible only by the transcendent ego. Thus, the categorical imperative in Bakhtin's view is absolute and unchanging. One need only acknowledge its existence (in reflective contemplation) and obey its precepts to be relieved of any doubt about the specific action to be taken at any given moment of intersubjective exchange. All subsequent social interactions following on from this acknowledgment will simply be the iterative application of the core insight that it provides. It is never necessary for us to consider the individual character of the human agents involved in any given exchange, the context in which an ethical judgment is being deployed, or the broader ramifications of a specific course of action. Rather, the only essential guide in shaping our moral relationship to others exists as a quasi-metaphysical entity, that we simply come to obey but not to question.

As a result, as Bakhtin argues, the source for the insight necessary to coexist in a complex society lies in the transcendent ego itself rather than evolving through the forms of human intersubjective exchange that are actually necessary to establish practical norms. Ultimately, it is not something to be constructed or achieved but simply revealed in the psyche of the individual human self. This is why its existence can be confirmed by privatized aesthetic experience, as outlined in the third *Critique*. Once again, the actual social processes necessary to live together in a complex society (and to construct the ethical norms that could guide this coexistence) are seen as secondary to a prior, transcendental insight that is only available through the experience of contemplative self-reflection. We are in dialogue not with other concrete subjects but with an axiomatic principle against which we measure our actions and determine their rightness but that remains indifferent to and uninflected by these actions in their practical and situational unfolding. In *Toward a Philosophy of the Act*, Bakhtin identifies the essentially recursive nature of autonomous self-reflection in the Kantian tradition, in which "the

will itself prescribes the law to itself.... We can see here a full analogy with the construction of an autonomous world of culture.... The will describes a circle, shuts itself in, excluding the actual-individual and the historical self-activity of the performed act."[23]

The "performed act" for Bakhtin refers to the unique, unreproducible nature of social interaction, its latent generative potential, against the flattening effects of systematicity (of language, ideology, or a "universal" moral law). Any given moment of intersubjective exchange opens up the possibility that we might transform and not merely reproduce the normative conventions of both selfhood and the social. We must perform this insight, here and now; it must be reconstructed and brought into practical existence, expanded and supplemented, by referring to our own concrete position in the world and what Bakhtin terms the "truth of situation." We might, in fact, construct more enduring truths through this "answerable" process, but they can never be wholly universal or entirely untouched by the ongoing diachronic evolution of human consciousness and social practice itself. In Kant, Bakhtin identifies what he terms "the common contraposition of eternal truth and our pernicious temporality... here the eternal truth (and that is good) and here is our transitory and deficient temporal life (and that is bad)."[24] Even in its expression of moral truths, the theoreticist tradition treats our actual interlocutors as interchangeable figures in a universe overseen by a divinity who remains entirely indifferent to the specific nature of their being. In this manner, what is intended as the necessary elevation of moral judgment above the exigencies of human difference, placing it on a higher plane and a less subjective footing, simultaneously has the effect of effacing the unique character of the individual selves whom this law seeks to legislate.

It is possible to read Bakhtin's analysis of theoreticism as a veiled "Aesopian" critique of the revolutionary traditions of the bourgeois intelligentsia and the Leninist vanguard. In this respect, it is suggestive for my analysis of that tradition and its imbrication with avant-garde artistic discourse. I have identified two aspects of Bakhtin's concept of theoreticism that are of particular importance for a reconfigured notion of the aesthetic. The first is his interest in breaking down the Manichean opposition between avant-garde art or poetry and forms of popular culture, especially those associated with the poor and working class. Bakhtin offers a more nuanced account of prosaic expression that coincides with the emancipatory aspect of working-class culture that is central to the concept of social labor. This is also a significant feature in the evolution of anticolonial cultural theory (evident in the work

of figures such as Frantz Fanon, C. L. R. James, and Amílcar Cabral, among others), which seeks to identify the critical potential specific to forms of vernacular creativity that have evolved outside the circuits of bourgeois or colonialist art institutions. The second aspect of Bakhtin's work concerns his concept of the "performed act," which refers us to the liberatory possibilities that are available to us in our quotidian interactions with others. Each of these ideas is linked by a sense of hope in the potential of human creativity and resistance, against the grain of an otherwise monolithic form of repression. Bakhtin provides a useful framework for thinking through the ways in which the processes of social interaction that are so central to engaged art practice might mobilize a form of critical or transformative consciousness. In the following section, I will seek to understand more precisely how Bakhtin defines the creative potential of intersubjective exchange and how this experience bears on our understanding of aesthetic autonomy.

From Finalization to Answerability

For Bakhtin, discursive systems that claim absolute universality can come to serve as "alibis" that we use to rationalize our individual behavior or beliefs and that can prevent us from taking responsibility for our actions in the world. The prototypical example would be the bourgeois subject, achieving a spurious transcendence of their class specificity in their ostensibly "universal" contemplation of beauty. For Kant, of course, the linkage between a universal principle and internal, "compellent" feeling is accomplished through the individual aesthetic encounter, as we intuit the possibility of an eventually realized sensus communis. Bakhtin challenges this transcendent concept of the aesthetic, whose consummation is always deferred to an indefinite future or displaced to a hypothetical viewer yet to be. He offers instead a dialogical concept of the aesthetic in which we reclaim our incarnated particularity and act from our "own unique place," answerable to each situation, context or interlocutor.[25] Bakhtin's work can be understood, at its core, as a series of meditations on the interrelationship between human agency and broader systems of meaning, which can become instruments of both emancipation and repression. This is why his work has such rich implications, not just for the study of Kantian ethics or linguistic structures but for all forms of thought (including Marxism) that threaten to treat structures of meaning that are merely pervasive as if they were entirely autonomous, thereby diminishing the necessarily dialogical relationship between any totalizing system (language, reason, and capital-

ism itself) and individual human agency and expression. Bakhtin's work also challenges the tendency to believe that these totalizing systems can only be fully comprehended through self-reflection. Bakhtin associates this attitude with a "monological" understanding of human intelligence. It is monological precisely because it argues that truth derives entirely from the self, contemplating the mechanisms of its own consciousness (recognizing the universality of human cognition in an apperceptive awareness of our own mental structures or grasping the reified nature of the linguistic structures that we use to describe the "external" world). As he writes: "With a monologic approach (in its extreme or pure form) *another person* remains wholly and merely an object of consciousness, and not another consciousness. No response is expected from it that could change everything in the world of my consciousness. Monologue is finalized and deaf to the other's response, does not expect it and does not acknowledge in it any *decisive* force."[26]

This monological orientation has three related effects. First, it entails the uncoupling of the mind (defined as a vehicle of internally directed, reflective thought) from the body and from the outwardly oriented sensory envelope of the "incarnated" body in particular. It also identifies critical thought with the detached observation of one's own cognitive faculties, effectively marginalizing forms of affect-based knowledge or insight. Second, it entails the separation of the individual self from its surrounding material context. In this view, the external environment is of (epistemological) value only to the extent that it can serve as a passive, physical stimulus allowing for closer observation of the internal processes of the subject's own consciousness. And third, it entails the segregation of the self from the other (and our own "obligatively unique" relationship to the other). Each of these operations is predicated on the assertion of a core autonomy, of mind from body, of subject from environment, and of self from other. In each case, one assumes the existence of an ontologically prior entity (mind, subject, self) that can generate meaningful insight only through a process of segregation from an "external" medium that is secondary and inessential. Bakhtin seeks to transform our understanding of knowledge and subjectivity through a concept of "answerability" that acknowledges the reciprocally transformative connection between mind and body, subject and situation, and self and other.

It is, of course, not enough to simply replace a unitary autonomy with a generic notion of relationality. What specific form does this "answerable" relationship take? This question requires us to look more closely at the various ways in which the relationship between self and other has been historically framed within modernity. We have, thus far, identified three modalities in

this relationship between self and other (which can be taken as a template for the series of subjective relations outlined above). The first involves the instrumental mastery or negation of one self by another. Here the other is reduced to a raw material for the economic or cognitive enrichment of the self. This is, of course, the model of selfhood that the aesthetic has traditionally sought to challenge, from Schiller's attack on "economic self-interest" to Adorno's critique of instrumental reason. The second relationship entails an absolute fusion of self with other, under the auspices of a universalizing notion of communal or collective life that effectively negates the specific identities of the individual selves who are its constituents. This is the problematic specter of the "self dissolved into the collective" that Rancière warns of in his critique of participatory theater (and which takes an extreme form in the psychic mechanisms of fascism or Stalinism). Here the self is entirely subsumed into the collective, leaving no remainder. This constitutes the negative antithesis of the condition of instrumentalizing autonomy evident in the first model. The third social paradigm offers an ostensible resolution to the impasse represented by a predatory possessive individualism on the one hand and an equally instrumentalizing form of collectivity on the other. This is the utopic condition of full Communism that follows after the dictatorship of the proletariat, when the newly autonomous masses are able to exercise their own instrumentalizing violence, released from all societal constraint or reciprocal obligation to the oppressor class. Following this interregnum (and the transformation of human nature signaled by the emergence of a "New Man"), all intersubjective violence will be banished, while individual selves will be able to retain their full autonomy even as they live in absolute social harmony. Here, the reconciliation of self and other is a permanent and static condition, marking the evolutionary telos of a perfectionist concept of human consciousness and requiring no further negotiative competence to sustain.

This third social paradigm constitutes the implicit political horizon of the avant-garde schema while also paralleling the utopic form of the aesthetic state in Enlightenment philosophy. It is, however, less useful in capturing the specific nature of socially engaged art. Bakhtin offers us a fourth model of intersubjective experience that is better suited for this purpose. For Bakhtin, the social labor necessary to diminish instrumentalization and enhance harmony, rather than being a vestige of humanity's evolutionary past to be shed, chrysalis-like, in our final, utopian apotheosis, is instead a central feature of what it means to be human. In Bakhtin's writing, one becomes a "self" precisely through this form of labor. Thus, Bakhtin seeks to preserve the necessary and productive tension between self and other

and between individual and collective rather than viewing it as something to be transcended or outgrown. In *Art and Answerability* and *Toward a Philosophy of the Act*, Bakhtin stresses the fundamentally dialogical and interdependent nature of human identity. This raises a set of questions about how we come to reflect on (and constitute) our own selfhood that are essentially aesthetic in nature.

Here it is necessary to review a key transformation that occurs in Bakhtin's work. In his earlier research, Bakhtin argues that proper self-understanding can only occur through our exposure to a coherent "picture" of our "externally finished personality" that must be "as full and concrete as possible."[27] This is not something we can do on our own, however. While we can call up "indelible images of *other* people in all their externally intuitable completeness," as Bakhtin notes, this same imaginative capacity fails us when we attempt to produce a coherent image of our selves.[28] We are dependent, then, on the intervention of the other who can serve as a kind of benign mirror, reflecting back to us a view of our self as a reassuringly finite "totality" that we can never experience on our own. Here is (intersubjective) mediation in its Hegelian guise; we require an externalized, finalized image of our own selfhood to recognize it within ourselves. While Kantian aesthetic experience implies a latent relationship of the self to the world, the other remains essentially abstract and highly attenuated. Otherness or the social world is something we extrapolate as a generic possibility when we intuit the universality of our own cognitive processes. Bakhtin's aesthetic paradigm, on the other hand, entails a direct and reciprocal correlation to a concrete other, who provides us with a materialized image of our own self. Now the other is not simply a metaphysical potential that we fabricate within our own monadic consciousness, but another living being with "with equal rights and equal responsibilities" and, importantly, with an equal ability to affect us and to be affected in turn. This transformation has significant consequences for our understanding of art and the aesthetic.

Bakhtin will ground his model of self-consciousness in the analysis of a specific aesthetic genre, drawing a correlation between the author/hero (or "protagonist") relationship in the novel and the broader self/other dynamic elaborated in his philosophical research. Bakhtin defines aesthetic experience as a two-part process. It begins with what Tzvetan Todorov terms an "exit from the self" via "fusion" with another sensibility. "I must see his world," as Bakhtin writes, "axiologically from within as he sees this world; I must put myself in his place."[29] Empathy and identification, the movement out of a coherent and delimited self, must be followed by a return to the self in

order to produce a properly "unified" aesthetic expression, enriched by a deeper understanding of the experience of the other.[30] The author effectively transcends the social constitution of the other because their "excess of seeing" allows them to recognize aspects of the other's personality and action in the world that the other is unaware of, taking into consideration their unique life history, the anticipated and unanticipated effects of their past actions, the tension between their internal psychic life and external reality, and the whole complex ensemble of forces that constitute the totality of that self.[31] This is not the transcendence of the Kantian aesthetic in which the viewer sheds their individual subjectivity in order to identify with a universal sensus communis. Nor is it the transcendence of the vanguard theorist or avant-garde artist, who is uniquely able to decipher the ideological mystifications of which all others remain ignorant. First, the insight that is achieved in Bakhtin's account is not "universal" in nature but constitutes only a situational transcendence of the specific lifeworld of the other. It is precisely not intended to be valid for all other human subjects. In fact, the other's own material imbrication (including their class identity) would be a constitutive part of this portrayal, not something to be conjured away. And second, the distribution of insight is not unilateral, with the "author" endowed with a fixed capacity for critical insight and the viewer defined by their a priori ignorance. In Bakhtin's aesthetic, the author is equally ignorant of their own totality, a truth that can only be produced through a process of intersubjective triangulation with another self qua author. This implicit reciprocity and situational transcendence are key to Bakhtin's reconfigured aesthetic. Rather than a paradigm in which we gain access to the decisive formative structures of the self only through an introspective withdrawal from social interaction, for Bakhtin the self is materially shaped through this interaction. In this process, the self becomes more open, more permeable, to other consciousnesses while at the same time returning to the other a richer sense of their own identity beyond the insights available through self-reflection alone.

Bakhtin's theory of dialogical intersubjectivity implies a potential decentering of expressive autonomy, in which the positions of "author" and "subject" alternate in a reciprocal cycle (each figure switching roles in a subsequent moment of interaction). This insight has implications of our understanding of the plasticity of authorship within the traditions of socially engaged art as well. In practice, however, the author's structural identity (as enacted through the medium of the novel) remains fixed as the singular locus of an autonomous creative intelligence. And, even if this sequential reordering of

authorship were possible, the creative act itself is still defined in terms of an active author and a passive other. Thus, the subject of the authorial portrayal cannot exercise any creative or generative agency in the coproduction of their own self-image; they function simply as the inert source of experiential data to be collected by the author. As Bakhtin writes: "Form expresses the *author's* self-activity in relation to a hero—in relation to another human being.... The hero, however, is passive in this interaction: he is not someone who expresses, but someone who is *expressed* . . . the form must be adequate to him, although not in the least as his possible self-expression."[32] At this stage in Bakhtin's development, the generation of critical or creative insight only occurs as the author withdraws back into a space of autonomous reflection to assemble the experiential raw material provided by their immersion in the social world into a coherent whole. Empathy and identification, the journey out of a coherent and delimited self, must be followed by a return to the self in order to produce a properly "unified aesthetic expression."[33] The primary aesthetic act, as noted above, is the creation of discrete works that exhibit "unity," "completion," and "finitude."[34]

Here we encounter a symptomatic tension in Bakhtin's work. In his philosophical writings, Bakhtin seeks to acknowledge the generative potential of actual human social interaction, against the grain of a "theoreticist" paradigm in which this capacity is displaced to the privatized consciousness of the theorist or metaphysical conceits like the categorical imperative. At the same time, in Bakhtin's aesthetic theory, we encounter an implicit process of re-transcendentalization, as the monadic self is again identified as the sole locus of generative insight. In fact, Bakhtin will argue that while aesthetic experience might approximate the dialogical cycle of lived experience, it remains, at its core, a theoreticist undertaking. "Aesthetic contemplation," as Bakhtin contends, "is unable to grasp the once-occurrent Being-as-event in its singularity." In "aesthetic seeing," as he writes, "just as in theoretical cognition, there is the same essential and fundamental non-communication between the *subiectum* and his life as the *object* of aesthetic seeing, on the one hand, and the *subiectum* as the *bearer* of the act of aesthetic seeing, on the other."[35] Abandoning the self *too* fully to empathetic identification, lingering too long in the liminal zone between self and other, dissolves the very position of ontic stability necessary to author a full and complete image of the other in the first place. One can collect data in this space but not generate creative insight.[36] This is the basis for Bakhtin's early criticisms of Fyodor Dostoevsky, in which he accuses the writer of surrendering the "right of the author to stand outside life and complete it" by failing to maintain the

proper control over the characters in his novels. The result is what Bakhtin calls "a crisis of authorship" in which "the very position of the author's outside-ness is shaken and is no longer considered essential: one contests the author's right to be situated outside lived life and to consummate it. All stable transgredient forms begin to disintegrate."[37]

During the 1920s, Bakhtin's analysis of the aesthetic underwent a dramatic transformation, which came to fruition with the publication of *Problems of Dostoevsky's Poetics* in 1929. In this research, the moment of aesthetic production no longer occurs only after the author returns to the sanctuary of the self to produce a coherent portrayal of the other. Now, Bakhtin argues, the process of intersubjective exchange with the other becomes a significant part of the aesthetic work itself. As he describes it, the value of Dostoevsky's novels is that they bring us to an understanding of the self "not . . . in the form of a sole and single I, but precisely [in] the interactions of many consciousness; not many people in the light of a single consciousness, but . . . many equally privileged and fully valid consciousnesses."[38] In this new "polyphonic" approach, the "other consciousness is not inserted into the frame of authorial consciousness, it is revealed from within as something that stands *outside* and *alongside* and with which the author can enter into dialogic relations."[39] Bakhtin contends that Dostoevsky allowed the characters (or "personalities") in his novels to take on their own autonomous existence within his consciousness, as if they were actually discrete selves. As a result, the imaginative unfolding of these "selves" has the effect of taking Dostoevsky's novels in directions that he could not have anticipated otherwise. Now, the character, the other self with whom the author interacts, is no longer merely a passive accomplice to their own portrayal but becomes an active and creative agent. In Dostoevsky's novels, as Bakhtin writes, "no human events are developed or resolved within the bounds of a single consciousness. . . . Hence Dostoevsky's hostility to those worldviews which see the final goal in a merging, in a dissolution of consciousnesses in one consciousness, in the removal of individuation. . . . Not another *person* remaining the object of my consciousness, but another autonomous consciousness standing alongside mine, and my own consciousness can exist only in relation to it."[40]

Here Bakhtin elucidates a new understanding of the nature of aesthetic experience. In his earlier writing, the novelist would honor our true, interdependent nature by devoting their art to the creation of images that allow others to glimpse their own totality. However, while one self is opened to another in this process, the dialogical circuit remains incomplete because

the very mechanism set in motion to fulfill it carries traces of the monological tendency it seeks to challenge. In transforming the concrete other into a totalizing image, the author also subjects the other to a process of abstraction. Moreover, the image of the other produced by the author is subordinated to the larger formal demands of the novel. It is employed to advance certain plot lines or fulfill specific narratological goals under the mastering consciousness of the author, who never really surrenders their decisive control over the ways in which the other self is mobilized within the a priori structure of the novel. In this manner, the dependence of the self *on* the other that is elaborated in Bakhtin's philosophical writings becomes the author's independence *from* the other in his aesthetic writings.

In his subsequent writing on Dostoevsky, Bakhtin is able to recognize the implicitly monological nature of his earlier formulation (in which meaningful insight only arises with the author's return into self-enclosure). Now he comes to identify the mastery of the author (which, however benign, excludes the other from active participation in their own self-fashioning) as an extension, rather than a repudiation, of the monologic imperative. As a result, "separation" and "enclosure" within the self (the very precondition for self-reflective experience and authorial mastery) are seen as contributing to the loss of self rather than its revelation. In this manner, the fundamentally aesthetic act of "reflecting" on the self now implies an entirely different version of the "self" that is being reflected upon. Rather than a recursive loop, in which one withdraws into the interiority of the self in order to "discover" a form of being that is defined precisely by its segregation from the social world, one discovers that selfhood is produced by moving outward, toward the "*boundary* between one's own and someone else's consciousness, on the *threshold*" between self and other.[41] This threshold space is central to Bakhtin's reconfigured aesthetic. It suggests that generative experience can unfold within the interstitial zone between self and other (rather than being confined entirely to the contemplative consciousness of the autonomous subject).

The Dialogics of Engaged Art

I want to return to the key insights that I identified in Bakhtin's early critique of theoreticism and monadic self-reflection. I divided those insights into three thematic areas. First, Bakhtin sought to overcome the bifurcation between the mind and the body and somatic or affect-based forms of knowledge in the theoreticist tradition. Second, Bakhtin challenged the

segregation between the self and its surrounding environment in this tradition (and the consequent tendency to diminish the reciprocal agency and material specificity of that environment). And third, Bakhtin argued for the essential interdependence of self and other in their own "obligatively unique" interrelationship. "I am conscious of myself and become myself," as he writes, "only while revealing myself for another, through another, and with the help of another."[42] I would argue that each of these reconfigured relationships has a direct bearing on our understanding of socially engaged art. Thus, the forms of passional, bodily experience that emerge in the escrache performances or the Cleveland Convening, for example, constitute an important component of their aesthetic behavior. Here we find a parallel with the role of affect in the Enlightenment aesthetic, in which the pleasurable experience of beauty is meant to demonstrate our subjective inclination toward social harmony. In the case of the escraches, pleasure is linked with the joyful sense of transformative agency released by collective resistance against a system of monological domination. Rather than associating this emotion with the prefigurative anticipation of a future sensus communis, it is called forth by the creation of social or political change in a context in which no change seemed possible, as both an enactment of change and an anticipation of more systematic change yet to come. In the same way, creativity is generated in engaged art practices through an interactive engagement with the specific material, institutional, and social forces that structure their surrounding environment. This is evident in projects such as Dialogue and *Tamms Year Ten*. Here the practitioner seeks to decipher the complex forms of situational experience that unfold in a given site with the implicit understanding that any effort to represent the "totality" of this context will necessarily remain incomplete. This experiential matrix and the unique modes of haptic, cognitive, and affective knowledge that unfold within it provide the decisive points of creative intervention for any project. Much of the generative potential of these projects derives precisely from the reciprocal call-and-response dynamic that unfolds between the site (and the aggregation of agents, institutional forms, physical conditions, and social forces that constitute it) and the gestures, interventions, and new forms of relationality set in motion by a given project.

Finally, in almost all of the projects I have referenced here, from the intimate exchanges of *Radio Khiaban* and *Offering of Mind* to the reparative social forensics of the pre-escrache encounters and the viral proliferation of *Lava la Bandera*, we encounter an experimental engagement with new forms of intersubjective exchange and with the relationship between self and

other. More specifically, these projects share a commitment to developing alternative modes of social interaction, creation, and decision-making that have practical effects (in advancing specific forms of resistance) while also facilitating the creative, dialogical transformation of the individual agents undertaking this resistance. In socially engaged art, we have a paradigm of political transformation that no longer uncouples these two valuative systems (externally directed praxis and self-transformation) under the assumption that the "social labor" of creative and compassionate coexistence will be rendered redundant by a violent revolutionary transformation and the utter reinvention of the human personality that it will, ostensibly, precipitate. Instead, these projects insist that this work, the work of living and creating together in a manner that enhances our individual and collective freedom, of devising new and more equitable social forms, can no longer be deferred or displaced. In their practical engagement with resistance, these projects acknowledge that we can and must produce concrete changes in existing structures of domination. But, at the same time, they contend that this pragmatic orientation must be integrated with rather than exiled from visionary and prefigurative insight into the constitution of the self and the social precisely in order for us to gain some experiential sense of the new society for which we are fighting (and toward which resistance must always be oriented).

Here, again, we encounter a symptomatic contrast with existing aesthetic paradigms. In conventional aesthetic experience, the decisive moment of self-transformation occurs in the individual's apperceptive intuition of the sensus communis. Moreover, for Kant, those forms of affect and experience that entail an outwardly directed relationship to the world are collapsed into variant expressions of possessive instrumentality or cognitive mastery. As a result, the experience of taste-based "liking" that is meant to represent the self in its most authentic form actually requires us to empty out the desires, values, and personal histories of that self, leaving only a vestigial psychic core of "disinterested" subjectivity. Thus, one is only prepared to engage with otherness, even virtually, by disavowing an experientially specific sense of self and being in the world. (This is what gives our aesthetic judgments a fully "objective" quality in Kant's view.) In the aesthetics of socially engaged art, the specific life histories, interests, and value systems of each self, far from being impediments, are the very media through which intersubjective experience acquires its transformative potential. These are the materials, the modes of difference and differentiation, that must be worked through in practice in order to redefine the relationship between self and other.

When the individual Peruvian citizens banded together in improvisational coalitions to conduct the flag-washing ceremony in Lima's Plaza Mayor or when the members of Colectivo Situaciones ventured into the neighborhoods of Buenos Aires to conduct the pre-escraches, they had to engage in complex negotiations across differences of culture, geography, personal history, and so on. Drawn together in praxis, the participants in these actions gained a new sense of themselves and their place in the world. They also came to realize that the agency they experienced as a group or social assemblage was greater and more variegated than the agency they possessed on their own. Equally importantly, all of these projects entailed interactions between self-identified artists and members of a more general public or community. However, these interactions were not driven by the assumption that the artists possessed an intrinsically superior insight into the operations of power or the mechanisms of creative resistance. Rather, we encounter in all of these works a more open-ended and less static engagement between artists and nonartists and between art, as its conventionally understood, and elements of what Bakhtin identified as prosaic culture, the forms of creative expression (public singing, dancing, murga bands, communal washing) that unfold through our daily interactions. This does not mean that these interactions are not also characterized by moments of dissensus and shifting forms of authority. What is different, however, is the fact that these subjective modalities are not permanently assigned to fixed individuals (the "artist" versus the "public") but are mobile and transient. Insight is not carried into these situations by a single, privileged agent but, rather, is generated *through* these situations and the social interactions that they precipitate.

For Viktor Shklovsky, cultural forms associated with daily life (work songs, for example) are invariably assumed to be habitualized and utilitarian. In socially engaged art practice, however, the prosaic social labor of resistance is seen as generative, not iterative, and capable of reshaping the personality of the individual participants as well as the broader social environment. This brings us to an important set of observations regarding the underlying conceptual architecture of Bakhtin's aesthetic. In each case outlined above we can identify a set of terms that were previously organized around a concept of absolute autonomy (of mind from body, of individual from material environment, of the poetic from the prosaic, and of self from other) reconfigured into a new relationality. But how precisely is this new relation different? This is the question that Bakhtin answers in the second phase of his aesthetic research, as he seeks to overcome the incongruity between his aesthetic and philosophical research. In Bakhtin's turn toward

a "polyphonic" interpretation of Dostoevsky, he provides a more detailed account of the actual form taken by this new mode of intersubjectivity. It is, of course, opposed to the "monological" drive of the bourgeois individual (the self, seeking to master the other), which takes on an increasingly efficient form in the modern era. "Capitalism," as Bakhtin wrote, "created the conditions for a special type of inescapably solitary consciousness."[43] In this respect, Bakhtin's work is consistent with the longer history of the aesthetic, which has always defined itself against the grain of possessive individualism, from Kant's "disinterested" subject to Adorno's attack on instrumental reason. However, the social form that Bakhtin proposes as an alternative to this tendency is founded on a very different ontological paradigm.

While both the Enlightenment and the avant-garde aesthetic traditions seek to challenge intersubjective violence, they nonetheless retain key elements of a conventionally autonomous model of the self. For Kant, this is evident in the monological ethical paradigm that Bakhtin critiques. In the case of the avant-garde tradition, autonomy is reinvented as a defensive mechanism, as the individual artist or theorist becomes the repository of an otherwise endangered form of critical or revolutionary consciousness. Bakhtin's research is significant for my inquiry precisely because it calls into question the mode of (subjective) autonomy that is otherwise so often normalized in the long history of aesthetic thought. Bakhtin was able to experience firsthand the persistence of certain aspects of monological consciousness within the lifeworld of a postrevolutionary communist society and therefore also able to grasp the continuities across both capitalism and communism of certain pathological effects associated with the singular privileging of autonomous thought (the absolute autonomy of the party and the absolute autonomy of the bourgeois self). This does not mean, however, that Bakhtin sought to simply invert the principle of autonomous selfhood. He was fully aware of the profound costs of the political imperative to fuse the individual with the collective, which, for Bakhtin, was just as destructive as the drive to deny the necessarily social foundations of the individual self.[44] Thus, he echoes Dostoevsky's "hostility to those world-views which see the final goal in a merging, in a dissolution of consciousnesses in one consciousness, in the removal of individuation." He advocates, instead, "Not another person remaining the object of my consciousness, but another autonomous consciousness standing alongside mine, and my own consciousness can exist only in relation to it.[45]

By extension, Bakhtin does not seek to simply dismantle the concept of authorship in its entirety. As he makes clear, dialogic experience does not

entail the simple dissolution of the self, either through the subordination of the individual to the social or through forms of empathetic identification in which the self is entirely submerged in the experience of the other. Instead, Bakhtin insists on the necessity of "not merging with another, but of preserving one's own position of *extralocality* and the surplus of vision and understanding connected with it."[46] One must retain a sufficiently stable form of selfhood to engage in dialogical exchange in the first place to allow the reciprocal unfolding of the identities of both self and other (in a context in which both agents exercise their unique "surplus" of vision relative to the other). However, the stability of this unmerged self is no longer dependent on a fixed notion of autonomous subjectivity. Thus, Bakhtin seeks to rethink the very constitution of the self and the ethico-ontological principle of autonomy on which it is based. This extends to the psycho-spatial model on which autonomous selfhood depends, defined by fixed categories of "inside" (the realm of authentic selfhood and the singular locus of reflective and critical insight) and "outside" (the source of alien, determinant forces that threaten the integrity of the internalized self). It also extends to the idea that the stability of the self is not a constant and unchanging feature of subjectivity but one moment within an unfolding continuum that necessarily fluctuates between intersubjective vulnerability and receptivity and reconsolidation. For Bakhtin, the self is precisely located at the interstices of self and other, where it is continually being produced and reproduced, disassembled and reinvented. Thus, Dostoevsky's novels perform, in a manner of speaking, the coexistence of discrete selves, each possessing the same potential for agency and creativity. Here the mastery of the author that was so central to Bakhtin's earlier account of the novel gives way to a description of the essential mobility of the author function within the social landscape of the novel.

Bakhtin's analysis of the reciprocal opening of self to other and the creative invention that occurs in this interstitial space provides a useful framework for understanding the prefigurative processes set in motion by socially engaged art. This prefigurative dimension does not imply a simple lapse into unmediated sociality (the individual "dissolved into the collective"), nor does it imply that these interactions represent some finalized moment of absolute intersubjective reconciliation. Bakhtin rejects a notion of intersubjective exchange "where a full and dead balance is achieved, where there is no struggle, where there is no living I and other, no living and lasting interaction between them."[47] Rather, he will insist that dialogical interaction necessarily incorporates moments of dissent and disagreement because this resistance, this dissension, is the very material through which two equally

active selves achieve new insight into the constitution of both the self and the social. These interactions are no longer defined by "completion," "unity," and "finitude" but, rather, exhibit an essentially "unfinalizable" nature. The invention of self through an engagement with otherness is no longer arrested in the production of a single, fixed image but instead is viewed as an ongoing, creative process defined by mobility and incompletion.

By the same token, the prefigurative interactions that unfold in socially engaged art are not intended to evoke some final, frictionless melding of self and other. Rather, what these processes seek to generate is an experiential and experimental insight into the mechanisms by which self and other are drawn together and pushed apart, moving through phases of dissensus and conciliation as they think, act, and perform together in a manner that diminishes violence and facilitates the creative transformation of the surrounding world. These are precisely the skills, the modes of thinking and being, that will be essential now and in the future in order to secure any practical improvement in our shared social condition. Here the limitations of premature desublimation are revealed. Premature desublimation can only envision any manifestation of social harmony in the guise of its teleological endpoint, as a fixed and absolute social condition. Since this condition is understood as the final stage in the development of a universal human capacity, any partial or provisional realization of it necessarily constitutes a betrayal of its underlying potential. In this tradition of thought, it is impossible to recognize the reciprocal interaction of dissent and reconciliation, negation and solidarity, in socially engaged art as part of a broader transformative process. Thus, any artistic practice that facilitates the practical expression of a conciliatory relationship between self and other here and now must surely intend it to mark the completed expression of utopic future rather than the situationally specific manifestation of the social labor necessary to produce change in the first place. Alternately, the premature desublimation critique assumes that these practices are driven by the naive belief that all that is necessary to bring this utopic condition into universal existence is to simply actualize it in a single site or instance.

Here I want to summarize some of the central insights that have emerged from my analysis of Bakhtin's work, as it bears on the aesthetics of socially engaged art. First, I have argued that socially engaged art is defined by its ability to sustain, within a single field of praxis, prefigurative modes of intersubjective experience and action-oriented forms of resistance. This is consistent with the aesthetic recoupling of the self and its surrounding environment that emerges out of Bakhtin's initial critique of (Kantian)

theoreticism, in which our perception of the external world is merely a pretext for attending more closely to the cognitive operations of our own minds. In socially engaged art, the "external" environment with which the self interacts is no longer simply a static trigger for deeper, self-reflective insight but, rather, possess an active, reciprocal agency of its own, both affecting the formation of the self and being affected in turn. And, in socially engaged art, the materiality of this environment extends to the ensemble of ideological and institutional (as well as physical) forces that structure a specific site of praxis. If social labor implies a concept of sociality oriented toward concrete political change, Bakhtin's work can help us complicate the forms of solidarity-based interaction that are typically associated with this process. In the Marxist tradition, an emancipatory solidarity is generated by the shared experience of oppression and the imperative to band together in order to destroy a common class enemy. This requires, however, recourse to potentially instrumentalizing forms of collectivity, as proletarian subjectivity is defined against the grain of a negated bourgeois other. As a result, the recognition and negotiation of any actual differences (of race, ethnicity, sexuality, etc.) among the individual subjects who constitute the proletariat are repressed under the assumption that its future transmogrification into a "universal" class will render them politically irrelevant. Bakhtin suggests a form of solidarity that acknowledges our necessarily differentiated subjectivity here and now rather than depending on the reflexive negation of one form of collective selfhood by another.

As this outline suggests, the coexistence of prefigurative expression and social or political resistance entails a complex interrelationship between very different modes of insight. Resistance implies, of course, pragmatic action oriented toward the achievement of specific, concrete changes in a given system of domination. This interaction is reciprocal, to the extent that it involves ongoing transformations in the underlying compositional structure of artistic practice as it responds to the counterforce mobilized by a specific regime of power (the provocateurs who sought to disrupt the flag-washing performances in Peru, the police barricades around the homes of junta members in Argentina). While this necessarily involves forms of speculative creativity, it also requires an instrumental orientation toward the specific ideological and institutional systems that are impeding change. And while the relationship that socially engaged art takes up to these institutions and the individuals who sustain them can potentially enhance a reflective awareness of the meta-conditions that structure individual and social identity (or that predetermine the value structures of domination itself) they are

often primarily antagonistic in nature. Moreover, they often speak both to and through the targeted individual to another audience (in the way that the escraches were less concerned with catalyzing remorse among former junta members than with mobilizing a sense of agency among the assembled crowds). Here the other serves as an embodied (and clearly objectified) locus of repression, which can be used instrumentally to produce a subjective transformation in the consciousness of project participants or audience members. The same dynamic occurs in the *Lava la Bandera* performances, relative to the personality of Alberto Fujimori. At the same time, the intersubjective exchanges that unfold within and among the participants and, in some cases, between those participants and a larger public have a different orientation. These interactions, too, are reciprocal, but here reciprocity is predicated on a conscious disavowal of sovereignty and a deliberate receptivity to the shaping influence of the other on the self and the self on the other, evident in the virtual community created by *Radio Khiaban*. External determination is no longer viewed solely in terms of an antagonistic relationship to the other but as the very precondition for the fuller articulation of the self. The result is a drawing together of self and other in a way that that has emancipatory potential. One self is not collapsed into the other through empathetic overidentification, but neither does one self seek to vanquish or objectify the other. Instead, these dialogical relationships challenge the very concept of "self" reflection as the sole origin of critical insight.

This process entails a decentering but not a dissolution of the self. Rather than surrendering authorship per se, Bakhtin's dialogical paradigm simply calls into question authorship in its monological form. As he writes:

> Our point of view in no way assumes a passivity on the part of the author, who would then merely assemble others' points of view, others' truths, completely denying his own point of view, his own truth. This is not the case at all; the case is rather a completely new and special interrelationship between the author's and the other's truth. The author is profoundly *active*, but his activity is of a special *dialogic* sort. . . . This is a questioning, provoking, answering, agreeing, objecting activity; that is, it is dialogic activity.[48]

This insight has important implications for the analysis of socially engaged art projects in which authorial subjectivity is openly thematized rather than being seen as a fixed capacity assigned to specific, institutionally demarcated individuals. At the same time, the function of artistic subjectivity is

transformed in Bakhtin's analysis. Rather than the artist standing "outside life" to offer the other a unified or "complete" image of an experiential totality that is beyond their grasp, the author is conceived as an unfinalized project, possessed of only a partial knowledge and requiring the dialogical interaction of other selves to gain any meaningful insight into a given site of praxis. And, rather than unilaterally awakening the consciousness of the other, insight is produced situationally between self and other or artist and collaborator, each of whom possesses the capacity for ignorance and insight, dialogical openness and defensive isolation.

Just as Bakhtin's analysis implies a reconfiguration of authorship, it also provides us with new insight into the status of the work of art itself as a "finalized" or "complete" system of meaning. For Bakhtin, conventional aesthetic finalization operates on two levels. First, the "finalized" work of art is one in which a full and complete image of the other, only accessible to the author, is rendered into a comprehensive literary representation that captures the totality of their being. Finalization is also imposed when the desires, intentions, and actions of the discrete "selves" represented in a novel by individual characters are entirely subordinated to an overarching narrative goal, determined by the author. Only those characterological actions or thoughts that advance this a priori goal are permitted. As a result, the novel is understood as a vessel for the expression of single fixed meaning that emanates from and is always controlled by the unilinear consciousness of the "author."[49] These two gestures function in tandem, as the narratological telos of the novel operates as a form of totality "hidden" from the individual agents who are assigned to act it out and available only to the author. In the polyphonic novel, by contrast, the reader is presented with a range of voices, values, and story lines rather than a single, resolved truth. As Bakhtin writes, this attitude challenges the transcendence of conventional authorship. "This is no stenographer's report of a *finished* dialogue," as he writes of Dostoevsky, "from which the author has already withdrawn and *over* which he is now located as if in some higher decision-making position." Rather, "in Dostoevsky's novels the author's discourse about a character is organized as discourse about someone actually present, someone who hears him (the author) and is *capable of answering him*."[50]

A monological orientation is also evident in the image of the avant-garde artwork as a self-contained formal totality that remains "hermetically closed off or blind" to the surrounding social world. This "closed off" quality extends, of course, to the artwork's relation to actual viewers. Thus, the avant-garde work, as Adorno argues, must "show no concern for a viewer,

real or ideal, whose reflexes become unimportant."[51] In fact, the circulation of a given work within a larger social or cultural circuit, according to Adorno, is inversely proportional to its critical power. Thus, the more widely a work is seen, the less able it is to properly "negate" the culture surrounding it, as its subversive power is depleted by repeated exposure to the degraded consciousness of the general public.[52] This perception offers a symptomatic contrast with the ways in which we understand reception in socially engaged art. Here the perceptions, consciousness, and agency of collaborators or participants are an essential component of the aesthetic work itself. Moreover, the proliferation of a given gesture over time (the re-performance of the flag-washing gesture or public singing) can actually serve to enrich and complicate the forms of insight it generates as it passes from one set of interlocutors to another. This entails a fundamentally different paradigm of artistic agency. "It is one thing," as Bakhtin writes, "to be active in relation . . . to voiceless material that can be molded and formed as one wishes, and another thing to be active *in relation to someone else's living, autonomous consciousness.*"[53]

The implications of aesthetic finalization extend from the realm of authorship to our understanding of the ontology of the artwork itself. Here again Bakhtin can help us more clearly comprehend the distinctive nature of contemporary socially engaged art practice. We can identify corollary expressions of finalization on two related levels in mainstream art. First, finalization is produced by the spatial and ideological enclosure of the institutional art world that privileges works of art that are presented as discrete, fixed events or objects with clearly demarcated points of inception and conclusion and in which the work of art is produced and finished by the artist in a space that is separate from the space of reception (the studio versus the museum). In this case, the primary generative moment, the moment when decisive choices are made regarding the formal, material, and discursive constitution of the work as a unified, apprehensible object, occurs prior to the arrival of the viewer. Here production and reception are sequential, while in socially engaged art practices they are often simultaneous within a single site. Because the boundaries of the work are finite and often predetermined by the limitations of a specific exhibition space or commissioning process, it is a simple enough matter to identify the "object" of analysis (an installation, project, painting, or performance that begins and ends at clearly marked points in time).

Socially engaged art practices, on the other hand, can unfold over weeks, months, and even years, and their spatial contours or boundaries typically

fluctuate, expand, and contract over time (evident in the seriality of the escraches or *Radio Khiaban*). The spatial parameters of the work cannot be predetermined and follow instead the immanent logic of the dialogical process itself. For example, the work of Dialogue in India shifted over time from the construction of water pumps to the creation of children's temples, as its ongoing creative practice opened up new insights into the operation of power and agency in the villages around Kondagaon. As a result, this work confronts us with a very different set of questions. When does the work "begin," and when does it "end"? What are the boundaries of the field within which it operates, and how were they determined? Because we are dealing with an unfolding process rather than or in addition to a discrete image, object, or event defined by set limits of space (the walls of a gallery) or time (the duration of a performance or commission), these questions become decisive in the analysis of the work. The un-finalizable quality of dialogical aesthetic production requires us to understand and conceptually thematize the boundedness of the field of practice and how these boundaries have been produced, modified, and challenged rather than taking them as givens, dictated by the protocols of the institutional art world.

The process of finalization in conventional, object-based art practice also operates at the hermeneutic level. For Adorno, it is the internalized perfection of the "flawlessly structured" work of art that ensures its survival against the appropriative mechanisms of capitalism, as well as its "truth content" as the only remaining site of cognitive opposition to these same mechanisms.[54] While the work of art must necessarily preserve certain unresolved tensions within its immanent formal structure, these tensions must be carefully contained within "finished congealed objects."[55] Here an internalized, symbolic dissonance is subsumed within a "closed," "seamless," and "tightly organized" formal whole (a musical composition, painting, or novel).[56] For Adorno, the principle of nonidentity, the resistance to categorical stasis, can only be preserved in a finalized formal matrix that must remain closed off from "external" influence and is thereby dependent on the very form of categorical thought (in this case exemplified by the division between interiority and exteriority) that it seeks to unsettle. This is, of course, precisely the distinction that is questioned by Bakhtin in his effort to challenge the theoreticist tradition and recouple mind and body, subject and environment, and self and other. The spatial autonomy exhibited by Adorno's "closed" and "finished" artwork is paralleled by a model of hermeneutic temporality that is entirely discontinuous with existing experiential reality. Thus, new insight is transmitted to the viewer through a singular moment of synchronic disruption

or "tremor" as the viewer, according to Adorno, finds the "whole of their consciousness transformed ... in an instant."[57] This model of reception assumes a viewer who is operating under the enforced thrall of an imposed ideological system, which can only be broken by a countervailing moment of homeopathic violence. As a result, there is no understanding of receptive time beyond the moment of disruption itself, no account of the sustainability of this transformed consciousness in subsequent forms of social interaction. With socially engaged art practices, the transformation of consciousness is diachronic. Its temporality is both extensive and irregular, marked by a series of incremental subdivisions within the larger, unfolding rhythm of a given work, passing through phases of conflict and resolution, dissent and reconciliation, resistance and accommodation. These tensions are no longer contained within a discrete and finished whole but, rather, distributed along a continuum of interactions and encounters. They are generated by the gathering together and disaggregation of bodies within a given project and the ways in which these varying proximities inflect the meaning of the work and the consciousness of the participants through language, movement, action, and physical gesture.

Bakhtin, writing in the midst of one of the most authoritarian regimes of the modern era, nonetheless retained his faith in the emancipatory potential carried in the most quotidian forms of daily human interaction. Throughout his life, he sought to assert the creative agency of the individual against a structuring mechanism (language, ideology, or theoreticism) that threatens to efface this agency and impose instead a monolithic and coercive nomos. It is this capacity, of course, that is called into question by the discourse of the avant-garde, with its persistent skepticism regarding the intellectual acuity of the masses. It is easy enough to understand this skepticism, given the demonstrated human propensity for self-interest and delusion. Here it is worth noting that the Marxist concept of "social labor" outlined in chapter 5, which attributes a critical-expressive agency to the working class through the "media" of language and work, is drawn from *Marx's Economic and Philosophic Manuscripts of 1844*. It is precisely this body of work that will be rejected by Louis Althusser during the efflorescence of structural Marxism during the 1960s as a relic of the young Marx's youthful and "ideological" naïveté before he achieved a properly "scientific" mode of analysis in his later writing.[58] Althusser contends that the early Marx retains an embarrassing attachment to the idea of an essential human condition and, by extension, an investment in the cognitive agency and autonomy of the working class that might be mobilized through it.[59]

Only the theorist, employing the insights provided by a scientific form of Marxism, is capable of penetrating this veil of mystification or of even recognizing its existence in the first place. The theorist is called upon, in Althusser's words, to "purify our concept of the theory of history, and purify it radically, of any contamination by the obviousness of empirical history."[60] Michel Foucault, observing the response of French intellectuals to the publication of Aleksandr Solzhenitsyn's *Gulag Archipelago* in 1973, draws our attention to the implications of this "purification."

> Now, an entire Left has sought to explain the gulag, if not, like wars, by a theory of history, at least by the history of theory. Massacres, yes, yes; but it was a terrible error. Reread therefore Marx and Lenin, compare with Stalin, and you will well see where the latter went wrong. So many deaths, it is clear, could only have come from a misreading.... Against Stalin, do not listen to the victims; they would only have their torments to relate. Reread the theoreticians; they will tell you the verity of truth.[61]

Here the brute facticity of the past, the "empirical" unfolding of actually existing communism, is a matter of relative indifference within the broader historical telos of capitalism. The suffering of the gulag is simply the result of the failure of Marx's epigones to apply his theory with the proper, scientific rigor and can be corrected by a renewed exegesis of the a priori truth contained in the original theory. Only a theory that entirely transcends the incidental and accessory events of empirical reality, in whatever form it might take, is capable of shedding any light on our current condition or our future emancipation. By the same token, the prosaic events of daily life and the human actions, expressions, and interactions that unfold within it are defined by impurity and ideological overdetermination and are incapable of generating any meaningful insight. It is symptomatic, then, that the most influential feature of Althusser's writing among Anglophone readers derives from his account of the relentless ideological "interpellation" of the masses through a seamless hegemonic system that collapses together state, capital, and civil society into a single, coordinated "Ideological State Apparatus."[62]

What theory promises, within the avant-garde schema, is twofold. First, it offers us a way to grasp the macropolitical totality of the capitalist system. Without its guidance, we are destined to lose sight of the systematic, structuring force of capitalist domination that subtends all its epiphenomenal expressions, which bourgeois (or humanist) thought can address only in a piecemeal and reformist manner. And second, theory offers us a distilled force

of absolute negation, which refuses any accommodation with existing power and makes demands on behalf of a (utopian) future that has yet to come into practical existence. How, then, do we navigate between the macropolitical dimension disclosed by theory and the situational and "empirical" forms of intersubjective micro-politics evoked by Bakhtin? Theory provides one way to access this macropolitical dimension, but it is not the only avenue. It is also the function of social labor, in its dialogical mediation between theory and practice, and the individual consciousness and collective action to open up a potential awareness of the broader totality of capitalist domination as individual forms of practice and resistance are transmitted, modified, and expanded over time. It is precisely this continuum of experience that is evident in the broad range of socially engaged art practices that have emerged since the 1990s. Moreover, these practices sustain a form of critical negation in their antagonistic relationship to concrete forms of social and political domination, no longer sublimated into the immanent conditions of art. In the final chapter I will ask how the dialogical relationship between the micro and macro political registers outlined here can help us understand the potential for meaningful social transformation today, and the role that engaged art might play in that transformation.

7

BEING HUMAN AS PRAXIS

The World Symposium

To live means to participate in dialogue: to ask questions, to heed, to respond, to agree, and so forth. In this dialogue a person participates wholly and throughout his whole life: with his eyes, lips, hands, soul, spirit, with their whole body and deeds. They invest their entire self in discourse, and this discourse enters into the dialogic fabric of human life, into the world symposium.

—Mikhail Bakhtin, *Problems of Dostoevsky's Poetics* (1929)

Bakhtin's writing can help us recognize the potentially aesthetic qualities inherent in the forms of intersubjective exchange that unfold in socially engaged art practices. This interpretation depends in part on the complex interrelationship between Bakhtin's early philosophical analysis of intersubjective experience and his theory of dialogical aesthetics in the novel. In each context, Bakhtin stresses the generative qualities of the face-to-face encounter and the "dialogic nature" of both "consciousness" and "human life

itself." Here, at the experiential level, we can access a form of sociality that challenges the monological imperative that is otherwise so prevalent in contemporary life. Of course, we engage in face-to-face encounters virtually every day, but they seldom result in a consciousness-altering experience of interdependent selfhood. In the same way, we regularly experience moments of contemplative self-awareness that do nothing to enhance our consciousness of the contingency of our own perceptions (or, for that matter, to induce a "tremor" of critical class consciousness). What Bakhtin suggests is simply that there is always an emancipatory possibility implicit in these encounters.[1]

One of the defining characteristics of socially engaged art is the desire to actualize what Bakhtin calls the "event potential" of human social interaction: to bring it out of the "narrow sphere" of normative discourse and, by situating it in the charged context of a specific site of praxis, to lift it to a higher level of articulation. This intention is evident across the wide scalar range of projects I have addressed, from the covert performances of *Radio Khiaban* to the boisterous street actions of the escraches. Whether and to what extent this emancipatory insight is actually produced will vary from one project and one context to the next, but I would contend that this goal *orients* socially engaged art in a fundamental way (just as the goal of a privatized ontic destabilization orients conventional avant-garde practices). This perception, of course, conflicts with Shklovsky's description of the unremitting habitualization of daily life, as well as the bleak assessment of the human potential for emancipatory consciousness that emerges in Adorno's later writing. This accounts for the important interconnection between Bakhtin's work and the more optimistic view of human nature that motivates the concept of social labor in Marx. Bakhtin's work places us in touch once again with the de-transcendentalizing ethos of Marxism itself, as it sought to challenge the displacement of human agency and consciousness to some higher authority (god, king, and eventually party). Bakhtin also returns us to the foundational role of the aesthetic and aesthetic autonomy in this process.

Autonomy emerges in the Enlightenment to challenge the repressive transcendental authority associated with absolutism. To be autonomous was to be free to think and act on one's own behalf and to participate directly in the dialogical creation of the societal norms that structure daily existence. But the concept of autonomy conceals a deeper aporia; how can an entirely self-generated process lead to the creation of normative values that will be freely embraced by other selves? The aesthetic emerges, in part, to cover over this tension through the metaphysical device of a *sensus communis* that will re-transcendentalize the foundational question of how differences

between self and other might be reconciled in practice. It does so through the individual subject's privatized discovery of an innate altruistic capacity (via the experience of beauty), which effectively renders the actual technics of collective interaction (as a creative form of social practice that generates new insight and mobilizes an ongoing process of reciprocal learning) redundant. At the same time, the aesthetic offers us a unique articulation of the material and phenomenological conditions necessary to actualize, rather than defer, this dialogical process in the experimental interplay between cognition, affect, and somatic experience in our encounters with art. We might say, then, that the migration of autonomy and its corollary political potential, into aesthetic form resulted in a dual movement. Even as it was subjected to its own re-transcendentalization, through the fear of our human inadequacy (set in place by the perceived prematurity of the French Revolution), the aesthetic also marked the potential realization of this norm-generating process in the somatic and cognitive interaction of human selves seeking to frame their own collective coexistence. It is this alternative trajectory of the aesthetic and of modernity that runs from the Paris Commune to Varvara Stepanova to Tucumán Arde to Colectivo Sociedad Civil and beyond. It has been my contention that socially engaged art seeks to activate this latent potential in the current historical moment.

Bakhtin's work is important for the analysis of socially engaged art because he so cogently captures the implications of the transcendentalist turn and the accompanying displacement of conscious human agency. As he writes in *Toward a Philosophy of the Act*: "The power of the people, according to Hobbes, is exercised at one time only, in the act of renouncing themselves and surrendering themselves to the ruler; after that the people become slaves of their own free decision. Practically, this act of an original decision, the act of establishing values, is located, of course, beyond the bounds of each living consciousness."[2] The "act of establishing values . . . beyond the bounds of each living consciousness" is, of course, epitomized by the categorical imperative, sensus communis, and the ongoing series of metaphysical principles that have been employed in the history of liberal thought to justify existing inequality and defer the moment of its eventual overcoming. Bakhtin returns us, then, to the potential implicit in the aesthetic before it underwent its symptomatic re-transcendentalization (into privatized consciousness, into the realm of semblance alone, into the choreographed tension of "immanent" artistic form). Or we might say that Bakhtin seeks to recover a potential that has been implicit in the unique intellectual nexus of the aesthetic since its inception, a potential that would return us to the actual moment of embodied,

democratic norm generation among individual selves. The transcendental aesthetic is founded on the belief that we must first unlock an innate capacity for social harmony (or reflective self-awareness) before we engage in the collective generation of new norms. Socially engaged art practice is based on a very different understanding of the aesthetic, in which we have the capacity to transform our world here and now. This is the ongoing "world symposium" of human dialogical interaction: inevitably inadequate, provisional and constrained, but also always charged with potential. The affect that is generated by these de-transcendentalized aesthetic encounters is driven by the realization that we have the power to create our own norms: to reclaim the meaning of the Peruvian flag or public space or to reinvent the concept of a defiled justice. And it is mobilized as well by the prefigurative awareness that this capacity can be cultivated, expanded, and enriched through ongoing practice. Rather than being oriented toward the telos of a finalized condition of total social harmony (full Communism, the aesthetic state), these projects are linked with the recognition that this process of dialogical reinvention is an essential feature of our social existence, not a vestigial trace of a more primitive human condition.

There remains, however, a potential incongruity in Bakhtin's account of artistic practice. His aesthetic paradigm is predicated on the essential distinction between a monological form of artistic production in which the other is reduced "to voiceless material that can be molded and formed as one wishes" and a dialogical practice in which the author only comes fully into existence "in relation to someone else's living autonomous consciousness."[3] However, this alternative aesthetic paradigm unfolds in the context of an artistic genre that remains resolutely monological. The modern novel is, in many ways, the quintessential expression of bourgeois interiority and self-reflective consciousness (the "last surviving literary art form in bourgeois culture," as Christopher Caudwell famously observed).[4] The paradigm of dialogical selfhood outlined in Bakhtin's philosophical writing requires the ongoing, reciprocal interaction of two or more concrete selves. But the novel is created by a single author, generating a narrative that inevitably comes to a point of completion. While that narrative may well represent an other self at a heightened level of clarity, there is no way for that other self to register their reciprocal response in the unfolding form of the novel itself. Moreover, when the author employs their "excess of seeing" to produce an enriched image of the other, they are not, by and large, representing a living human subject. Rather, they are inventing a fictional character in a universe of their own creation.[5]

This outline suggests a paradigm of creative expression in which the author's own subjectivity is not fixed, but remains open to the shaping influence of otherness, even if this is only experienced within the imaginary confines of the novel and individual creative production. At the same time, we might describe this process, of an artificial introjection of otherness into the author's own consciousness, as yet another iteration of the transcendental reduction. We have here not an actual dialogue but a facsimile that is all the more problematic because it covers over the fundamental and ultimately determinant authority of the actual, monological author. Bakhtin's writing offers an exemplary expression of the generative tension between transcendentalization and actualization in the aesthetic. On the one hand, we have a persistent desire to overturn the theoreticist displacement of critical consciousness and return it to actual processes of embodied, social interaction. On the other hand, Bakhtin's discussion of artistic practice focused almost exclusively on the genre of the novel. From Bakhtin's perspective, can art perform dialogically only at the symbolic level, within the enclosed consciousness of the author in communion with other selves of his or her own creation? Is it still necessary, even for Bakhtin, for the artist to remain detached from reciprocal, physically proximate interaction with other actual selves? And, by attempting to use Bakhtin's theory to discuss socially engaged art, am I abandoning what he would consider an essential component of artistic practice: the specific mode of semblance-based mediation provided by the novel? Finally, would socially engaged art, in Bakhtin's view, constitute a form of premature de-sublimation, in which art is perilously collapsed into the routinized banality of "real life"?

To phrase the question in this manner, I would argue, already concedes too much. The concept of premature de-sublimation assumes that art's role is to sustain a form of consciousness that no longer exists in contemporary social life, preserving it for some future moment of authentic praxis. But Bakhtin's aesthetic paradigm is predicated on the underlying continuity between art and life, neither of which is singularly privileged as a locus of meaning. His concept of prosaics is intended to acknowledge the fundamental creativity (and emancipatory potential) of everyday communication, here and now. In this view, art does not preserve something absent from life, but rather seeks to enhance, intensify, or thematize an existing aspect of human intersubjective experience. Here art's relationship to life is not primarily compensatory, but rather complimentary and synergistic. This is not to ignore the extent to which daily life is, quite often, riven with forms of ideological domination, just as the realm of artistic (or theoretical) production is defined by

its own contradictions and complicities. It is, rather, the projection onto this complex social dynamic of an overarching schema of absolute purity or autonomy that Bakhtin helps us challenge. Bakhtin's analysis of the novel is not driven by the fear that its utopic potential might somehow transgress the blood–brain barrier between life and art, effectively giving itself over to immediate co-optation. Life itself already carries this potential and no longer requires art to serve as its exclusive vessel. The novel is simply one expression, in its own idiom, of a more general dialogical capacity that takes on many different forms, including, I would argue, that of socially engaged art.

As I have noted, my goal in writing about socially engaged art has never been to simply invert the binary opposition on which existing avant-garde discourse is based (in which advanced art is defined by its differentiation from an abject cultural other). Here avant-garde art practice would be consigned to the subordinate position (unknowingly elitist and solipsistic), while socially engaged art would be defined by its privileged and unmediated relationship to the social or political real. Rather, I would simply argue that each mode of artistic practice is capable of producing criticality and critical distance in its own unique manner, just as each mode suffers from its own constraints. The forms of insight generated by contemplative theoretical and artistic production (novels and sculptures, paintings and critical theory) are indispensable. In fact, Bakhtin's entire career exemplifies the value of individual, reflective thought. While I have discussed some of the limitations of avant-garde artistic practice in this study, I have no interest in questioning its ontological status as art, only in denaturalizing its claim to be the only legitimate form *of* art. Experience, at whatever scale it might be (from individual self-reflection to collective interaction) is, of course, always mediated and never "direct." It is, moreover, always infused with the potential for both emancipation and further repression. The problem, for me, emerges with the claim that artistic practices based on the absolute autonomy or monological authority of the artist offer the only source of legitimate critical or reflective insight and that all forms of artistic production that challenge this model of the self or that open themselves more fully to the dialogical influence of praxis are inevitably doomed to complicity and instrumentalization.

When trying to assess Bakhtin's own perspective on which forms of mediation are necessary to sustain a legitimate artistic practice and which forms of mediation threaten to dissipate art's emancipatory potential, we must also consider the historical context in which he was writing, especially after the 1920s. In particular, we must ask to what extent Bakhtin himself was forced to repress his early interest in intersubjective experience, outside the

formal genre of the novel. Thus, Bakhtin's reluctance to more fully explore prosaic social interaction can be attributed in part to the political context of Stalinist Russia, where theorists and writers could often speak of the social or political only indirectly, via metaphor or allegory.[6] In this sense, Bakhtin, in restricting his analyses to the novel form or historical research into the carnivalesque, demonstrates the mechanism of sublimation from the perspective of an achieved communist system, which would be threatened by the implication that existing social forms were anything less than ideal. Having said that, what interests me in this study is less Bakhtin's investment in a specific genre or medium than it is the underlying trajectory of his thought, as he consistently pushed against the constraints of dominant aesthetic paradigms that remained rooted in a monological orientation. In this respect, at least, he lays the groundwork for an analysis of the subsequent evolution of dialogical aesthetics across a broad range of artistic practices and media.

The Senses as Theoreticians

All of this moves toward the secret Marx revealed by way of the music he subjunctively mutes. Such aurality is, in fact, what Marx called the "sensuous outburst of [our] essential activity." It is a passion wherein "the senses have . . . become theoreticians in their immediate practice." The commodity whose speech sounds embodies the critique of value, of private property, of the sign. Such embodiment is also bound to the (critique of) reading and writing, oft conceived by clowns and intellectuals as the natural attributes of whoever would hope to be known as human.

—Fred Moten, *In the Break*

As I noted in the previous chapter, there are significant parallels between Bakhtin's concept of a dialogical aesthetic and notions of cross-cultural exchange or "creolization" that have emerged in the field of anticolonial theory, evident in the work of figures such as Glissant. Thus, Homi Bhabha, in his influential book *The Location of Culture* (1994), proposes a concept of ontological "hybridity" that draws directly on Bakhtin's work. For Bhabha, the complex cultural encounters that unfolded through European colonial expansion inadvertently laid the groundwork for the emergence of an (emancipatory) "Third Space" of enunciation, "in between the designations of identity," that renders all claims to an absolute cultural or subjective autonomy suspect.[7] "How are subjects formed 'in-between,'" as Bhabha writes, "or in excess of, the sum of the 'parts' of difference?"[8] Here the colonized subject

coming to recognize the continency of ostensibly transcendent forms of European identity mirrors the insights generated through the deconstructive ethos of postmodern theory. For his part, E. San Juan Jr. has advocated a rapprochement between Bakhtin and Antonio Gramsci to form a theoretical apparatus capable of grasping the politics of subaltern cultural resistance, against the grain of what he views as Bhabha's advocacy of a "radical alterity" that severs all operational linkage to the world of "objective reality" in which meaningful change is actually produced.[9] In this view, as San Juan argues, one can easily enough embrace forms of identity that subvert the sovereignty of the imperial self while doing nothing to link this liberated subjectivity to the forms of resistance necessary to question the power structure on which the imperial self depends. Bhabha thus challenges the notion of a self-identical and autonomous subjectivity rooted in European colonialism by recourse to an equally autonomous aesthetic paradigm drawn from that same tradition.

It is certainly true that Bakhtin's work can encourage a fetishization of the individual intersubjective encounter that sets aside or brackets entirely the necessary correlation between this level of ontological transformation and the processes of collective political emancipation. For me, one of the central lessons of a dialogical analysis lies in its capacity to unsettle a much broader series of hierarchical relays, not simply the relationship between self and other or fine art and prosaic culture but also the relationship between artistic production and praxis. This is why San Juan combines Bakhtin and Gramsci to affect a kind of theoretical cross-fertilization that joins the micro-political and macro-political registers (from the "changing of self" to the "changing of circumstances," as Marx wrote). This parallels my own gesture here in linking Bakhtin to the discourse of social labor in order to capture the essential interdependence of these two levels of experience. At the same time, there is something more at stake in the question of intersubjective experience than a privatized mode of self-transformation that only gains significance when it is actualized at a larger scale. As I have suggested through this study, one of the primary limits of existing Marxist paradigms of political change is the disconnection between often totalizing theories of class domination and the lived experience of both repression and resistance. There is little attention paid in this tradition to the specific forms of intersubjective experience out of which all larger coalitions and forms of praxis emerge. How do we come to act? Why do we choose to resist? And how does the experience of collective resistance change the nature of the individual self in a manner that has both practical and prefigurative potential?

Here we come to a significant distinction between mainstream Marxist theory and the broader field of intellectual inquiry focused on forms of oppression that operate at the intersection of class, race, gender, and sexuality. With some notable exceptions, Marxist theory has been composed by white, male bourgeois intellectuals (Marx, Engels, Lenin, Kautsky, Althusser, Adorno, Lukács, etc.). While these individuals might express some vicarious identification with the working class, their formative lived experience was determined by their economic, racial, and sexual privilege even as they strenuously rejected the underlying structure of the bourgeois social order that provided it. While they were able to learn, in a quite detailed manner, about the nature of working-class life, they had no direct, material experience of the myriad ways in which class subjugation was performed in and through the body of the worker, as well as the psychological and psychic mechanisms of both repression and resistance among workers. They had no idea how these forms of repression or emancipation felt at the bodily and experiential level. This absence is even more striking when it comes to the variegated forms of oppression that operate though the imbrication of class, racial, and sexual difference evident in the context of both colonial and European social orders. As it happens, these are also the same vectors of oppression that came to play a central role in the emergence of new social movements during the 1960s and 1970s, which I discussed in chapter 5. This accounts, in part, for the increased emphasis in the theoretical writing associated with these movements on questions of somatic experience.

This is evident, for example, across the field of feminist theory. As early as 1949, we find Simone de Beauvoir drawing on Maurice Merleau-Ponty's notion of "embodiment" to address the lived experience of women in *The Second Sex*. An interest in the forms of knowledge produced in and through the body has remained a central feature of subsequent feminist theory, as we see in the work of influential thinkers such as Luce Irigaray and Hélène Cixous during the 1970s and 1980s and, more recently, Susan Bordo, Rosi Braidotti, and Elizabeth Grosz, among many others. This set of concerns reemerged in second wave feminism during the 1960s and 1970s in conjunction with the embodied sharing of experiences of oppression through "consciousness raising," which I explore in *The Sovereign Self*. We can observe a similar interest in somatic knowledge in the area of Black Studies and artistic practice, ranging from Ralph Ellison's exploration of the complex phenomenology of race in *Invisible Man* to Fred Moten's recent writing on embodiment and Black cultural production. Here Moten employs a concept of "Black performance" to identity the "aesthetic, political, sexual and racial

force" of resistance that is registered in and through the body and the voice (he associates it specifically with diasporic musical traditions). Adorno viewed the avant-garde artwork as "the historical voice of repressed nature" because he believed the oppressed as such were incapable of resistance on their own. Moten, for his part, insists that "the history of blackness is testament to the fact that objects can and do resist."[10] In this body of work, we come to understand "the senses as theoreticians," as Moten writes, in a manner that has the potential to reframe our understanding of the aesthetic as entailing the dialogical linkage of mind and body in the act of dissent, thus transcending the "somatophobia" of the Enlightenment aesthetic.[11]

In both of these fields, the theorist has access to the bodily and cognitive experience of oppression. No matter how economically privileged you may be as a woman or person of color you also have to live with forms of sexism and racism, from the earliest stages of your existence, in a manner that will elude a theorist who has not. This is not to fetishize embodied experience, but it is to contest the often-implicit assumption that this form of experience, beyond "reading and writing," has no real epistemological value and is incapable of facilitating theoretical insight into the conditions of both oppression and resistance. The same set of concerns recurs in the field on anticolonial theory. Notwithstanding their ability to partially transcend forms of economic exploitation, figures like Fanon, Cabral, James, Léopold Senghor, Aimé Césaire, and Sylvia Wynter all shared a lived experience of racist and colonialist domination. They possess a knowledge of this repression that is almost entirely absent among the pantheon of white bourgeois intellectuals who dominate the world of Marxist theory. And it is this level of experience, the embodied aesthetics of resistance and subordination, that is decisive in understanding how we might reconceptualize praxis today and the unique role that forms of engaged art might play in this reconceptualization. Moten's reference to "Black performance" alerts us to an important feature of this process, which finds a corollary in Wynter's concept of "Being Human as Praxis." As she writes in *Black Metamorphosis*, "The black man, in defending the particularity of his black right to human status, has in the context of the emerging world system, created the matrix of a heraldic vision which is formed about the universal right to human status. This human status is not seen as an a priori essence, but as a potential invention which all men should be allowed to create for themselves."[12] It is not simply the fact that the sheer survival of an autonomous black cultural identity after centuries of slavery and displacement constitutes its own form of meaningful resistance. Rather, as Wynter argues, this very experience has brought about a reconceptualization

of the ontology of the human self that has emancipatory potential ("It is the natives, all the wretched of the earth, who ... are now called upon to reinvent the very concept of the human").[13] This is not a self predicated on an "a priori essence" (the possession of reason, an innate capacity to instrumentalize nature, or the intrinsic superiority of European culture) but a self that is produced or "invented" in a manner that challenges the possessive individualism of the bourgeois subject as well as the transcendent universality of the proletariat. Thus, Wynter writes of the human capacity to "auto-institute ourselves as human through symbolic, representational processes."[14] While this prefigurative or "heraldic" capacity (based on what Wynter terms "the revolutionary demand for happiness") is carried forward in the forms of prosaic and poetic expression specific to African diasporic cultures, it also aligned with ongoing struggles for Black liberation. Thus, this resistance unfolds via collective forms of cultural and political action, beyond the privatized aesthetic encounters normalized in the European aesthetic tradition.

I want to return here to the analysis I presented earlier in this book, outlining the key features of a dialogical aesthetic paradigm evident across a broad range of historical and contemporary engaged art practices. I have already referenced the shift from self-contemplative forms of aesthetic experience to modes of reception based on social interaction and production. This implies, as I have noted, a challenge to the incapacity of the masses thesis and a commitment to the transformative potential of collective experience. Three other features are especially relevant here. The first entails the relatively porous boundaries between engaged art and popular or prosaic culture in place of the hierarchical ordering of advanced art and vulgar kitsch evident in the avant-garde and neo-avant-garde traditions. The second feature concerns a recognition of the epistemologically generative potential of performative and embodied action. While engaged art practices may well involve the production of discrete objects or engagement with the physical materiality of specific media, these gestures often unfold in conjunction with performance-based elements of various kinds, as we will see in the examples below. The third feature concerns the dialogical linkage of both tactical and prefigurative experience, as artistic production is imbricated with praxis (evident in the escraches, *Lava la Bandera*, Dziga Vertov Group, and many other projects). As we will see below, this prefigurative dimension often entails a speculative and critical engagement with the norms of communal or collective identity.

We can identify salient examples of this alternative aesthetic paradigm in two recent projects that are engaged with the historical legacy of colonialist

violence. The first occurred in conjunction with the "Shackville" demonstrations on the campus of the University of Cape Town (UCT) in South Africa during the winter of 2016, protesting the lack of housing for lower-income Black students at the university. The name "Shackville" derives from the initial gesture of the protesting students, which involved the construction of a corrugated iron shack on Residence Road in an open space between two of the main dormitories on the UCT campus. The shack was intended to literally and symbolically claim a space for Black students who were prevented from attending the university due to the lack of housing, a problem that was especially acute for working-class students. UCT activist Lindiwe Dhlamini describes the transformative effects of the shack construction: "When I saw that truck [with the corrugated iron] my heart was just pumping and I wanted to be in that moment and I was just picking up zincs and helping [to build the shack]. It felt so good to disrupt whiteness. It felt so good to just barricade that area and own that land for those couple of hours. To sit in that space and be like, I own this. This is my space. You have no right to pass here."[15] Dhlamini's comments suggest the unique forms of affect and situational agency opened up by the act of resistance. The image of the metal shack carried a powerful symbolic resonance in Cape Town, since it was an emblematic feature of township life under apartheid while also referencing the ongoing problem of homelessness among poor Black South Africans.[16] Here, then, is a symbolic armature drawn from the realm of prosaic cultural experience, which was remobilized to link contemporary efforts to address housing justice with the broader history of anti-apartheid resistance.

The Shackville protests were led by members of the Rhodes Must Fall (RMF) collective, which grew out of efforts during the previous year to address ongoing forms of institutional racism at UCT. The symbolic focal point of these protests was a large statue of Cecil Rhodes, a diamond magnate and architect of the apartheid system, that was located in front of UCT's main hall. UCT was, in fact, built on land that was originally acquired by Rhodes using profits derived from enslaved Black laborers in mines owned by the De Beers corporation.[17] The statue had come to represent, in monumental form, UCT's insensitivity to the presence of Black students on a campus built with the labor of Black South Africans held in a condition of virtual servitude. After several weeks of protests by the RMF movement, the statue was finally removed in April 2015, but efforts to further "decolonize" UCT continued, laying the groundwork for the Shackville actions.

After completing their improvised shack the following year, the RMF activists subsequently entered nearby Fuller Hall and removed or defaced

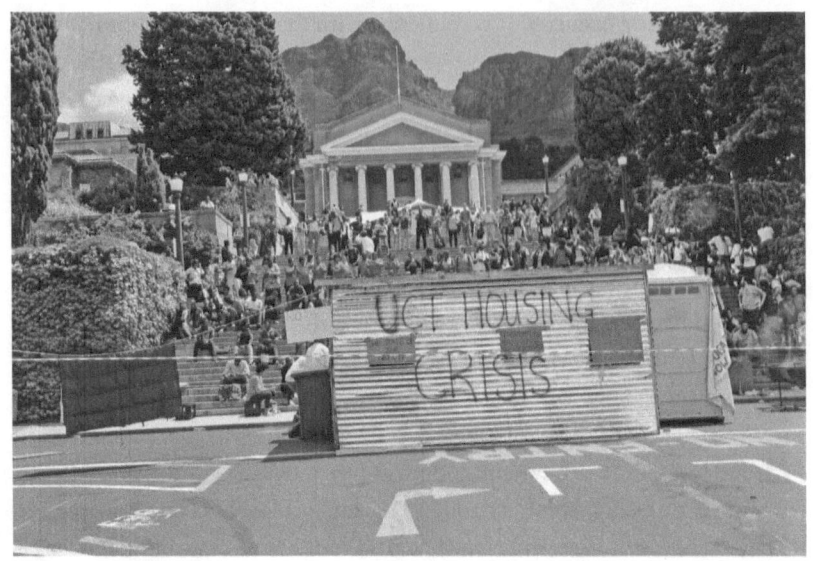

FIGURE 7.1. Lerato Maduna, *Shackville, University of Cape Town, South Africa* (February 15, 2016). Photograph from Lerato Maduna.

several paintings, sculptures, and plaques, primarily portraits of past UCT leaders but also including images of figures such as former Prime Minister Jan Smuts. RMF activist Wanelisa Albert describes what happened next: "The police fired stun grenades and rubber bullets at unarmed students for three hours. Private security kidnapped and violently assaulted one student, who is part of RMF but was not at the protest. Throughout the night, police escalated the violence (even shooting at students who were not protesting). As a result, students burnt a UCT vehicle and the office of the vice-chancellor."[18] Following these events, the university expelled a number of RMF members and charged several others with arson and vandalism. As Nomusa Makhubu notes, the protestors were widely pilloried in the South African media and the broader university community for having committed acts of "cultural barbarism."[19] While these commentators "lamented the 'ruined artworks,'" according to Makhubu, they "missed the potent symbolism of the shack as a live art installation, which had been destroyed/ruined by the university management." In fact, in subsequent court proceedings, the protestors defended their construction of the shack as an attempt to "thoughtfully create an artistic form of protest with the idea to showcase the experience of hardship of Black students and their daily pains and struggles.'"[20] In claiming an artistic status for their own intervention, the RMF activists effectively destabilized the conventional cultural hierarchy that would identify

paintings and bronze busts of European settlers as intrinsically valuable, notwithstanding their rootedness in past colonial violence, while treating the shack structure as an unnatural excrescence on the body of the campus, undeserving of care or recognition. As Makhubu observes, "Interventions like Shackville are considered the work of the angry, 'uncultured' youth who burn, ruin and destroy things. . . . This signals the inherent contradiction in what is currently accepted as 'cultural sophistication': the constrained modes inherited from Eurocentric disciplines in which art is expected to look and function in certain ways; expected to be executed by certain people; and what bearing these factors might have on overlooked creative political processes in African contexts."[21]

Despite the backlash that occurred following the Shackville actions, the members of RMF continued to stage interventions on the UCT campus. Only a month later, they organized a series of events to mark the one-year anniversary of the removal of the Rhodes statue. These included an exhibition at the UCT Center for African Studies Gallery, which was preceded by a series of performances. Now the frame of reference for their gestures shifted, from the unauthorized intervention on Residence Road to an authorized art space. The exhibition was preceded by a walking performance in which RMF members (shadowed by UCT security) traversed the campus, reconstructing the violent history of its colonialist past and neo-colonialist present. They led participants past a series of dance performances, through an access tunnel running beneath a highway where cleansing herbs were being burned, and then to a rugby field marked by a series of white crosses representing the striking mine workers killed by the South African Police Service in 2012 as well as the slaves on whose burial site the campus was built (an association of both literal and figural internment further enhanced by the participant's prior passage through the tunnel). They then paused at the site of the plinth on which the Rhodes statue once stood and moved on to the location of the Shackville structure. At each of these stages, the symbolic resonance of specific sites was further reinforced by poetry readings, musical performances, and other gestures that referenced the historical and contemporary violence visited on the bodies of Black South Africans. The gallery installation featured a set of photographs that documented the RMF protests.

In this manner, the violent history of the UCT campus was subject to a process of embodied recollection and reclamation. At the same time, at the culmination of these events during the exhibition opening, a second performance occurred that was not part of the RMF collective's original event planning. Makhubu describes the scene: "As the opening address was

about to begin, unclothed members of the Trans Collective interjected and stopped the opening by laying naked at the entrances of the gallery, blocking access. The photographic works were smeared with red paint. Trans Collective gave a public statement expressing their rejection of the RMF narrative as the meta-narrative. The unexpected turn of events led to the cancellation of the opening and of the exhibition."[22] Through this action, the Trans Collective members were expressing their concern about their exclusion from the emerging narrative of RMF solidarity and "speaking back to the RMF." Notwithstanding their own important role in the RMF movement, they complained that "only three out of more than 1,000 images that ended up making it onto the exhibition... featured a trans person's face." Further, in a formal statement, the Trans Collective noted that they had repeatedly "flagged the issue of a rigid loyalty to patriarchy, cisnormativity [and] heteronormativity" within the RMF since shortly after it was founded the previous year.[23]

Thus, at the very moment at which the collective identity of the RMF movement was formally represented as a unified whole, it was subject to a process of creative deconstruction by some of its constituent members. Notably, the RMF collective chose to cancel the exhibition, creating space for the Trans Collective's concerns to be heard and registered. In this manner, the exhibit, representing an enunciative expression of the RMF movement, was simultaneously closed and expanded, allowing the ontic structure of that identity to be opened up to further reconfiguration. "What had originally been conceptualized as a 'contained' canvas of the four walls [of the gallery]," as the collective stated, "became a real living, moving and still evolving... platform for contestation and debate."[24] Rather than being predicated on a coercive and universalizing consensus, the RMF movement demonstrated a capacity to problematize the very notion of collectivity itself. In this manner, the unfolding chain of events that constituted the RMF movement were defined by a characteristic interlacing of consensus and dissensus, critical self-reflexivity, and tactical solidarity, evolving in dialogical sequence. We can also observe a form of practice based on dispersed enunciative positions, as critical agency circulates within a network of agents rather than being the property of a single individual, uniquely able to transcend the ideological constraints of a given context. As we saw with the BLM Convening in Cleveland, the problematizing of collective identity, rather than marking the dissolution of coherent agency, allowed the RMF movement to expand its reach and create a firmer foundation for future practical action.

A similar dynamic occurs in a set of related projects created half a world away by indigenous artists working in Canada. The first was produced by Anishinaabe artist Nadia Myre and curator Rhonda Meier in 1999–2000. Titled *Indian Act*, it involved the collaborative production of a series of fifty-six beaded panels, each corresponding to a page of the 1876 Indian Act. The Indian Act is a piece of Canadian legislation that governs all aspects of interaction between the federal government and First Nations peoples in Canada. Its original intent was explicitly assimilationist. (It was founded on previous legislation that included the Gradual Civilization Act.) Canada's history of forced assimilation of Native Peoples was centered on the removal of indigenous youth from their families and their compulsory relocation to "Residential Schools," run by religious organizations with the deliberate intention of "Christianizing" what were seen as "heathen" children. In these schools, the children were subject to horrifying forms of physical and sexual abuse, as part of what a 2008 government investigation termed a deliberate process of "cultural genocide." While the Indian Act has been amended over the years to address some of its most egregious provisos, it remains a potent reminder of Canada's historical and ongoing repression of First Nations peoples.

Between 1999 and 2002, Myre staged of a series of sixty-six beading workshops with over two hundred participants drawn from a variety of backgrounds. During each session, the participants would sew decorative red and white beads to facsimile pages of the Indian Act, using a beading technique associated with First Nations culture and specifically with the creative labor of women. In addressing the Indian Act, Myre is reclaiming a sense of agency over a document that codified the systematic eradication of her own culture. The red and white beads represented white settlers and indigenous peoples, with the white beads obscuring the text and the red beads marking the negative space of each page. In the beading process, the written text was effectively "lacerated" and obscured, as historian Julie Burelle notes, "visually foregrounding Indigenous presence." *Indian Act* was predicated on both a complex representational matrix (in the fifty-six panels) and an equally significant process of collective production. As Burelle argues in her study of Myre's work: "In bringing together individuals from all origins through the common task of undoing the Indian Act, the beading bees reduced the distance, real and symbolic, between the beading volunteers. . . . At a political level, this sustained encounter between beaders from Indigenous and settler communities performed an undoing of the

silence that surrounds the Indian Act in the public sphere."[25] In her analysis, Burelle notes the important performative dimension of beading as a collective act of cultural production. Thus, the dialogues that unfolded during the beading sessions, among both native and settler participants, allowed for an embodied exchange across boundaries of differences that had both critical and prefigurative potential. As Burelle argues, it provided "the time frame necessary for settler participants . . . to 'sit with' [the native] participants resentment and, perhaps, let its power affect and unsettle them."[26] In this manner, the extended beading sessions were predicated on a collective solidarity in the act of beading while also opening a space of dissensus.

Burelle links Myre's *Indian Act* with *La Marche Amun* (*Amun* means "gathering" in Innu), a 2010 project led by Native activists Michèle Taïna Audette and Viviane Michel. In May of that year, Audette and Michel staged a three-hundred-mile march from Wendake, a Huron-Wendat community in Québec, to the Canadian capital in Ottawa "to demand an end to the gendered discrimination embedded in the Indian Act." As Burelle notes, the women faced "thirst, fatigue, blisters, stiff joints and waves of flies . . . not to mention the indifference or hostility of some segments of the population."[27] "Along the way," Burelle continues, "the marchers traversed Algonquian and Iroquoian ancestral territories in towns like Trois-Rivières, Donnacona, Montréal, Gatineau, and Ottawa, where they attended informal and mediatized events organized by and for Indigenous and non-Indigenous groups."[28] They arrived in Ottawa on June 1, 2010, where they delivered a message to Prime Minister Harper and the Minister of Indian Affairs demanding the elimination of gender discrimination associated with the ongoing provisions of the Indian Act. In contrast with traditions of Western performance art that valorize "bravura" gestures of individualized endurance, typically by male artists, Burelle calls attention to the collective nature of both of these projects: "*Indian Act* and *La Marche Amun* conjugate endurance through a communal participation and via seemingly less spectacular quotidian practices."[29] The march also sought to destabilize conventional claims of indigenous solidarity among French-speaking Canadians who often assert a spurious equivalence between their own linguistic exclusion from Anglophone Canadian culture and the lived experience of European colonization faced by First Nations peoples (what Burelle terms "competing Nativeness"). "The women thus foreclosed," as she writes, "the tendency of the province's nationalist leaders and thinkers to align French Québécois de souche [ostensibly 'pure' descendants of the original French colonists] and Indigenous sovereignist aspirations as a common anticolonial struggle." In this manner, collective

identity in *La Marche Amun* was simultaneously asserted (in the staging of the march and its conclusion on Parliament Hill), constructed (in the ongoing dialogues that occurred along the march's route), and called into question.

Rearguard Theory

As Lewis Carroll's White Queen would have it, there can be revolution yesterday (in heroic past defeats) and tomorrow (in the promise of a pure event); there might even be revolution elsewhere, among distant others whom we invest with the authority of subjects supposed to know; but never revolution here, never revolution today.

—Rodrigo Nunes, *Neither Vertical Nor Horizontal*

The projects described above unsettle many of the central precepts of the avant-garde schema I outlined earlier in this book. Most centrally, they reject the underlying belief that art can only produce a meaningful criticality by attacking normative conventions that are, at least ostensibly, immanent to the discursive and institutional systems of the art world itself. By extension, it is assumed that art practices that do engage with processes of political resistance beyond the art world are doomed to failure because any form of change that they might help facilitate can only be limited in nature. By contrast, Shackville, *The Indian Act*, and *La Marche Amun* embrace the potential of change here and now. Moreover, in these projects, embodied action and collective experience are seen as epistemologically generative rather than ontologically suspect. At the same time, they demonstrate a capacity for critical self-reflection on the formation of collective identity through the act of resistance itself. While these projects resulted in some concrete changes (Shackville led to the creation of an Institutional Reconciliation and Transformation Commission at UCT, and *La Marche Amun* helped increase pressure on the Canadian Parliament to address gender inequities in the Indian Act), they were, indeed, relatively modest.[30] However, my concern here is less with the scale at which change was affected in these works than with the interrelationship that occurs here *between* forms of political resistance and the aesthetic protocols of engaged art practice.

There is, as I have suggested throughout this study, a significant generative potential in this relationship. This entails, in turn, an alternative paradigm of political transformation, which recognizes the importance of cumulative processes in the broader mechanisms of political change. This is evident in an interview with Michèle Taïna Audette cited by Burelle in which she contends, "I see change as incremental . . . it happens through the stubborn steps of

First Nations women."[31] Audette's view stands in contrast to the paradigm of political transformation that has been carried over into the discourse of the avant-garde, a chiliastic model of total revolution that fundamentally alters society in its entirety and, along with it, the very nature of the human self. It is a paradigm that has clear roots in the convulsive, transformative ethos of the bourgeoisie. This accounts, in part, for the persistent skepticism within art critical discourse regarding projects that seek to contribute to some material transformation in mechanisms of repression. As a recent study argues, these "micro-political" gestures, inevitably "confined to local communities," are fated to have "very little impact."[32] This critique, as I have already suggested, does not originate within the art world, but rather is taken up there in order to bolster claims for the perceived radicality of artistic practices that operate within gallery and museum spaces. We find a parallel expression of this view in the work of political theorists such as Jodi Dean, who laments the contemporary proliferation of "small projects and local actions, particular issues and legislative victories, art, technology, procedures, and process ... the branching, fragmented practices of micro-politics, self-care, and issue awareness."[33] Dean's concern, of course, is not with validating art world practices but, rather, with preserving what she views as the analytic cogency of a Marxist political analysis. But in each case, we encounter the perception that genuine critical insight is always generated somewhere else, beyond the site of resistance itself (in the galleries of the art world or the seminar rooms of the academy).

This criticism echoes Slavoj Žižek's condemnation of "pseudo-activist pressure" within contemporary anticapitalist movements, which is itself a reiteration of Adorno's attack on the "noisy optimism of immediate action" during the 1960s.[34] "In the twentieth century," as Žižek contends, "we maybe tried to change the world too quickly. The time is to interpret it again, to start thinking."[35] Rather than trying to change things here and now, the only meaningful course of action involves further theoretical reflection. In this view, substantive insight into the nature of domination and resistance only emerges in isolation from praxis. Žižek's avatar here is Lenin, who in the years prior to the Russian Revolution "withdrew to a lonely place in Switzerland, where he 'learned, learned and learned', reading Hegel's logic."[36] While the implication that the 1917 revolution was the product of Lenin's penetrating exegesis of *The Science of Logic* is dubious, it has the virtue of capturing a central tension in the broader attack on political action in contemporary theory. Žižek calls for a "return" to thinking, as if it were a lost art. But it's hardly the case that theoretical analysis has languished over

the past forty years. Rather, the field of contemporary scholarship is filled with books devoted to precisely the analytic questions that are the focus of Žižek's own research. In this respect, Rudi Dutschke's "long march through the institutions" has succeeded only too well.[37] What concerns me here is not the uncontroversial claim that theoretical analysis is essential, but the corollary belief that there is literally nothing to be gained, creatively or intellectually, from the process of resistance, and that action as such possesses no meaningful heuristic value.

In Dean's view, the contemporary proliferation of new forms of situational activism is a needless distraction from the "real" work of class-based politics, which requires a return to the single-minded discipline and intellectual leadership of vanguard politics (albeit without the distasteful authoritarianism). Here a renewed version of the Communist Party will serve to "channel" or "organize" the spontaneous somatic energies of the "crowd," which is, on its own, capable only of unplanned and epiphenomenal forms of "egalitarian discharge," rooted in bodily affect ("beautiful moments," limited to specific times and locales, whose intoxicating "eruptions" are rapidly dissipated).[38] As Rodrigo Nunes argues, for Dean the party is necessary "as the 'carrier' of a politically disruptive event that enables a part (the crowd) 'to see itself (and be seen)' as the imaginary, ever-absent totality at the center of politics (the people)."[39] There is, thus, no "politics" until the party begins "concentrating and directing the energies of the people . . . shaping and intensify the people's practical struggles."[40] We find a parallel argument in Žižek's withering, albeit Eurocentric, critiques of "identity politics" that are seen as surrendering any systematic analysis of the broader forces of capitalism, which he views as the one true source of all other forms of oppression.[41] Here, any political action that finds its locus in the lived experience of racism, for example, is fundamentally misguided and serves as an ontological corollary to the scalar limitations of localized forms of resistance. This view rests, in turn, on the questionable assumption that the capitalist system, given enough pressure, will happily eliminate racism per se, so long as capitalism as such is allowed to continue unhindered. As Nick Nesbitt notes in his analysis of Édouard Glissant, this view has also emerged in recent critiques of anticolonial practices, which contend that "the struggle for the recognition of minority rights, so-called 'identity politics,' though certainly necessary in specific situations, is not to be considered properly 'political' at all."[42]

This perspective ignores, however, the complex imbrication of race and class that emerged at the very dawn of modern capitalism in the development of European colonialism during the sixteenth century.[43] Race has never

been peripheral to class. Rather, for large segments of the global population, as Stuart Hall famously observed, "race is the modality in which class is lived."[44] Hall is referring here to the central role played by race, and racism, in dividing and disempowering the poor and the working class. Given this history, one would imagine the most productive response to contemporary antiracist activism would be twofold. First, to learn from Black or indigenous resistance about the process by which the experience of oppression moved people to organize and take action. And second, to consider the ways in which these struggles could be brought into dialogue with a systematic critique of capitalism. This was certainly the intention of seminal figures such as Lucy Parsons, W. E. B. Du Bois, Ben Fletcher, C. L. R. James, and Walter Rodney. If one's goal is the creation of a broad-based anticapitalist movement, surely a key starting point must be the lived experience of the individuals who might be drawn to participate in such a movement. Given the dramatic expansion of neo-fascist movements globally, the benefit of building a popular coalition of antiracist and antifascist forces would seem self-evident. Instead, as the example of Žižek suggests, we often encounter an outright disdain for antiracist struggles as naive or even openly reactionary in contemporary Marxist academic theory.

As political theorist Asad Haider argues, this response is linked with the "institutional weakness of the Left."[45] The result has been a more general sense of frustration among left intellectuals, unable to come to terms with the limitations of their own theoretical discourse, and with the failure of Marxist economic and political analysis to engage and motivate a larger public. "I'm not convinced by the argument," Haider writes, "that if you point to racial disparities in policing or whatever, that means your politics will just be about overcoming that disparity rather than overcoming the broader inequalities of the whole society." Rather, "many people will see a racial disparity which shows how our society is unjust, and move from there to recognize all of the other ways in which our society is unjust and want to change them all."[46] We discover in these critiques what Haider describes as a "knee jerk functionalist response ... which immediately sees in any kind of actual social change a kind of co-optation."[47] Or, expressed another way, we can identify a tendency for academic theorists to assume that they are uniquely equipped to anticipate in advance all the possible lines of influence and subsequent transformation that might extend out from any given political action here and now. Rather than learning from resistant praxis, with all the contradictions that accompany any form of meaningful change, the default assumption is that their role is simply to adjudicate its errors

while never considering the possibility that their own modes of analysis and address might be equally in need of reassessment. Even more striking is the inability of many academic theorists, eager to resuscitate some version of Lenin's vanguard party, to grasp the simple fact that one of most significant factors impeding its contemporary revival is the history of actually existing communism itself.[48] But coming to terms with that historical reality would also require challenging some of the foundational assumptions behind their own self-image as radical intellectuals. Critical self-reflection is an essential feature of any social movement. What I would question is the underlying belief that the theorist, alone among all other social actors, is exempt from it.

The challenge facing us today does not lie at the level of rhetoric (the willingness of a given movement to openly espouse a critique of capitalism or to hurl a set of utopic "demands" into the ether). Rather, we have to ask why BLM was able to mobilize thousands of people across the United States and Europe, while the Socialist Equity Party (affiliated with the Fourth International) struggles to win more than 1 percent of the vote when it runs candidates in American elections. By dismissing the efficacy of groups such as BLM, we return to the figure of the communist intellectual perennially disappointed in the agents of revolution and the vanguardist belief that the theorist's primary role is to instruct and "orient" the otherwise misguided masses. More specifically, the theorist's task is to ensure that the agents of revolution preserve the transcendent centrality of class rather than being distracted by the temptations of identity politics or opportunistic reformism. What is normalized, in turn, is an adjudicatory relationship of mind over body and theorist over the "energetic" but undisciplined crowd. This entails a consistent underestimation of the insights generated by resistance itself, and of the capacity of those who resist to make sense of these insights and carry them forward in a coherent manner.

There is a barely suppressed yearning in much of this writing for a modern-day Lenin to bring theoretical rigor to the muddle-headed chaos of current social movements. Thus we find Žižek lecturing the General Assembly at Occupy Wall Street in 2011 like a firm but benevolent uncle: "Don't fall in love with yourselves. We have a nice time here. But remember, carnivals come cheap."[49] There is, as well, a curiously exalted view of the academic theorist for whom it is essential to disparage all existing forms of change, precisely in order to assert their own powers of critical transcendence.[50] Toni Negri captures this dynamic in a 1988 interview: "This practico-material inertia of the real presupposes the exceptional moment, the *Blitz* of reason, the *Jetzt* of the moment of rupture. I see this as an internalization of Leninism. . . . Along

with this comes an aristocratic attitude and a definition of the intellectual as one who is capable of voluntaristically pointing the way, as a Nietzschean intellectual capable of breaking through by force of will."[51] The central issue is not that people are simply too ignorant to imbibe the lessons so generously offered by academic theorists, but that in too many cases theorists remain locked in a discursive paradigm that only allows them to acknowledge those aspects of contemporary political resistance that can be used to demonstrate its complicity with capitalist domination while remaining blind to those elements that carry some prefigurative or critical dimension.

There is a good reason for remaining skeptical of the appropriative power of capitalism and its ability to use incremental change to rationalize its ongoing survival. But it is also reasonable to exercise some caution, given how frequently these same critiques come from white, Euro-American academics who often have little direct experience of contemporary forms of political repression. For this reason, it is necessary, as Boaventura de Sousa Santos reminds us, to retain some skepticism regarding the truth claims of theory, especially in those cases where it assigns to itself an absolute transcendent authority.[52] "Keeping a distance" from Western theory, as he writes, "does not mean discarding the rich Eurocentric critical tradition and throwing it into the dustbin of history, thereby ignoring the historical possibilities of social emancipation in Western modernity. It means, rather, including it in a much broader landscape of epistemological and political possibilities. It means exercising a hermeneutics of suspicion regarding its 'foundational truths' by uncovering what lies below their 'face value.'"[53] The vanguard tradition described by de Sousa Santos centers on the ritualistic moment when the viewer or reader, having been exposed to the exemplary forms of critical insight imbedded in the work of vanguard theory or art, undergoes a Damascene conversion, after which they finally become conscious of the totality of capitalist domination, their own role within it, and the absolute necessity of revolutionary action. Adorno evokes this mythic scene in an exchange with Max Horkheimer from 1956 cited in the introduction to this book: "What we want is for the people who read what we write to feel the scales falling from their eyes."[54] This is a cherished fantasy on the left. In practice, however, it rarely occurs with actual viewers or readers. In the absence of a viable revolutionary agent able to receive the truths that revolutionary theory alone can provide, the role of critical theory is less pedagogical than talismanic.

At the same time, the hermetic nature of avant-garde art and theory, sequestered in the art world and academia, ensures that the audiences who

actually do come into contact with it are already predisposed to accept the truths that it communicates. Here the work of art plays a primarily affirmative role, rather than a genuinely transformative one. And all too often it carries with it an undercurrent of contempt for the intelligence, or lack thereof, of the broader public whom the work is, ostensibly, intended to benefit. What is lost sight of here is precisely an awareness of the process by which people become politicized: how we come to take action, through our unique, material experience of oppression. These insights are available to us across a broad range of practices from the surreptitious intimacy of Saba Zavarei's singing performance, to the bureaucratic decipherment of *Tamms Year Ten*, to the performative police encounter following the BLM Convening, to the raucous street theater of the escraches. At each scale, there are important insights to be gained regarding the forms of bodily and cognitive insight generated through the act of resistance. To discard the significance of this process and this experience, to condemn it as simply an error to be corrected, and to refuse to learn from it is, I believe, fatal for any theoretical orientation that hopes to contribute in some meaningful way to political transformation.

My concern here is not with the argument that a systemic account of capitalist domination (and the operations of capitalist hegemony) is essential today. This is, as I have noted, self-evident. The key question instead is how specific actions at the local, regional, or even national scale might combine to take on a broader or more enduring power. And for that we require a far less functionalist understanding of the micro-politics of resistance and the complex practical and creative process by which people come to understand their own agency in building an alternative future. As I have suggested, this can occur at many scales and in many contexts. My problem, as this study has suggested, is with the ways in which the proponents of a conventional avant-gardist schema imagine that this truth might be made relevant in the lives of people who suffer the consequences of capitalist domination in their daily lives. In fact, the actual reception of avant-garde art and theory entails a far more complex and ambivalent process than the schema suggests. A substantive analysis of this process would require, first of all, a frank assessment of the limitations of the broader discursive system that underlies the contemporary avant-garde and, in particular, of the subjectivity of the vanguard theorist or avant-garde artist. Rather than being seen as the organic and singular expression of a transcendent revolutionary truth, it is necessary to understand this subject position itself as the product of a set of ideological determinants and institutional constraints. Some of these constraints have

been addressed in a more recent body of "neo-leftist" thought that explores the underlying "ontological" claims of Communism and Marxism.[55]

This work, which is associated with figures such as Michael Hardt and Antonio Negri, Alain Badiou, Chantal Mouffe, Žižek, and others, seeks to reconcile the deconstructive ethos of postmodern theory (which challenges transcendence in all its guises) with a Marxist tradition structured around the metaphysical concept of the proletariat as a "universal class" and the vanguard party as the vehicle through which its essence will be realized. But even in this tradition, as valuable as it is, we rarely encounter an attempt to think critically about theory itself as a discursive and institutional form. Bruno Bosteels is one of the few figures within this tradition who is willing to extend the critique of transcendentalism to the personality of the theorist him or herself. As he writes in *The Actuality of Communism*, the emergence of neo-left philosophy can be traced in part to the perception among a recent generation of thinkers that the past historical "failures of the Left can be remedied only by addressing, if not also correcting, the metaphysical illusions that undergird all previously existing emancipatory practices."[56] Here, again, the schema of theory over praxis, of the vanguard thinker over the activist mired in "illusion," is retained and carried forward. Bosteels's goal, as he describes it, "is to instill a degree of modesty and realism in the reflection concerning politics and philosophy. Really existing socialism and communism, if in fact they are now bankrupt beyond salvage, did not fail but were defeated; their defeat and bankruptcy . . . are primarily not philosophical but political and ideological issues."[57]

For Bosteels, the failure of past Leftist struggles will not be resolved by simply devising a more perfect theoretical paradigm to govern their future evolution.[58] Rather, political theory must also learn from praxis, as Bosteels writes, "delving into the archives of popular insurrection and plebian revolt without sinking them even deeper into the dustbins of history where they risk being crushed under the heavy paperweight of philosophic reflections whose perverse effect consist in obliterating a second time in theory what has already been defeated in practice."[59] Theory, in this view, must take on a dialogical, rather than a purely adjudicatory, relationship to praxis. We might say, following Benjamin, that theory must undergo its own "melting down" process. While I have spent some time here discussing Bakhtin's contribution to this transformation, his work represents only one possible resource. In fact, we can identify an important kinship across a broad range of historical and contemporary thought, from the traditions of anarchism and Black Marxism, to forms of "militant research," to Ana Cecilia Dinerstein's

recent analyses of "concrete utopias" in Latin American activism, to Stefano Harvey and Fred Moten's concept of the "Undercommons," to research on alternative economies, exemplified by the work of J. K. Gibson-Graham. In the realm of contemporary political theory, we find figures such as Hamed Hosseini and Rodrigo Nunes developing new analytic modalities that capture the complex cross-fertilization that can occur between local and situational political actions and a broader mosaic of resistant praxis. In *Neither Vertical Nor Horizontal,* Nunes challenges the binary opposition between the political imaginary of 1917, predicated on brute force and class terror, and the political imaginary of 1968, in which cultural production and prefigurative experience play a central role. In doing so, Nunes seeks to dismantle the antimony between "consciousness and spontaneity, horizontal and vertical, micro and macro-politics," arguing instead that both the tactical and the prefigurative can be dialogically linked in activist work.[60] And Hosseini, in *Alternative Globalizations*, argues that we must "transcend the polarity of soft-praxis versus hard-praxis" while also proposing a notion of "flexible solidarity based on a collaborative inclusion of the Other into the definition of the Self" in a manner that can allow for the productive interlinking of critiques of class, gender, race, and cultural identity.[61]

Each of these bodies of thought is marked by a receptive openness to the insights generated by social and political resistance and by forms of "prosaic" cultural expression beyond the institutional structures of the bourgeois art world. They are also concerned with the emancipatory forms of affect and feeling (the "touch of the undercommons," as Harvey and Moten write) that sustain resistance as a kind of "social poesis" that asks how we might create a more just social order here and now, with the resources we have at hand.[62] Their work contains, by necessity, an affirmative dimension that is alien to conventional modes of vanguardist theorization. And it attends closely to those elements of existing reality that carry within them, even embryonically, the creative, practical, and intellectual potentials that might contribute to the building of this new system. It thus combines a tactical aspect, in coming to terms with the political and institutional forces that impede the creative reinvention of the social, with a prefigurative dimension, as it assumes that the precise nature of this new socius cannot be predicted in advance (by theory or otherwise) but only produced through a process of experiential testing among the agents of its actual accomplishment. This does not mean accepting existing institutional structures or the values on which they claim to be based uncritically. Rather, it means actively intervening in these institutions and structures in order to transform or reinvent them.

I would argue that this form of knowledge is being generated, among other places, in the larger body of contemporary socially engaged art. As a result, the analysis of this work requires an opening out from the Marxist tradition to other paradigms of creation, criticality, and insight. For the purposes of this study, it requires that contemporary art history undergo a disciplinary reorientation akin to the paradigm shift that occurred with the expansion of the field into "social" art history during the 1980s and into the domain of semiotics and visual culture during the 1990s. Of particular importance in this reorientation is the complex intersection of capitalism, colonialism, and patriarchy explored in de Sousa Santos's research, cited above. In *Epistemologies of the South,* de Sousa Santos examines the development of new forms of resistance and critical practice in Latin America over the past two decades, in which anticapitalist activism is joined with a decolonizing imperative linked with the struggles of indigenous peoples. As he argues, in order to adequately understand this work, we must be willing to interrogate the preconscious horizons of conventional Western models of knowledge (a process that would include Marxism itself). In place of "vanguard" theories that always defer to the "clairvoyant leadership" of the theorist or party, de Sousa Santos advocates what he terms a "rearguard" theory that "follows . . . the practices of . . . social movements very closely, raising questions, establishing synchronic and diachronic comparisons, symbolically enlarging such practices by means of articulations, translations, and possible alliances with other movements, providing contexts, clarifying or dismantling normative injunctions."[63] "Vanguard theories," as de Sousa Santos contends, "do not let themselves be taken by surprise."[64] A rearguard theory, on the other hand, remains open to the transformative potential of existing forms of practice and to a diversity of worldviews, creative paradigms, and forms of thought. "Knowledges born in struggles," as de Sousa Santos argues, "possess an invaluable cognitive dimension, combining a tactical 'reflex of action' and a critical 'reflection on action itself.'"[65] Within the broader "ecologies of knowledge" necessary to produce change these "artisanal" forms of intelligence, rooted in struggle, are accorded equal validity with more conventional theoretical or "scientific" knowledge, whether anchored in concrete acts of resistance or generated independently from them.[66] It is this dialogical openness, the willingness to be surprised by and to learn from the inventiveness of resistance itself, that is essential in writing about socially engaged art today.

CONCLUSION
BEYOND THE WHITE WALL

> I recognized why it's so hard for me to work in a gallery. It's because I can't build the world I need to inside these white walls.
> —Patrisse Cullors in Kester, "Interview with Patrisse Cullors"

I began the research that led to this book by exploring the interrelationship between the aesthetic and the political during the modern period. I identified autonomy in particular as one of the central vectors for this relationship. Thus, what we encounter in the history of modernist art is a series of dialectical movements as autonomy is opened out and then reasserted, eroded, and fortified again. Each of these movements is driven by art's ongoing struggle to define and differentiate itself within the often violent social and political upheavals that characterize modernity. Throughout this history, autonomy has carried forward a principle of freedom that remains central to liberatory politics and creative practice to the present day. But autonomy is a complex and multivalent term. The ways in which it is produced must, by necessity,

be transformed over time in response to changing forms of domination and evolving insights into the nature of liberation itself. The avant-garde tradition, in its varying permutations, has provided one of the most important articulations of this potential. At the same time, we are faced today with a unique historical moment with its own perils and potentialities. The result is a new mode of artistic practice that seeks to reconcile the generative, prefigurative capacity of the Enlightenment aesthetic and the dissensus and criticality of the avant-garde in the context of action-oriented forms of resistance and social change. Further, this work seeks to challenge the conventional forms of autonomy on which both of these aesthetic paradigms are based. This challenge unfolds in the opening up of art's relationship to other cultural practices and in the thematizing of artistic subjectivity itself as a site of creative intervention. T. J. Demos identifies this shift in his research on the intermingling of art, activism, and affiliated forms of cultural production in response to the "state of emergency" created by global climate change. "Maybe we are witnessing," as Demos writes, "not a failure of the imagination, but rather a structural transformation of the conditions of cultural practice—including a blurring of art, performance, media, theater, and architecture—that is adapting to and critically negotiating the shifting challenges of life at the very moment when the reality of the Anthropocene . . . is sinking in."[1]

This hybridity is also evident in a figure like Patrisse Cullors, who is both a performance artist who addresses issues of racial injustice and a cofounder of Black Lives Matter. For Cullors, her artistic practice and her activist work are interdependent rather than antithetical, each complicating, and enriching, the other. New forms of socially engaged art also challenge existing models of subjective autonomy, destabilizing the conventions of authorial sovereignty that are central to both the Enlightenment and the avant-garde traditions. Tania Bruguera, in her performance *Self-Sabotage* (2009), argues for precisely such a productive unsettling of the artist's own certitude and mastery. "Artists should self-sabotage by quitting their work," as she writes, "by leaving their comfortable positions and looking for a difficult site, one that they do not understand, leaving doing design aside and do living. Artists should stop and start from scratch, from a place that is not self-nostalgic, a site where all our insecurities are present, an insecure place, a place that is not self-important, a place where art is not an important concept. Art should be a concept appearing later, after the fact, not an a priori decision."[2] The "difficult" site, for Bruguera, is the site of practice that challenges rather than reinforces the artist's sovereignty and that requires

in turn the ability to recognize the limits of their own cognitive mastery as marking a creative potential rather than an impairment.

The essential question today is twofold: How do we preserve the crucial value of negation and dissensus cultivated within the historical avant-garde while also recognizing the desire among a new generation of artists to take up a more complex and dialogical relationship to prefiguration and praxis? And second, how do we preserve our capacity to grasp an existing system of domination in its totality (epitomized by Marx's ability to make visible the previously unrecognized structures of capitalism itself) while retaining a meaningful grounding in the concrete manifestation of this power in our daily lives? In short, can we detach the necessary values of negation and critique from the social architecture of conventional avant-garde practices and mobilize them in new social and creative contexts? Neo avant-garde works that rely on representational forms of mediation are able to critique capitalism through a well-established set of protocols, either by incorporating semantic material that directly references a revolutionary past or by staging a displaced, symbolic assault on the formal or ideological conventions of the art world.[3] An art practice that engages with social or political action faces a different set of challenges, precisely because of its reciprocal relationship to resistance here and now in contexts where simply invoking the mythos of a communist revolution or critiquing yet again the institutional art world is unlikely to be compelling.

These are questions that have only become more pressing with the rise over the past decade of virulent forms of neofascism, which seek to harness the alienation and discontent produced by the ongoing failure of neoliberal capitalism to a program of right-wing authoritarianism. This is a sadly familiar script, and its overcoming will require us to understand as deeply as possible the unique forms of knowledge that emerge through the experience of both oppression and resistance. How do we make sense of this experience through theoretical and affect-based insight and through pragmatic engagement and contemplative reflection? How do we acquire a sense of our own autonomy and agency as we engage in creative resistance and visualize alternative futures? And how do we negotiate the complex tensions, dissensions, and points of affiliation in our ongoing relationship to others and in the creation of new forms of solidarity? It is this underlying set of concerns that unites a broad range of socially engaged practice, from small-scale experiments with new modes of collective creation to complex social assemblages involving dozens or hundreds of participants. Neofascist movements have developed new forms of cultural solidarity and new political

narratives that have drastically expanded their reach. In order to challenge this destructive force, it is necessary for us to more fully understand the crucial political role of culture itself and to develop a narrative of liberation that is not continually facing toward the past. We require, instead, a culture of resistance that people will find compelling precisely because it is rooted in their own recognizable experience of repression today. While it is essential to acknowledge the ongoing salience of class as a key mode of oppression (a reality that is, of course, systematically denied in mainstream political discourse), it is equally necessary for us to recognize the overlapping and mutually reinforcing operations of many different modes of oppression, oriented around sexuality and gender, race and ethnicity, and so on, as well as the global devastation imposed on the natural world by extractivist economies. While all of these might well be reinforced by the underlying structure of the capitalist world system, their significance as experiential forms of oppression or sites of resistance is clearly not exhausted by the analytic language of class alone.

Given the record of actually existing communism, it is no longer persuasive to argue that all other forms of oppression are merely epiphenomenal expressions of an ontologically prior mode of class domination, which will magically dissipate of their own accord once a true revolution has been achieved. This intersectionality is, of course, a central feature of socially engaged art today, which ranges across multiple sites of resistance and repression, from work associated with climate change and environmental degradation documented by figures like Demos; to projects focused on race and the criminal justice system such as *Tamms Year Ten* (discussed earlier); to practices that examine the politics of immigration such as Bruguera's *Immigrant Movement International*; to the work of Bijari in São Paulo, which focuses on institutional racism in Brazil; to the literary programs of the Migrant Workers Home in Beijing. There are also a growing number of new projects dedicated to challenging authoritarian state systems.[4] In fact, we know more than we ever have about the remarkable range of engaged art practices being produced today, thanks to the efforts of a younger generation of critics and historians. We now have studies devoted to contemporary socially engaged art in Central and Eastern Europe, the Caribbean, Latin America, Japan, and China.[5] While I have concentrated here on the relevance of social labor as part of a critical framework for socially engaged art, it is also clear that the ongoing analysis of this practice will require a dialogical engagement between art history and new forms of political theory, including non-Western epistemologies, new research methodologies, and new paradigms

of political transformation.⁶ This later point is especially crucial. As Rosa Luxemburg observed over a century ago, "the negative, the tearing down, can be decreed," but the "positive" moment of political change, the "building up" of a new and more just system, is precisely not something that can be determined or dictated in advance or generated within the consciousness of the individual theorist.⁷ Rather, it emerges from the unanticipated new lines of thought and practice opened up by the act of creative reconstruction itself. It is this spirit that animates much of the socially engaged art produced over the past three decades.

NOTES

Introduction

Section epigraph: Friedrich Schiller, letter to Duke Friedrich Wilhelm Augustenberg, 1793, in Beiser, *Enlightenment, Revolution, and Romanticism*, 97.

1. See Corlin Frederiksen, *Bishan Commune*; Kamanzi, "'Rhodes Must Fall'"; Gilbert, "Autonomous Determination"; Awde, "Renata Carvalho"; Jesty, "Japan's Social Turn"; Black Lives Matter, "The Provocateurs"; Hofman, "Disobedient."
2. See, for example, Lacy, *Mapping the Terrain*.
3. See Kester, "Activist and Socially Engaged Art."
4. Brown, *Autonomy*, 37.
5. Schiller, *Aesthetic Education*, 197.
6. Bakhtin, *Problems of Dostoevsky's Poetics*, 287.
7. This institutionalization is evident in the proliferation of foundations, conferences, graduate programs, and commissioning agencies dedicated to this work. On the one hand, this has provided important funding opportunities, along

with a set of online forums that publish interviews, project descriptions, and other coverage. While often affirmative in nature (a funding agency is unlikely to commission an essay critical of the work that it supports), these forums have contributed significantly to promoting dialogue among artists, administrators, and curators working in this area. At the same time, the process of institutionalization, like any other system of patronage, carries its own liabilities. This is evident in the often-superficial concept of social engagement evident in the "participatory" art practice encountered in museums, biennials, and art fairs. It can also make artists complicit in burnishing the reputations of wealth-driven institutions. This was evident in the May 2015 announcement of "Guggenheim Social Practice," an initiative that commissions "socially engaged art" projects that "engage community participants . . . and foster new forms of public engagement." "Guggenheim Social Practice" is funded by the Edmond de Rothschild Foundation, the philanthropic arm of Edmond de Rothschild Investment Partners, a private asset management firm in France. On its website, the Rothschild Foundation professes its dedication to "social entrepreneurship" (a neoliberal catchphrase that signals its support for projects that seek to imbue the poor with a properly bourgeois commitment to economic self-actualization and that implies, by extension, that their poverty is the result of a lack of entrepreneurial zeal). Not surprisingly, the same language is reproduced on the Rothschild Investment website, which praises the virtues of risk-taking "entrepreneurs and investors." The timing of the Guggenheim's announcement is particularly revealing. It came only a few weeks after the museum decided to break off negotiations with the Gulf Labor Coalition in April 2016. The Gulf Labor Coalition consists of artists, activists, and scholars who have been working since 2010 to encourage the museum to adopt fair labor practices in the construction of a new Guggenheim branch in Abu Dhabi.

8 See, for example, Jackson, *Social Works*; Helguera, *Education for Socially Engaged Art*; González, *Pepón Osorio*; Demos, *Decolonizing Nature*; Castellano, *Beyond Representation*; Sholette, *Delirium and Resistance*; Thompson, *Seeing Power*; Léger, *Vanguardia*; La Berge, *Wages against Artwork*; Ponce de León, *Another Aesthetics*; Charnley, *Sociopolitical Aesthetics*.

9 Bishop, "The Social Turn," 181.

10 Schneewind, *Invention of Autonomy*, 4–8.

11 This quote is from *The Oldest Systematic Program of German Idealism*, written in 1796–1797 by Hegel, Hölderlin, and Schelling. Ferrer, *Oldest Systematic Program*, 22.

12 Schiller, *Aesthetic Education*, 25.

13 Schiller, *Aesthetic Education*, 45.

14 Schiller, *Aesthetic Education*, 217.

15 Wynter, "Unsettling the Coloniality of Being," 266.

16 Schiller, *Aesthetic Education*, 197.

17 Schiller, *Aesthetic Education*, 25–27.

18 For a useful account of the political implications of the aesthetic, see Schoolman, *A Democratic Enlightenment*.
19 Hegel, *Hegel's Aesthetics*, 54.
20 Woodmansee, *The Author, Art, and the Market*, 34.
21 Poggioli, *The Theory of the Avant-Garde*, 9.
22 Mao Tse-tung, "Introducing a Co-operative."
23 Beiser, *Enlightenment, Revolution, and Romanticism*, 97.
24 Lenin, "The Economic Basis."
25 For a useful overview of the theoretical rationale for Bolshevik revolutionary tactics, see Lovell, *From Marx to Lenin*. Here is Maxim Gorky's assessment of Lenin in 1917: "He possesses all the qualities of a 'leader' and also the lack of morality necessary for this role, as well as an utterly pitiless attitude, worthy of a nobleman, towards the lives of the popular masses. Lenin is a 'leader' *and* a Russian nobleman, not without certain psychological traits of this extinct class, and therefore he considers himself justified in performing with the Russian people a cruel experiment." Gorky, *Untimely Thoughts*, 88.
26 In fact, even after surviving the violent upheaval of the Russian Revolution, Lenin would insist that the "de-classed" proletariat was still incapable of an autonomous revolutionary consciousness and required the ongoing oversight of the Communist Party.
27 Lukács, *History and Class Consciousness*, 41.
28 Adorno and Marcuse, "Correspondence on the German Student Movement," 131. There is, of course, more than a grain of truth to Adorno's contention that 1960s activists deluded themselves when they imagined that their protests could precipitate real revolutionary change. However, the most symptomatic expression of this naive action-ism can be found not in the student movement he disdained but among those organizations that relied on the same vanguardist principles that are transposed into aesthetic form in his own critical theory. In groups such as the Weather Underground in the United States, the Red Army Faction in Germany, and the Red Brigades in Italy, we encounter the characteristic appeal to "exemplary violence," undertaken by a cadre of radically autonomous militants who have become the vessels for a form of pure revolutionary consciousness. We encounter, as well, the belief that this violence (bombings, kidnappings, assassinations) will provoke the otherwise indolent masses to rise up and seize power ("Strike one to educate one hundred," as the Red Brigades argued). Drawing on Guevara's notion of "foquismo," these groups believed they could bring the conditions necessary for true revolution into practical existence through the sheer force of their will and their privileged knowledge of the totality of capitalist oppression. As a result, these practices possessed neither an immediate efficacy (in producing meaningful forms of situational political change) nor any prefigurative potential that might have laid the foundation for a broad-based social movement to come. Rather, they served only to alienate large segments of the public in both the United States

and Europe from the form of political liberation that they claimed to champion. See Varon, *Bringing the War Home*; Beck et al., *Strike One to Educate One Hundred*.

29 Adorno, "The Artist as Deputy," 67.
30 Adorno, "Commitment," 180.
31 Badiou, "Avant-gardes," 142.
32 Badiou, "Avant-gardes," 141.
33 See Ono-Dit-Biot, "Regardez." Between 1975 and 1979, the Khmer Rouge (supported by the Chinese Communist Party) was responsible for the Cambodian genocide, in which 1.5 to 2 million Cambodians were systematically murdered. For a critique of Badiou's romanticization of the Cultural Revolution, see Chu, "Alain Badiou." Badiou assumes, of course, that he would be exempt from the violence that is inevitably visited upon independent thinkers in the wake of the kind of revolution he hopes to precipitate.
34 Wolin, *The Wind from the East*, 164.
35 Badiou, "Avant-gardes," 132.
36 See, for example, his critique of "popular democratic processes" in Badiou, *The Rebirth of History*, 97.
37 Foster, "What's Neo about the Neo-Avant-Garde?"
38 For a more contemporary version of this argument, see Roberts, *Revolutionary Time*. As Roberts argues, art's critical power is defined through the "restless, *ever vigilant positioning* of art's critical relationship to its own traditions of intellectual and cultural formation and administration" (p. 54).
39 Kleinmichel, "The Symbolic Excess of Art Activism," 236.
40 Kleinmichel, "The Symbolic Excess of Art Activism," 237.
41 Roberts, *Revolutionary Time*, 67.
42 Jeffries, *Grand Hotel Abyss*.
43 Adorno and Horkheimer, "Towards a New Manifesto?," 58.

1. The Incommensurability of Socially Engaged Art

1 Roberts, *Revolutionary Time*, 55.
2 Laclau and Mouffe address the concept of "antagonism" in *Hegemony and Socialist Strategy*, and Mouffe introduces a further distinction between "antagonism" and "agonism" in *The Return of the Political*.
3 As Mouffe writes, "According to my conception of 'adversary,' and contrary to the liberal view, the presence of antagonism is not eliminated but 'tamed.'" Mouffe, "Agonistic Public Sphere," 91.
4 Mouffe, *The Return of the Political*, 19.
5 Mouffe, "Activism and Agonistic Spaces," 4.
6 Mouffe, "Activism and Agonistic Spaces," 4–5.
7 Laclau and Mouffe, *Hegemony and Socialist Strategy*, 164.

8. For a more detailed discussion of Laclau and Mouffe's research as it relates to engaged art practice, see Kester, "The Sound of Breaking Glass."
9. Mouffe herself remains a staunch proponent of a fairly conventional model of parliamentary democracy that is difficult to distinguish from Habermas in practice. See Erman, "What Is Wrong with Agonistic Pluralism?," and Knops, "Agonism as Deliberation."
10. Bishop warns here of the "fictitious whole subject of harmonious community." "Antagonism and Relational Aesthetics," 67.
11. Bishop, "The Social Turn," 181.
12. See Walker, *After the Globe*, 278. For a similar analysis, see Beckstein, "Dissociative and Polemical Political," 39.
13. Erman, "What Is Wrong with Agonistic Pluralism?," 1049.
14. Wright et al., "Exchange with Jacques Rancière."
15. Wright et al., "Exchange with Jacques Rancière."
16. Rockhill, *Radical History*, 182.
17. Rockhill, *Radical History*, 170.
18. Cited by Rockhill, *Radical History*, 170.
19. "But the life of art in the aesthetic regime of art consists precisely of a shuttling between these scenarios, playing an autonomy against a heteronomy and a heteronomy against an autonomy, playing one linkage between art and non-art against another such linkage." Rancière, "Aesthetic Revolution and Its Outcomes," 150.
20. Rancière, *The Politics of Aesthetics*, 63.
21. Rancière, *The Politics of Aesthetics*, 63.
22. 16 Beaver Group, "Monday Night."
23. Rancière, "Aesthetic Revolution and Its Outcomes," 151.
24. For an overview of recent critical responses to Rancière's work, see Rockhill and Watts, *Jacques Rancière*.
25. 16 Beaver Group, "Monday Night."
26. Gratton, "*Aisthesis* by Rancière."
27. Rancière, *Althusser's Lesson*, 109.
28. Althusser, *For Marx*, 167. See also Bosteels, "Reviewing Rancière."
29. Panagia, *Rancière's Sentiments*, 24.
30. Rancière, *The Politics of Aesthetics*, 13.
31. See Hallward, "Staging Equality."
32. Panagia, *Rancière's Sentiments*, 31.
33. "Art obviously enjoys a place of pride in Rancière's system. But it appears paradoxical that whereas other bodies and phenomena are seen to produce dissensus by cropping up where they are not supposed to . . . art is supposed to remain in place. Unlike everything else, art is political when it does what it is supposed to: being produced and exhibited within the performative framework of the art world." Wright, "Behind Police Lines."

34 On Wright's concept of "stealth" art, see "The Future of the Reciprocal Readymade." See also Wright, "Users and Usership of Art."
35 Wright et al., "Exchange with Jacques Rancière." See also Perez de Miles, "The Antinomy of Autonomy," 43.
36 Wright, "Behind Police Lines."
37 Grupo de Arte Callejero, *Thought, Practices and Actions*, 306.
38 Carnevale and Kelsey, "Art of the Possible," 263.
39 Carnevale and Kelsey, "Art of the Possible," 263.
40 Carnevale and Kelsey, "Art of the Possible," 263.
41 For a related critique, see Bosteels's analysis in *Actuality of Communism*.
42 Sand and Flaubert, *The George Sand–Gustave Flaubert Letters*, 81.
43 See Kester, *The One and the Many*, 36–42.
44 Rancière, *The Ignorant Schoolmaster*, 12.
45 Rancière, "The Emancipated Spectator," 272.
46 Rancière, "The Emancipated Spectator," 272.
47 Rancière, "The Emancipated Spectator," 275.
48 Rancière, "The Emancipated Spectator," 280. I outline the concept of a "textual" paradigm in *The Sovereign Self*.
49 Rancière, "The Emancipated Spectator," 278.
50 Rancière, "The Emancipated Spectator," 278.
51 Rancière, "The Emancipated Spectator," 278.
52 Rancière, "The Emancipated Spectator," 280.
53 Rancière, "The Emancipated Spectator," 280
54 Carnevale and Kelsey, "Art of the Possible," 259.
55 Rancière, *The Ignorant Schoolmaster*, 101.

2. Escrache and Autonomy

1 Foster, "What's the Problem with Critical Art?"
2 Hirschhorn, "Eternal Flame."
3 Badiou, *Metapolitics*, 121.
4 Wright et al., "An Exchange with Jacques Rancière."
5 See Longoni, "A Long Way," 98–116.
6 See Blustein, *The Money Kept Rolling In*, and Lavaca Collective, *Sin Patrón*.
7 The 1976–1983 *Proceso* began with a coup d'etat that overthrew Isabel Perón and installed in her place a junta formed by General Jorge Rafael Videla, Admiral Emilio Eduardo Massera, and Brigadier-General Orlando Ramón Agosti. It was preceded by the 1966 coup in which Juan Carlos Onganía ousted the democratically elected president Arturo Illia. A month after this, the police used batons to violently break up an occupation of the University of Buenos Aires by students and faculty. See Guest, *Behind the Disappearances*.

8 See the HIJOS organizational website, http://www.hijos-capital.org.ar/.
9 Colectivo Situaciones, *Genocide in the Neighborhood*, 146.
10 My thanks to Fabián Cerejido for his insights into this traumatic history.
11 See Druliolle, "H.I.J.O.S. and Spectacular Denunciation." See also Lessa and Levey, "From Blanket Impunity."
12 Reuters Staff, "Argentine Court Sentences."
13 On Grupo Etcetera, see https://grupoetcetera.wordpress.com/. For another account of the escraches, see Benegas, "If There's No Justice."
14 For a description, see La Vaca, "#GenocidaSuelto."
15 For a discussion of GAC's work, see Grupo de Arte Callejero, *Thought, Practices and Actions*.
16 See Benegas, "The Escrache Is an Intervention."
17 See Benegas, "The Escrache Is an Intervention."
18 Colectivo Situaciones, *Genocide in the Neighborhood*, 20, 23.
19 Benegas, "The Escrache Is an Intervention."
20 Colectivo Situaciones, *Genocide in the Neighborhood*, 78.
21 Colectivo Situaciones, *Genocide in the Neighborhood*, 67.
22 Colectivo Situaciones, *Genocide in the Neighborhood*, 44.
23 The escraches seek, as Colectivo Situaciones writes, "to overcome the conventional subordination of those who do to those who think . . . what we see today are groups working within a given situation that observe what works and what doesn't. And it's always, in the beginning, an independent investigation because the one who thinks it, does it, instead of (as the strategists would have it) the subordination of those who do to those who think." *Genocide in the Neighborhood*, 125.
24 Colectivo Situaciones, *Genocide in the Neighborhood*, 22.
25 Benegas, "The Escrache Is an Intervention."
26 Colectivo Situaciones, *Genocide in the Neighborhood*, 31.
27 Colectivo Situaciones, *Genocide in the Neighborhood*, 100, 123.
28 Rancière, "The Emancipated Spectator," 278.
29 Colectivo Situaciones, *Genocide in the Neighborhood*, 102–3.
30 The image of the artist "kicking off" against a "rigid surface" comes from Rosalind Krauss. Bois, "Interview with Rosalind Krauss."
31 Colectivo Situaciones, *Genocide in the Neighborhood*, 101, 98.
32 Colectivo Situaciones, *Genocide in the Neighborhood*, 75.
33 Colectivo Situaciones, *Genocide in the Neighborhood*, 75.
34 Benjamin, *Understanding Brecht*, 90.
35 Benjamin, *Understanding Brecht*, 88.
36 Gerald Raunig provides a useful translation of Tretyakov's field notes from this period. See Raunig, "Changing the Production Apparatus." It is also necessary to acknowledge the ambivalent nature of the collective farm relative to pro-

cesses of forced collectivization in the USSR. See Gough, "Radical Tourism," 159–78.

37 Raunig, "Changing the Production Apparatus."
38 Benjamin, *Understanding Brecht*, 89.
39 Benjamin, *Understanding Brecht*, 91.
40 Mann, *Doctor Faustus*, 339.
41 Stepanova, "A General Theory of Constructivism," 70–71.
42 As *October*'s editors insist in its founding issue, "art begins and ends with a recognition of its conventions." "About OCTOBER," 4.
43 See Wilder, *Freedom Time*; Morgan, *The Black Arts Movement*.
44 Césaire, *The Original 1939 Notebook*, 30.
45 On Zavarei's work, see Dinkins, "Interview with Saba Zavarei." On Chu Yuan's work, see Kester, *The One and the Many*, 145–152. See also Kakande, "On the Fashion Parade."
46 On the Tambo Colectivx, see Lxs Colectiverxs, "Lurawi, Doing." On Tabacalera, see Durán and Moore, "La Tabacalera of Lavapiés." On the civil rights movement, see Polletta, *Freedom Is an Endless Meeting*.
47 See, for example, Florido, "Developer of Cell Phone Tool for Migrants."
48 On Prestes Maia, see Adams, "Art Collectives and Prestes Maia." On La Plataforma de Afectados por la Hipoteca, see Herbst, "On the Relational Transformation of Law."
49 On Bell, see "About Shamell," Shamell Bell, https://www.shamellbell.com/about-shamell. On Denise, see "DJ Lynnée Denise," http://www.djlynneedenise.com/.
50 See Rasmussen, "A Note on Socially Engaged Art," and Kester, "The Limitations of the Exculpatory Critique."
51 Colectivo Situaciones, *Genocide in the Neighborhood*, 44.
52 Roberts, *Revolutionary Time*, 151.

3. Dematerialization and Aesthetics in Real Time

1 Martin, *The Theater Is in the Street*.
2 See Foster, "What's Neo about the Neo-Avant-Garde?," 22. Foster returns to this analysis in a 2012 essay where he laments what was "lost" during the 1960s with the emergence of new forms of art practice that "threatened to push art into an arbitrary realm beyond aesthetic judgement." "Critical Condition," 147–48. For a useful corrective to Foster's analysis, which situates Kaprow's work in the broader context of 1960s cultural politics, see Rodenbeck, *Radical Prototypes*.
3 Foster, *Bad New Days*, 140, 133.
4 See Burnham, "Real Time Systems."
5 Piper, "Concretized Ideas," 42.
6 Piper, "Concretized Ideas," 43. See also Bowles, *Adrian Piper*.

7 This is evident in her discussion of a Catalysis performance that involved implicating passersby in her "private" monologues, as described in a 1976 interview. Piper, "Concretized Ideas," 43.
8 Lippard, "Catalysis," 76.
9 Cerejido, "Tucumán Arde," 121.
10 Cerejido, "Tucumán Arde," 122. Masotta, along with Lucy Lippard and John Chandler, introduced the terminology of "dematerialization" in 1967 to describe new forms of performance-based artistic production. See Lippard and Chandler, "The Dematerialization of Art," and Masotta, "After Pop, We Dematerialize." See also Mazadiego, *Dematerialization and Social Materiality*.
11 See Phillips, *Mierle Laderman Ukeles*.
12 Alberro, *Abstraction in Reverse*, 2.
13 Lewitt, "Paragraphs on Conceptual Art," 12. See also Buchloh, "Conceptual Art 1962–1969," 107.
14 Kosuth, "Art after Philosophy," 163.
15 Kosuth, "Art after Philosophy," 166.
16 Kosuth, "Art after Philosophy," 158.
17 Kosuth, "Art after Philosophy," 164.
18 Kosuth, "Art after Philosophy," 170.
19 Habermas, "From Kant to Hegel."
20 See, for example, Jones, *Performing the Subject*.
21 Stark, "'Cinema in the Hands of the People,'" 122.
22 See also Grant, *Cinéma Militant*.
23 Stark, "'Cinema in the Hands of the People,'" 126.
24 Stark, "'Cinema in the Hands of the People," 126.
25 On Medvedkin, see Leyda, *Kino*, 286–287, 336. It is worth noting Marker's romanticized image of Medvedkin, who used agit-prop films to "shame" insufficiently productive workers during Stalin's First Five Year Plan. Stark, "'Cinema in the Hands of the People,'" 130.
26 Stark, "'Cinema in the Hands of the People,'" 137.
27 Stark, "'Cinema in the Hands of the People,'" 139.
28 Stark, "'Cinema in the Hands of the People,'" 140.
29 Stark, "'Cinema in the Hands of the People,'" 140.
30 These terms were employed by Godard in a voice-over from *Pravda* (1969). Stark, "'Cinema in the Hands of the People,'" 141.
31 Stark, "'Cinema in the Hands of the People,'" 143–44.
32 Goldmann, *The Human Sciences*, 129.
33 Stark, "'Cinema in the Hands of the People,'" 146.
34 Cited by Lenin in *What Is to Be Done?*, 40.
35 A copy of the original manifesto is available at La Revue des Ressources (Revue électronique culturelle pluridisciplinaire: Littérature, arts & idées),

posted June 14, 2013, https://www.larevuedesressources.org/Que-faire-What-is-to-be-done. The following quotes are all from this source: https://www.larevuedesressources.org/que-faire-what-is-to-be-done,2575.html.

36 Stark, "'Cinema in the Hands of the People,'" 144.
37 MacBean, "Godard and the Dziga Vertov Group," 34.
38 See Wolin, *The Wind from the East*, 353.
39 In a 1972 interview in *Politique Hebdo*, Gorin speaks of "having the courage to say [our films] are made for only ten people." Catalog for Jean-Luc Godard, dir., *Godard and Gorin: Five Films 1968–1971*, 50. Film historian Steve Cannon bears this out in a 1993 essay: "*Groupe Dziga Vertov* addressed their films *not* in any way to the working class as a whole, *not* to the large sections of it radicalized in 1968 . . . *not* to the mass of students and intellectuals whose view of the world was similarly shifting massively to the left in the period and *not* even to those amongst it who had already reached revolutionary conclusions." Cannon, "Godard, the Groupe Dziga Vertov," 81.
40 Starr, *Logics of Failed Revolt*, 129.
41 Starr, *Logics of Failed Revolt*, 159.

4. The Aesthetics of Answerability

1 See Barker, Dale, and Davidson, *Revolutionary Rehearsals*.
2 See Žižek, *Lenin 2017*.
3 Zavarei, "The Song of Disobedience," 122.
4 Dinkins, "Interview with Saba Zavarei."
5 This and the preceding quotes are from Zavarei, "Dancing into Alternative Realities." We see this same approach in the work of Iranian dancer Tanin Torabi, also discussed in Zavarei's essay.
6 Kakande, "On the Fashion Parade."
7 Kakande, "On the Fashion Parade."
8 Kakande, "On the Fashion Parade."
9 This same movement, toward larger social configurations and more direct engagement with institutional systems, is evident in the work of Gezi-Park Fiction in Hamburg. See Kester, *The One and the Many*, 199–210.
10 Fleetwood, *Marking Time*, 165.
11 Fleetwood, *Marking Time*, 165.
12 See Bernstein, *America Is the Prison*.
13 Fleetwood, *Marking Time*, 159.
14 Fleetwood, *Marking Time*, 70.
15 See Buntinx, "Lava la Bandera."
16 Buntinx, "Lava la Bandera," 27.
17 Buntinx, "Lava la Bandera," 28.

18 Buntinx, "Lava la Bandera," 21.
19 On the "priority of the object," see Adorno, *Negative Dialectics*, 183–97.
20 See Lxs Colectiverxs, "Lurawi, Doing," and Adams, "Art Collectives and the Prestes Maia." See also Castellano, "The Boda Moment."
21 Hirschhorn, "Unshared Authorship," 54. I examine Hirschhorn's work in greater detail in *The Sovereign Self*.
22 Roberts, *Revolutionary Time*, 67.
23 I provide a detailed analysis of this dynamic in my discussion of Thomas Hirschhorn's work in *The Sovereign Self*, 180–211.

5. Social Labor and Communicative Action

1 See Habermas, *Theory and Practice* and *Knowledge and Human Interests*.
2 This and the following quotes are from Habermas, "From Kant to Hegel," 132.
3 Habermas, "From Kant to Hegel," 132.
4 Habermas, "From Kant to Hegel," 131.
5 Wynter, "Unsettling the Coloniality of Being," 277.
6 Habermas, "From Kant to Hegel," 130.
7 Habermas, "From Kant to Hegel," 136.
8 Habermas, "From Kant to Hegel," 136.
9 Habermas, "From Kant to Hegel," 150.
10 Habermas, "From Kant to Hegel," 150.
11 Marx, *Early Writings*, 141.
12 Habermas, "From Kant to Hegel," 149.
13 Habermas, "From Kant to Hegel," 148.
14 Habermas, *Theory and Practice*, 164.
15 Habermas, "From Kant to Hegel," 130.
16 Habermas, "From Kant to Hegel," 149.
17 Feuerbach, *The Fiery Brook*, 128.
18 Marx, *Critique of Hegel's Philosophy*.
19 Habermas, *Theory and Practice*, 40.
20 Habermas, *Theory and Practice*, 36.
21 Habermas, *Theory and Practice*, 34–35.
22 Habermas, *Theory and Practice*, 35.
23 Habermas, *Theory and Practice*, 36.
24 Habermas, *Theory and Practice*, 36.
25 Habermas, *Theory and Practice*, 36.
26 Habermas, *Theory of Communicative Action*; Honneth, *The Critique of Power*.
27 Habermas, "From Kant to Hegel," 129. The phrase is taken from Michael Theunissen's research. See *The Other*.

28 See Berki, "Marx's Concept of Labor," 35–56.
29 Honneth, "Work and Instrumental Action," 33.
30 Habermas, *Knowledge and Human Interests*, 31.
31 Marx, *Economic and Philosophic Manuscripts*, 114.
32 Marx, *Early Writings*, 277.
33 Marx, *Early Writings*, 278.
34 Avineri, *The Social and Political Thought*, 71.
35 Marx, *Economic and Philosophic Manuscripts*, 155.
36 Avineri, *The Social and Political Thought*, 141.
37 Max Scheler cited by Honneth, "Work and Instrumental Action," 39.
38 Honneth, "Work and Instrumental Action," 33.
39 Honneth, "Work and Instrumental Action," 37.
40 Marx, *Capital*, 13.
41 Marx and Engels, "The Communist Manifesto," 25.
42 See Honneth and Joas, *Social Action and Human Nature*, 24.
43 Deranty, *Beyond Communication*, 45.
44 See Habermas, *Legitimation Crisis*.
45 James and Lee, *Facing Reality*, 67–68.
46 During the 1940s and 1950s, James was aligned with the Johnson Forest tendency, an offshoot of Trotskyism in the United States that sought to advance an alternative form of communism that acknowledged the generative agency and critical intelligence of the working class. It anticipated subsequent developments in France associated with figures such as Cornelius Castoriadis, as well as the emergence of Operaismo or "workerism" in Italy during the 1960s and 1970s by Mario Tronti, Antonio Negri, and other theorists who argued for the "autonomy" of the working class from both the capitalist system and the bureaucratized communist party.
47 Fanon, *The Wretched of the Earth*, 145.
48 Rodney, *The Groundings with My Brothers*, 64.
49 Habermas, "Systematically Distorted Communication."
50 As Habermas writes in *The Logic of Social Sciences*, "Today the problem of language has replaced the traditional problem of consciousness." McCarthy, *The Critical Theory*, 273.
51 McCarthy, *The Critical Theory*, 284–86.
52 McCarthy, *The Critical Theory*, 290.
53 See, for example, the work of Dutch artist Erik Hagoort: http://www.erikhagoort.nl/Erik_Hagoort_English_homepage.html.
54 Habermas, *Communication and the Evolution of Society*, 64.
55 Theunissen, "Society and History," 254–56.
56 Honneth, *Struggle for Recognition*.
57 Honneth, "On the Epistemology of 'Recognition.'"

58 Honneth, "On the Epistemology of 'Recognition,'" 111.
59 Honneth, "On the Epistemology of 'Recognition,'" 126.
60 Honneth, *Struggle for Recognition*, 164.
61 Honneth, "Work and Instrumental Action," 50.
62 Honneth, "Work and Instrumental Action," 46.
63 For useful critiques, see the dialogue between Honneth and Nancy Fraser in *Redistribution or Recognition*, and Thompson, *The Domestication of Critical Theory*.
64 Honneth, "Integrity and Disrespect," 194.
65 Gramsci, *Selections from the Prison Notebooks*, 268.
66 Marx, *The Economic and Philosophic Manuscripts*, 144.
67 Baudrillard is writing here of the Marxist version of the self outlined in *The German Ideology*. Baudrillard, *The Mirror of Production*, 106.
68 As early as November 1917, Maxim Gorky observed, "Lenin, Trotsky, and their companions have already become poisoned with the filthy venom of power, and this is evidenced by their shameful attitude toward freedom of speech, the individual, and the sum total of those rights for the triumph of which democracy struggled." Gorky, "For the Attention of the Workers," 86.
69 Marx and Engels, *The German Ideology*, 83.
70 As Adorno writes, "precisely in his solitariness and isolation the composer carries out social demands; that society itself dwells in the inmost cells of the self-enclosed technical problems, and he registers its demands all the more legitimately, the less he is prompted from the outside." Buck-Morss, *The Origin of Negative Dialectics*, 35.
71 See Keep, *The Debate on Soviet Power*, and Polan, *Lenin and the End of Politics*. For an analysis of Lenin's "Jacobin" orientation, see Williams, *The Other Bolsheviks*, 1–15.
72 Adorno, *Aesthetic Theory*, 43.
73 Thomas, *Karl Marx and the Anarchists*, 112.
74 Arendt, *The Human Condition*.
75 I discuss the influence of Nikolay Chernyshevsky's *What Is to Be Done?* on Lenin in *The Sovereign Self*.
76 Woodly, *Reckoning*, 37.
77 Woodly, *Reckoning*, 39.
78 Woodly, *Reckoning*, 41.
79 Woodly, *Reckoning*, 41.
80 Woodly, *Reckoning*, 43.
81 Woodly, *Reckoning*, 43.
82 Woodly, *Reckoning*, 39.
83 Woodly, *Reckoning*, 44.

6. Our Pernicious Temporality

1. See my discussion (Kester, *The One and the Many*, 76–95) and Affourtit, "Televising the Revolution."
2. Thomas, *Karl Marx and the Anarchists*, 112.
3. Glissant, "Creolization in the Making," 84. See also Coombes, *Édouard Glissant*.
4. Glissant, "Creolization in the Making," 88.
5. See Erlich, *Russian Formalism*, 83. See also Clark and Holquist, *Mikhail Bakhtin*, 36.
6. Clark and Holquist, *Mikhail Bakhtin*, 99. See also Holquist, "Bakhtin's Life," 25–34.
7. Bakhtin, *Toward a Philosophy*, 9.
8. See Bakhtin and Medvedev, *The Formal Method*.
9. Shklovsky, "Art as Device," 5.
10. Shklovsky, "Art as Device," 6.
11. Mayakovsky, "A Slap in the Face."
12. Shklovsky, *Theory of Prose*, 189.
13. Mayakovsky, "A Slap in the Face."
14. Volosinov, *Marxism and the Philosophy of Language*, 86.
15. The question of Bakhtin's role in the authorship of *The Formal Method* and *Marxism and the Philosophy of Language* remains contentious. Katerina Clark and Michael Holquist have argued that Bakhtin himself was the probable author of both texts, while Gary Saul Morson and Caryl Emerson have argued that Medvedev and Volosinov are the original authors. See Morson and Emerson, *Mikhail Bakhtin*, 101–20, and Clark and Holquist, *Mikhail Bakhtin*, 146–70.
16. Mayakovsky, "A Slap in the Face."
17. See Bakhtin and Medvedev, *The Formal Method*, 93.
18. Bakhtin, "Discourse in the Novel," 273, 262–63.
19. Bakhtin, "Discourse in the Novel," 261–62.
20. See Volosinov, *Marxism and the Philosophy of Language*, 60.
21. Bakhtin, *Toward a Philosophy*, 2; Volosinov, *Marxism and the Philosophy of Language*, 57–58.
22. See Kant, *Groundwork of the Metaphysics*.
23. Bakhtin, *Toward a Philosophy*, 26.
24. Bakhtin, *Toward a Philosophy*, 11.
25. Bakhtin, *Toward a Philosophy*, 48.
26. Bakhtin, *Problems of Dostoevsky's Poetics*, 292–93.
27. Bakhtin, *Art and Answerability*, 60.
28. Bakhtin, *Art and Answerability*, 60. "I, as a self, am unable to have a complete picture of my own being. I need an Other, who can view me as a totality, to create that for me." Bakhtin, *Art and Answerability*, 12.

29 Todorov, *Mikhail Bakhtin*, 99.
30 Bakhtin, *Art and Answerability*, 25.
31 Bakhtin, *Art and Answerability*, 14.
32 Bakhtin, *Art and Answerability*, 83–84.
33 Todorov, *Mikhail Bakhtin*, 100.
34 Bakhtin, *Toward a Philosophy*, 14.
35 Bakhtin, *Toward a Philosophy*, 14.
36 Thus, Bakhtin warns that the artist must never become too enmeshed with the life of the other (to become a "direct participant"), as this would sacrifice too much of their authorial sovereignty and imply an "ethical" rather than an "aesthetic" relationship to the other's existence. The failure to "return into myself" can lead to the "pathological phenomenon of experiencing another's suffering as one's own." *Art and Answerability*, 26.
37 Bakhtin, *Art and Answerability*, 203.
38 Bakhtin, *Problems of Dostoevsky's Poetics*, 284.
39 Bakhtin, *Problems of Dostoevsky's Poetics*, 284.
40 Bakhtin, *Problems of Dostoevsky's Poetics*, 288.
41 Bakhtin, *Problems of Dostoevsky's Poetics*, 287.
42 Bakhtin, *Problems of Dostoevsky's Poetics*, 287.
43 Bakhtin, *Problems of Dostoevsky's Poetics*, 288.
44 In a provocative interpretation, Boris Groys accuses Bakhtin, through his concepts of the polyphonic novel and his writing on carnival, of advocating a quasi-Stalinist collapse of the individuated self into the collective. See Groys, "Between Stalin and Dionysus."
45 Bakhtin, *Problems of Dostoevsky's Poetics*, 288.
46 Bakhtin, *Problems of Dostoevsky's Poetics*, 299.
47 Bakhtin, *Problems of Dostoevsky's Poetics*, 295.
48 Bakhtin, *Problems of Dostoevsky's Poetics*, 285.
49 Bakhtin cites Tolstoy and Goncharov as examples. Curtis, "Mikhail Bakhtin," 237.
50 Bakhtin, *Problems of Dostoevsky's Poetics*, 63.
51 Adorno, *Aesthetic Theory*, 257, 136.
52 "Reception tends to dull the critical edge of art.... Works are most critical when they first see the light of day." Adorno, *Aesthetic Theory*, 325.
53 Bakhtin, *Problems of Dostoevsky's Poetics*, 285.
54 Adorno, "The Artist as Deputy," 67.
55 Adorno, *Aesthetic Theory*, 253.
56 Adorno, "The Artist as Deputy," 107.
57 Adorno, *Aesthetic Theory*, 347.
58 Althusser, "Marxism and Humanism."
59 It was, in particular, the threat posed to Stalinism by Khruschev's revelations at the Twentieth Party Congress, and new forms of resistance against the Soviet

state associated with events such as the Prague Spring, that Althusser hoped to circumvent in his theoretical work. For this reason, Althusser sought to reinvent Marxism as an entirely "self-enclosed, autochthonous conceptual system," as Richard Wolin has observed: "Marx's theoretical corpus contained absolute truth—as long as one knew how to read it and what to look for. By emphasizing Marxism's internal coherence, Althusser sought to safeguard its doctrinal purity, no matter how badly the theory might play out in reality. Stalin may have committed egregious crimes; the Soviet Union might be a degenerate workers' state; yet Marxism's pristine theoretical truths would persevere unscathed." Wolin, *The Wind from the East*, 120.

60 Althusser, *Reading Capital*, 105.
61 Foucault, "The Great Rage of Facts." It was during this period that Foucault became more sympathetic to the "New Philosophers" in France. See Zamora and Behrent, *Foucault and Neoliberalism*.
62 Althusser, "Ideology and Ideological State Apparatuses."

7. Being Human as Praxis

1 "Practical interchange is full of event-potential, and the most insignificant philological exchange participates in this incessant generation of the event." Morson and Emerson, *Mikhail Bakhtin*, 22.
2 Bakhtin, *Toward a Philosophy*, 35.
3 Bakhtin, *Problems of Dostoevsky's Poetics*, 285.
4 Caudwell, *Studies and Further Studies*, 47.
5 Morson and Emerson address this inconsistency in their book *Mikhail Bakhtin*, where they acknowledge that, in the novel, it is "impossible for the author and the character to 'exist on a single plane' and hence to enter into dialogue as equals." "It would therefore seem impossible," they conclude, "for there to be a genuinely polyphonic novel." See pp. 241, 246–47, 257.
6 See Clark and Holquist, *Mikhail Bakhtin*, 266–69.
7 Bhabha, *The Location of Culture*, 5, 37.
8 Bhabha, *The Location of Culture*, 5, 37, 2.
9 See San Juan, *Hegemony and Strategies*, 97.
10 Moten, *In the Break*, 1.
11 Spelman, "Woman as Body."
12 Wynter, *Black Metamorphosis*, 244. Wynter worked on this unpublished manuscript between 1971 and 1982. The original manuscript is held at the Schomberg Center for Research in Black Culture in New York.
13 Wynter, *Black Metamorphosis*, 249.
14 See da Silva, "Before *Man*," 99–100.
15 Charlie and Dougan, "Shackville Two Years On."
16 Makhubu, "On Apartheid Ruins," 578.

17 Makhubu, "On Apartheid Ruins," 579.
18 "How Shackville Started a War."
19 Makhubu, "On Apartheid Ruins," 577.
20 Makhubu, "On Apartheid Ruins," 577.
21 Makhubu, "On Apartheid Ruins," 581.
22 Makhubu, "On Apartheid Ruins," 584. See also Hendricks, "Rhodes Must Fall Exhibition."
23 See "Trans Collective."
24 Makhubu, "On Apartheid Ruins," 585.
25 Burelle, *Encounters on Contested Lands*, 127.
26 Burelle, *Encounters on Contested Lands*, 129.
27 Burelle, *Encounters on Contested Lands*, 124.
28 Burelle, *Encounters on Contested Lands*, 116.
29 Burelle, *Encounters on Contested Lands*, 120.
30 See University of Cape Town, *The Final Report*.
31 Burelle, *Encounters on Contested Lands*, 139.
32 Höttcke and Kettner, "The Dead Are Coming," 287.
33 Nunes, *Neither Vertical Nor Horizontal*, 53.
34 See Kester, "Noisy Optimism."
35 Žižek "Don't Act, Just Think."
36 Žižek, *Violence*, 8.
37 On Dutschke's "long march," see Marcuse, *Counterrevolution and Revolt*, 55–56.
38 Dean, *Crowds and Party*.
39 Nunes, *Neither Vertical Nor Horizontal*, 228.
40 Nunes, *Neither Vertical Nor Horizontal*, 152.
41 Žižek, "A Leftist Plea for 'Eurocentrism.'"
42 Nesbitt, "Glissant and the Poetics of Truth," 103.
43 See my discussion of Sylvia Wynter's research in Kester, *The Sovereign Self*.
44 Hall et al., *Policing the Crisis*, 394.
45 Amaral and Cicerchia, "Race and Class."
46 Amaral and Cicerchia, "Race and Class."
47 Amaral and Cicerchia, "Race and Class."
48 See, for example, Žižek, *Lenin 2017*.
49 See "Slavoj Zizek at OWS."
50 This attitude is linked with what Alan Johnson has described as Žižek's "Wild Blanquism," in reference to the nineteenth-century French revolutionary Louis Auguste Blanqui, who believed that the overthrow of the bourgeoisie could only be accomplished by a small group of dedicated political visionaries, uniquely able to glimpse the telos of revolutionary change. Rather than revolutionary

change being initiated by the working class itself, in a process that entailed democratic decision-making, Blanqui's vanguard would take power through a violent assault on the existing system of government, spearheaded by an authoritarian "dictatorship" that viewed all forms of cumulative, democratic change with contempt. As Johnson writes, "Žižek's 'Jacobin Spirit' is the latest in a long (and, lest we forget, sometimes genocidal) line of 'socialisms from above.' The useful term was coined by Hal Draper to describe the tendency of socialists to think of socialism not as the act of the immense majority in the interests of the immense majority (popular self-emancipation), but as 'a societal rearrangement to be handed down to the grateful masses . . . by a ruling elite which is not in fact subjected to the masses' control . . . or indeed, to be imposed upon the people from above, whether they are grateful or not.'" This process will be carried forward by a hardened cadre of radical intellectuals defined by their absolute autonomy from all existing societal constraints. "The only 'realistic' prospect," as Žižek writes, "is to ground a new political universality by opting for the impossible, fully assuming the place of the exception, with no taboos, no a priori norms ('human rights,' 'democracy'), respect for which would prevent us from 'resignifying' terror, the ruthless exercise of power, the spirit of sacrifice . . . if this radical choice is decried by some bleeding-heart liberals as *Linksfaschismus* [Left Fascism], so be it!" Elsewhere he contends, "There are no 'democratic (procedural) rules' one is a priori prohibited to violate. Revolutionary politics is not a matter of 'opinions,' but of the truth on behalf of which one is compelled to disregard the 'opinion of the majority' and to impose the revolutionary will against it." Žižek, "Holding the Place," 326; Johnson, "The Power of Nonsense." See also Johnson, "Slavoj Žižek's Linksfaschismus."

51 Jardine and Massumi, "Interview with Toni Negri," 74–75. This mirror's Žižek's own description of the "revolutionary subject," defined by "an 'inhuman' position of absolute freedom (in my loneliness I am free to do whatever I want, nobody has any hold over me) coinciding with an absolute subjection to a Task (the only purpose of my life is to exact revenge)." Žižek, *Lost Causes*, 171.

52 It also requires an analysis of the symptomatic forms of exclusion that often define their production of an ostensibly "objective" theoretical truth. Jamaican philosopher Charles Mills has developed a concept of "non-ideal" theory to challenge this tendency. Mills, "'Ideal Theory' as Ideology."

53 de Sousa Santos, *Epistemologies of the South*, 44.

54 Adorno and Horkheimer, "Towards a New Manifesto?," 33–34.

55 See, for example, Strathausen, *A Leftist Ontology*.

56 Bosteels, *The Actuality of Communism*, 267.

57 Bosteels, *The Actuality of Communism*, 274.

58 "Nor should we accept," as Bosteels writes, the self-validating claim that "ontological inquiries into the essence of the political [are] more radically political . . . than all hitherto existing politics." Bosteels, *The Actuality of Communism*, 268.

59 Bosteels, *The Actuality of Communism*, 272.
60 Nunes, *Neither Vertical Nor Horizontal*, 13.
61 Hosseini, *Alternative Globalizations*, 92, 100.
62 "Hapticality, the touch of the undercommons, the interiority of sentiment, the feel that what is to come is here. Hapticality, the capacity to feel through others, for others to feel through you, for you to feel them feeling you, this feel of the shipped is not regulated, at least not successfully." Harvey and Moten, *The Undercommons*, 98.
63 de Sousa Santos, *Epistemologies of the South*, 44.
64 de Sousa Santos, *Epistemologies of the South*, 44.
65 de Sousa Santos, *Epistemologies of the South*, 131.
66 de Sousa Santos, *Epistemologies of the South*, 132.

Conclusion

1 Demos, "The Great Transition."
2 Sanromán and Kantor, *Tania Bruguera*, 133–35.
3 There are, of course, any number of contemporary artists who have no interest in invoking the Bolshevik Revolution or interrogating art-world conventions. Their work carries forward its own forms of situational criticality with greater or lesser success without claiming any special immunity from the ideological forces of the art market or institutional art world. As I have argued here, the goal of neo-avant-garde discourse has always been to indemnify art world–based practices from critique by arguing that the co-option of the market is entirely neutralized or offset by the work's ability to preserve a deeper or more foundational revolutionary truth.
4 See Sholette, "Anti-Globalism and the Neo-Authoritarian Turn."
5 For further information on several of these projects, see Kelley and Kester, *Collective Situations;* Galliera, *Socially Engaged Art after Socialism*; Jesty, *Art and Engagement in Japan*; Castellano, *Beyond Representation*; and Wang, *Socially Engaged Art in China*. See also Jesty's two-volume issue of *FIELD*, "Japan's Social Turn," and Nomusa Makhubu and Carlos Garrido Castellano's issue of *FIELD*, "Creative Uprisings," devoted to art and social movements in Africa. We also have promising new interpretations focused on the archival reconstruction of participatory art projects during the 1980s. See Routhwaite, *Asking the Audience*.
6 See Gibson Graham's work on new paradigms of political transformation in *Postcapitalist Politics* and Ana Cecilia Dinerstein's research into prefigurative cultural practices in *The Politics of Autonomy*. On the importance of non-Western epistemologies, see Castellano, *Art Activism*. On new methodologies, see Kester, "The Device Laid Bare."
7 Luxemburg, "The Russian Revolution," 306.

WORKS CITED

"About OCTOBER." *October* 1 (Spring 1976): 3–5.

Adams, Gavin. "Art Collectives and the Prestes Maia Occupation in Sao Paulo." In *Collective Situations: Readings in Contemporary Latin American Art, 1995–2010*, edited by Bill Kelley Jr. and Grant H. Kester, 149–64. Durham, NC: Duke University Press, 2017.

Adorno, Theodor. *Aesthetic Theory*. Edited by Gretel Adorno and Rolf Tiedemann. Translated by C. Lenhardt. London: Routledge, 1984.

Adorno, Theodor. "The Artist as Deputy." In *Notes to Literature*, vol. 1, translated by Shierry Weber Nicholsen, 98–108. New York: Columbia University Press, 1991.

Adorno, Theodor. "Commitment." In *Aesthetics and Politics: Debates between Bloch, Lukács, Brecht, Benjamin and Adorno*, translated and edited by Ronald Taylor, 177–95. London: Verso, 1977.

Adorno, Theodor. *Negative Dialectics*. Translated by E. B. Ashton. New York: Continuum, 1995.

Adorno, Theodor, and Max Horkheimer. "Towards a New Manifesto?" (1956). *New Left Review* 65 (September–October 2010): 33–61.

Adorno, Theodor, and Herbert Marcuse. "Correspondence on the German Student Movement." *New Left Review* 233 (January–February 1999): 123–26.

Affourtit, Lorraine. "Televising the Revolution: Oaxacan Women on CORTV." *Third Text* 34, no. 1 (January 2020): 22–36.

Alberro, Alexander. *Abstraction in Reverse: The Reconfigured Spectator in Mid-Twentieth-Century Latin American Art*. Chicago: University of Chicago Press, 2017.

Althusser, Louis. *For Marx*. London: New Left Books, 1969.

Althusser, Louis. "Ideology and Ideological State Apparatuses." In *Lenin and Philosophy and Other Essays*, translated by Ben Brewster, 142–76. New York: Monthly Review Press, 1971.

Althusser, Louis. "Marxism and Humanism." *Cahiers de l'I.S.E.A.*, June 1964. https://www.marxists.org/reference/archive/althusser/1964/marxism-humanism.htm.

Althusser, Louis. *Reading Capital*. London: New Left Books, 1970.

Amaral, Aaron, and Lillian Cicerchia. "Race and Class / Reed and Reductionism: An Interview with Asad Haider." *Tempest Magazine*, August 25, 2020. https://www.tempestmag.org/2020/08/haider-interview-part-1/.

Arendt, Hannah. *The Human Condition*. Introduction by Margaret Canovan. Chicago: University of Chicago Press, 1958.

Avineri, Shlomo. *The Social and Political Thought of Karl Marx*. Cambridge: Cambridge University Press, 1988.

Awde, Nick. "Renata Carvalho: I've Never Known a Play to Raise Discussion in So Many Places." *The Stage*, October 23, 2019. https://www.thestage.co.uk/features/renata-carvalho-ive-never-known-a-play-to-raise-discussions-in-so-many-places.

Badiou, Alain. "Avant-gardes." In *The Century*, translated, with a commentary and notes, by Alberto Toscano, 131–47. Cambridge: Polity Press, 2005.

Badiou, Alain. *The Century*. Translated, with a commentary and notes, by Alberto Toscano. Cambridge: Polity Press, 2005.

Badiou, Alain. *Metapolitics*. Translated by Jason Barker. New York: Verso, 1998.

Badiou, Alain. *The Rebirth of History: Times of Riots and Uprisings*. London: Verso, 2012.

Bakhtin, Mikhail. *Art and Answerability: Early Philosophical Essays*. Edited by Michael Holquist and Vadim Liapunov. Translated and notes by Vadim Liapunov. Austin: University of Texas Press, 1990.

Bakhtin, Mikhail. "Discourse in the Novel." In *The Dialogic Imagination: Four Essays*, edited by Michael Holquist, translated by Caryl Emerson and Michael Holquist, 259–422. Austin: University of Texas Press, 1981.

Bakhtin, Mikhail. *Problems of Dostoevsky's Poetics*. Edited and translated by Caryl Emerson. Minneapolis: University of Minnesota Press, 1984.

Bakhtin, Mikhail. *Toward a Philosophy of the Act*. Translated and notes by Vadim Liapunov. Austin: University of Texas Press, 1993.

Bakhtin, Mikhail, and Pavel Medvedev. *The Formal Method in Literary Scholarship: A Critical Introduction to Sociological Poetics*. Translated by Albert J. Wehrle. Baltimore: Johns Hopkins University Press, 1978.

Barker, Colin, Gareth Dale, and Neil Davidson, eds. *Revolutionary Rehearsals in the Neoliberal Age*. Chicago: Haymarket Press, 2021.

Baudrillard, Jean. *The Mirror of Production*. St. Louis: Telos Press, 1973.

Beck, Chris Aronson, Reggie Emilia, Lee Morris, and Ollie Patterson. *Strike One to Educate One Hundred: The Rise of the Red Brigades in Italy in the 1960s–1970s*. Chicago: Seeds Beneath the Snow / Cooperative Distribution Service, 1986.

Beckstein, Martin. "The Dissociative and Polemical Political: Chantal Mouffe and the Intellectual Heritage of Carl Schmitt." *Journal of Political Ideologies* 16, no. 11 (February 2011): 33–51.

Beiser, Frederick C. *Enlightenment, Revolution, and Romanticism: The Genesis of Modern German Political Thought*. Cambridge, MA: Harvard University Press, 1992.

Benegas, Diego. "The Escrache Is an Intervention on Collective Ethics." 2004. https://hemi.nyu.edu/cuaderno/politicalperformance2004/totalitarianism/WEBSITE/texts/the_escrache_is_an_intervention.htm.

Benegas, Diego. "If There's No Justice . . . Trauma and Identity in Post-dictatorship Argentina." *Performance Research* 16, no. 1 (2011): 20–30.

Benjamin, Walter. "The Author as Producer." In *Understanding Brecht*, translated by Anna Bostock, 85–104. London: Verso, 1998.

Berki, R. N. "On the Nature and Origins of Marx's Concept of Labor." *Political Theory* 7, no. 1 (February 1979): 35–56.

Bernstein, Lee. *America Is the Prison: Arts and Politics in Prison in the 1970s*. Chapel Hill: University of North Carolina Press, 2010.

Bhabha, Homi. *The Location of Culture*. London: Routledge, 1994.

Bishop, Claire. "Antagonism and Relational Aesthetics." *October* 110 (Fall 2004): 51–79.

Bishop, Claire. *Artificial Hells: Participatory Art and the Politics of Spectatorship*. London: Verso, 2012.

Bishop, Claire. "The Social Turn: Collaboration and Its Discontents." *Artforum* 44 (February 2006): 178–83.

Black Lives Matter. "The Provocateurs: A Master Series." Accessed March 28, 2021. https://blacklivesmatter.com/the-provocateurs-a-master-series/.

Blustein, Paul. *And the Money Kept Rolling In (and Out): The World Bank, Wall Street, the IMF, and the Bankrupting of Argentina*. New York: PublicAffairs, 2005.

Bois, Yve-Alain. "Interview with Rosalind Krauss." *The Brooklyn Rail*, February 1, 2012. http://www.brooklynrail.org/2012/02/art/rosalind-krauss-with-yve-alain-bois.

Bosteels, Bruno. *The Actuality of Communism*. New York: Verso, 2011.

Bosteels, Bruno. "Reviewing Rancière. Or, the Persistence of Discrepancies." *Radical Philosophy* 170 (November–December 2011): 25–31. https://www.radicalphilosophy.com/article/reviewing-ranciere-or-the-persistence-of-discrepancies.

Bowles, John P. *Adrian Piper: Race, Gender and Embodiment*. Durham, NC: Duke University Press, 2011.

Brown, Nicholas. *Autonomy: The Social Ontology of Art under Capitalism*. Durham, NC: Duke University Press, 2019.

Buchloh, Benjamin H. D. "Conceptual Art 1962–1969: From the Aesthetic of Administration to the Critique of Institutions." *October* 55 (Winter 1990): 105–43.

Buck-Morss, Susan. *The Origin of Negative Dialectics: Theodor W. Adorno, Walter Benjamin, and the Frankfurt Institute*. New York: Free Press, 1977.

Buntinx, Gustavo. "Lava la Bandera: The Colectivo Sociedad Civil and the Cultural Overthrow of the Fujimori-Montesinos Dictatorship." In *Collective Situations: Readings in Contemporary Latin American Art, 1995–2010*, edited by Bill Kelley Jr. and Grant H. Kester, 21–42. Durham, NC: Duke University Press, 2017.

Burelle, Julie. *Encounters on Contested Lands: Indigenous Performances of Sovereignty and Nationhood in Québec*. Evanston, IL: Northwestern University Press, 2018.

Burgin, Victor. "Yes, Difference Again: What History Plays the First Time Around as Tragedy, It Repeats as Farce" (1988). In *Conceptual Art: A Critical Anthology*, edited by Alexander Alberro and Blake Stimson, 428–30. Cambridge, MA: MIT Press, 1999.

Burnham, Jack. "Real Time Systems." *Artforum* 8, no. 1 (September 1969): 49–55.

Camnitzer, Luis. "Contemporary Colonial Art" (1969). In *Conceptual Art: A Critical Anthology*, edited by Alexander Alberro and Blake Stimson, 224–30. Cambridge, MA: MIT Press, 1999.

Cannon, Steve. "Godard, the Groupe Dziga Vertov and the Myth of 'Counter Cinema.'" *Nottingham French Studies* 32, no. 1 (March 1993): 74–83.

Carnevale, Fulvia, and John Kelsey. "Art of the Possible: An Interview with Jacques Rancière." *Artforum* 45, no. 7 (March 2007): 256–69.

Castellano, Carlos Garrido. *Art Activism for an Anti-Colonial Future*. Albany: State University of New York Press, 2021.

Castellano, Carlos Garrido. *Beyond Representation in Contemporary Caribbean Art: Space, Politics and the Public Sphere*. New Brunswick, NJ: Rutgers University Press, 2019.

Castellano, Carlos Garrido. "The Boda Moment: Positioning Socially Engaged Art in Contemporary Uganda." *FIELD: A Journal of Socially Engaged Art Criticism* 10 (Spring 2010). http://field-journal.com/issue-10/the-boda-moment-positioning-socially-engaged-art-in-contemporary-uganda.

Caudwell, Christopher. *Studies and Further Studies in a Dying Culture*. New York: Dodd, Mead, 1958.

Cerejido, Fabián. "Tucumán Arde and the Changing Face of Censorship." In *In and Out of View: Art and the Dynamics of Circulation, Suppression, and Censorship*, edited by Catha Paquette, Karen Kleinfelder, and Chris Miles, 119–36. New York: Bloomsbury Visual Arts, 2020.

Césaire, Aimé. *The Original 1939 Notebook of a Return to the Native Land*. Translated by A. J. Arnold and Clayton Eshelman. Middletown, CT: Wesleyan University Press, 2013.

Charlie, Ayanda, and Leila Dougan. "Shackville Two Years On: A Perspective from the Student Who Graduated." *Daily Maverick*, February 28, 2018. https://www.dailymaverick.co.za/article/2018-02-28-no-filter-volume-4-shackville-two-years-on-a-perspective-from-the-student-who-graduated/.

Charnley, Kim. *Sociopolitical Aesthetics: Art, Crisis and Neoliberalism*. London: Bloomsbury, 2021.

Chu, Xiaoquan. "Alain Badiou and the Multiple Meanings of the 'Cultural Revolution.'" *China Perspectives* (April 2016): 85–88.

Clark, Katerina, and Michael Holquist. *Mikhail Bakhtin*. Cambridge, MA: Harvard University Press, 1984.

Colectivo Situaciones. "Colectivo Situaciones in Conversation with HIJOS." In *Genocide in the Neighborhood*, edited by Brian Whitener, translated by Brian Whitener, Daniel Borzutzky, and Fernando Fuentes, 53–86. Oakland: Chainlinks Press, 2009.

Coombes, Sam. *Édouard Glissant: A Poetics of Resistance*. London: Bloomsbury, 2018.

Corlin Frederiksen, Mai. *The Bishan Commune and the Practice of Socially Engaged Art in Rural China*. London: Palgrave Macmillan, 2020.

Curtis, James M. "Mikhail Bakhtin, Nietzsche, and Russian Pre-Revolutionary Thought." In *Mikhail Bakhtin*, vol. 1, edited by Michael E. Gardiner, 228–48. London: Sage, 2003.

da Silva, Denise Ferreira. "Before *Man*: Sylvia Wynter's Rewriting of the Modern Episteme." In *Sylvia Wynter: On Being Human as Praxis*, edited by Katherine McKittrick, 90–105. Durham, NC: Duke University Press, 2015.

Dean, Jodi. *Crowds and Party*. New York: Verso, 2016.

Demos, T. J. *Decolonizing Nature: Contemporary Art and the Politics of Ecology*. Berlin: Sternberg Press, 2016.

Demos, T. J. "The Great Transition: The Arts and Radical System Change." *E-flux Architecture*, April 2017. https://www.e-flux.com/architecture/accumulation/122305/the-great-transition-the-arts-and-radical-system-change/.

Deranty, Jean-Philippe. *Beyond Communication: A Critical Study of Axel Honneth's Social Philosophy*. Leiden: Brill, 2009.

de Sousa Santos, Boaventura. *Epistemologies of the South: Justice against Epistemicide*. London: Routledge, 2014.

Dinerstein, Ana Cecilia. *The Politics of Autonomy in Latin America: The Art of Organizing Hope*. Basingstoke, UK: Palgrave Macmillan, 2015.

Dinkins, Bria. "Interview with Saba Zavarei." *FIELD: A Journal of Socially Engaged Art Criticism* 17 (Fall/Winter 2021). http://field-journal.com/editorial/interview-with-saba-zavarie.

Druliolle, Vincent. "H.I.J.O.S. and the Spectacular Denunciation of Impunity: The Struggle for Memory, Truth and Justice and the (Re-)Construction of Democracy in Argentina." *Journal of Human Rights* 12, no. 2 (2013): 259–76.

Durán, Gloria G., and Alan W. Moore. "La Tabacalera of Lavapiés: A Social Experiment of a Work of Art?" *FIELD: A Journal of Socially Engaged Art Criticism* 2 (Fall 2015). http://field-journal.com/issue-2/duran-moore.

Erlich, Victor. *Russian Formalism: History-Doctrine*. New Haven, CT: Yale University Press, 1981.

Erman, Eva. "What Is Wrong with Agonistic Pluralism?" *Philosophy and Social Criticism* 35, no. 9 (2009): 1039–62.

Fanon, Frantz. *The Wretched of the Earth*. Translated by Richard Philcox. New York: Grove Press, 1961.

Ferrer, Daniel Fidel. *Oldest Systematic Program of German Idealism: Translation and Notes*. Verden, Germany: Kuhn von Verden Verlag, 2021.

Feuerbach, Ludwig. *The Fiery Brook, Selected Writings*. Translated by Zawar Hanfi. London: Verso, 2012.

Fleetwood, Nicole. *Marking Time: Art in the Age of Mass Incarceration*. Cambridge, MA: Harvard University Press, 2020.

Florido, Adrian. "Developer of Cell Phone Tool for Migrants under Investigation by UCSD." *Voice of San Diego*, April 6, 2010. https://www.voiceofsandiego.org/topics/education/developer-of-cell-phone-tool-for-migrants-under-investigation-by-ucsd/.

Foster, Hal. *Bad New Days*. London: Verso, 2015.

Foster, Hal. "Critical Condition." *Artforum* (September 2012): 147–48.

Foster, Hal. "What's Neo about the Neo-Avant-Garde?" *October* 70 (Fall 1994): 5–32.

Foster, Hal. "What's the Problem with Critical Art?" *London Review of Books* 35, no. 19 (October 2013): 14–15. https://www.lrb.co.uk/the-paper/v35/n19/hal-foster/what-s-the-problem-with-critical-art.

Foucault, Michel. "The Great Rage of Facts (La grande colère des faits)." *Le Nouvel Observateur* 652 (May 9–15, 1977): 84–86.

Fraser, Nancy. *Redistribution or Recognition? A Political-Philosophical Exchange*. London: Verso, 2004.

Galliera, Izabel. *Socially Engaged Art after Socialism: Art and Civil Society in Central and Eastern Europe*. London: I. B. Tauris, 2017.

Gibson Graham, J. K. *Postcapitalist Politics*. Minneapolis: University of Minnesota Press, 2006.

Gilbert, Alan. "Autonomous Determination: On the Rojava Film Commune." *Art Forum*, September 2020. https://www.artforum.com/print/202007/alan-gilbert-on-the-rojava-film-commune-83689.

Glissant, Édouard. "Creolization in the Making of the Americas." *Caribbean Quarterly* 54, no. 1–2 (March–June 2008): 81–89.

Godard, Jean-Luc, dir. *Godard and Gorin: Five Films 1968–1971*. Shenley, UK: Arrow Films, 2018.

Goldmann, Lucien. *The Human Sciences and Philosophy*. Translated by Hayden V. White and Robert Anchor. London: Jonathan Cape, 1969.

González, Jennifer. *Pepón Osorio*. Minneapolis: University of Minnesota Press, 2013.

Gorky, Maxim. "For the Attention of the Workers." In *Untimely Thoughts: Essays on Revolution, Culture and the Bolsheviks 1917–1918*, translated by Herman Ermolaev, 86–89. New Haven, CT: Yale University Press, 1995.

Gough, Maria. "Radical Tourism: Sergei Tret'iakov at the Communist Lighthouse." *October* 118 (Fall 2006): 159–78.

Graham, Dan. "Art Worker's Coalition Open Hearing Presentation" (April 10, 1969). In *Conceptual Art: A Critical Anthology*, edited by Alexander Alberro and Blake Stimson, 91–94. Cambridge, MA: MIT Press, 1999.

Gramsci, Antonio. *Selections from the Prison Notebooks*. Edited and translated by Quinin Hoare and Geoffrey Nowell Smith. New York: International Publishers, 1971.

Grant, Paul Douglas. *Cinéma Militant: Political Filmmaking and May 1968*. New York: Columbia University Press, 2016.

Gratton, Peter. "*Aisthesis* by Jacques Rancière." *Society and Space*, August 15, 2014. https://www.societyandspace.org/articles/aisthesis-by-jacques-ranciere.

Groys, Boris. "Between Stalin and Dionysus: Bakhtin's Theory of the Carnival." *Dialogic Pedagogy: An International Online Journal* 5 (2017). https://dpj.pitt.edu/ojs/index.php/dpj1/article/view/212.

Grupo de Arte Callejero. *Thought, Practices and Actions*. Translated by the Mareada Rosa Translation Collective. Brooklyn, NY: Common Notions, 2019.

Grupo Etcetera Archive. https://grupoetcetera.wordpress.com/.

Guest, Iain. *Behind the Disappearances: Argentina's Dirty War against Human Rights and the United Nations*. Philadelphia: University of Pennsylvania Press, 1990.

Habermas, Jürgen. *Communication and the Evolution of Society*. Translated by Thomas McCarthy. Boston: Beacon Press, 1979.

Habermas, Jürgen. "From Kant to Hegel and Back Again—The Move towards Detranscendentalization." *European Journal of Philosophy* 7, no. 2 (1999): 129–57.

Habermas, Jürgen. *Knowledge and Human Interests*. Translated by Jeremy Shapiro. Boston: Beacon Press, 1971.

Habermas, Jürgen. *Legitimation Crisis*. Translated by Thomas McCarthy. Boston: Beacon Press, 1975.

Habermas, Jürgen. "On Systematically Distorted Communication." *Inquiry: An Interdisciplinary Journal of Philosophy* 13, no. 1–4 (1970): 205–18.

Habermas, Jürgen. *Theory and Practice*. Translated by John Viertel. Boston: Beacon Press, 1971.

Habermas, Jürgen. *Theory of Communicative Action: Reason and the Rationalization of Society*, vol. 1. Translated by Thomas McCarthy. Boston: Beacon Press, 1984.

Hall, Stuart, Chas Critcher, Tony Jefferson, John N. Clarke, and Brian Roberts. *Policing the Crisis: Mugging, the State and Law and Order*. London: Macmillan, 1978.

Hallward, Peter. "Staging Equality: Rancière's Theatrocracy and the Limits of Anarchic Equality." In *Jacques Rancière: History, Politics, Aesthetics*, edited by Gabriel Rockhill and Philip Watts, 140–57. Durham, NC: Duke University Press, 2009.

Harvey, Stefano, and Fred Moten. *The Undercommons: Fugitive Planning and Black Study*. New York: Minor Compositions, 2013.

Hegel, G. W. F. *Hegel's Aesthetics: Lectures on Fine Art*, vol. 1. Translated by T. M. Knox. Oxford: Clarendon Press, 1988.

Helguera, Pablo. *Education for Socially Engaged Art*. Bethesda, MD: Jorge Pinto Books, 2012.

Hendricks, Ashraf. "Rhodes Must Fall Exhibition Vandalised in UCT Protest." GroundUp, March 10, 2016. https://www.groundup.org.za/article/rhodes-must-fall-exhibition-vandalised-uct-protest/.

Herbst, Marc. "On the Relational Transformation of Law through Common Sense, via Objects and Movements." *FIELD: A Journal of Socially Engaged Art Criticism* 16 (Spring 2020). http://field-journal.com/editorial/on-the-relational-transformation-of-law-through-common-sense-via-objects-and-movements.

Hirschhorn, Thomas. "Eternal Flame." *Artforum* 45, no. 7 (March 2007): 268. https://www.artforum.com/print/200703/eternal-flame-12846.

Hirschhorn, Thomas. "Unshared Authorship." In *Gramsci Monument*, 54–55. New York: Dia Art Foundation, 2013.

Hofman, Ana. "Disobedient: Activist Choirs, Radical Amateurism, and the Politics of the Past after Yugoslavia." *Ethnomusicology* 64, no. 1 (Winter 2020): 89–109.

Holquist, Michael. "Bakhtin's Life." In *Mikhail Bakhtin*, vol. 1, edited by Michael Gardiner, 25–34. London: Sage Publications, 2003.

Honneth, Axel. *The Critique of Power: Reflective Stages in a Critical Social Theory*. Cambridge, MA: MIT Press, 1991.

Honneth, Axel. "Integrity and Disrespect: Principles of a Conception of Morality Based on the Theory of Recognition." *Political Theory* 20, no. 2 (May 1992): 187–201.

Honneth, Axel. "Invisibility: On the Epistemology of 'Recognition.'" *Proceedings of the Aristotelian Society* 75 (2001): 111–39.

Honneth, Axel. *The Struggle for Recognition: The Moral Grammar of Social Conflicts*. Translated by Joel Anderson. Cambridge, MA: MIT Press, 1996.

Honneth, Axel. "Work and Instrumental Action." *New German Critique* 26 (Spring–Summer 1982): 31–54.

Honneth, Axel, and Hans Joas. *Social Action and Human Nature*. Translated by Raymond Meyer. Cambridge: Cambridge University Press, 1988.

Hosseini, Hamed S. A. *Alternative Globalizations: An Integrative Approach to Studying Dissident Knowledge in the Global Justice Movement*. London: Routledge, 2010.

Höttcke, Aude Bertrand, and Matthias Kettner. "The Dead Are Coming: Contemporary Interventionist Art, Political Beauty and the Power of Reason." In *Arts and Power: Policies in and by the Arts*, edited by Lisa Glaupp et al., 287–309. Berlin: Spring Publishing, 2022.

"How Shackville Started a War." *City Press*, February 21, 2016. https://www.news24.com/citypress/voices/how-shackville-started-a-war-20160219.

Hudis, Peter, and Kevin B. Anderson, eds. *The Rosa Luxemburg Reader*. New York: Monthly Review Press, 2004.

Jackson, Shannon. *Social Works: Performing Art, Supporting Publics*. New York: Routledge, 2011.

James, C. L. R. *The Black Jacobins: Toussaint L'Ouverture and the San Domingo Revolution*. New York: Vintage, 1989.

James, C. L. R., and Grace Lee. *Facing Reality* (with the collaboration of Cornelius Castoriadis). Detroit, MI: Bewick Editions, 1958.

Jardine, Alice, and Brian Massumi. "Interview with Toni Negri." *Copyright* 1 (1988): 72–84.

Jeffries, Stuart. *Grand Hotel Abyss: The Lives of the Frankfurt School*. London: Verso, 2017.

Jesty, Justin. *Art and Engagement in Early Postwar Japan*. Ithaca, NY: Cornell University Press, 2018.

Jesty, Justin, ed. "Japan's Social Turn." *FIELD: A Journal of Socially Engaged Art Criticism* 7–8 (Spring and Fall 2017). http://field-journal.com/category/issue-7.

Johnson, Alan. "The Power of Nonsense." *Jacobin* magazine, July 14, 2011. https://jacobin.com/2011/07/the-power-of-nonsense.

Johnson, Alan. "Slavoj Žižek's Linksfaschismus." In *Radical Intellectuals and the Subversion of Progressive Politics: The Betrayal of Politics*, edited by Gregory Smulewicz-Zucker and Michael J. Thompson. New York: Palgrave Macmillan, 2015. https://link.springer.com/chapter/10.1057/9781137381606_5.

Jones, Amelia G. *Body Art/Performing the Subject*. Minneapolis: University of Minnesota Press, 1998.

Kakande, Angelo. "On the Fashion Parade 2017: Pushing Back against the Shrinking Deliberative Space in Uganda." *FIELD: A Journal of Socially Engaged Art Criticism* 17 (Winter 2021). http://field-journal.com/issue-17/on-the-fashion-parade-2017-pushing-back-against-the-shrinking-deliberative-space-in-uganda.

Kamanzi, Brian. "'Rhodes Must Fall'—Decolonisation Symbolism—What Is Happening at UCT, South Africa?" *The Postcolonialist*, March 29, 2015. http://postcolonialist.com/civil-discourse/rhodes-must-fall-decolonisation-symbolism-happening-uct-south-africa/.

Kant, Immanuel. *Groundwork of the Metaphysics of Morals*. Translated by Mary Gregor. Cambridge: Cambridge University Press, 2012.

Keep, John L. H., ed. and trans. *The Debate on Soviet Power: Minutes of the All-Russian Central Executive Committee of the Soviets (October 1917–January 1918)*. Oxford: Clarendon Press, 1979.

Kelley, Bill, Jr., and Grant Kester, eds. *Collective Situations: Readings in Contemporary Latin American Art 1995–2010*. Durham, NC: Duke University Press, 2017.

Kester, Grant. "Activist and Socially Engaged Art." *Oxford Bibliographies*, January 12, 2021. https://www.oxfordbibliographies.com.

Kester, Grant. "The Device Laid Bare: On Some Limitations in Current Art Criticism." *e-flux journal* 50 (December 2013). https://www.e-flux.com/journal/50/59990/the-device-laid-bare-on-some-limitations-in-current-art-criticism/.

Kester, Grant. "Interview with Patrisse Cullors." *FIELD: A Journal of Socially Engaged Art Criticism* 12–13 (Spring 2019). http://field-journal.com/issue-14/interview-with-patrisse-cullors.

Kester, Grant. "The Limitations of the Exculpatory Critique: A Response to Mikkel Bolt Rasmussen." *FIELD: A Journal of Socially Engaged Art Criticism* 6 (Winter 2017). https://field-journal.com/issue-6/mikkel-bolt-rasmussen.

Kester, Grant. "The Noisy Optimism of Immediate Action: Theory, Practice and Pedagogy in Contemporary Art." *Art Journal* 71, no. 2 (Summer 2012): 86–99.

Kester, Grant. *The One and the Many: Contemporary Collaborative Art in a Global Context*. Durham, NC: Duke University Press, 2017.

Kester, Grant. "The Sound of Breaking Glass Part 1: Spontaneity and Consciousness in Revolutionary Theory." *e-flux journal* 30 (December 2011). https://www.e-flux.com/journal/30/68167/the-sound-of-breaking-glass-part-i-spontaneity-and-consciousness-in-revolutionary-theory/.

Kester, Grant. *The Sovereign Self: Aesthetic Autonomy from the Enlightenment to the Avant-Garde*. Durham, NC: Duke University Press, 2023.

Kleinmichel, Philipp. "The Symbolic Excess of Art Activism." In *The Art of Direct Action: Social Sculpture and Beyond*, edited by Karen van den Berg, Cara M. Jordan, and Philipp Kleinmichel, 211–38. Berlin: Sternberg Press, 2019.

Knops, Andrew. "Agonism as Deliberation: On Mouffe's Theory of Democracy." *Journal of Political Philosophy* 15, no. 1 (2007): 115–26.

Kosuth, Joseph. "Art after Philosophy" (1969). In *Conceptual Art: A Critical Anthology*, edited by Alexander Alberro and Blake Stimson, 158–77. Cambridge, MA: MIT Press, 1999.

La Berge, Leigh Claire. *Wages against Artwork: Decommodified Labor and the Claims of Socially Engaged Art*. Durham, NC: Duke University Press, 2019.

Laclau, Ernesto, and Chantal Mouffe. *Hegemony and Socialist Strategy*. London: Verso, 1985.

Lacy, Suzanne, ed. *Mapping the Terrain: New Genre Public Art*. Seattle: Bay Press, 1994.

La Vaca. "#GenocidaSuelto: Escrache Poético y Señalización." *La Tinta: Peridismo hasta Mancharse*, November 14, 2016. https://latinta.com.ar/2016/11/genocida suelto-escrache-poetico-y-senalizacion/.

Lavaca Collective, ed. *Sin Patrón: Stories from Argentina's Worker-Run Factories*. Chicago: Haymarket, 2007.

Léger, Marc James. *Vanguardia: Socially Engaged Art and Theory*. Manchester: Manchester University Press, 2019.

Lenin, V. I. "The Economic Basis of the Withering Away of the State." In *State and Revolution*. Accessed June 22, 2022. https://www.marxists.org/archive/lenin/works/1917/staterev/ch05.htm#s4.

Lenin, V. I. *What Is to Be Done? Burning Questions of Our Movement*. New York: International Publishers, 1978.

Lessa, Francesca, and Cara Levey. "From Blanket Impunity to Judicial Opening(s): H.I.J.O.S. and Memory Making in Postdictatorship Argentina." *Latin American Perspectives* 42, no. 3 (2015): 207–25.

Lewitt, Sol. "Paragraphs on Conceptual Art" (1967). In *Conceptual Art: A Critical Anthology*, edited by Alexander Alberro and Blake Stimson, 12–16. Cambridge, MA: MIT Press, 1999.

Leyda, Jay. *Kino: A History of the Russian and Soviet Film*. Princeton, NJ: Princeton University Press, 1983.

Lippard, Lucy. "Catalysis: An Interview with Adrian Piper." *The Drama Review* 16, no. 1 (March 1972): 76–78.

Lippard, Lucy, and John Chandler. "The Dematerialization of Art." *Art International* 12, no. 2 (February 1968): 31–36.

Longoni, Ana. "A Long Way: Argentine Artistic Activism of the Last Decade." In *Collective Situations: Readings in Contemporary Latin American Art, 1995–2010*, edited by Bill Kelley Jr. and Grant H. Kester, 98–116. Durham, NC: Duke University Press, 2017.

Lovell, David W. *From Marx to Lenin: An Evaluation of Marx's Responsibility for Soviet Authoritarianism*. Cambridge: Cambridge University Press, 1984.

Lukács, Georg. *History and Class Consciousness*. Translated by Rodney Livingstone. Cambridge, MA: MIT Press, 1983.

Luxemburg, Rosa. "The Russian Revolution." In *The Rosa Luxemburg Reader*, edited by Peter Hudis and Kevin B. Anderson, 281–310. New York: Monthly Review Press, 2004.

Lxs Colectiverxs. "Lurawi, Doing." In *Collective Situations: Readings in Contemporary Latin American Art, 1995–2010*, edited by Bill Kelley Jr. and Grant H. Kester, 343–66. Durham, NC: Duke University Press, 2017.

MacBean, James Roy. "Godard and the Dziga Vertov Group: Film and Dialectics." *Film Quarterly* 26, no. 1 (Autumn 1972): 30–44.

Makhubu, Nomusa. "On Apartheid Ruins: Art, Protest and the South African Social Landscape." *Third Text* 34, no. 4–5 (November 2020): 569–90.

Makhubu, Nomusa, and Carlos Garrido Castellano, eds. "Creative Uprisings: Art, Social Movements and Mobilization in Africa." *FIELD: A Journal of Socially Engaged Art Criticism* 17 (Winter 2021). https://field-journal.com/category/issue-17.

Mann, Thomas. *Doctor Faustus*. Translated by John E. Woods. New York: Vintage International, 1999.

Mao Tse-tung. "Introducing a Co-operative." April 15, 1958. https://www.marxists.org/reference/archive/mao/selected-works/volume-8/mswv8_09.htm.

Marcuse, Herbert. *Counterrevolution and Revolt*. Boston: Beacon Press, 1972.

Martin, Bradford D. *The Theater Is in the Street: Politics and Public Performance in 1960s America*. Boston: University of Massachusetts Press, 2004.

Marx, Karl. *Capital: A Critique of Political Economy*. New York: Modern Library, 1906.

Marx, Karl. *A Contribution to the Critique of Hegel's Philosophy of Right*. 1843. https://www.marxists.org/archive/marx/works/1843/critique-hpr/intro.htm.

Marx, Karl. *The Economic and Philosophic Manuscripts of 1844*. Edited by Dirk J. Struik. Translated by Martin Milligan. New York: International Publishers, 1972.

Marx, Karl. *Karl Marx: Early Writings*. Translated by Rodney Livingstone and Gregor Benton. Harmondsworth, UK: Penguin Books, 1975.

Marx, Karl, and Friedrich Engels. "The Communist Manifesto." In *Essential Works of Marxism*, 13–44. New York: Bantam Books, 1971.

Marx, Karl, and Friedrich Engels. *The German Ideology*, Part One. Edited by C. J. Arthur. New York: International Publishers, 1970.

Masotta, Oscar. "After Pop, We Dematerialize." Originally published as "Después del Pop: Nosotros desmaterializamos." In *Oscar Masotta, Conciencia y estructura*, 15–16. Buenos Aires: Editorial Jorge Alvarez, 1969.

Mayakovsky, Vladimir, et al. "A Slap in the Face of Public Taste." 1917. https://www.marxists.org/subject/art/literature/mayakovsky/1917/slap-in-face-public-taste.htm.

Mazadiego, Elize. *Dematerialization and the Social Materiality of Art: Experimental Forms in Argentina, 1955–1968*. Leiden: Brill, 2021.

McCarthy, Thomas. *The Critical Theory of Jürgen Habermas*. Cambridge, MA: MIT Press, 1991.

Mills, Charles W. "'Ideal Theory' as Ideology." *Hypatia* 20, no. 3 (Summer 2005): 165–84.

Morgan, Jo-Ann. *The Black Arts Movement and the Black Panther Party in American Visual Culture*. London: Routledge, 2019.

Morson, Gary Saul, and Caryl Emerson. *Mikhail Bakhtin: Creation of a Prosaics*. Stanford, CA: Stanford University Press, 1990.

Moten, Fred. *In the Break: The Aesthetics of the Black Radical Tradition*. Minneapolis: University of Minnesota Press, 2003.

Mouffe, Chantal. "Artistic Activism and Agonistic Spaces." *Art and Research: A Journal of Ideas, Contexts and Methods* 1, no. 2 (Summer 2007): 1–5. https://www.artandresearch.org.uk/v1n2/mouffe.html.

Mouffe, Chantal. "For an Agonistic Public Sphere." In *Democracy Unrealized: Documenta 1 Platform*, edited by Okwui Enwezor et al., 87–97. Ostfildern-Ruit, Germany: Hatje Cantz Publishers, 2002.

Mouffe, Chantal. *The Return of the Political*. London: Verso, 1993.

Nesbitt, Nick. "Edouard Glissant and the Poetics of Truth." *The CLR James Journal* 18, no. 1 (Fall 2012): 102–15.

Nunes, Rodrigo. *Neither Vertical Nor Horizontal: A Theory of Political Organization*. London: Verso, 2021.

Ono-Dit-Biot, Christophe. "Regardez: Alain Badiou 'Je regrette.'" *Le Point Culture*, March 14, 2012. https://www.lepoint.fr/culture/regardez-alain-badiou-je-regrette-14-03-2012-1441309_3.php.

Panagia, Davide. *Rancière's Sentiments*. Durham, NC: Duke University Press, 2019.

Perez de Miles, Adetty. "The Antinomy of Autonomy and Heteronomy in Contemporary Art Practice." *Knowledge Cultures* 4, no. 5 (September 2016): 43–50.

Phillips, Patricia C. *Mierle Laderman Ukeles: Maintenance Art*. Munich: Prestel, 2016.

Piper, Adrian. "Concretized Ideas I've Been Working Around." In *Out of Order, Out of Sight: Selected Writings*, vol. 1, 42. Cambridge, MA: MIT Press, 1996.

Poggioli, Renato. *The Theory of the Avant-Garde*. Translated by Gerald Fitzgerald. Cambridge, MA: Belknap Press of Harvard University Press, 1968.

Polan, A. J. *Lenin and the End of Politics*. Berkeley: University of California Press, 1984.

Polletta, Francesca. *Freedom Is an Endless Meeting: Democracy in American Social Movements*. Chicago: University of Chicago Press, 2012.

Ponce de León, Jennifer. *Another Aesthetics Is Possible: Arts of Rebellion in the Fourth World War*. Durham, NC: Duke University Press, 2021.

Rancière, Jacques. "The Aesthetic Revolution and Its Outcomes." *New Left Review* 14 (March–April 2002): 133–51.

Rancière, Jacques. *Aisthesis: Scenes from the Aesthetic Regime of Art*. London: Verso, 2013.

Rancière, Jacques. *Althusser's Lesson*. London: Continuum, 2011.

Rancière, Jacques. "The Emancipated Spectator." *Artforum*, 45, no. 7 (March 2007): 271–80.

Rancière, Jacques. *The Ignorant Schoolmaster: Five Lessons in Intellectual Emancipation*. Translated with an introduction by Kristin Ross. Stanford, CA: Stanford University Press, 1991.

Rancière, Jacques. *The Politics of Aesthetics*. Translated by Gabriel Rockhill. London: Bloomsbury, 2004.

Rasmussen, Mikkel Bolt. "A Note on Socially Engaged Art Criticism." *FIELD: A Journal of Socially Engaged Art Criticism* 6 (Winter 2017). http://field-journal.com/issue-6/a-note-on-socially-engaged-art-criticism.

Raunig, Gerald. "Changing the Production Apparatus Anti-Universalist Concepts of Intelligentsia in the Early Soviet Union." Translated by Aileen Derieg. *Transversal* 9 (September 2010). https://transversal.at/transversal/0910/raunig/en.

Reuters Staff. "Argentine Court Sentences 29 to Life for Dictatorship Crimes." Reuters World News, November 29, 2017. https://www.reuters.com/article/us-argentina-rights/argentine-court-sentences-29-to-life-for-dictatorship-crimes-idUSKBN1DU021.

Roberts, John. *Revolutionary Time and the Avant-Garde*. New York: Verso, 2015.

Rockhill, Gabriel. *Radical History and the Politics of Art*. New York: Columbia University Press, 2014.

Rockhill, Gabriel, and Philip Watts, eds. *Jacques Rancière: History, Politics, Aesthetics*. Durham, NC: Duke University Press, 2009.

Rodenbeck, Judith. *Radical Prototypes: Allan Kaprow and the Invention of Happenings*. Cambridge, MA: MIT Press, 2014.

Rodney, Walter. *The Groundings with My Brothers*. Kingston, Jamaica: Miguel Lorne Publishers, 1990.

Routhwaite, Adair. *Asking the Audience: Participatory Art in 1980s New York*. Minneapolis: University of Minnesota Press, 2017.

Sand, George, and Gustave Flaubert. *The George Sand–Gustave Flaubert Letters*. Translated by Aimee L. MacKensie. New York: Liveright Press, 1949.

San Juan, E., Jr. *Hegemony and Strategies of Transgression*. Albany: State University of New York Press, 1995.

Sanromán, Lucía, and Susie Kantor, eds. *Tania Bruguera: Talking to Power/Hablándole al Poder*. Yerba Buena, CA: Yerba Buena Center for the Arts, 2018.

Schiller, Friedrich. *Letters on the Aesthetic Education of Man*. Translated and edited by Elizabeth M. Wilkinson and L. A. Willoughby. Oxford: Oxford University Press/Clarendon Press, 1987.

Schmitt, Carl. *Political Romanticism*. Translated by Guy Oakes. Cambridge, MA: MIT Press, 1986.

Schneewind, J. B. *The Invention of Autonomy: A History of Modern Moral Philosophy*. Cambridge: Cambridge University Press, 1998.

Schoolman, Morton. *A Democratic Enlightenment: The Reconciliation Image, Aesthetic Education, Possible Politics*. Durham, NC: Duke University Press, 2020.

Shklovsky, Viktor. "Art as Device." In *Theory of Prose*, translated by Benjamin Sher, 1–14. Champaign, IL: Dalkey Archive Press, 1991.

Sholette, Greg, ed. "Art, Anti-Globalism and the Neo-Authoritarian Turn." *FIELD: A Journal of Socially Engaged Art Criticism* 12–13 (Spring 2019). http://field-journal.com/issue-12.

Sholette, Gregory. *Delirium and Resistance: Activist Art and the Crisis of Capitalism*. London: Pluto Press, 2017.

16 Beaver Group. "Monday Night—05.08.06—Discussion on Rancière's Politics of Aesthetics. 2. Berkeley Talk 'Aesthetics and Politics: Rethinking the Link.'" 16 Beaver Group, May 6, 2006. http://16beavergroup.org/mondays/2006/05/06/monday-night-05-08-06-discussion-on-Rancieres-politics-of-aesthetics/.

"Slavoj Zizek at OWS, Oct 9, 2011." YouTube. https://www.youtube.com/watch?v=vdwF3j1F2pg.

Spelman, Elizabeth V. "Woman as Body: Ancient and Contemporary Views." *Feminist Studies* 8, no. 1 (Spring 1982): 109–31.

Stark, Trevor. "'Cinema in the Hands of the People': Chris Marker, the Medvedkin Group and the Potential of Militant Film." *October* 139 (Winter 2012): 117–50.

Starr, Peter. *Logics of Failed Revolt: French Theory After May '68*. Stanford, CA: Stanford University Press, 1995.

Stepanova, Varvara. "A General Theory of Constructivism." In *Art and Social Change: A Critical Reader*, edited by Will Bradley and Charles Esche, 70–71. London: Tate Publishing/Afterall, 2007.

Strathausen, Carsten, ed. *A Leftist Ontology: Beyond Relativism and Identity Politics*. Minneapolis: University of Minnesota Press, 2009.

Theunissen, Michael. *The Other: Studies in the Social Ontology of Husserl, Heidegger, Sartre and Buber*. Translated by Christopher Macann. Cambridge, MA: MIT Press, 1986.

Theunissen, Michael. "Society and History. A Critique of Critical Theory." In *Habermas. A Critical Reader*, edited by Peter Dews, 241–71. London: Blackwell, 1999.

Thomas, Paul. *Karl Marx and the Anarchists*. London: Routledge, 1980.

Thompson, Michael. *The Domestication of Critical Theory*. London: Rowman and Littlefield, 2016.

Thompson, Nato. *Seeing Power: Art and Activism in the Twenty-First Century*. New York: Melville House, 2014.

Todorov, Tzvetan. *Mikhail Bakhtin: The Dialogical Principle*. Translated by Wlad Godzich. Minneapolis: University of Minnesota Press, 1984.

"Trans Collective Trashes RMF Exhibition." IOL, March 11, 2016. https://www.iol.co.za/news/south-africa/western-cape/trans-collective-trashes-rmf-exhibition-1996847.

University of Cape Town. *The Final Report by the Institutional Reconciliation and Transformation Commission (IRTC)* (March 2019). https://www.news.uct.ac.za/downloads/irtc/IRTC_Final_Report_2019.pdf.

Varon, Jeremy. *Bringing the War Home: The Weather Underground, the Red Army Faction and Revolutionary Violence in the Sixties and Seventies*. Berkeley: University of California Press, 2004.

Volosinov, V. N. *Marxism and the Philosophy of Language*. Translated by Ladislav Matejka and I. R. Titunik. Cambridge, MA: Harvard University Press, 1986.

Walker, R. B. J. *After the Globe, before the World*. London: Routledge, 2009.

Wang, Meiqin. *Socially Engaged Art in Contemporary China: Voices from Below*. New York: Routledge, 2019.

Wilder, Gary. *Freedom Time: Négritude, Decolonization, and the Future of the World*. Durham, NC: Duke University Press, 2015.

Williams, Robert C. *The Other Bolsheviks: Lenin and His Critics, 1904–1914*. Bloomington: Indiana University Press, 1986.

Wolin, Richard. *The Wind from the East: French Intellectuals, the Cultural Revolution and the Legacy of the 1960s*. Princeton, NJ: Princeton University Press, 2010.

Woodly, Deva R. *Reckoning: Black Lives Matter and the Democratic Necessity of Social Movements*. New York: Oxford University Press, 2021.

Woodmansee, Martha. *The Author, Art, and the Market: Rereading the History of Aesthetics*. New York: Columbia University Press, 1994.

Wright, Stephen. "Behind Police Lines: Art Visible and Invisible." *Art & Research: A Journal of Ideas, Contexts and Methods* 2, no. 1 (Summer 2008): 1–8. http://www.artandresearch.org.uk/v2n1/wright.html.

Wright, Stephen. "The Future of the Reciprocal Readymade: The Use-Value of Art." Apexart, March 17–April 17, 2004. https://apexart.org/exhibitions/wright.php.

Wright, Stephen. "Users and Usership of Art: Challenging Expert Culture." *Transform* (European Institute for Progressive Cultural Policies), April 6, 2007. http://transform.eipcp.net/correspondence/1180961069.

Wright, Stephen, et al. "An Exchange with Jacques Rancière." *Art & Research: A Journal of Ideas, Contexts and Methods* 2, no. 1 (Summer 2008): 1–11. http://www.artandresearch.org.uk/v2n1/jrexchange.html.

Wynter, Sylvia. *Black Metamorphosis: New Natives in a New World*. Unpublished manuscript, 1977–1982, accessed June 22, 2022. https://monoskop.org/log/?p=22948.

Wynter, Sylvia. "Unsettling the Coloniality of Being/Power/Truth/Freedom: Towards the Human, after Man, Its Overrepresentation—An Argument." *CR: The New Centennial Review* 3, no. 3 (Fall 2003): 257–337.

Zamora, Daniel, and Michael Behrent, eds. *Foucault and Neoliberalism*. London: Polity Press, 2015.

Zavarei, Saba. "Dancing into Alternative Realities: Gender, Dance, and Public Space in Contemporary Iran." *FIELD: A Journal of Socially Engaged Art Criticism* 21 (Spring 2022). http://field-journal.com/editorial/dancing-another-reality-dance-gender-and-public-space-in-contemporary-iran.

Zavarei, Saba. "The Song of Disobedience: Interrupting the Patriarchal Order in Everyday Spaces in Iran through Feminist Intervention." *Performance Research* 26, no. 5 (May 2022): 122–27.

Žižek, Slavoj. "Don't Act, Just Think" (undated). Big Think, video transcript. https://bigthink.com/videos/dont-act-just-think/.

Žižek, Slavoj. "Holding the Place." In Judith Butler, Ernesto Laclau, and Slavoj Žižek, *Contingency, Hegemony, Universality: Contemporary Dialogues on the Left*. London: Verso, 2000.

Žižek, Slavoj. *In Defense of Lost Causes*. London: Verso, 2008.

Žižek, Slavoj. "A Leftist Plea for 'Eurocentrism.'" *Critical Inquiry* 24, no. 4 (Summer 1998): 988–1009.

Žižek, Slavoj. *Lenin 2017: Remembering, Repeating and Working Through*. London: Verso, 2017.

Žižek, Slavoj. *Violence: Six Sideways Reflections*. New York: Picador, 2008.

INDEX

absolutism, Enlightenment challenge to, 14–16, 203–4
Abstract Expressionism, 92
academic theory, social engagement and, 222–28
The Actuality of Communism (Bosteels), 226
Adorno, Theodor: on aesthetics, 19, 162–63, 169; on avant-garde, 5, 28–29, 89, 125, 159, 211; communicative action and, 12; on critical theory and revolutionary consciousness, 45; on culture and art, 197; on finalization in art, 198–99; Frankfurt School and, 145; on German student movement, 23–24, 237n28; on human potential, 203; on instrumental reason, 182, 191; on kitsch, 34; on Marxism, 162–65; object-based paradigm and, 24, 89, 119–20; on political transformation, 22–24, 28–29, 237n28; on protest movements, 129–30, 220; on Schoenberg, 95; on shame and guilt, 132–33; social labor and, 138; on socially engaged art, 41, 101
aesthetic autonomy: anticolonialism and, 209; artistic practice and, 62–68; avant-garde and, 19–29; Bakhtin's critique of, 176–79, 183–87, 190–201, 203–8; contemporary activist art and, 1–10; dematerialized art and, 91–93; Enlightenment paradigm and, 10, 14–19; event-based paradigm and, 11, 128–29; in experimental cinema, 97–104; Marxism and, 6–7, 161–65; materialism and, 159–60; neo-avant-garde and, 34–35; personal freedom and, 14–17; plasticity of, 74, 87, 128; political transformation and, 14, 21–23, 64–68, 74–76, 86, 229–33; prefiguration and,

aesthetic autonomy (continued)
 166–70; Rancière on, 39–53, 55–56;
 resistance and, 106–8; social labor and,
 12, 14; socially engaged art and, 39–53,
 66–69, 90–93, 119–26, 138–39
Aesthetics (Hegel), 96
Aesthetic Theory (Adorno), 164
affect: artistic practice and, 88–90; emancipatory forms of, 227; socially engaged art and, 188–89
agency: Bakhtin on, 178, 199–201, 204–5; Conceptualism and, 93–96; Rancière's discussion of, 50–53; socially engaged art and, 123–24, 217–19
agonism discourse, 35–38; communicative action and, 154
Agosti, Orlando Ramón, 240n7
Aisthesis (Rancière), 43, 45–46
Alberro, Alexander, 93
Albert, Wanelisa, 214
alternative economies research, 227
Alternative Globalization (Hosseini), 227
Althusser, Louis, 44–45, 199–200, 249n59
Althusser's Lesson (Rancière), 44–45
Amini, Mahsa, 110
analytic philosophy, 94
Andrews, Benny, 114
answerability: avant-garde withdrawal from, 25–26; Bakhtin's discussion of, 179, 181–87; mediation and, 120; in socially engaged art, 64, 67, 108, 125–26
anticolonialism: critiques of, 221–22; cultural erasure and, 150–51; dialogical aesthetic and, 13–14, 173, 208–9, 212; Marxism and, 211; socially engaged art and, 212–19
Arab Spring, 106
Arcanum 17 (Breton), 24–25
architectonics of art, 69
Arde Arte! (Argentina), 56
Arendt, Hannah, 165
Argentina: disappearances and kidnappings in, 58–59; economic collapse and political unrest in, 56–57, 240n7; escraches activism in, 2, 10–11, 29, 39–40, 55–57; impunity laws in, 57–58; socially engaged art in, 90–91; World Cup held in, 59
Aristotle, 139

art: agonist discourse on, 35–37; political freedom and, 17–19
"Art after Philosophy" (Kosuth), 94–95
Art and Answerability (Bakhtin), 183
Artaud, Antonin, 50–51
art criticism: socially engaged art and, 220. *See also* criticality; critical theory
Artforum, 48
Artificial Hells (Bishop), 37
artistic criticality, avant-garde and, 27–28, 238n38
artistic practice: aesthetic autonomy and, 62–68, 230–33; Bakhtin on, 196–97, 203–8, 249n36; community interaction and, 171–73; critical theory and, 7–10; dematerialized practices, 3, 11, 85–93; exculpatory critique and, 8–9; finalization in, 197–201; institutionalization of, 7–8, 235n7; as mediation, 80–81; mediation and, 68–69; melting down during Russian Revolution, 69; performance-based practice, 11; revolution and, 78–81; social or political praxis and, 126–27. *See also* praxis; prematurity of practice thesis
artistic subjectivity, escraches performances and, 67
Arts and Crafts movement, 3
Asher, Michael, 87
Aspects of the Liberal Dilemma (Piper), 89
assimilationism, anticolonial resistance to, 217
Atelier Populaire, 86
Attica Liberation Front, 114
Attica Uprising of 1971, 114
Audette, Michèle Taïna, 218–20
"Author as Producer" (Benjamin), 69
authoritarianism: event-based paradigm and, 122; in Marxist discourse, 44; socially engaged art and, 40
authorship, Bakhtin on crisis of, 186–87, 191–92, 195–96
autonomy: absolutism and, 203–4; avant-garde ethos of, 26–29; collective and intersubjective experience of, 165–70; socially engaged art and, 40–53, 121–23; transcendental knowledge and, 140–41
avant-garde: aesthetic autonomy and, 11, 19–29, 55–56, 68–69, 89–90, 127–28, 230–33;

affirmative role of, 224–28; art and kitsch in, 19; artistic practices and, 87; Bakhtin and, 179–80; critique of socially engaged art and, 33–38; escraches performances and, 62–68; experimental cinema and, 97–104; Frankfurt School and, 145; identity of, 10; incapacity of the masses thesis and, 128–29; individual consciousness and, 76; institutional structure and, 87; political transformation and, 73–74; post-Revolution Russian art and, 72–73, 102, 174–76; praxis and, 139–40; Rancière's discussion of, 53; revolution and, 78–79, 164–65; schema of, 12; self-reflexivity and, 132–33; self-transformation and, 106–8, 125, 164–65; social labor and, 158–59; socially engaged art and, 33–35, 207–8, 212–19; in Soviet-era art, 71–73, 93; spatiality and, 88–89; temporality and, 88–89; theoreticism and, 200–201; vanguard politics and, 137–38
"Avant-gardes" (Badiou), 24–25
Avineri, Shlomo, 148
Ayer, A. J., 94

Bachelard, Gaston, 44
Badiou, Alain, 24–26, 55, 226, 238n33
Bakhtin, Mikhail: on aesthetic autonomy, 1, 6–7, 13, 176–79, 183–87, 190–201, 203–8; on agency in art, 178, 199–201; on avant-garde, 179–80; dialogical aesthetic of, 172–74, 180–87, 205–9; early career of, 174–75; on intersubjectivity, 202–4; monadic self-reflection thesis and, 187–97; object-based and event-based paradigm and, 120; on poetry and literature, 176–80; post-Revolution era and, 69, 174–75; prosaic culture concept of, 190; selfhood in work of, 183–202; socially engaged art and, 170, 187–201; theoreticism and, 171
Baudrillard, Jean, 160
Bearden, Romare, 114
Beauvoir, Simone de, 210
Bell, Shamell, 78
Benegas, Diego, 62, 66
Benjamin, Walter, 11, 69–71, 74, 93, 226
Be Seeing You (film), 97–99

Beuys, Joseph, 86, 88, 96, 127
Bhabha, Homi, 13, 208–9
Bijari, 232
Billopps, Camille, 114
Bishan Commune, 2
Bishop, Claire, 37
Black Emergency Cultural Coalition (BECC), 114–15
The Black Jacobins (James), 150
Black Lives Matter Movement, 2, 78, 165–67, 216, 223, 225, 230
Black Metamorphosis (Wynter), 211–12
Black Panther Party, 4
Black performance, Moten's concept of, 210–11
Black Power Movement, 114
Black South Africans, socially engaged art of, 213–16
Black Studies, 173; dialogical aesthetics and, 13–14, 208–12; experience of oppression and, 222
Blanqui, Louis Auguste, 251n50
Boal, Augusto, 4, 171–72
bodily experience, socially engaged art and, 188–89
Bogdanov, Aleksandr, 74, 173
Bolshevism: Benjamin on, 69–71; millenarianism and, 73; specialist Bolshevik paradigm and, 70–71. *See also* Russian Revolution
Bordo, Susan, 210
Bosteels, Bruno, 226
bourgeoisie: avant-garde view of, 21; socially engaged art and, 101–2
Braidotti, Rosi, 210
Brecht, Bertolt, 50–51
Breton, Andre, 24–25
British Sounds (film), 101–2
Brown, Nicholas, 4
Bruguera, Tania, 230, 232
Buntinx, Gustavo, 116–18
Burelle, Julie, 217–20
Buren, Daniel, 87
Burgin, Victor, 93
Burnham, Jack, 88

Cabral, Amílcar, 180, 211
Cacerolazo rallies (Argentina), 56
Camnitz, Luis, 105–6

Canada, indigenous artists and activists in, 14
Cannon, Steve, 244n39
Capital (Marx), 149
capitalism: anticolonialism and, 222; appropriation of art and, 83; autonomous selfhood and individualism and, 15; Bakhtin on, 191; Frankfurt School view of, 149–51; incapacity of the masses thesis and, 128–29; Marx on labor and, 143–51, 160–70; praxis and, 139; prematurity of practice thesis and, 129–30; socially engaged art and, 232–33
Carvalho, Renata, 2, 77
Castoriaded, Cornelius, 150, 246n46
Catalysis street performance series (Piper), 89
Caudwell, Christopher, 205–6
Centre Culturel Populaire de Palentes-les-Orchamps (CCPPO), 98–99, 102
Cerejido, Fabián, 90–91
Césaire, Aimé, 211
Chandler, John, 243n10
Charnley, Kim, 8
Chu Yuan, 76
civil rights movement, 77, 156
Cixous, Héléne, 103, 210
Class of Struggle (film), 97–99
class politics: agonism discourse and, 35; anticapitalism and, 222–28; in experimental cinema, 97–104; Marxism and, 143–51, 209–13; neo-leftist critique of, 226–28; race and, 221–22; Rancière's discussion of working class, 44–46, 50–53; socially engaged art and, 221–28. *See also* working class
Colectivo Situationes, 39–40, 57, 65–66, 68, 80, 172, 190, 241n23
Colectivo Sociedad Civil (CSC) (Peru), 115–18, 204
collaborative art practices: communicative action and, 154; community formation and, 171–73; experimental cinema and, 97–104; of indigenous artists, 218–19; political transformation and, 86–93; socially engaged art and, 108–17
colonialism. *See* anticolonialism
communicative action: Habermas on, 151–58; Honneth on, 156–58; social labor and, 138–40, 172–73

communism: neo-leftist critique of, 226–28; socially engaged art and, 221, 223, 232–33
Communist Lighthouse, 70
The Communist Manifesto (Marx), 149
community interaction: artistic practices and, 171–73; escraches (Argentinian art performances) and, 62; Marxist concept of, 161–62
Conceptualism, dematerialism of art and, 93–97, 126–27
"Concretized Ideas I've Been Working Around" (Piper), 89
Confederación General del Trabajo de los Argentinos (General Confederation of Labor or CGTA), 90–91
consciousness raising, 210
consensus, agonist view of, 36–38
Constructivism, 20; Russian art and, 71–72
contemporary activist art. *See* socially engaged art
Cornered (Piper), 89
Courbet, Gustave, 20
creolization, 13, 173, 208–9
critical distance. *See* mediation
criticality: collaborative art practices and, 86–93; event-based paradigm and, 120–21; self-reflexivity and, 133–34; of socially engaged art, 67–68, 108
critical theory: anticolonialism and, 150; artistic practice and, 7–10; collectivity and, 167–68; dematerialized art practices and, 88–93; Frankfurt School and, 145–46; Marxism and, 162–63; Rancière on, 33–34, 49–53
Critique of Hegel's Philosophy of Right (Marx), 143
Critique of Judgment (Kant), 178
Cullors, Patrisse, 229–31
cultural hybridity, 13
cultural production: Bakhtin on, 190; neo-avant-garde and, 34–35; political transformation and, 77; Rancière on labor and, 45–46
Cultural Revolution (China), 25

Dadaist movement, 20; escraches and, 120; street theater of, 58
"Dancing into Alternative Realities" (Zaverei), 109

Daumer, Honoré, 3
Dean, Jodi, 220–21
De Beers corporation, 213
Debord, Guy, 52
decisionism, agonism and, 38
dematerialized art practices: discourse on, 85–93; double movement of, 93–96; emergence of, 3, 11, 243n10; socially engaged art and, 126–27
Demos, T. J., 230, 232
Denise, Lynnée, 78
Deranty, Jean-Philippe, 149
de Sousa Santos, Bovaentura de, 13–14, 224, 228
de-transcendentalization, 11, 92, 95, 104; aesthetic autonomy and, 205; collaborative art practices and, 172–73; communicative action and, 151–53; praxis and, 140
Dhlamini, Lindiwe, 213
Dialectic of Enlightenment (Horkheimer and Adorno), 145
dialogical aesthetic: Bakhtin's concept of, 172–74, 180–87, 205–8; creolization and, 173, 208–9; politics and, 13–14; selfhood and, 172–74; socially engaged art and, 187–201, 212–19
Dialogue project (India), 172, 188, 198
Diderot, Denis, 50
Dinerstein, Ana Cecilia, 226–27
Dirty War (Argentina), 57–58
displacement, event-based paradigm and, 122
dissensual specificity of art, 35, 36–37
Döblin, Alfred, 70–71
Doctor Faustus (Mann), 71
Dostoevsky, Fyodor, 185–86, 191–92
Douglas, Emory, 4
Du Bois, W. E. B., 222
Dutschke, Rudi, 221
Dziga Vertov Group, 11, 101–2, 244n39

Economic and Philosophy Manuscripts (Marx), 138, 146, 148–49, 160, 199
Edmond de Rothschild Foundation, 235n7
Eisenstein, Sergei, 20
Electronic Disturbance Theater 2.0/b.a.n.g. lab, 77
Elements of the Philosophy of Right (Hegel), 142

Ellison, Ralph, 156, 210–11
El Taller de Gráfica Popular (Mexico), 3–4
El Teatro Campesino, 4
The Emancipated Spectator (Rancière), 46, 50–51
embodiment: communicative action and, 155; Marxism and theories of, 210–12; Rhodes Must Fall collective productions and, 215–16
Enlightenment: aesthetic autonomy and, 14–19, 126–27, 203–4; affect and, 188; avant-garde break with, 20–29; prefigurative knowledge and, 123–24, 162–63; schema structure and, 10
Epistemologies of the South (de Sousa Santos), 228
Erman, Eva, 38
Escrache a Olea, 60
Escrache Leopoldo Fortunato Galtieri, 60–61
escraches (Argentinian art performances): aesthetic autonomy and, 29, 39–40, 63–68, 241n23; Argentina's political violence reflected in, 2, 10–11, 57–61, 66; call and response cycle in, 170; communicative action and, 155–56; community interaction preceding, 62; criticality of, 123; event-based paradigm and, 121; political transformation and, 10–11, 29, 77, 115, 118; self-reflexivity and, 134, 190; theoretical reflection and, 107–8
event-based paradigm, 11; aesthetic autonomy and, 11, 128–29; socially engaged art and, 119–27
event potential, Bakhtin's concept of, 203–4
exculpatory critique: aesthetic practice and, 8–9; communicative action and, 155; socially engaged art and, 119–26
experimental cinema, aesthetic autonomy in, 97–104

fábricas tomadas (worker-occupied factories) (Argentina), 56
Falklands War, 57–58
Fanon, Frantz, 150, 180, 211
Far from Vietnam (film), 99
Fashion Parade (Makerere University), 76, 110–13, 120

feminist theory, Marxism and, 210. *See also* women
Feuerbach, Ludwig, 143
finalization, artistic practice and, 197–201
First Nation peoples, Canadian repression of, 217
Flaubert, Gustave, 45, 49
Fleetwood, Nicole, 114–15, 122
Fletcher, Ben, 222
foquismo, Guevara's concept of, 237n28
Formalism, Bakhtin's critique of, 174–79, 248n15
The Formal Method (Bakhtin?), 248n15
Foster, Hal, 26, 29, 34, 54, 87–88, 107, 242n2
Foucault, Michel, 200
"Fragment on James Mill" (Marx), 147
France, May 1968 unrest in, 98–104
Frankfurt School, 12, 138, 145, 149–51
freedom: Lenin's suspicion of, 101, 145, 161–64, 247n68; risk of violence and, 17
Free International University, 86
Freire, Paolo, 151
French intellectualism, 44–45
French Revolution: autonomous selfhood and, 15–16; millenarianism and, 73; Schiller's assessment of, 129–30
Fuerza Artística de Choque Comunicativo (FACC), 59
Fujimori, Alberto, 2, 115–16, 195
Futurism, 174, 176–77

Gallery Goers Birthplace and Residence Profile, 92
Galliera, Izabel, 8
Galtieri, Leopoldo, 58–59, 61
Gandhi, Mohandas K., 86
Garrido Castellano, Carlos, 8
Gasht-e-Ershad (Iranian morality police), 110
Geist, Hegel's concept of, 142–43, 149
gender, Marxism and, 210
"General Theory of Constructivism" (Stepanov), 71
geopolitics, socially engaged art and, 125–26
The German Ideology (Marx), 149, 161, 165
German student movement, 23–24, 237n28
Germany, activist tendency in, 20–21, 93
Gezi-Park Fiction (Hamburg, Germany), 77, 120, 170, 244n9

Gibson-Graham, J. K., 227
Glissant, Édouard, 13, 173, 208, 221
Godard, Jean-Luc, 97, 99–104, 107
Goldmann, Lucien, 101, 103
González, Jennifer, 8
Gorin, J. P., 101, 244n39
Gorky, Maxim, 174, 237n25, 247n68
Gradual Civilization Act (Canada), 217
Graham, Dan, 85
Gramsci, Antonio, 158–59, 173, 209
Gratton, Peter, 43
Greenberg, Clement, 34, 52, 95
Green movement protests (Iran), 108–10
Grosz, Elizabeth, 210
Grotius, Hugo, 14
Groys, Boris, 249n44
Grupo Argentino de Vanguardia (GAV), 90
Grupo de Arte Callejero (GAC), 39–42, 46–48, 55–57, 60–61, 63–67, 69, 90, 115
Grupo Etcetera, 39–40, 56–58, 64–67, 90, 115
Guevara, Che, 237n28
Guggenheim AbuDhabi, 78
Guggenheim Social Practice initiative, 235n7
Gulag Archipelago (Solzhenitsyn), 200
Gulf Labor Artists Coalition, 77-78, 235n7

Haacke, Hans, 92
Habermas, Jürgen, 12, 36–37, 95, 239n9; on critical theory, 145–46; on Marxism, 143–45, 149; on resistance, 150–51; on social labor, 146–51, 165, 172–73; on transcendentalism, 138, 140–43
habitualization, in post-Revolution Russian art and literature, 175–76, 203
Haider, Asad, 222
Haitian Revolution, 150
Hall, Stuart, 222
Happenings, 87
Hardt, Michael, 226
Harper, Stephen, 218
Harrison, Helen, 88, 96
Harrison, Newton, 88, 96
Harvey, Stefano, 227
Hegel, G. W. F., 17–19, 47; Bakhtin and, 183; communicative action and, 153; Conceptualism and, 95–96; Frankfurt School interpretations of, 146; Lenin and, 76, 221; Marx and, 143–51; praxis and work

of, 139; transcendentalism and work of, 141–43
Helguera, Pedro, 8
HIJOS (Children for Identity and Justice against Forgetting and Silence), 39–40, 56–59, 62, 115
Hirschhorn, Thomas, 127
Hobbes, Thomas, 14
Honneth, Alex, 12, 138, 145–46, 149–52, 156–58, 165, 172
Hooks, Mary, 166–67
Horkheimer, Max, 12, 138, 145
Hosseini, Hamed, 227
Howard Wise Gallery, 92
Huebler, Douglas, 93, 96
Hume, David, 50
hypothesis in practice, escrache as, 68

Ibsen, Henrik, 46, 98
identity politics, criticism of, 221
The Ignorant Schoolmaster (Rancière), 50
Illia, Arturo, 57, 240n7
immanence, dematerialization and, 126–27
Immigrant Movement International (Bruguera), 232
incapacity of the masses thesis, 18, 23, 128–29
Indian Act (Canada), 217–19
Indian Act collaboration, 217–19
Indian Independence movement, 3
indigenous cultures: assimilationist policies and, 217; experience of oppression and, 222; socially engaged art and, 126
individual consciousness: political transformation and, 76, 118; socially engaged art and, 108–17
individualism: autonomous selfhood and, 15–17; collectivity vs., 182–83; communism and, 70–71
Institutional Critique, 26–27, 29
institutionalization of art: agonist discourse and, 36–37; dematerialized art practices and, 93–96; performance-based practice and, 87–88; prison art programs and, 115; Rancière and, 46–47; skepticism of socially engaged art and, 220; of social art practices, 7–8, 235n7
Institutional Reconciliation and Transformation Commission (UCT), 219

instrumentalized labor, Marx's concept of, 148–49, 160–61
interpretive agency, Rancière's discussion of, 50–53
intersubjectivity: aesthetics and, 22; anti-colonialism and, 209; autonomy and, 15; avant-garde aesthetics and, 89–91; Bakhtin on, 13, 178–86, 191–93, 202–4; communicative action and, 152–54; dematerialization and, 95–96; mediation of, 91–92, 141–42; political resistance and, 24, 68; prefigurative dimensions of, 73–74, 124–25, 154–59; Rancière on, 51–53; selfhood and, 19; social labor and, 13, 146–50, 162, 165–70; socially engaged art and, 113–14, 133–35, 188–89, 195–97; violence and, 35–38, 73, 143–44, 160–61, 173, 182, 191–92
Invisible Man (Ellison), 156, 210
Iran, socially engaged art in, 2, 12, 76, 108–10, 113, 117–18, 121–22, 173–74
Irigaray, Luce, 210

Jackson, Shannon, 8
James, C. L. R., 150, 180, 211, 222, 246n46
Jesty, Justin, 8
Joas, Hans, 12, 128, 145
Johnson, Alan, 251n50
Johnson Forest tendency, 246n46
July Revolution, 3

Kakande, Angelo, 110–11
Kant, Immanuel: on aesthetics, 15–17, 43, 52, 189, 191; Bakhtin on, 177–81, 183–84, 191; monological paradigm and, 191; transcendentalism of, 140–44
Kaprow, Alan, 87–88, 92
Kautsky, Karl, 101
khadi cloth revival, 3
Khmer Rouge, 25, 238n33
kitsch: avant-garde critique of, 19, 34–35, 52; Godard on, 100; socially engaged art and, 212–13
Kleinmichel, Philipp, 26–27
kolkhoz collective farm, 70
Kolokol movement, 76
Kosuth, Joseph, 11, 93–97
Kristeva, Julia, 103

labor: experimental cinema and, 97–104; Hegel's discussion of, 141–43; Marxist view of, 143–51; prison art programs as, 115; socially engaged art and, 45–46, 50–53, 77–78, 90–91. *See also* social labor; working class

Labowitz, Leslie, 86, 96

Laclau, Ernesto, 35

Lacy, Suzanne, 86, 96

Laderman Ukeles, Mierle, 92, 96

La Marche Amun collaboration, 218–19

language and linguistics, 94; Bakhtin on, 177–79, 248n15; Habermas's communicative action and, 152–58; labor and, 141–43; Shklovsky on, 176; social labor and, 151–58

Latin American activism, 226–27

Lava la Bandera ("Washing the Flag") actions (Peru), 2, 12, 78, 115–18, 120–24, 134, 155, 170, 172, 188, 190, 195

Laverdant, Gabriel-Désiré, 20

law, Kant's discussion of, 177–78

Lee, Grace, 150

left intellectualism, failure of, 222–23

Léger, Marc, 8

legislative art, 113

Le Joli Mai (film), 99

Lenin, Vladimir: Hegel and, 76, 221; Marxism and, 161–65; New Man concept of, 21, 73, 182; Russian Revolution and, 20, 22–23, 237nn25–26; vanguardist discourse and, 101, 145; Žižek on, 220

Letters on the Aesthetic Education of Man (Schiller), 4–5, 15–17

Lewitt, Sol, 94

Ley del Punto Final, 57, 79

Ley de Obediencia Debida, 57

liberalism, autonomous selfhood and, 15

Lippard, Lucy, 243n10

literature: Bakhtin's discussion of, 177–79, 205–6, 249n44; in post-Revolution Russia, 175–76

The Location of Culture (Bhabha), 208–9

Locke, John, 14

Logose, Vivian Naume, 111

Lukács, Georg, 28–29, 144–45

Luxemburg, Rosa, 233

MacBean, James, 102

Madres de Plaza de Mayo archives, 62

Makhubu, Nomusa, 214–16

Mallarmé, Stéphane, 45, 47, 98

Mann, Thomas, 71

Mao Tse-tung, 20

Marcuse, Herbert, 162

Margaret Trowell School of Industrial and Fine Art (MTSIFA), 110–13

Marker, Chris, 97–104, 170

market, Rancière's discussion of, 48, 131

Marking Time (Fleetwood), 114–15

Marret, Mario, 99

Marx, Karl, 143

Marxism: aesthetic autonomy and, 6–7, 161–70; Althusser on, 199–200, 249n59; anticolonialism and, 209–13, 222–28; authoritarianism and, 44; avant-garde discourse and, 20–29; class politics and, 209; Frankfurt School interpretations of, 146; Full Communism mythos and, 21; neo-leftist critique of, 226–28; praxis in, 139; selfhood and, 160–70, 173; skepticism of socially engaged art and, 220; social labor and, 12, 143–51, 157–70, 199–201

Marxism and the Philosophy of Language (Bakhtin?), 248n15

Masotta, Oscar, 88, 91, 243n10

Massera, Emilia Eduardo, 240n7

materialism, aesthetics and, 159–60

Maurivard, George "Yoyo," 98

mediation: aesthetic autonomy and, 2; artistic practice as, 68–69; Bakhtin's perspective on, 207–8; dematerialized art practices and, 87–88, 91–93; event-based paradigm and, 120–21; language and labor and, 151–58; object-based paradigm and, 119–20; political transformation and, 80–81; production and labor, 147–48

Medvedkin, Aleksandr, 97, 99, 243n25

Medvedkin Group, 11, 99–104

Meier, Rhonda, 217

Meireles, Cildo, 92–93

melting down: of aesthetic autonomy, 74, 87; of artistic practices, 11, 69, 74, 87–93; of post-Revolution Russian art, 69

memory trace of revolution, 73, 78–79; aesthetic autonomy and, 27

Menem, Carlos, 56–57
mentalist paradigm: communicative action and, 152; Conceptualism and, 96
Merleau-Ponty, Maurice, 210
Michel, Viviane, 218–19
Migrant Workers Home, 232
militant research, 226
millenarianism, political transformation and, 73
Mills, Charles, 252n52
Minjung Movement (South Korea), 4
Mitra (Iranian photographer), 109–11
modernism: art and, 6; history of, 69; Rancière on, 47, 49–53; selfhood and, 141
modernity: aesthetic autonomy and, 204; Enlightenment view of, 18–19; postsacral tradition of, 140
MoMA Poll (Haacke), 92
monadic self-reflection thesis, 19, 131–32; Bakhtin and, 187–97; communicative action and, 153–54
monological understanding, Bakhtin's concept of, 181–87, 190–92, 195–96
Moritz, Karl Philipp, 19
Moten, Fred, 208, 210–11, 277
Mouffe, Chantal, 155, 226; agonism discourse and, 35–38; art criticism and, 33–34; on democracy, 36–37, 239n9
movement of the squares (Spain and Greece), 106
Movimiento de Trabajadores Desocupados (Argentina), 56
Müller, Robert, 70
murga bands (Argentina), 58
Museveni, Yoweri, 110–11
Myre, Nadia, 217–18
Mythic Being (Piper performance), 170

Nabulime, Lilian Mary, 126
Naigino, Sanyu Loyce, 111–12
Nakisanze, Sarah, 110
National Convening of the Movement for Black Lives (2015), 166, 225
National Endowment for the Arts (NEA), 114
National Movement of Trans Artists (Brazil), 2, 77
Navy Mechanics School (Argentina) detention center, 58

negation: in avant-garde discourse, 24–25; critique and, 123; of self, 182; socially engaged art and, 232–33
Negative Dialectics (Adorno), 145
Negri, Antonio, 223–24, 226
neighborhood assemblies, Argentine political unrest and, 56
Neither Vertical Nor Horizontal (Nunes), 227
neo-avant-garde: Foster on, 26, 34–35, 87–88; political and social resistance and, 66, 232–33, 253n3; socially engaged art and, 119–26, 133–34, 212–13; stealth art and, 48; surrogacy of the artist thesis and, 130–31
neo-fascism, expansion of, 222, 231–33
Neo-Impressionists, 3
neo-leftist theory, 226–28
Nesbitt, Nick, 221
New Man, communist concept of, 21, 73, 125, 182
Nights of Labor (Rancière), 45
nonartistic factors, dematerialized art practices and, 88–93
nonidentity, principle of, 198
non-pragmatic intersubjectivity, communicative action and, 154–55
norms, autonomous selfhood and, 15–16
novel: Bakhtin's discussion of, 177–79, 205–6, 249n44, 250n5; in post-Revolution Russian culture, 175–76
Nunes, Rodrigo, 219, 221, 227

Oaxaca Commune (Mexico), 171–72
object-based paradigm, 11; Adorno on, 24, 89, 119–20; Conceptualism and, 93–96; Constructivist art and, 71–72; dematerialized art practices and, 88–92; finalization in art and, 197–201; performance art and, 89; Rancière and, 46–47, 53, 55, 80; socially engaged art and, 105, 108; subject-immanence vs., 126–27. *See also* event-based paradigm
Occupy Wall Street, 77, 223
October (art journal), 72
Offering of Mind project, 76, 188
Oiticica, Hélio, 88, 92–93, 127
Ongania, Juan Carlos, 57, 240n7
operative writer paradigm, 69–71, 86

Panagia, Davide, 45
Paris Commune, 3, 20, 23, 204
Parsons, Lucy, 222
partage du sensible, Rancière's concept of, 45–46
participatory art: critique of, 34–35; de-transcendentalization and, 96; examples of, 108–17; experimental cinema and, 97–104; Foster's critique of, 87–88; political movements and, 86–93; Rancière's critique of, 39–53, 182
Peasant Movement, 76
performance-based practice, 11; Bakhtin's performed act and, 180; Black performance, 210–11; Foster's critique of, 87–88; political transformation and, 86–93, 103–4, 115–18; Rhodes Must Fall collective and, 215–16
Perón, Isabel, 240n7
Phenomenology of Spirit (Hegel), 142–43
The Philosopher and His Poor (Rancière), 44
Pink Tide (Latin America), 69, 76
Piper, Adrian, 11, 88–90, 92, 96, 103, 127, 170
piquetero movement (Argentina), 56
Platform for People Affected by Mortgages (La Plataforma de Afectados por la Hipoteca), 77
Plato, 50
poetry, in post-Revolution Russia, 175–77
political action and transformation: aesthetic autonomy and, 14, 21–23, 64–68, 74–76, 229–33; agonism discourse and, 35–37; artistic projects and, 5–10, 115–18; avant-garde discourse on, 24–29, 72–73, 106–8; categories of, 76–78; collaborative and participatory art practices and, 86–93; experimental cinema and, 97–104; mediation and, 80–81; neo-leftist critique of, 226–28; Rancière's theory of, 55; rearguard theory and, 219–28; selfhood and, 137–38; social labor and, 147–51; socially engaged art and, 40–53, 63–68, 74, 76–80
Ponce de León, Jennifer, 8
popular culture: neo-avant-garde critique of, 34–35; socially engaged art and, 212–16
post-Concrete art, 92
post-Marxist political theory, 35

postmodern theory: anticolonialism and, 209; neo-leftist thought and, 226–28
power, socially engaged art and, 123–24
praxis: Adorno's analysis of, 164–65; communicative action and, 155–58; political transformation and, 145; social labor and, 139, 158–70; socially engaged art and, 123–24, 212–19
prefigurative knowledge: Bakhtin's work and, 192–97; collective and intersubjective experience and, 165–70; communicative action and, 154–55; Marxism and, 161–70; participatory art and, 111–13; political transformation and, 24, 77; praxis and, 159; socially engaged art and, 123–27, 212–19
premature desublimation: Marxism and, 162–63; socially engaged art and, 206–8
prematurity of practice thesis, 18–19, 21–23, 129–30
Prestes Maia occupation (Brazil), 77, 126
Prison Arts Program (BECC), 114
prison-based art programs, 113–15
Prison Cultural Exchange Program, 114
Problems of Dostoevsky's Poetics (Bakhtin), 186, 202
Proceso (National Reorganization Process, Argentina), 57, 240n7
Prolekult tradition, 97
proletariat: agency of, 143–45; experimental cinema and, 98–104; Rancière on, 45–46; selfhood of, 148; social labor and, 160–70
prosaic culture, Bakhtin's concept of, 190
public art, activist and "new genre" emergence in, 3
public policy, political transformations and, 77–78
public space, artists' occupation of, 77–78, 173–74

The Question of Uganda's Independence (Naigino), 111–13

racism and racial violence: class and, 221–22; cultural production and, 78; Marxism and, 210–12
Radio Khiaban (Zavarei), 76, 108–10, 113, 117–18, 121, 134, 188, 198

Rancière, Jacques: aesthetic autonomy and, 55–56; Althusser and, 44–45; art criticism and, 33–34, 49–53; escrache activism in Argentina and, 10–11, 29, 39–40, 55–56, 61, 67, 90; mediation in work of, 80–81; neo-avant-garde and, 54–55; on participatory theater, 51–52, 182; on socially engaged art, 39–53, 69, 72, 98; on uniformity of commodification, 131
Rasmussen, Mikkel Bolt, 79
Raunig, Gerald, 70
rearguard theory, 219–28
reciprocity: Bakhtin and, 194–97; communicative action and, 152–53; recognition and, 158; socially engaged art and, 91–93
recognition, Honneth's theory of, 156–58
Red Army Faction (Germany), 237n28
Red Brigades (Italy), 237n28
regime change, political transformation and, 78
Rep History (New York), 61
Residential Schools (Canada), 217
resignation, revolution and, 25–26
resistance: aesthetics of, 211–12; artistic practice and, 127–28; collective and intersubjective experience of, 165–70; communicative action and, 138, 155–58; event-based paradigm and, 120–22; Lukács's analysis of, 144–45; neo-avant-garde and, 66; prison art programs and, 115; reciprocity and, 194; recognition and, 156–58; socially engaged art and, 106–7, 172; women's acts of micro-resistance, 110
re-transcendentalization, 11, 95–96; communicative action and, 155; Hegel and, 142–43; in Marxist discourse, 164–65; praxis and, 140
retrogressive anthropogenesis, Adorno's concept of, 163–64
"The Revolt of the Arts and Letters in Advanced Civilizations" (Goldmann), 101
revolution: cultural production and, 78–79; France, May 1968 unrest and, 98–104; Lenin on, 163–65; Marxist view of, 164–70; resignation and, 25–26; resuscitation of, 107–8; socially engaged art and, 106–7; surrogacy of the artist thesis and, 130–31; temporal continuity and, 25–26
Reynolds, Laurie Jo, 113

Rhodes, Cecil, 213
Rhodes Must Fall collective (South Africa), 2, 77, 127, 213–16
Rhodiaceta factory strike (France), 97–101, 170
Ringgold, Faith, 114
Roberts, John, 35, 130–31
Rockhill, Gabriel, 40, 46
Rodin, Auguste, 46–47
Rodney, Walter, 150–51, 222
Rojava Film Commune (Syria), 2, 77
Rúa, Fernando de la, 56
rupture, Rancière's concept of, 44–45
Russian art: avant-garde and, 72–73; Bolshevism and, 71–73
Russian Revolution: avant-garde art and, 78–81; Bakhtin and, 174–75, 208; Benjamin on, 69–71; melting down of artistic practices during, 69; millenarianism and, 73; origins of, 76; rationale for, 27, 237n25; Russian art and, 72–73

Saint Petersburg Religious-Philosophical Society, 175
Salt March (India), 86
Sánchez Ruiz, Raul, 58
San Juan, E., Jr., 13, 209
Saussure, Ferdinand de, 177
Schiller, Friedrich, 2; aesthetic education theory of, 4–5, 10, 14–19, 125, 182; on French Revolution, 129–30; on political transformation, 21; Rancière on, 34, 41–42, 50–52, 55
Schmitt, Carl, 33, 35
Schoenberg, Arnold, 95
The Science of Logic (Hegel), 220
The Second Sex (Beauvoir), 210
second wave feminism, 210
selfhood: agonist view of, 37–38; in Bakhtin's work, 183–201; communicative action and, 152–58; Enlightenment paradigm and, 14–19; in escraches performances, 66–67; Marxist model of, 160–70, 173; neo-avant-garde and, 133–34; political action and transformation and, 137–38; praxis and, 139; prefigurative knowledge and, 123–25; revolution and transformation of, 106–8; social labor and, 139, 172–73

self-reflexivity: academic theory and, 223; avant-garde art practice and, 132–33; collective identity and, 219–20; transcendental knowledge and, 140–41
Self-Sabotage (Brueguera), 230–31
Senghor, Léopold, 211
sensus communis: aesthetic autonomy and, 203–4; Kant's aesthetics and, 180, 184, 189; Rancière's interpretation of, 43, 50–51; selfhood and, 125; socially engaged art and, 121, 188
seriality of performative art, 197–98; political transformation and, 117–18, 121
sexism, 210–11
sexuality, Marxism and, 210
sexual violence, artistic projects on, 86
Shackville protests (Cape Town, South Africa), 14, 213–16, 219
Shklovsky, Viktor, 34, 52, 174–76, 190, 203
shock, Rancière's discussion of, 42, 44, 46, 49, 52–53
Sholette, Gregory, 8
Sichere, Bernard, 103
singularity of art thesis, 131
Situationist urbanism, 58, 79
Socialist Equity Party, 223
social labor: Bakhtin and, 179–80, 199–201, 203–4, 209; Frankfurt School interpretation of, 145–51; language and mediation and, 151–58; Marxist concept of, 138–46; praxis and, 158–70; socially engaged art and, 172–73, 189
socially engaged art: aesthetic autonomy and, 39–53, 68–69, 90–93, 124–25, 138–39; agonist discourse and, 35–38; Argentina's political unrest and, 56–57, 90–91; avant-garde critique of, 33–35, 207–8; Bakhtin and analysis of, 187–201, 203–8; communicative action and, 153–58; dematerialization and, 126–27; dialogical aesthetic and, 187–201, 212–19; dialogical selfhood and, 172–74; escraches as example of, 62–68; geopolitics and, 125–26; incapacity of the masses thesis and, 129; institutionalization of, 7–8, 235n7; mediation and, 69; melting down of, 72–74; neo-avant-garde and, 119–26; political transformation and, 40–53, 63–68, 74, 76–80, 114–18; pre-

maturity of practice thesis and, 129–30; rearguard theory and, 219, 228; self-transformation and, 106–8, 169–70; social labor and, 138–39, 158–70; subjectivity and, 172–73; temporality of, 86–93
social movements: aesthetic autonomy and, 12–13; art and, 7–10, 62–68; collective and intersubjective experience of, 165–70; communicative action and, 153; criticism of, 223–24; institutional skepticism of, 220–21; vectors of oppression and, 210
social reality, aesthetic autonomy and, 18–19
Solzhenitsyn, Aleksandr, 200
The Sovereign Self: Aesthetic Autonomy from the Enlightenment to the Avant-Garde (Kester), 9–10, 14, 17, 210
spatial boundaries: of avant-garde, 88–89; political transformation and reshaping of, 77; Rancière's discussion of, 51; socially engaged art and, 123
Stalinism, 249n59
Stark, Trevor, 98–101
stealth art, Wright's concept of, 48
Stendahl (Marie-Henri Beyle), 45, 47
Stepanova, Varvara, 71–72, 204
Stieglitz, Alfred, 46
subaltern cultural resistance, 209
subjectivity: affect and, 189; social labor and, 13
Surrealism, 20, 25
surrogacy of the artist thesis, 130–31
"The Symbolic Excess of Art Activism" (Kleinmichel), 26–27
systems theory, 94

Tabacalera de Lavapiés (Madrid), 77
Taller Popular de Serigrafia, 56
Tambo Colectivx (La Paz, Bolivia), 77, 126
Tamms Correctional Center, 113
Tamms Year Ten Committee, 113, 117
Tamms Year Ten project, 2, 12, 77, 113–15, 118, 122, 188, 225, 232
Tatlin, Vladimir, 20
temporality: of avant-garde, 88–89; finalization in art and, 198–99; political transformation and, 79–80; revolution and, 25–26; of socially engaged art, 86–93
theater, Rancière's discussion of, 50–52

Theater of the Oppressed (Brazil), 4, 171–72
theoreticism: Bakhtin's critique of, 179–80, 193–94, 200–201; neo-leftist critique of, 226–28
Theory and Practice (Habermas), 144
Theory of Communicative Action (Habermas), 152
"Theses on Feuerbach" (Marx), 144
Theunissen, Michael, 155
Thompson, Nato, 8
thought, action and, 139–40
Todorov, Tzvetan, 183
Togikwatako campaign (Uganda), 110–11, 116
Touch Sanitation (Ukeles), 92
Toward a Philosophy of the Act (Bakhtin), 183, 203–4
Transborder Immmigrant Tool, 77
transcendentalism: Bakhtin's discussion of, 178–79, 204–5; Kant's model of, 140–41; neo-leftist critique of, 226–28
Trans Collective (South Africa), 215–16
Tretyakov, Sergei, 11, 69–70, 86, 241n36
Tucumán Arde project (Argentina), 86, 90–91, 96, 103, 204

UCT Center for African Studies, 215
Ugandan Young Democrats, 111
undercommons, political theory and, 227
University of Cape Town (UCT), "Shackville" demonstrations and, 213–16, 219
urban interventions, socially engaged art as, 61

vanguard politics: academic theory and critique of, 223–28; Lukács's analysis of, 144–45; selfhood and, 140, 165; socially engaged art and, 106, 137. *See also* rearguard theory
Venice Biennial 2003, 48
Vertov, Dziga, 20
Videla, Jorge Rafael, 57, 240n7
violence: freedom and risk of, 17; revolution and, 237n28

Wall of Respect (Chicago), 86
Wang, Meiquin, 8
Washington Consensus, neoliberal reforms of, 56
Water Protectors (Standing Rock, South Dakota), 77
Weather Underground, 237n28
Weiner, Lawrence, 11, 93
Wellmer, Albrecht, 145
What Is to Be Done? (Chernyshevsky), 165
"What Is to Be Done?" (Godard), 101–2
Whitman, Walt, 46
Wittgenstein, Ludwig, 94
women: in experimental cinema, 98; Iranian participatory art and, 108–11; political transformation by, 219–20; sexism and, 210–11; socially engaged art by, 76, 108–10, 113, 117–18, 121–22. *See also* feminist theory
Woodly, Deva, 78, 165–68, 170
Worker's Photo movement, 86
working class: anticolonialism and, 150–51; Bakhtin and, 179–80; experimental cinema and, 97–104; incapacity of the masses thesis and, 18, 23, 128–29; Marxism and, 209–13; Rancière's discussion of, 44–46, 50–53; social labor and, 163–64, 246n46. *See also* class politics; labor
World Cup of 1978, 59
The Wretched of the Earth (Fanon), 150
Wright, Stephen, 56; Rancière and, 39–40, 46–49, 61, 239n33
Wynter, Sylvia, 141, 211

Young Russia movement, 76

ZAD (Zone à Defender) occupations, 77
Zapatista movement, 106
Zavarei, Saba, 76, 108–10, 173–74, 225
Zedet, Suzanne, 98
Zemlya i Volya, 76
Žižek, Slavoj, 107, 220–23, 226, 251n50, 252n51

www.ingramcontent.com/pod-product-compliance
Lightning Source LLC
Chambersburg PA
CBHW020855180526
45163CB00007B/2514